GEMS AND JEWELRY APPRAISING

TECHNIQUES OF PROFESSIONAL PRACTICE

ANNA M. MILLER, GG, ASA

Van Nostrand Reinhold Company
New York

Copyright © 1988 by Van Nostrand Reinhold Company

Library of Congress Catalog Card Number 87-25383

ISBN 0-442-26467-4

Printed in the United States of America

Van Nostrand Reinhold Company Inc.
115 Fifth Avenue
New York, New York 10003

Van Nostrand Reinhold Company Limited
Molly Millars Lane
Wokingham, Berkshire RG11 2PY, England

Van Nostrand Reinhold
480 La Trobe Street
Melbourne, Victoria 3000, Australia

Macmillan of Canada
Division of Canada Publishing Corporation
164 Commander Boulevard
Agincourt, Ontario M1S 3C7, Canada

16 15 14 13 12 11 10 9 8 7 6 5 4 3 2 1

Library of Congress Cataloging-in-Publication Data

Miller, Anna M.
Gems and jewelry appraising: techniques of professional
practice Anna M. Miller.
p. cm.
Bibliography: p.
Includes index.
ISBN 0-442-26467-4
1. Jewelry—Valuation. 2. New business enterprises—
Management.
I. Title.
NK7306.M54 1988
739.27'0723—dc19 87-25383
 CIP

c¹

To Joanna, for her help,
friendship, and support

CONTENTS

PREFACE

Only a few years ago, if you needed an appraisal of gems and jewelry for any reason, you asked your local jeweler, who hastily scribbled a one-line handwritten note. He or she usually performed the appraisal for free, and did so with reluctance, accommodating you only because as a customer you held the promise of a future sale. The price your jeweler may have assigned to the jewelry was granted without the least regard for market research, legalities, or ethics. In most instances, the estimate was no more than a properly completed sales receipt.

Gemologists were usually pushed into the role of appraiser by their jeweler employers, who were eager to gain an advantage over their competitors by advertising an experienced, well-educated staff. Assured by their bosses and gemological instructors that gemological training constituted a knowledge of appraisal, gemologists took on this role and muddled through the subsequent difficulties. No one ever asked jewelers or gemologists if they knew (or cared) about the differences between value and price.

The first hint that a professional jewelry appraiser might be a distinct entity from a jeweler and separate from a gemologist occurred in the 1970s, during which gems and jewelry gained widespread popularity as investments. Consumers, newly conscious of the effect of grading standards for diamonds and gemstones on their price, began to demand precise reports with exact figures of "value." While gemologists could identify and grade, and jewelers could keystone merchandise to come up with a price, few were qualified to go into court to substantiate their "value" judgments or explain, logically, how it was estimated on a particular item. To make matters worse, no universal appraisal standards for jewelry appraisers were known or used industry-wide.

The revolution in the personal property appraisals field (of which jewelry is a part) is a little more than a decade old. There now exist uniform standards and procedures for personal property appraisers, classes in valuation techniques, and degree programs in the valuation sciences.

Professional jewelry appraisers are on the edge of a new vocation. Banks, insurance companies, and governmental agencies have all helped bring about the changes and contribute to the birth of the profession; they have realized that they can demand and get high standards of performance and integrity from jewelry appraisers, as they can from appraisers of real property.

This book is a guide to becoming a professional jewelry appraiser, not a textbook on gemology or value theory. Valuation theory is a complex study best obtained in structured classes. Similarly, you should already have gemological expertise if you plan to become an appraiser. This book, while recognizing that jewelry appraising as a learned profession is in its infancy, attempts to enlighten both the new and practicing appraiser in current valuation techniques, research methods, markets, liabilities, and legalities.

The prices and values stated in *Gems and Jewelry Appraising* are actual prices compiled from quotes by wholesale and retail gems and jewelry dealers, antique jewelry dealers, manufacturer's price lists, and New York spot commodity prices—precious metals and sales realized from auctions. Since the supply and demand of gems and jewelry vary greatly, sharp differences in price are likely to occur from one geographical location to another, based on regional tastes and local economy. The prices stated in the text are therefore to be viewed as guides rather than exact values.

ACKNOWLEDGMENTS

I owe a debt of gratitude to many people who have helped me with this book. Special thanks to Joanna Angel for editorial assistance. Acknowledgments go to people who specifically contributed information and suggestions to the manuscript: David S. Atlas, Pamela J. Abramson, Dona M. Dirlan, Fabio Graminga, Lynette Proler, Richard F. Digby, Carol P. Elkins, Edward Tripp, Marcia Hucker, Kay and Anthony Valente, Judith Osmer, Dianna Chatham, Dr. Richard Rickert, Shelly Kuehn, Lary Kuehn, Therese Kienstra, Kim Hurlbert, Gail B. Levine, Myra L. Waller, Erin Randall, Emyl Jenkins, Gerhard Becker, Denise DeLuca, Joy McGeorge, Silva Salakian, Tannis Bilkoski, Alfred Brown, Howard Rubin, Patricia Soucy, Berangere Hannedouche, and Ellen Epstein.

Many thanks to the members of the Association of Women Gemologists who enthusiastically participated in several years' research on appraisers and methods of valuation. Thanks to contributors of ideas and suggestions from individual members of the Gemological Institute of America, the American Society of Appraisers, the National Association of Jewelry Appraisers, the American Gem Society, the Accredited Gemologists Association, the Appraisers Association of America, and the International Society of Appraisers.

Special thanks to Dr. Charles D. Peavy, ASA; Joseph W. Tenhagen, ASA; Fred L. Iusi, ASA; and ASA Director of Education Arthur Wilson for providing useful critiques of the manuscript.

I express my appreciation to Elizabeth Hutchinson for the artwork and to Alfred Lee for providing some illustrations. To John Miller for countless hours spent reading the manuscript, thank you.

Finally, thanks to friend and mentor Sara Levy, who was there at the start.

CHAPTER 1

THE APPRAISER

"The whole subject of appraisal of property: it's not an art and it's not a science; in my opinion, it's a mystery."
Tax Court Judge Carlisle B. Roberts
Astoria, Oregon, June 1974

Appraising is a profession that started booming a few years after Judge Roberts pronounced it "a mystery."

The practitioners are a far cry from the old-time traders and miners—those romantic figures of the Gold Rush years. The glamor men and women of the industry today are the gems and jewelry appraisers, who understand gemstone treatments and can determine the country of origin and fair market value of precious gemstones and metals.

For many years, jewelry appraising hardly commanded prestige. "It was more like another hat the retail jeweler put on when absolutely necessary," remembers a New York jeweler. "Most people thought there were a few good ones and the rest were sleazy."

The status and number of jewelry appraisers changed dramatically during the late 1970s, the period of investment gemstones, tax-shelter donations, and barter deals. The demand for independent jewelry appraisers to handle the burgeoning investment market as well as the need to establish ethical standards for appraising were met by a plethora of new appraisal organizations, while creative leadership and guides encouraging those already involved with personal-property valuations spewed forth from established appraisal societies.

Amid the turmoil, the new codes of ethics, the sanctions and the certifications, something exciting happened. To this profession in transit, a separate and elite progeny was born: professional gems and jewelry appraisers. These men and women were wise enough to obtain state-of-the-art gemological and valuation training and aware enough to comprehend that the public's and industry's outcry for reform would probably result in government licensing and a new set of appraisal legislation.

Who Is a Professional Gems and Jewelry Appraiser?

At the present time anyone can call oneself a professional appraiser. However, self-anointing does not confer expertise. The key is *education*. A gemologist or jeweler who has undergone gemological training, holds a degree or special education in valuation science, and has buying and selling experience either on a wholesale or retail level, has the basic prerequisites of an appraiser. Those with a tested, certified ability to value, identify, and grade gems and precious metals, circa-date jewelry, determine manufacturing methods, research, write, and support valuations set forth in a report, have the fundamental skills required to gain a marketable reputation as professional appraiser.

Clientele who may be served by this specialized knowledge include diverse groups: jewelry retailers, wholesalers, collectors, the general public, investors, insurance agents, insurance claims adjustors, bank trust officers, attorneys, state and federal agencies—including the U.S. Customs and the Internal Revenue Service—auction houses, certified public accountants, museum curators, pawnshops, and so on. The possibilities are endless.

The evolution of the jeweler or gemologist into an independent, skilled appraisal specialist worthy of public trust is a welcome step in a trade with a history of misplaced ethics and misguided integrity. In refusing to be swayed from a strong code of ethics, or sense of moral obligation, appraisers will maintain their positions of trust and could act as catalysts to upgrade the credibility of the entire jewelry industry.

A Brief History of Appraising

It has been said that jewelry answers a deep human need for self-beautification. From the earliest known jewelry items, which consist of three fish vertebrae necklaces dating from the late Paleolithic era (25000 to 18000 B.C.) men and women have loved wearing jewelry. Every culture has a history of prizing necklaces, rings, bracelets, and other tokens. Most, if not all, have also treasured earrings. The collection, use, and love of jewelry have been motivated by emotions ranging from blind superstition to monetary security and social status.

The first great jewelry and gemstone collectors were royalty and the church. They were in lock step with the first valuation specialists—the tax collectors or assessors.

Like appraisers today, the tax collectors of old needed some knowledge of values. Interestingly, texts were available for their use from as early as the fourth century A.D. In an Indian text, the *Artha-Sastra,* developed between the fourth and six centuries A.D., a body of rules and standards regulating taxes and other charges were applied to diamonds and precious stones. The text, which has been translated as *The Estimation and Valuation of Precious Stones,* reveals an extensive knowledge of the subject that was used for over one thousand years before evolving into a genuine technical manual known as the *Ratna-Sastra.* This latter text, used by assessors, officials, merchants, and others, has a detailed list of factors to be considered in assessing the value of individual gemstones.

Mostly, however, the search for information about valuation methods throughout antiquity turns up only inventory lists, although the lists themselves can be highly informative and certainly entertaining. One example is the 1750 Treasure Inventory of the Hapsburg-Lorraine family of the House of Austria. It mentions a large holding of jewels, as well as works of art and such heirlooms of religious significance as the Agate Bowl, once believed to be the Holy Grail. To a jeweler and appraiser this inventory is exciting; it can still be viewed, along with much of the listed treasure, in the Kunsthistorische Museum in Vienna.

In 1874, H. M. Westropp wrote *A Manual of Precious Stones and Antique Gems,* in which he lists the item of the Townshend Collection, housed in the South Kensington Museum, London, and the British Museum's Blacas and Devonshire Gems, but does not give their values. He offers one interesting tidbit about value, however, in a quote from a September 25, 1874 issue of the London *Times:*

A valuable addition has just been made to the collection of gems in the British Museum, through the acquirement by purchase of a splendid specimen of the Zircon. It cost upwards of 700 £, and is no larger than a common garden pea. It is one of the finest known. It flashes and glows with a red lustre which seems to denote the actual presence of fire and flame.

Westropp added that he was in a position to state on the best authority that the zircon weighed about three carats.

An early appraisal report can be found in the work of the *Ratnapariska* of Buddhabhatta, written in Sanskrit and now kept in the Bibliothèque Nationale, Paris. This fifth-century manuscript states: "A diamond weighing 20 tandula is worth 200,000 rupakas."

Earlier still, the value of a gemstone can be found in Book 37 of Pliny the Elder's *Historia Naturalis,* written in the second century A.D. He quotes Theophrastus (c. 372–c. 287 B.C.) in giving a price for an anthrax (probably a ruby): "A small ring stone used to sell for forty aurei" (about $205.00). Pliny does not state the price per carat of the gem but he does mention the value factors of gems, which seem to be the same as those still held today: beauty, rarity, and demand. In Pliny's time crystal was valuable for goblets, and aventurine's price increased with the "greater number of stars upon the stone." This sounds a lot like gemstone appraising today, where visual phenomena command a higher valuation.

Some precious jewelry, however, is difficult to place any value upon. Major-General H.D.W. Sitwell, Keeper of the Jewel House of the Tower of London, has declared it impossible and fallacious to affix any monetary figure to the royal regalia:

"It is impossible," he writes, "because the Regalia really represent three values: (a) as precious stones, gold and plate, the value of which might be estimated by a jeweler; (b) as museum pieces, the value of which might be doubtfully assessed by an expert valuer; (c) their traditional value as the Regalia of Great Britain and the British Commonwealth and Empire, the most important value of all" (Sitwell, 1953, viii).

The majority of today's jewelry appraisers, of course, are not faced with the task of appraising crowns and coronets. Most see a lot of cluster rings, straight line bracelets, wedding sets, and pearl strands. They are delighted, however, when an especially elegant item from antiquity or elaborately jeweled object of unknown provenance turns up for valuation. It is this kind of variety that the appraisers enjoy most; the surfacing of a special treasure in an otherwise ordinary collection.

Qualifications and Equipment

Much has been written about who is qualified to appraise gems and jewelry. Does being a gemologist make you a qualified jewelry appraiser? No, but gemological training does provide one of the subskills necessary to appraise competently. Does being a jeweler, buying and selling goods every day, make a qualified appraiser? No, but it provides one of the tools of appraising: a necessary knowledge of the marketplace.

The fact is, many jewelers and gemologists who do appraisals are ignorant about what an appraisal really is: a statement of the value of an article in its common and most appropriate market, not its *price* in any one store in particular. Jewelers set prices; appraisers analyze prices in relevant markets to define value.

Just what is an appraisal? A definition of the term from the North American Conference of Appraisal Organizations (NACAO) was recently quoted in the trade publication *Modern Jeweler:*

A written statement, independently and impartially prepared by a qualified appraiser, setting forth an opinion of defined value of an adequately described property, as of a specific date, supported by the presentation and analysis of relevant market information (Federman, 1986, 44).

The key words here are "qualified appraiser" and "defined value." To determine value requires training and education in long-established appraisal principles, procedures, value theory, and research methods. Furthermore, a knowledge of basic communications is necessary for report writing. Clearly the appraising of gems and jewelry is outside the scope of gemology and requires much more of the gemologist/appraiser than just knowledge of gemstone identification and grading. Similarly, the jeweler who appraises needs to know more than the product. Although formal education in gemology and practical trade experience lay the groundwork, formal appraisal training is necessary to complete the framework for a professional appraiser.

Several jewelry trade, gemological, and appraisal groups have considered the qualifications a professional appraiser must have and list the following basic requirements:

1. Formal education in gemology
2. Training in principles of valuation
3. Training in evaluating various manufacturing methods
4. Experience in buying and selling
5. Knowledge of various levels of value and how they affect the market from source to consumer
6. Knowledge of current wholesale and retail prices of gemstones, jewelry, and watches
7. Knowledge of actual sales prices with access to verifiable data
8. A complete gemological laboratory, which includes the following:
 - Binocular microscope with dark field illumination
 - Refractometer
 - Polariscope
 - Spectroscope
 - Dichroscope with calcite lens
 - Ultraviolet lights, SW/LW
 - Leveridge micromillimeter gauge
 - Table gauges
 - Thermal conductivity probe
 - Metal testing kit
 - Fiber-optic illuminator
 - Diamond color grading light
 - Master grading set of diamond stones, graded by the GIA; five stones minimum with weights of at least a quarter carat each
 - Photographic equipment that will photograph on a 1:1 ratio
 - Specific gravity liquids
 - Gold weight scale (dwt. scale or gram scale)
 - Diamond balance scale or carat weight scale
 - Colored gemstones grading system
 - Tweezers
 - Color filters
 - Chelsea filter

It should be clear that appraising is a discipline separate from gemology, with a recognized education and certification program for the appraiser to follow. As with any professional certification, however, mastery of principles and methods and allegiance to a code of ethics are only the start. Education must remain on a continuing basis for the appraiser to keep up with developing techniques, legal matters, and to hone professional skills to a fine point.

Gemological and Appraisal Organizations and Designations

In the early 1980s, only a handful of gemological and appraisal associations offered designations of members. With the recent proliferation of appraisal societies, however, the industry has found itself submerged in an alphabet soup of acronyms. It would be in the best interest of all concerned if each association and society required stringent testing and/or education of its members, but some do not, the only entry requirement being a fee. The following list should

clarify the confusion about the abbreviations G, GG, FGA, CGA, DGG, and so on. Of course, only you can determine which association best suits your needs, but it is clear that your peers and the public will perceive your gemological expertise and professional standing in the field by the string of initials after your name.

Gemological Associations and Titles

Gemological Institute of America (GIA): Founded by Robert M. Shipley, a retail jeweler and one of America's first trained gemologists, in 1931. Shipley responded to requests for education and gemological information by his associates with a series of lectures that soon turned into the first home-study gemological courses in the United States. Growth was swift and in the 1930s and 1940s the GIA established a laboratory for testing gems and grading diamonds. Improvements were made on existing instruments and new tools for gem testing were developed. Since becoming a nonprofit institution in 1942, the GIA has become a recognized worldwide leader in gem and jewelry studies and training.

Gemologist (G): This designation is given by the Gemological Institute of America, whose headquarters are located in Santa Monica, California, to individuals who successfully complete courses in gem identification, diamonds, colored stones, and colored-stone grading, and who pass a written examination. This course is usually accomplished by home study.

Graduate Gemologist (GG): The designation is awarded to students who have met all gemologist requirements and attended additional classes in diamond appraising and gem identification. Conducted by GIA instructors, the classes are usually one week long each, and are offered in cities throughout the United States during the year.

In a class by itself is the *Graduate Gemologist in Residence* diploma. For many, this is the premier accomplishment. The course covers all subjects taught at the gemologist and graduate-gemologist levels, but the students are taught in residence at the GIA facility in Santa Monica, or at the institute's New York campus. The residency program lasts about seven months. Other courses can be added—such as retail jewelry training, pearls, appraisals, and jewelry design—that can extend the total training time to a little over a year.

Certified Gemologist (CG): The title is awarded by the American Gem Society, in Los Angeles, California. The AGS is a nonprofit professional organization with members throughout the United States and Canada. Its purpose is to advance gemological knowledge, promote ethical practices, and enhance the public image of the jewelry industry. The AGS was founded in 1934 by Robert M. Shipley, who was also the founder of the GIA. The certified gemologist title may be obtained by AGS members who have already qualified as registered jewelers and completed an advanced course of study in gemology. Candidates must function as registered jewelers for one year before they can become certified gemologists. Candidates must also have a gemologist or graduate gemologist title from the GIA. Although the individual gemologist is given the title, actual membership is held by the gemologist's employing firm; if the title holder leaves the firm, he or she can no longer use the certified gemologist designation.

Professional Gemologist (PG): The title is awarded by the Columbia School of Gemology, located in Silver Spring, Maryland. The course of study is four-and-one-half months long, eight hours per week, and is approved by both the Maryland State Board of Higher Education and the Veterans Administration. Those who successfully complete the program and pass a written and practical examination are certified as professional gemologists.

Fellow of the Gemmological Association (FGA): This title is awarded to the successful candidate for the gemological diploma of the Gemmological Association of Great Britain, the United Kingdom's equivalent of the GIA. The program is a correspondence course backed by coaching and guidance from the GA. The course involves two years of study and is divided into two parts, preliminary and diploma. This diploma is recognized worldwide as having a high professional and scientific standing.

Fellow of the Gemmological Association of Australia (FGAA): A course of study closely equivalent to that of the Gemmological Association of Great Britain, leading to a diploma for the designation FGAA.

Gemmologist, Accredited Gemmologist, Accredited Jewellery Appraiser (G, AG, AJA): These titles are given by the Pacific Institute of Gemmology, a registered trade school in Vancouver, Canada. The gemmologist certificate is awarded to students who have successfully completed the introductory course in gemmology or an equivalent study, as well as the courses on diamond grading and advanced gemmology. The accredited gemmologist diploma requires the gemmologist certificate (or equivalent) and completion of courses in coloured stone grading and practical gemmology. The accredited jewellery appraiser program requires four additional courses on appraisal procedures, grading, and appraising; a recognized diploma in gemmology; recertification after three years; and annual maintenance fee.

German Gemmological Society (DGG): The Deutsche Gemmologische Gesellschaft, or German Gemmological Society, awards its members a diploma equivalent

to the GIA's graduate gemologist diploma. Applicants must successfully complete a gemological study program in Idar-Oberstein, West Germany, and pass an all-day written, oral, and practical examination. The program of study is similar to that given by the GIA.

Appraisal Organizations and Titles

The American Society of Appraisers (ASA): This group, founded in 1936, is open to individuals engaged in the appraisal or valuation profession or in related activities. The society has approximately five thousand members worldwide, with fewer than one hundred and fifty of these falling within the gems and jewelry discipline. The ASA has an affiliate level as well as three grades of membership: candidate, member, and senior member. The affiliate level is for those who wish to be associated with the ASA but do not desire to advance within the organization. Membership is on an individual basis, and is not offered to business firms. Persons applying for the entry-level candidate grade of membership are required to take and pass an ethics examination during their first year in the ASA. Those seeking to join the ASA at the member level or to be promoted to member must pass an eight-hour written examination testing the applicant's knowledge, expertise, and competence within his or her discipline; submit two sample appraisal reports; have two years of full-time appraisal experience; and possess a degree in evaluation sciences, engineering, accounting, law, or business administration from a qualified school, or the equivalent of such education, as approved by the ASA's Board of Examiners. Senior members must meet all of the above requirements and have a minimum of five years' full-time appraisal experience. Only senior members may use the designation ASA after their names. In addition, senior members must recertify every five years. Fellowships (FASA) may be bestowed upon senior members by the ASA Board of Governors, in recognition of outstanding services to the appraisal profession or to the society. Fellows are entitled to use the designation FASA.

Master Gemologist Appraiser (MGA): This program was developed by the Accredited Gemologists Association in 1983, and became part of the American Society of Appraisers in 1987. The designation "master gemologist appraiser" is the highest appraisal title awarded in the gems and jewelry division of the ASA.

Rigid requirements must be met to earn the title. The candidate must have an accredited gemological laboratory (with a specific number of gem instruments); must have three to five years of documented appraisal experience; must be a graduate gemologist or the equivalent, such as FGA; must pass an investigation of character, integrity, and past appraisal performance; and must submit to policing of appraisal practice. A three-day program covering appraisal practice and procedures as well as valuation theory prepares the candidate for the five-hour practical test, in which each appraiser receives three major pieces of jewelry for valuation. The candidate must test and conclusively identify each stone and piece of metal; calculate weights; grade for color, clarity, and proportion; plot the inclusions of major diamonds; and photograph the item. The candidate must finish all work before leaving the examination room, and the entire appraisal must be prepared just as it would be for a client, except that the appraisal is hand-written. All of the worksheets and notes used by the candidates are submitted with the completed appraisal document. Candidates may use their own master diamonds and any charts, price lists, or notes. Furthermore, all candidates are given the Farnsworth-Munsell hundred-hue test to determine their color perception.

In addition to the practical examination, the candidates have three hours to take a forty-question written test covering such areas as appraisal procedures, ethics, and market-value definitions. Finally, the MGA candidate must submit copies of three appraisals that he or she has completed within the past year.

American Gem Society Certified Gemologist Appraiser (CGA): This society was the first to test and title jewelry appraisers. Although at this time the AGS has no formal training program for appraisers, they do test the competency of a candidate. Candidates for the certified gemologist appraiser title are given four hours to take the examination; they may divide their time among the practical and written portions as they choose. The written portion of the examination consists of twenty multiple-choice questions testing knowledge of appraisal theory. For the practical test, the candidate is required to appraise six items: one strand of pearls and five rings. Each ring must contain at least one major center stone, and all items must be described in detail, evaluated, and priced. The candidates do not have to test either the metal or the stones—the AGS believes that since its candidates are already certified gemologists, they need not prove their gemological competence. After the candidates turn in their worksheets and evaluations, they return home to translate their copies of the worksheet into a finished appraisal, to be returned to the AGS within two weeks. The candidates are graded on their ability to describe and evaluate jewelry items as well as on the professionalism of their presentation.

International Society of Appraisers (ISA): Founded in 1979, the ISA has approximately thirteen hundred members, of which about two hundred and fifty are

gems and jewelry appraisers. As of January 1, 1987, there are three levels of membership: associate, member, and CAPP (certified appraiser of personal property), a certified grade. Associate is an entry-level membership that can be obtained by paying an entry fee. To be designated a member of ISA, one must attend three core courses and complete their examinations. The courses cover legal, ethical, and theoretical aspects of appraising, and are basic to all disciplines of personal property appraising. Earning the CAPP designation requires the successful completion of the core courses and exams as well as specialized appraisal education in the candidate's discipline. Home study, professional development activities, and specialty reports are also requirements.

Appraisers Association of America (AAA): This group began testing and certifying its members late in 1986. Based in New York, the group meets monthly and conducts seminars and special conferences. AAA and ASA are the two largest nonprofit personal-property appraisal organizations in the United States. Currently, it offers membership only, not titles signifying certification.

The National Association of Jewelry Appraisers (NGJA, NJA): No certification or testing of members is made at the present time, but the NAJA does grant an accreditation to members who meet requirements of documented education and appraisal experience. Designations granted are national jewelry appraiser (NJA) and national gem and jewelry appraiser (NGJA), the latter being the senior member designation.

Educational and Vocational Programs for Appraisers

In addition to the programs offered by the various gemological and appraisal organizations, several United States colleges and universities offer baccalaureate and master's degrees in the valuation sciences, including Hofstra University, Hempstead, New York; Loretto Heights College, Denver, Colorado; Skidmore College, Saratoga Springs, New York; Southwest Texas State University, San Marcos, Texas; Dyke College, Cleveland, Ohio; and Lindenwood College, St. Charles, Missouri. Serious personal-property appraisers will find a degree in the valuation sciences to be an asset to their careers, and should give it earnest consideration.

Lindenwood College at St. Charles, Missouri, offers an appraisal degree program unique because of its format. A four-year program with annual two-week intensive course of study on campus at Lindenwood can enable a candidate to earn a bachelor's or master's degree in valuation science. Each two-week program is structured to provide the nine required credit hours for one trimester's work and meets the standards of the North Central States Accreditation Association. When the student leaves the course and returns home, he or she is then required to complete course requirements of research and writing. The program enables applicants to earn a bachelor's or master's degree in valuation sciences by combining existing college credits from an approved institution with the hours earned at Lindenwood. With appropriate transfer and other credits, students can normally earn a degree within four years. The thirty-six credit hours earned in the four trimesters are used to meet the requirements and complete the one hundred and twenty semester hours necessary for graduation for undergraduates; graduate students need thirty-six semester hours of credit for a master's degree.

The major topics in the program consist of the theory and foundations of appraisal; focused studies for appraisers of real estate, business, and personal property; a term of study in investment analysis and strategy for the income approach; and a final study of writing techniques and thesis research for preparing advanced appraisal reports. All students complete a culminating thesis.

The American Society of Appraisers has a career development program consisting of four three-and-one-half-day courses. The courses explore the concepts of value theory and its application to the specific discipline, such as business valuation, fine arts, gems and jewelry, and machinery and equipment. The course of study for the disciplines of personal property and gems and jewelry are designed to expand comprehension of basic value theory as well as the report-writing and research skills necessary for professional appraisers. Designed to provide appraisers with the fundamentals and background to become more professional in their practice, the courses also aid the ASA candidate and other aspiring appraisers in preparing for ASA's examination and certifying process. Continuing education units (CEUs) are awarded for attending all hours of instruction and passing the exam for an individual course. In addition, by arrangement with Lindenwood College, undergraduate and graduate college credits can also be earned by participants.

A series of classes in the basics of appraising is also offered by the International Society of Appraisers (ISA), in conjunction with Indiana University's School of Continuing Studies. The classes are offered in different cities throughout the year and the curriculum includes instruction in professional ethics, business practice, methodology, and the legal aspects of

appraising. Those willing to fulfill some additional requirements can earn the certified appraiser of personal property (CAPP) title. Although the program does not award an academic degree, it presents important information and instruction to appraisers. Much of the information provided is directly applicable to the appraisal of gems and jewelry.

National Certification of Appraisers

Although at this time appraisers may undertake formal training and education in the valuation sciences simply to increase their knowledge and gain greater professional status, it is inevitable that appraisers will soon have to undergo national testing and certification. Legislation on testing and certification is expected to be passed by the end of this decade.

In the House of Representatives, the Commerce, Consumer and Monetary Affairs Subcommittee on Government Operations, chaired by Representative Doug Barnard, Jr. (D., GA), opened hearings in Washington late in 1985 concerning the impact of faulty and fraudulent appraisals on both real estate loans granted by federally insured financial institutions and on related real estate activities.

Congress has become concerned. The testimony presented at the hearings painted a picture of a totally unregulated profession, with only 10 to 20 percent of all persons who do appraisals holding any form of membership in a national testing and certifying appraisal society. Moreover, the only kind of licensing that now exists is aimed at real estate appraisers and is based on an examination of basic real estate knowledge, not technical appraisal knowledge. Even this regulation has not been adopted by all states.

The vast majority of appraisers in this country—both real-property and personal-property appraisers—are not currently accountable under any licensing laws, standards of professional practice, codes, or professional ethics, nor have they been examined as to their knowledge of appraising. National certification may make it possible that any individuals found guilty of unethical and/or fraudulent appraisals could, upon proof of incompetence or unethical practice, be prevented from engaging in all future appraising.

At the request of the Congressional committee, representatives from nine appraisal groups got together and drafted the Uniform Standards of Professional Appraisal Practice. The nine organizations represented were the American Institute of Real Estate Appraisers; the American Society of Appraisers; the International Right of Way Association; the National Association of Independent Fee Appraisers; the Society of Real Estate Appraisers; the National Society of Real Estate Appraisers; the American Society of Farm Managers and Rural Appraisers; the International Association of Assessing Officers; and the Appraisal Institute of Canada. The only organization representing personal-property appraisers (of which gems and jewelry is a part) is the ASA. The ASA insists that these standards be applied to *all* appraisers, of both real and personal property. The nine organizations have formed an umbrella group called the Appraisal Foundation, which will form a standards board and a certification board that will conduct a national certification program. Under the projected certification program, all accepted, qualified appraisers will have a certification number that will qualify them to do work for federal agencies, such as the Internal Revenue Service, as well as insurance companies and banks. The federal intervention will eliminate some flagrant abuses in the appraisal industry that have surfaced across the country owing to the lack of standards.

The majority of tested and certified personal-property appraisal practitioners are in favor of the installation of such standards and boards because they recognize that unqualified appraisers will not be stopped or swayed by self-imposed standards. Strict and impartial national codes may be the only way to keep the incompetent out of the industry.

The Importance of Belonging to Associations

Since 1930 the Gemological Institute of America has graduated over ten thousand gemologists. It cannot be doubted that a large percentage of those people have combined work in the jewelry business with appraising as a means of making a living. Regardless of how they have used their gemological education, they have felt the need to assemble together from time to time to swap information with their peers and reassess their goals. History tells us that individuals with similar interests have always tended to congregate in one particular section of a city or town. This was true of the communities of jewelers and artisans in ancient Alexandria, Rome, and Smyrna. The early artisans recognized that by joining together to form a society or guild they could exert pressure upon the state and church, and thereby influence the politics and the economics of the country indirectly.

In a similar sense, this still holds true today. Many gemologists, jewelers, and appraisers belong to an association or society of their peers in order to gain the "protection" of the assembly and reap the benefits of the association's good reputation. Concurrently, gemological and appraisal associations, like the Marines,

are always looking for "a few good men" and women to swell their membership. If fan mail is any barometer, certified jewelry appraisers are as good as gold —and just as eagerly sought.

In the early 1980s, the American Society of Appraisers received over ten thousand requests for appraisal help. In reply, the ASA sent names of its members. This is the first benefit of belonging to an association: you establish credibility as an appraiser and profit from advertising provided by the association.

Belonging to an association of your peers can also give you greater potential media exposure. Local radio and television talk-show hosts are generally eager to find gemologists and appraisers to interview because the subject of gems is romantic, and determining value of an object mystifying and interesting. Hosts seek out articulate experts by contacting gemological and appraisal associations, since they often perceive professionals belonging to such organizations as having greater status than those who operate alone and unaffiliated. In addition, newcomers to town are more likely to search the Yellow Pages for an association that they know from previous contact. Your listing under the association's umbrella advertisement may often turn out to be a substantial source of clientele.

Participation in local and national meetings helps you develop close bonds with other appraisers in your field, and this networking experience can be the most important tangible in your career. Before joining any group however, make sure that the organization will operate with your best interests in mind as a member of the team. Attend a meeting or two and meet the people with whom you will be sharing the title of member. Ask your friends and associates what they know about the organization and its members. Are they respected as professionals in the community because of their superior knowledge and ethics, or is the organization just a social club? You can find out a lot about an association with a simple question to a few of its members: What does this association do for you? Your decision to join should be based on careful attention to the answers you receive.

Ideally, an association should offer continually updated information in your special field, and should provide contacts to further your vocational goals.

The most vital reason, however, for belonging to an association is a legal one. If your career as a jewelry appraiser lasts long enough, you will almost certainly be called upon to serve as an expert witness at one time or another. When you do appear in court, your credentials will be carefully scrutinized; being a tested and certified member of a national association of appraisers can go a long way toward making you a

credible witness. (See chapter 5 for further discussion of expert witnesses.)

On the other hand, some courts may accept any association as worthwhile and fail to distinguish among those indigenous to the field and those that are totally irrelevant.

A highly respected personal-property appraiser, Dr. Charles D. Peavy of Houston, testified in a trial and was quizzed about his credentials as expert witness. Peavy explained that he was a senior member of the American Society of Appraisers and had been examined, tested, and certified by ASA in his discipline of personal property. The opposing witness, when asked about her credentials, stated that she was a Smithsonian Associate. The judge agreed with the opposing witness that the Smithsonian was a fine institution, and commented that he had never heard of the ASA.

Dr. Peavy was later able to explain to the court that being a Smithsonian Associate simply means that the member receives *Smithsonian* magazine and has discount buying privileges and a few other perquisites at the Washington facility. When opposing counsel tried to defend the SA title, Dr. Peavy observed, "I have just been elected to the National Geographic Society, but that doesn't make me a geographer."

Conflict of Interest

Because many appraisers are also jewelers, antiques dealers, auctioneers, consultants, and pawnshop owners, the question of whether a dealer can stop dealing during an appraisal is often raised. Can the obvious conflict of interest be kept under control? It is a much debated issue. Jewelers who appraise maintain that because they are active in the marketplace, they know what an item will sell for; thus, they reason, they are better qualified to know the true value of a gem or jewelry item than is an appraiser who is not a dealer. The number of professional gems and jewelry appraisers who handle appraisals only is growing, but until the demand for appraisers without vested interests is met, jewelers and appraisers may continue to coexist in the same business, if not the same body. The problem of conflict of interests has been addressed by the ASA in this way:

. . . it is unethical and unprofessional for an appraiser to accept an assignment to appraise a property in which he has an interest or a contemplated future interest.

However, if a prospective client, after full disclosure by the appraiser of his present or contemplated future interest in the subject property, still desires to have that appraiser do the work, the latter may properly accept the engagement, provided

he discloses the nature and extent of his interest in his appraisal report (American Society of Appraisers, 1968).

By making a simple declaration, jewelers who buy, sell, and appraise can prevent possible misunderstandings.

Opening an Appraisal Service

Every year people try to escape from ordinary jobs and dreary vocations. It has been estimated that as many as twenty-five million Americans change jobs annually. Those who are in the jewelry business can easily believe these statistics, for it often seems that every other person they meet was once in the business, is in the business, or wants to be in the jewelry business. Gemstones and jewelry, with their aura of glitter, money, and excitement, draw many into the industry. However, it takes motivation and staying power to succeed.

The U.S. Census Bureau tells us that 60 percent of all new businesses fail, dissolve, or reorganize within the first two years of operation. Most failures can be traced to mismanagement; one-third fail from undercapitalization. A budding businessperson needs a clear concept of the business, clients, and goals. A sound plan of action is essential. Plan to do a lot of research before you make a commitment, and be sure to consider the following points.

How will you raise capital and how much money will you need to establish the new business? The first rule for opening your own business is to have enough cash on hand to cover all overhead expenses and forego drawing a personal salary for at least six months, and preferably for one year.

A major problem for many women, however, is raising the money for a new enterprise. Most banks are not interested in loaning venture capital money, although they do look favorably upon wage earners. When you consider how to raise money, it would seem wise to hold onto your present job while in the process of applying for a personal loan to be used for a new business.

The amount of money you will need for start-up will certainly be dictated by your personal life-style, ambition, and a careful analysis of projected business income and overhead. However, an operation can be launched on a shoe-string for as little as three thousand dollars if you already own gemological instruments or have access to them, as one woman gemologist in Tucson discovered. Bent on success, she borrowed three thousand dollars from a friend after her loan applications were turned down by banks, and opened a one-room 750-square-foot office in a strip shopping center. She furnished it with antiques from her own home and prepared appraisals off a desktop that doubled as a salescounter. It took a few years of devoted application to drumming up business and clientele, but her imagination and talent paid off. When she eventually expanded her business, she tripled her office space and opened a completely equipped gem laboratory, diamond selling room, and retail sales area.

If you do not have sufficient capital, or are unable to obtain financing, you may consider a partnership. By combining money and talent, two partners can often accomplish what one cannot do alone. Be aware, however, that there are pitfalls involved in partnerships. A high degree of mutual trust is required for both parties.

There are two forms of partnerships that seem workable: the silent partnership, in which the silent partner puts up half the money in return for half of the profit but does not participate in the day-to-day business operations; and the limited partnership. Like the silent partner, the limited partner shares in the profits of the business and does not have a voice in management. However, the limited partner is liable only for the amount of his or her monetary contribution to the business. A limited partnership is often created for the express purpose of obtaining additional business funds.

Whichever you decide upon, be sure to have an attorney prepare a written agreement drawing up the terms of the partnership. The agreement will spell out exactly who has what authority and set the limits of individual expenditures. The agreement will also stipulate how the partnership may be dissolved, for reasons of disagreement or death.

If you are planning to be an independent appraiser working for a jewelry store or individual jeweler, the partnership will probably take the form of a handshake or gentlemen's agreement, with both parties filling the needs of the other. Some jewelry vendors who lease space in large department stores, including department-store chains, hire independent appraisers to appraise in the store on a full-time or piecemeal basis.

A common and quick way to open a business is to rent an office in a building housing similar jewelry operations, usually wholesalers and jewelry repair shops. These people can be a good source of appraisal income and you may also get walk-in customers who have other jewelry business in the building. There are also cooperative offices in most large cities in which your contract for office space also pays for a group receptionist and telephone answering services.

After you have selected a site, check the location and the apparent prosperity of the neighboring busi-

nesses. Is the office or store in a stable, changing, or deteriorating part of town? Who are your neighbors? Do the surrounding businesses sell a product compatible with yours? How is the customer traffic? Is parking adequate or public transportation accessible? Will there be much competition from other jewelers, discounters, or department stores? Inquire about municipal codes that might affect your business, including any permits necessary or building codes regulating the remodeling or restoring of sites (especially historic buildings), and do the basic research needed to build a profile of customer demographics.

If yours is a low-budget operation, try not to spend money on fancy decorating, at least not initially. You can profit nicely with a few hundred feet of space divided into two rooms with a partition or clever furniture arrangement. The idea is to create a private area that you can use as a laboratory. Since many clients will not want to let their jewelry out of their sight, have extra chairs in the lab so that customers can watch as you conduct the examination. The front office should be furnished with a desk, typewriter, telephone, and comfortable chairs. A computer is optional for a new business, but you will need fireproof filing cabinets to safeguard your records and a UL-approved high-security safe to store customer property if you plan to hold anything overnight.

Decorating can be accomplished with a bit of creative effort and imagination. Offices need not all be furnished from an office furniture store. An Indian or Oriental-style rug, bookcases or armoires, and a few green plants can create a serene yet professional ambiance. Of course, you should hang your diplomas and certificates on the walls; be sure they are handsomely framed.

Painting and carpentry will not be a problem if you decide to locate in an office building. If you opt to move to a shopping center, find out whether you will be required by the terms of the lease to provide your own wall and floor coverings, do your own carpentry, and supply your own heating, cooling, and lighting systems. These are expenses you can do without when you are just going into business. If nothing but a shopping-center location will do, try to find a previously occupied space that needs little or no alteration. In most cities, you will have to pay a deposit for electrical service. Some office complexes include this in the rent.

Office buildings generally list each business in their directory, which is usually located in the lobby. Freestanding buildings and shopping centers, on the other hand, sometimes stipulate that individual business signs must conform to specific sizes, types of lettering, and materials. Most banks and office buildings will not permit freestanding signs.

Your professional letterhead and other basic appraisal documents need to be considered early in the process of opening an office. Quality printing takes time but is essential—your professionalism will be reflected in your stationery and appraisal forms.

You should contract for an advertisement in the Yellow Pages as soon as your lease is signed, since it will usually be several months before the advertisement appears in the next issue of the publication. It is unethical, however, to advertise a title or group affiliation in such a way as to imply that you have been tested by the organization for your appraisal expertise *if* the title does not involve certification for such proficiency, or if you have not been granted full rights to the title by the association.

You should have an attorney review any lease before you sign it. Many people, especially those in smaller communities, hesitate to hire professional consultants to assist them when they open a business. The main reason is cost—a good lawyer or accountant can charge a hundred dollars an hour or more. However, saving money by scrimping on consultants' fees can be costly in the long run. Many leases require you to join merchants' associations, adhere to specific opening and closing hours, or pay a variety of hidden extra fees. Similarly, it is worthwhile to hire a bookkeeper or accountant to set up your initial bookkeeping system.

Find out if you need a resale number and obtain one if necessary. Most states require you to have a resale number even if you intend only to appraise and do not collect state sales tax for appraisals. A sales-tax deposit must be paid to the State Tax Board when you obtain a resale number. It is based on store rent, projected sales, and so on. You will probably also need to apply for a business license; most cities mandate these.

If you do not already have Errors & Omissions insurance, you will need to obtain it. An E&O policy covers any claims for damages arising from negligence, errors, or omissions resulting from professional services rendered, or that should have been rendered. It also covers the cost of defense against suits alleging damages for the above reasons, even if the suit proves false, groundless, or fraudulent. A solid policy will cover claims made anywhere in the world. It does not cover bankruptcy; libel or slander; any dishonest, fraudulent, malicious, or criminal acts or omissions by the appraiser; punitive damages; bodily injury; or property damage. However, it does provide a security blanket for appraisers, in recognition that the technical problems involved in appraising gems and jewelry are such that there is always the danger of errors from which loss may result.

E&O insurance is expensive and can be difficult to

obtain, especially for appraisers who cannot demonstrate a good track record. See whether your state jeweler's association offers group insurance rates (if you are a member) or, if you are an independent appraiser, try to obtain coverage through one of the appraisal organizations you belong to.

Becoming a Portable Appraiser

Many appraisers opt to be "portable"—that is, to maintain an office base in their home, but conduct appraisals at the client's home, office, or other location. There are many aspects to being a portable appraiser that do not apply to appraisers in fixed locations. The most obvious difference is that portable appraisers have no office or overhead costs. The second advantage is freedom of movement. In addition, portable appraisers do not have to fill out take-in forms or worry about clients accusing them of switching stones or damaging valuables, since they do not keep any jewelry overnight.

Of course, there are also disadvantages to working out of your home: heavy loads of equipment must be carried to each appraisal. Lighting and working conditions are often less than ideal, you may frequently have to put up with misbehaving children and/or pets, and the public will have access to you twenty-four hours a day unless you have a separate business telephone or answering machine. Also, you must gather, write, and interpret all information about the jewelry during the examination, for if you forget to check an item or option on an item, you may have to make another trip back to see the jewelry, thus losing time and money. Moreover, some people perceive portable appraisers as less professional than their storefront counterparts, although this attitude is changing. Many professionals—including real estate brokers, accountants, architects, and consulting engineers—work out of their homes. The United States economy is becoming more service oriented, and as a portable appraiser your services will be in demand.

All the equipment necessary to handle almost any appraisal can be carried in a small suitcase. The Gem Instruments Corporation sells the MaxiLab, and Gemological Products manufactures the Portalab (figs. 1-1, 1-2). Both are complete, self-contained gem testing laboratories that can be carried and used anywhere. With options, prices range around four thousand dollars.

In addition to a portable lab, you will also need to outfit another case with a movable office; a catalog or book salesperson's case is ideal. The case should contain photographic equipment and film; a pennyweight or gram-weight scale; a tape measure; a pocket calculator; a millimeter gauge; a carrying case of diamond masters; a diamond-weight scale; work-

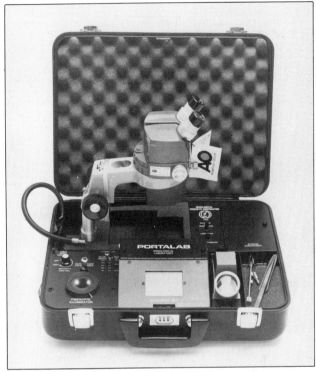

1-1. The Portalab, a convenient way for portable appraisers to carry a gemological laboratory into the field. (*Photograph courtesy of Gemological Products Corporation*)

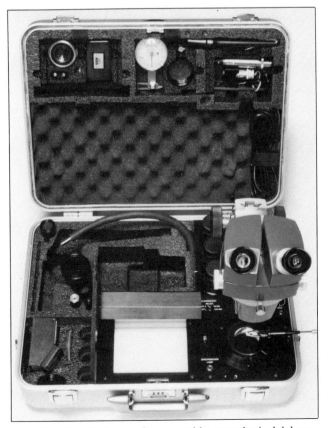

1-2. The MaxiLab, another portable gemological laboratory. (*Photograph courtesy of Gem Instruments Corporation*)

Table 1-1. The Costs Involved In Getting Started

1. Gem Instruments MaxiLab, with American Optics 790 binocular microscope (price on contract)	$4,300.00
2. Leveridge gauge and estimator, European model, Stoppani Bern 21 with case and book	175.00
3. Fuji Instant Camera CM1 Photorama color copying camera	875.00
4. Film (1 case)	340.00
5. OHAUS Port-O-Gram Electronic Balance C301P gram, ounce, dwt. (300 gr.), with carrying case	215.00
6. Gem utility lamp 3-way light source: Horizontal monochromatic yellow light; horizontal white light; vertical white light	210.00
7. GIA GEM Mini-Diamondmaster with warning buzzer	225.00
8. Gem Instruments Illuminator Polariscope	126.00
9. GEM Duplex II Refractometer	245.00
10. Lucifer lamp, with two daylight tubes; white with black base	180.00
11. FILE-A-GEM deluxe diamond wallet	59.00
12. Cordix pearl gauge, with carrying case	45.00
13. Tweezers:	
Pearl tweezers with pads, chrome	14.00
Extra fine point, 15cm, black	9.00
Fine point, 15cm, black	9.00
Locking tweezers, 14cm, black	10.95
14. Diamond Master Stones: GIA GEM trade laboratory certificates, five stones	2,700.00
15. Pearl master strands	600.00
16. Loop-closing pliers	11.95
17. Vigor rings, sizes 1–15	10.50
18. Square file	5.35
19. Kassoy cloth	1.65
20. Test stone box	19.95
21. Diamond manufacturing cut stones	195.00
22. Rubin parcel papers	8.95
23. Plastic box for loose stones	39.95
24. GIA property charts A & B	15.00
25. Mini-Vac	29.95
26. Diamond-shaped adhesive labels	5.95
27. Message rack	5.49
28. Dial caliper (metric)	21.00
29. Dues to professional organizations:	
American Society of Appraisers	115.00
Accredited Gemologists Association	125.00
National Association of Jewelry Appraisers	125.00
GIA Alumni Association	60.00
30. Subscriptions to price guides:	
Diamond Market Monitor; Precious Gems Monitor; Gemstones Monitor	225.00
The Guide	125.00
31. *Gems and Gemology* subscription	22.00
32. *Jewelers-Circular Keystone* subscription	24.00
33. *Journal of Gemmology* (Great Britain)	50.00
34. Gemology reference and text books:	400.00
35. Stationery, forms, report covers, brochures, business cards	700.00
36. Gemological Appraisal Association's *Appraisal Manual*	125.00
37. Desk, three chairs, lamp, carpeting	1,000.00
38. Gemline Information Service: *Kashan Ruby Identification Study*	85.00
39. #110 Thai (Siam) Ruby Identification Study	85.00

sheets; and any other hand tools you believe will be necessary.

Table 1-1 shows a breakdown of the typical costs involved in starting a new business. It includes an itemized list of all the equipment that one gemologist, who opened a new business in Illinois in 1986, needed to conduct appraisals both in his office and in the field. He already had a typewriter and hand tools; other equipment, such as heavy liquids and ultraviolet light, was provided as part of the MaxiLab. The appraiser later felt it necessary to add a color grading system with some colored-stone comparables to this list of "must haves." It cost him over fourteen thousand dollars to start his new business, not including rent, deposits, or licenses.

Building a Clientele

Whether your business will be large or small, you will need to budget money for advertising. You should advertise directly to the public if you are an independent businessperson, and advertise in trade journals or through direct mailings if you are working with or for a jeweler. Advertising can take several forms and can be an elaborate or a simple do-it-yourself project, as your budget permits.

Advertising agencies and public relations firms exist throughout the United States and can help you launch a business, improve your public image, or build a high public profile. Some will set up an account for you and charge you according to the time spent on your project; others charge a percentage of the money you spend on advertising; still others do both. However, it is likely that no agency will want your business if the billing will run to only a few hundred dollars. They simply will not want to expend the energy on such a small return. You can do it on your own and get good results by being creative, alert to opportunities, and persistent in making your own media and business contacts.

Whether you are opening up your own business or

forming a partnership, you should announce the new business in the local newspaper first. You may also consider advertising in the local legal newspaper—most metropolitan cities have one—in club or religious newsletters; in trade publications; and in direct mailings to attorneys and insurance companies, whose names can be found in the Yellow Pages directory. Your local weekly or daily community newspapers are likely to be a good bet, as they tend to be receptive to running announcements and press releases. If you take out an advertisement in the paper, you can reasonably request a feature story on your business, too. Bear in mind that during the summer, many local papers are without the copy they usually devote to schools and sports, and may be looking for space-filling material. It is most important, however, to remember that many weekly papers are understaffed and also that they prepare their newspapers many days in advance of printing. To maximize your chances for publication, submit a press release that needs as little rewriting as possible, and send it in early. Follow the standard format for press releases:

1. Type the release, double-spaced, on standard 8½″ × 11″ paper.
2. Begin typing a third of the page down from the top.
3. Place the date in the upper right corner.
4. Place your identification—name, business address, and telephone number—in the upper left corner, so that the editor can contact you for further information if necessary.

5. In the first paragraph, explain the who, what, when, where, why, and how of your story; fit this within the first sentence if you can.
6. Be concise. If you have a second page (try not to), identify the story in the upper left corner and write "continued" at the bottom of the first page.
7. Indicate the end of the release by writing "30," ###, or "end" at the bottom of the page.

In addition, you should read the newspaper to which you intend to send the release for several days or weeks to determine on which page or section your release would be considered news. Business page? Society page? Financial page? Call the newspaper to find out the name of the person who handles this page or section, and mail your press release to their attention. A sample press release announcing the opening of a new business is shown in figure 1-3. If the release does not get published, don't be disappointed. Try again.

Shortly after you open your doors to the public, you will be besieged by an army of salespeople badgering you to advertise in everything from civic newsletters to coupon mailings. Be prepared—have a plan of action already mapped out for your dollars and stick to it. Do not let anyone sign you up for services you do not need. Instead, focus on establishing your own personal mailing list of clients—it will become your most valuable resource for advertising gain. Begin your list of clients by keeping your customers' names, addresses, and telephone numbers on a card file. Keep it current and add the names and addresses

1-3. Sample press release announcing the opening of a new appraisal business.

Announcement

The grand opening of XYZ Gems and Jewelry Appraisers has been announced for this weekend in the ABC Building, 123 Main Street. An open house will be held from 9:00 A.M. through 3:00 P.M., Saturday and Sunday, November 1 and 2. A tour and explanation of the laboratory services will be offered.

Matthew Williams and Chris Williams, owners of the firm, are Graduate Gemologists of the Gemological Institute of America, and bring a combined total of twelve years of gems and jewelry appraising to the new business. The new facility uses state-of-the-art laboratory instruments and advanced technology for the examination and evaluation of diamonds, gemstones, precious metals, and jewelry items.

Each stone, loose or set, is checked to determine if it is genuine, synthetic, or imitation. It is examined for clarity, cut, and color, as well as size and carat weight. All jewelry is evaluated for its metal content, the quality of workmanship and design, and the period of its style. Color photographs of the jewelry accompany the Certified Appraisal Documents that XYZ Gems and Jewelry Appraisers render for insurance and estate purposes.

"We do not buy or sell," Matthew Williams said, "but we know fair market values and appreciation potentials, and we are familiar with replacement costs. Because of our portable equipment," he continued, "we can offer appraisals to our clients either in our office or at a site of their choosing."

Williams discussed the modest fees that they impose for appraisal work and emphasized that the charges are based on time, not on a percentage of the appraised value.

After this weekend, XYZ appraisers will be open from 9:00 A.M. to 5:00 P.M. Monday through Friday, and on weekends by appointment only. Call 555-1234 for additional information.

1-4. Sample follow-up letter to send to potential clients who have telephoned to inquire about appraisal prices.

Dear ——————:

 As you have requested, I am sending you a brochure and business card to explain our gems and jewelry appraisal service more fully. I have also enclosed a list of my qualifications as an appraiser.

 If, after reading this brochure, you have any questions regarding the professional appraisal of jewelry, please contact me at the number listed below.

 XYZ Appraisers has portable gemological equipment as well as a fully equipped office, so appraisals can be conducted at your convenience at the site of your choice. You are welcome to watch the appraisal being conducted and to ask any questions pertinent to the appraisal.

 Our work is by appointment, and we are available six days a week.

 Thank you for your interest in XYZ Appraisers.

Sincerely,

of people who call you on the telephone to inquire about prices for appraisals. These calls should be followed up with a letter and brochure from your office. A sample follow-up letter is shown in figure 1-4. This list of clients will be used for all kinds of mailings from your office, from those suggesting updates on appraisals to those offering a diamond brokerage service. Learn to work your list; these customers already know you, so take advantage of this edge.

If you work out of your home, get a post office box to use as your mailing address. Advertise that all appraisal work is by appointment only. Use the card file mailing list for your personal clients; if you work for a jeweler, establish a separate card file for those clients.

You need not limit your direct mail campaigns to customers you already have on file. Consider sending client solicitation letters to attorneys, bank trust officers, and insurance agents. Offer your services and let them know exactly why they would need expert jewelry appraisals—for probate, estate liquidations, community property settlements, and so on. Sample solicitation letters are shown in figures 1-5 and 1-6.

Networking is a very old method of getting business. It involves simply associating yourself with your peers and working the group with determination and diligence to get clientele. Get involved in committee work, attend meetings faithfully, and make yourself known to one and all. Send your card and brochure to each personal property appraiser in any appraisers' organization to which you belong—including jewelry and gemological associations.

Send a "Dear Colleague" letter to the jewelers in your area and let them know that you are available to perform their appraisals independently. If you are able to work in their store, advise them accordingly; if so, the jeweler can book appointments for you and then let you know when to come in and service the accounts. An offer of cooperative advertising announcing your visits may be of interest to the jeweler and help generate some appraising business.

Prepare a personal biography—a list of your qual-

1-5. Sample client solicitation letter to send to attorneys, bank trust officers, and insurance agents.

Re: Personal Property Appraisals

Dear ——————:

 We would like to offer our services to your clients who require appraisals of their gems and jewelry.

 ABC Appraisers, a fully certified gems and jewelry appraisal organization, will conduct examinations of personal property for appraisals in homes, offices, or banks. This ensures client privacy and that no property leaves its place of safekeeping. Color photographs of the complete inventory are included with each appraisal report.

 ABC Appraisers offers jewelry appraisals for probate, insurance, community property settlements, and estate purposes.

 Appraisals are by appointment and fees are based upon hourly rates. A brochure that explains our services in greater detail is enclosed. For additional information or business references, please call 555-1234.

Cordially,

1-6. Sample client solicitation letter to send to insurance agents.

Dear ————:

In these unsettled times, more and more people are converting their cash to jewelry and gemstones. As this trend continues, there is greater demand for personal-property insurance and, as part of that coverage, it becomes imperative to procure the best possible appraisals. Associated Gemologists is an independent appraisal firm that can fill this need.

Authenticity, quality, design, and value are the four most important criteria that our expert staff is dedicated to explaining to the prospective client. Associated Gemologists offers personalized services, such as consultations, appraisals, certifications, identifications, lectures, and buying services with direct contacts to mines and gemstone vendors world-wide. We also maintain a well-equipped modern laboratory.

Associated Gemologists wants to work with your company by offering our specialized services to you and your clients for their protection as well as for your own. Remember, an incorrect identification by an unqualified person could cause needless grief and expense.

Please feel free to contact us if you have any questions about our services.

Cordially,

ifications as an appraiser—have it printed, and use it as a handout to all potential customers; that is, anyone who shows an interest in getting an appraisal. Most consumers are not aware that qualified appraisers must undergo special training, and assume that all jewelers are appraisers.

Approach the professional groups of insurance agents in your community and offer to speak to them on the subject of proper appraisals for insurance purposes. One appraiser has had good luck with giving presentations to agency managers and explaining how his fully certified and proper appraisals can be of benefit to them. Offer your services as speaker to any group that will hear you—this can be a very valuable source of clientele. When you are invited to speak, discuss jewelry and appraising, not yourself. The fact that you are addressing the group will establish you as an expert in the field. To find groups that may welcome you as a speaker, investigate whether your community offers public information shows.

In addition, look into opportunities for teaching either gemology clinics or adult education classes at the local museum, community college, or high school. People who attend these classes may later become your clients.

If writing is not difficult for you, think about writing a gems and jewelry column for your local newspaper. Like speaking on radio and television, this advertises your expertise in the field and establishes you as an individual to be trusted. In addition, examine the possibility of writing a quarterly newsletter to be sent to your clientele. The newsletter can be a chatty one-page mailing discussing new gemstones on the market, jewelry fashion tips, the history and lore of gemstones and jewelry, pricing variables, and any number of informative articles to titillate your clients while keeping your name in front of them. If you sell gems and jewelry along with appraising, the newsletter could be the perfect medium to combine client contact with information and low-profile advertising.

Maintaining Your Clientele

To serve and maintain your clientele, realize the impact your image has on your customer and make your customer rely on you for dependable service. According to one consumer focus group, some consumers who were tested on what they expected to receive and actually did receive in the way of service stated that a major gap exists between services expected and those actually rendered. According to the survey, reliability was by far the most important service quality to clients. Clients also complain about poor communication. They need to know that you understand the kinds of appraisals they need and that you listen and respond to their requests. How do you compare with your competitors? Do you give your clients what they actually need? Moreover, your clients are placing their trust in your ability to do market research and provide them with correct evaluations for insurance or estate purposes. Too many appraisers fail on this one issue.

Ethics play a large part when you advise clients on purchases, set fees, and give objective appraisals. Some jewelers/appraisers purposely undervalue the quality of the clients' valuables so they can tout their own "fine quality" items in the interest of future sales. This is not appraising. This is an unethical practice that should be beneath the dignity of all professional appraisers. Ethics do not come with the graduate gemologist diploma and are not automatically con-

veyed with appraisal association membership. However, your clients expect and deserve your most competent and ethical service—your peers deserve it, too.

Handling Appraisal Updates

For clients who need updated appraisals on their jewelry items, this service should be handled in the same way that a dentist lets you know it is time for a check-up—send out notices.

Most insurance companies recommend an update every three years and a yearly new appraisal for very expensive items. Send cards to your clients reminding them of the changeability of the precious gems and metals markets, and advise them not to be without adequate protection of their valuables. The form shown in figure 1-7 can be used on a reminder card.

Establishing a Professional Image

There are no statistics available to show how many appraisers of gems and jewelry there are in the United States, but the number must be substantial. The GIA has recorded that over sixty thousand jewelers have taken educational courses in gemology, retailing, and merchandising, so the odds are great that a high percentage of these jewelers are also appraisers.

Education is, of course, the first requirement to establishing a professional image, followed by membership in peer-group associations. On a personal level, an appraiser builds image with proper dress, grooming, body language, communication skills, attitude, and the correct use of the English language.

Some key points to remember include:

- Maintain a professional demeanor.
- Stay calm under criticism.
- Do not joke about the serious—the value of gems and jewelry is a serious subject to your clients.
- Maintain a friendly relationship with your competitors.

Roberta Ely, a personal-property appraiser based in San Diego, teaches a course on the professional image. Ely points out that one's personal appearance is important. She admonishes appraisers in her classes to be well groomed, to carry neat briefcases, and to have a clean car if they visit clients in their homes. Ely warns it is not unusual for a client to peek out of the window to get a look at the appraiser and the car he or she is driving. "Clients pick up on subtle little things like body language. If you have vitality, grace, and a sense of authority, it will show and make an impression on the client." Ely adds, "You want them to remember you and your terrific work, not sloppy dress or bad manners."

Portable appraisers should keep their appointments as close to schedule as possible. No one likes to be kept waiting. If you are going to be delayed, call your client. If the appointment was made a week ago or longer, call to reconfirm before you start out. Do not book your appointments too closely together, as you never know what may delay you. Many clients, once they make an appointment for you to appraise one or two items of jewelry, end up bringing out several more pieces "because you are already here."

Most clients are eager to talk with the appraiser, be of help, ask questions, and watch what is going on. A few are nervous about getting in the appraiser's way. It is important to establish friendly client relations right away. First, establish the function of the appraisal (insurance, estate); then tell your clients what you are going to be doing (examining, taking inventory); and how you are going to do it (all the details of gemological instrumentation). Let them have a look at their jewelry or gems through your loupe. Most clients really appreciate the gesture. Ask for their assistance in providing any information that they may have about the provenance of the articles to aid in your valuation research.

There will come a moment when you will require quiet in which to do your work and most clients will respect this. Occasionally, there will be the nonstop conversationalist who makes your work difficult. If

1-7. Sample appraisal update notice. To personalize the mailing, write the client's name in by hand and sign each card.

Dear ————:

 With your best interest in mind, we advise that you obtain an updated appraisal on the jewelry we have examined and evaluated for you, as well as on any items you may have acquired since.

 While you may be aware of the changing values of gems and diamonds, gold and other precious metals, we at XYZ Appraisals have computer access to prices in the key world marketplaces. It is likely that the monetary worth of your possessions has increased since your last appraisal.

 Please call for an appointment at your earliest convenience.

Sincerely,

clients keep talking when you need to concentrate, ask them to write down all the information they can provide on an item or two—that will usually keep clients busy. If that ploy does not work to give you uninterrupted silence, however, you may have to remind them that you are working by the hour (if you are) and can finish faster without conversation. Of course, if you are charging the client by the item, you can always tell them that you have to hurry along because you have another appraisal job to attend. At the conclusion of your examination, pack away your tools, fold your worksheet, reiterate your payment policy, and tell your clients when they can expect a finished report. Later, if you find you cannot deliver the report by the finished date, notify your clients immediately.

Before leaving any on-site appraisal, be sure to check for overlooked items you may need to appraise. Is the client, for instance, wearing an expensive-looking wristwatch or earrings that should be appraised? Be alert and you may be able to expand the report validly.

Have all the contracts signed and obtain a retainer fee before you go. Do not quote any prices or values of items you have just examined, not even ball-park prices! You do not know what the client may do with the information and the market may have changed since you last checked it.

Attitude, it seems, has a lot to do with being a professional. In an article entitled "Professionalism and the International Society of Appraisers," C. Van Northrup writes: "Professionalism is a social process in which the individual must think and act as a professional in order to be recognized [as such] by the public" (Northrup, 1986, 10).

Protecting Your Reputation

Your reputation as a competent, fair, and trustworthy appraiser is your most valuable intangible. Guard and protect your reputation in several ways. First, refuse to do "freebies." Free appraisals are demeaning, and those who ask for free appraisals do not see you as a professional with years of education and experience. Off-the-cuff appraisals are worth exactly what someone pays for them—nothing—and they deprive you of the opportunity to extend your best professional appraisal of what may prove to be an important jewelry item. Second, dissociate yourself from gemologists and appraisers who handle questionable appraisals and jewelry deals. You know who they are. The trade journals spell out their sins of omission or commission and the appraisal association ethics committees work singlemindedly to oust them from membership. Third, check your valuations carefully and reread the report several times

before you sign your name at the bottom. Remember that any appraisal could be questioned in court and be certain you are correct. Are you positive you can substantiate the statements you made in the document? Make no verbal appraisals—they can be as binding as written ones and turn out to be legal headaches. Fourth, read the Federal Trade Commission's guides for the jewelry industry to be aware of the legal definitions of such terms as "flawless." A careless use of terms could turn your client into a litigator with you as the respondent.

Setting Fees

Money is a sensitive area. Plenty of people in business for themselves do not realize that they should be drawing a salary and earning on their investment in the business. In other words, the business needs to make a profit beyond salaries and overhead. If you have never worked for yourself before or charged for personal services rendered, you may be shy about asking for money. Develop a tough hide from the start, ask for your money without apology, and get it up front. Most appraisers working with or for a jeweler will have worked out a base salary and/or commissions. If you have not, finding out how others handle the situation may help you decide which arrangement would be best for your circumstances.

Only a short time ago, the standard way to charge for appraisals was to request a percentage of the total value of the items, usually 1 to 1.5 percent. If you were appraising very expensive jewelry, you could add up a tidy sum for your fee in a short while. Many appraisers and jewelers were not beyond edging up the valuations by hundreds or thousands of dollars to make their fees fatter. This temptation to disregard ethics was not lost on gemological and appraisal associations, jewelry trade groups, or the IRS, all of which have issued policy statements over the years condemning this practice. They view the percentage fee as too much of a temptation to inflate an appraisal figure and hold that it is unethical. Most suggest that appraisers charge by the hour, the day, or per piece. A survey of one hundred gems and jewelry appraisers conducted by the Association of Women Gemologists reveals that most charge by the hour, asking from thirty-five to one hundred and fifty dollars. A large percentage of respondents charged by the item, from five dollars to seventy-five dollars depending upon the complexity of the piece. Per-item charges were always coupled with a minimum fee of approximately forty-five dollars for the first item.

An experienced appraiser may charge from two hundred and fifty dollars per half-day (with a minimum of one hundred and fifty dollars) to a thousand dollars for a full day's work. If you are portable, this

includes your portal-to-portal time charge. Some appraisers combine several methods of charging: per diem when working for attorneys, bank, and courts; per item when working for the general public. Appraisers in California are able to charge a much higher per-item rate than are their counterparts in the Texas, Oklahoma, Louisiana, and Arkansas area. Prices in New York and Texas are similar, with a medium per-item charge of forty-five dollars, but even in Texas the rates vary across the state: south Texas appraisers are frequently able to charge and get more per item than their colleagues can in north Texas. It greatly depends upon the economic conditions of your region of the country, the demand, and the competition.

Some laboratories and appraisers have found success in using a sliding table of prices that vary according to the size of the gemstone and number of stones, or time and complexity required for an appraisal (table 1-2). Cos Altobelli writes in his *Jewelry Appraisal Guidelines* manual that the most equitable way to charge for an appraisal is with an hourly rate designed to cover all the services the appraiser has to perform, including time spent on telephone calls and any extra insurance coverage that may be needed. For the portable appraiser, the fee should include the time spent in travel. In addition, any extra expenses incurred, such as the cost of obtaining an outside expert opinion or analysis from a gem laboratory, should be passed on to the client.

On the other hand, some appraisers declare that to receive the same compensation for appraising a twenty-dollar item as for a twenty-thousand-dollar item is tantamount to insult. They argue that their years of experience as appraisers and the thousands of dollars they have spent in education and equipment entitle them to greater reward. Some appraisers charge a percentage of the value of the items they appraise while pointing out that the major auction houses commonly use the percentage-figure basis for fee structuring.

The entire issue of fees may ultimately be legislated. In Pennsylvania, Senator Stewart J. Greenleaf has sponsored and passed a bill regulating jewelry appraisers' fees, and there are strong indications that other state legislators may introduce similar proposals. The Pennsylvania bill requires jewelers who do appraisals in the state to charge a flat rate, and prohibits them from charging a fee based on a percentage of the value of the appraised jewelry item. The bill imposes a fine of a hundred dollars for the first offense; two hundred dollars is charged for the second or any subsequent offense. As it is presently worded, the bill does not cover appraisers operating independently of any retail jewelry business, but this could change.

The fee structures of portable appraisers can get complex: one arrangement is used for the public when the appraiser is working independently; another method for appraisals done at a jewelry store, in which the appraiser is wholesaling his or her services to the jeweler. The number of ways in which portable appraisers handle billing is limited only to the number of creative individuals working in this field. Some popular fee formulas found during a research of the question include the appraiser who is paid a base salary and works for the jeweler full-time, but may solicit and keep all revenues from appraisals, or the appraiser who conducts appraisals in the jewelry store on an appointment basis. In the latter case, the appointments are made in advance by the jeweler, but the appraiser values the jewelry, sets the fee, and collects the money from the customer. The jeweler *may* receive a set percentage of the appraisal fee (anywhere from 10 to 30 percent). Another variation is for the fee (set higher to accommodate the jeweler's percentage) to be collected by the jeweler, who in turn gives the appraiser his or her share. The perfect system for the appraiser is, of course, to bill the customer directly, keep all fees, and simply use the jeweler's space as a place to conduct business. Some appraisers and jewelers adopt this arrangement and consider it equitable, as it affords the jeweler greater opportunities to sell—first, when the customer brings the jewelry in to be examined, and second when the customer returns to pick up the appraisal report.

Another plus for jewelers who have independent appraisers work in their stores is the repair work that appraisals can generate. The responsible appraiser

Table 1-2. Sliding Scale of Appraisal Fees

Item	Price (in dollars)	Update Fee (in dollars)
All metal items	10.00	5.00
Single/multistone items, total weight up to .25 ct.	30.00	15.00
Single/multistone items, total weight .26 to 1.05 ct.	45.00	20.00
Additional carat or portion above 1.05 ct.	10.00	5.00
Watch, without diamonds	30.00	15.00
Watch, with diamonds	45.00	20.00
Beads (not pearls)	30.00	15.00
Pearls (cultured/imitation)	40.00	20.00
Gem identification	10.00	10.00
Coins	20.00	10.00
Photographs only	10.00	10.00
Gemprints	25.00	25.00

Note: Minimum fee for first item only, $45.00.

will point out to the client during the initial examination any repairs that should be made before the appraisal is undertaken. Such problems as broken or cracked shanks on rings, broken spring rings, prongs that need retipping or replacing, and/or stones that are loose should be reported and actually shown to the customer.

Jeweler/Independent Appraiser Relationships

This kind of arrangement requires total trust between appraiser and jeweler, and a strong bond of friendship. However, if the appraiser sells gemstones or jewelry on the side, there will be a gray area that may be difficult to overcome no matter how much the two trust each other. If the jeweler ever suspects that the appraiser is soliciting customers for sales along with appraisals, the entire fabric of trust will be shredded. A strong belief in fair play is necessary on both sides if this work arrangement is to be successful and mutually rewarding.

Appraisers, on the other hand, should be wary of any jeweler who wants expertise but is not willing to pay for it. You may be asked to "just look" at diamonds, colored stones, and other jewelry items while you are in the store between appointments. A certain amount of free information may reasonably be expected, but do not give away all of your expertise.

In addition, you could also be asked to value merchandise sold by a jeweler whose markups are greater than the area-established norms. If so, you may wish to plead conflict of interest and decline the evaluation. The conflict of interest arises from the implication that the jeweler wants to justify his or her markups with a validation from a professional appraiser, and the independent appraiser can lose the jeweler's patronage by pointing out that these mark-ups are excessive. It is a difficult position for the moral appraiser and calls for careful consideration of the available options.

Liability

Independent appraisers who work for jewelers can prepare their appraisal documents either on their own forms or on the store's forms. Regardless of whose forms you use, however, you are liable for the statements you make once you sign the document. Furthermore, even though you are an independent agent not affiliated with the jeweler's store in any way beyond appraising, the jeweler will also be liable to individuals damaged by you. If the setup gives the impression of partnership, it is legally considered a *partnership by estoppel*. In most cases, jewelers have no idea that they have undertaken such responsibility.

Independent appraisers should consider laminating their appraisal reports to preclude any tampering with the report numbers. Sadly, some retail merchants have been known to ask and pay for appraisals of store merchandise and then change either the valuation or the photograph on the report. If you suspect any merchant of this kind of offense, terminate your relationship with him or her.

The professional appraiser takes on a mantle of responsibilities and liabilities with each completed appraisal document. Although most appraisers understand their general fiduciary responsibilities to the public and to the profession, they may be unaware of the legal mechanisms now existing that hold appraisers accountable for error and fraud. Some of the most notable areas of potential liability include the following:

Identification and authentication negligence. In a celebrated IRS challenge case in New York that resulted in back-tax penalties for the taxpayer, the taxpayer sought and received damages from the appraiser who provided the original report. Not only was the property overvalued, it was found to be misidentified and misdated.

Insurance losses. Insurance fraud of scheduled personal property based upon the valuation established in an appraisal has become prevalent in the past few years. Some insurance companies are now asking for verification of the appraiser's credentials plus a second opinion appraisal. In some cases of suspected fraud, appraisers have been asked to give sworn statements of value.

Stolen property. The National Stolen Property Act amplifies the trade sanction agreement that was recently expanded and reinforced to protect the culturally important property of foreign countries. The sharply outlined liabilities state that anyone violating the provisions of the Act by buying, selling, storing, exhibiting, and appraising material protected under the treaty shall be liable to prosecution.

Donated property appraisals. Section 6659(c)(1) of the IRS Tax Code states that civil penalties can be assessed on the appraiser who is found guilty of gross valuation overstatement.

Questions Most Often Asked by Gemologists about Appraising

Five years of surveys of gemologists reveal that the following questions are most often on the minds of those who are considering getting into the field of appraising.

Q. What kind of equipment do I need to be an appraiser?
A. Among the essential tools are a binocular microscope, a refractometer, a polariscope, a Leveridge

micromillimeter gauge, and ultraviolet lights. One of the great advantages to having a portable laboratory such as a MaxiLab or Portalab is that almost all of the instruments necessary for appraising are available in one container. Some appraisers who have fixed lab locations buy regular laboratory instruments for their work stations; some buy and use only portable laboratories; some do both and have duplicate equipment. A host of hand tools are also necessary and desirable. For a list of other necessary appraisal instruments, see chapter 1, *Becoming a Portable Appraiser.*

Q. I have just finished the gem identification and colored-stone analysis portions of the GIA program. I plan to be an appraiser of diamonds and colored stones when I become a graduate gemologist. What kind of equipment or instruments should I buy right now?

A. You need to purchase a master set of diamond grading stones immediately. You should have at least five diamond master stones that have been color graded by the GIA laboratory. The diamonds should be at least a quarter-carat each, and larger if possible. The grading of colored stones is becoming more scientific, and you may wish to use one of the colored-stone grading systems on the market. A list of these and their manufacturers is given in chapter 3, *Colored Gemstones.*

A spectroscope is useful for distinguishing naturally colored green jadeite from dyed jadeite; color-treated diamonds from natural colored diamonds, and some hues of natural corundum from synthetic versions. For a list of other essential tools, see chapter 1, *Becoming a Portable Appraiser.*

Q. How much should I charge for an appraisal?

A. There are several different ways of setting fees and most are dictated by individual circumstances of experience, overhead expenses, on-site or office appraisals, etc. Some charge a minimum fee for the first item (perhaps forty-five to sixty-five dollars), with another set fee for each additional item. Some appraisers charge by the hour; some by the half-day or full day with an additional minimum. Fees are more fully discussed in chapter 1, *Setting Fees.*

Q. How do you evaluate gold teeth in an estate appraisal?

A. Treat it like scrap gold. It is usually around 16K.

Q. What do you say to a client who insists that a stone cannot be synthetic—that grandfather would never have bought grandmother a synthetic ring?

A. Tell the client that synthetic stones have been on the market since 1885, and that the original jeweler was probably unaware that this stone was synthetic.

Q. What steps can I take to maximize my personal security and increase the safety of my home or office?

A. If you are office-bound or hold jewelry overnight, you will need a secure safe, a well-written take-in form (see chapter 2), and possibly a buzzer system for the door as well as an alarm system for the store or office. You will also need Jeweler's Block Insurance to cover you in the event of a robbery or burglary.

Of course, if you conduct appraisals while the client waits and do not hold client jewelry overnight, security will be nearly a moot point.

For your bodily safety, vigilance is the best defense. Be alert going to and from your car when traveling to any appraisal appointment. If you travel out of town frequently, consider investing in a CB radio or a car mobile telephone. If your car breaks down, you will be able to summon help without leaving your automobile (and your equipment).

Q. Where can I go to update the pricing of colored gemstones and jewelry yearly besides the regular market shows?

A. The Tucson Gem and Mineral Show is held every February. Make it a point to go—your competitors do.

Q. I am considering a career move. Is jewelry appraising a good choice? I have the background.

A. Selling gems and jewelry and doing jewelry appraisals can be good careers if you have the education and certain personality traits. Ask yourself if you are well-organized, if you enjoy interacting with the public, whether you consider yourself someone with integrity, and whether you are motivated to be a self-starter.

Independent appraisers must be pleasantly aggressive and knowledgeable about market conditions. If you believe you meet the requirements, you can establish your business and maintain it as long as you care to work.

APPRAISAL PROCEDURES AND THE NATURE OF VALUE

Establishing and substantiating the value of an item are what appraising is all about. There are several steps that occur between the initial examination of the client's property and the final estimate of the property, and the wise appraiser does not skip any of these. The six steps involved in the appraisal process, which are detailed in table 2-1, are as follows:

1. Establish the scope of the appraisal.
2. Plan the appraisal.
3. Collect and analyze data.
4. Apply a valuation approach.
5. Set limitations and contingency conditions.
6. Supply the final estimate of value.

Table 2-1 may also be used as a physical work plan.

In this chapter, the different types of appraisals are discussed, as are the primary valuation approaches, and the recommended limiting and contingency conditions to be added to the final appraisal document. Chapter 3 provides a step-by-step guide to the other steps involved—the methods of jewelry analysis, evaluation, and documentation, including a breakdown of the identification and take-in stage, sources of data, and economic and item data analysis.

Establishing the scope of the appraisal. During the initial examination and inventory of the client's property, the appraiser asks why the client needs or wants the appraisal, in order to determine the purpose and function of the appraisal. In discussing the objectives of the appraisal, the appraiser has a responsibility to clarify the kind of value that is appropriate and to explain this to the client clearly.

It is important to establish both the purpose and function of the appraisal to ensure that the appraiser will provide the client with the correct appraisal doc-

ument. For example, the client may say that the purpose of the appraisal is to determine the retail-replacement of an item. This purpose, retail replacement, can serve any number of functions—insurance, comparison, hypothetical, damage, or barter—that may require the appraiser to submit particular information. Similarly, an appraisal to set the fair market value of an item could be used for such different estate functions as divorce settlement, probate, donation, auction, antique authentication, collateral, or casualty loss. The term *estate* describes second-hand, antique, or period jewelry, as well as other items sold for fair market value. Be certain to qualify the purpose and function of an estate appraisal when this designation is used.

It is the appraiser's role to represent the interests of the client objectively during the appraisal and to perform three primary tasks: identification, quality analysis, and evaluation. Researching the appropriate market for estimated costs is also the appraiser's responsibility. It is important that the appraiser explain why the market and particular value or cost estimate have been deemed appropriate, in order to avoid misunderstanding and to prevent unwitting or deliberate misapplication.

The "date of appraisal" that is also established during the first stage of the appraisal process is *not* the date on which the items are first examined, but the date on which the value estimate will apply. It identifies the market conditions that existed at the time appropriate for the appraisal function, such as the date of death for an inheritance tax appraisal. This date is especially sensitive for fair market value appraisals used for inheritance tax, when an alternate valuation date may be required and used. (See *Probate/Inheritance Tax Appraisal* later in this chapter for

Table 2-1. The Appraisal Process

ESTABLISH THE SCOPE OF THE APPRAISAL

Identify and take inventory of client property	Determine purpose of appraisal	Note date of appraisal	Establish function of appraisal

PLAN THE APPRAISAL

Determine Data Needed:	List Sources of Data:	Other Sources of Expertise:	Schedule the Appraisal:
Current prices on precious stones and metals	Dealers Wholesalers Manufacturers Other	Laboratory analysis Other appraisers	Initial exam Research Preparation Delivery date

COLLECT AND ANALYZE DATA

Location:	Economic:	Item by Item:
Residence Office Bank Other	Market analysis Market trends Supply and demand Special circumstances	Identification Description Weights and measurements Photographs

APPLY A VALUATION APPROACH

Cost	Market Data	Income*
Cost evaluation of instrinsic value, labor, mark-ups	Comparison of existing comparable items	Used in market value appraisals of income-producing property

SET LIMITATIONS AND CONTINGENCY CONDITIONS ON APPRAISAL DOCUMENT

SUPPLY FINAL ESTIMATE OF VALUE

* Rarely used by appraisers of gems and jewelry.

further information.) To avoid confusion, the appraiser may wish to add a "take-in date" line at the top of the work plan.

Planning the appraisal. The next step is determining what research data will be needed (such as price lists, books, and catalogs) and where this information may be found. If the article to be appraised is beyond the scope of the appraiser's expertise, it may be necessary to confer with other experts or to get authentication and identification from a laboratory, particularly if a gemstone's country of origin is an issue.

The amount of time needed for research and preparation should be calculated and the client should be advised of the estimated delivery date of the appraisal document.

Collecting and analyzing data. Making general notes on the location and atmosphere in which the initial examination and inventory take place is important. If the appraiser works under less-than-ideal conditions, this should be noted on the appraisal report as a limiting and contingent condition. It is difficult to work properly in a crowded bank safety-deposit room, or in an antagonistic atmosphere, such as in the residence of a couple undergoing a hostile divorce.

The appraisal report should also list the special economic, political, and social factors that influence the market: economic factors such as inflation, recession, and changes in tax laws; political events in countries where gemstones are mined that affect the supply of gemstones; and social and cultural trends and fads that sway property values.

Applying a valuation approach. Before proceding to an explanation of the cost and market-data comparison approaches to valuation, let us consider the nature of value—what it is and how it can be established. In the gems and the jewelry discipline, value is determined by the appraiser's research and analysis of numerous substantiated sales of comparable items. This analysis establishes a *mode,* which is the most frequently occurring price found for an item during the appraiser's research. A statistical definition of *mode* is the number that occurs most frequently in a

series of numbers. If eight out of ten jewelry stores carry a similar style of diamond ring priced at one thousand dollars, while two jewelry stores price the same style of ring at twenty-five hundred dollars, the mode of the ring is one thousand dollars. Realistically, the number of matches in a market would be around two to four.

Price is frequently confused with value. Price is set by a merchant according to his or her market or economic needs at the time of sale. The price of an item, however, may be more or less than its value. For example, if you offer a friend a ruby brooch for a certain figure, the friend may reject the figure but make you a counteroffer that you accept. The price of the brooch will have been established without regard to its value.

To determine the value of the particular items being appraised, gems and jewelry appraisers commonly rely on two processes, the market-data comparison approach and the cost approach, as the most viable means of valuation.

The market-data comparison approach involves researching the appropriate and most common markets for sales data of comparable jewelry or gemstones. It is used to establish an item's retail-replacement value or to determine its fair market value for tax purposes. The considerations in the market-data approach include the number of sales; the period of time covered; the rate of turnover; the motivation of buyers or sellers; and the degree of comparability. Comparable items are those of an equivalent uniqueness, rarity, quality, condition, period of design, origin, designer or craftsman, quality of design execution, appropriate market, and purpose. The cost approach provides an estimate of how much an item would cost to replace in the current market if it were reproduced identically, and is commonly used when no comparable item exists. The cost of each jewelry component is analyzed separately: for a ring, the appraiser would analyze the metal, method of manufacture, metal fineness, heads, assembly labor, cost of the gemstone(s), and setting fees. This approach is used to estimate retail-replacement value but is never used in determining fair market value for IRS purposes. Most appraisers like to use both methods and correlate the findings for a final estimate of value if a comparison item exists.

Another approach to valuation exists, the income approach. Although jewelry appraisers rarely use it, appraisers should at least be familiar with the approach. The income approach is typically used in appraisals of income-producing properties. It can also be used to estimate investment value—the subjective value of a property to a particular investor. For instance, if a jeweler is in the business of leasing fine jewelry and wants an appraisal of the items, the income approach would be used in order to analyze the property's capacity to generate monetary benefits as an indication of its present value.

Limiting and contingency conditions. Any conditions that are unique to your evaluation should be listed on the appraisal report. This subject is discussed more fully later in this chapter.

Final estimate of value. The final step in the process is the dollar figure estimated by the appraiser following due diligence in research of all information pertinent to the appraised property. Supporting data used in this estimate should be itemized, or at least acknowledged, on a reference page attached to the report.

The Purpose of the Appraisal

Retail Replacement (Insurance)

A retail replacement appraisal is required by an insurance company before it will schedule jewelry on an individual policy beyond a certain dollar amount. In insurance parlance, *scheduled property* is a list of personal valuables and the appraised value of each property item for which the insurance company will pay in the event of loss or damage. The appraisal is the record that will be consulted by the insurance firm to set the premium and determine the amount of insurance, depending on the terms of the insurance policy. Common examples of scheduled property include fine art, jewelry, furs, audio-visual equipment, stamp and coin collections, silverware, goldware, and plated items. Typical examples of unscheduled personal property include furniture, drapes, appliances, and other furnishings of a residence.

Howeowner's insurance coverage includes a specified total dollar amount for scheduled personal property. Among the unscheduled items, there are limited amounts to cover jewelry, furs, and coin and stamp collections, usually no more than five hundred dollars aggregate for each above category, with a limit of one thousand dollars per category in some cases.

The insurance appraisal must provide your client with sufficient information to ensure replacement with an item of equal quality and kind. Usually, the appraiser must supply for each item the *average current market price* (mode), which is generally construed to mean the most frequent value of a like item found in the average store (but not any one store in particular) selling like merchandise within the geographical area.

The appraiser must be aware that more than one *replacement* cost exists and should consider the client's

best interests before selecting the appropriate concept. The appraisal document should clearly indicate the option chosen:

1. Replacement cost (new) refers to the cost of property as good as, but no better than, the item replaced. The article should be identical to the item being replaced, therefore the term is useful only when a new identical item can be obtained.

2. Replacement cost with a comparable item means using the current market price for an item of like kind, quality, and condition. This is the appropriate option to use in a replacement insurance appraisal for antique jewelry. It should be carefully noted on the appraisal report that the replacement is for a comparable item, not an exact duplicate.

3. Reproduction cost is the current price of constructing an exact duplicate or replica jewelry item, using the same materials, design, and construction standards. This is used in jewelry appraisals of items that may be of very unusual custom design, or could be used in the case of an insurance appraisal to determine the cost of replacing half of a set.

State insurance-code definitions of replacement value vary widely from state to state. Some insurance companies will replace a lost or stolen item in like kind, some with the piece's monetary value, and some will deduct a discount from the monetary value. In Michigan, for instance, insurance replacement is defined as cash value less depreciation. Find out the insurance laws and limits in your state—your client will almost never know these facts and will appreciate your willingness to provide information, straight answers on values, and the necessary analysis of markets. For some very valuable items, the client and insurance agent may wish to negotiate value. This will be expressed as the price the insurance company is willing to accept as a risk and for which the customer accepts the premium. Although there is no easy formula for determining insurance value, it depends on proper appraising research.

Appraisers have long complained that insurance companies do not use the full description of the article, using instead a kind of insurance-company shorthand for the final schedule document. The truth is, insurance companies do not need to. They have a brief description of the article on the schedule and they have a copy of your full description on your report, which is filed with the client's other insurance paperwork. If you remain uneasy about your client's chances of getting back an item that is like in kind because your client's insurance schedule shows a shorthand version of your report, you are within your rights to demand that the complete appraisal report

appear on the schedule. The most important points to include are the quality grades. Many companies use a computer printout form that does not have enough space to hold your full description. In the event of a loss, the insurance company may not even pay the appraised value. The typical supplement contains a clause that reads "unless otherwise stated in this policy, the value of the property insured is not agreed upon but shall be ascertained at the time of loss or damage." Moreover, most insurance companies will not pay cash for lost or stolen jewelry. They will replace it, based on the appraiser's description, from their own wholesale sources, usually at 30 to 80 percent of the appraised value of the replacement price. For this reason, accurate and detailed descriptions and grading are absolutely essential. These descriptions not only determine the client's coverage, but assure him or her of receiving like-kind items if the need arises.

The declared price of valuation is the price upon which the premium is set, and reflects the retail costs that would be incurred to replace or reproduce any gems in like quality and jewelry mountings in like manufacture and degree of craftsmanship. This monetary figure is just a mathematical sum by which one's premium can be calculated. Therefore, the most important part of an insurance appraisal is the accurate descriptions of the appraised items because insurance companies insure the jewelry items, not their value. This may be a difficult point to convey to your client.

When researching the retail-replacement values of custom-made jewelry items or fine designer jewelry for insurance purposes, it is necessary to find out if your clients want an identical replacement (for instance, if they wish to have their fine Tiffany jewelry replaced in case of loss by identical Tiffany jewelry bearing that jeweler's trademark) or if they will be satisfied with a comparable but not an identical replacement. The clients' desires make a difference in the total replacement figure; whatever they decide should be fully explained in the appraisal report.

A well-known company or designer may be able to charge more for work than an unknown company or designer can because they have created a following and a market level that can be substantiated by past sales records. These records make known designer and/or company items appraise for higher prices than the average.

Jewelers often ask whether they can use the price they would replace an item for in their store as the appraised price of an item for insurance purposes. The answer is no. An appraisal is based on an analysis of numerous prices in the marketplace to determine the most often occurring price at which the item can be bought—this analysis cannot be based solely on

one store's price. One store's price is a replacement cost estimate. Therefore, unless the jeweler has made true market research, it would be wiser to offer the customer a "Statement of Replacement Cost" instead of an appraisal. This statement of replacement cost is generally written on the jeweler's letterhead and it is not called an appraisal anywhere on the form.

Jewelers who have sold items at special discounted prices because of their own wise buys may ethically appraise the item at a higher price, provided the value is based on current market research and actually reflects the mode of the article in its appropriate market. In your zeal to protect your client, beware of overevaluation, which could be grounds for negligence on your part. Substantial overevaluation for an object that runs counter to the market may result in cancellation of the client's policy and litigation for the appraiser.

If a client has submitted a claim and rejects the insurance company's replacement offer, the cash payment can be limited to "the amount for which the insured could reasonably be expected to replace the article." A national insurance underwriters company has been quoted as saying that insurers are "likely to understand this amount to be their own replacement cost" (*Changing Times*, 1985, 64). They explain that since lost or damaged articles can be replaced at discounted prices, the insured can "reasonably be expected to replace" the jewelry for that price.

To avoid the cash-or-replacement option, your client can purchase a "valued contract" policy. This type of policy guarantees to pay claims in cash in accordance with the scheduled values.

A schedule will cost about ten to forty dollars for every added thousand dollars of jewelry coverage. Silverware and art objects are also subject to dollar limitations; you need to advise your client on protection of these items.

Counsel your client to ask the agent the following questions before you write an appraisal. The insurance agent's answers will help you and the client reach a greater understanding of the conditions affecting any claim subsequent to your valuation:

1. How are claims paid, in cash or replacement jewelry?
2. Would the client have a say in the selection of a replacement article?
3. What happens if an article is not replaceable?
4. Does the insurance cover all risks, including mysterious disappearance, and all geographic areas?
5. What are the exceptions and exclusions?
6. Is the client covered if negligence is involved in a loss?
7. Are there deductibles?
8. Is depreciation ever imposed? Which items are subject to depreciation and how is it computed?
9. What is the pair and set clause? Will the insurance provide an additional amount to cover the cost of matching a missing item in a set if the fact that there is a set or pair has not been previously stated?
10. What type of proof is needed to justify a claim?
11. Does the insurer require the appraiser to have special qualifications?

The last question in the preceding list may evoke some interesting answers. While some of the larger national companies are starting to make progress in requesting qualified appraisers, most still set no standards for jewelry appraisers. Interviews with agents of twenty insurance agencies revealed that most companies do not require the jewelry appraiser to have appraisal knowledge, or for that matter, gemological knowledge. That explains why so many are willing to accept a handwritten receipt of sale as an "appraisal." The blame falls squarely on insurance underwriters who have failed to establish criteria for qualified appraiser practitioners.

Fair Market Value: Estate

Fair market value is used for estate-evaluation purposes, and is an assessment based on what a willing buyer and seller would agree to without a forced sale. Appraisal criteria for estates have been legislated to include specific information and data, but do not include the factors that an insurance replacement appraisal does, and so this is usually a lower value. The following is the U.S. Department of Treasury definition of fair market value:

The fair market value is the price at which the property would change hands between a willing buyer and a willing seller, neither being under any compulsion to buy or to sell and both having reasonable knowledge of relevant facts. The fair market value of a particular item of property includible in the decedent's gross estate is not to be determined by a forced sale price. Nor is the fair market value of an item of property to be determined by the sale price of the item in a market other than that in which such item is most commonly sold to the public, taking into account the location of the item wherever appropriate. Thus, in the case of an item of property includible in the decedent's gross estate, which is generally obtained by the public in the retail market, the fair market value of such an item of property is the price at which the item or a comparable item would be sold at retail [Treasury Regulation 20.2031-1 (b)].

The definition of "retail" used in the context of fair market value is not the definition generally accepted in the jewelry business. As the IRS uses it, retail means any market, other than wholesale, where goods change hands and where the buyer is the ultimate consumer or end purchaser of the goods. There are numerous retail markets: estate sales, second-hand stores, antique stores, flea markets—even auctions—can be considered retail if the buyer is the ultimate consumer and is not purchasing goods as a dealer or for wholesale.

The key words in this definition of fair market value are "most common market." It is the appraiser's responsibility to research and be able to document on the appraisal report the most common market, as well as to explain why this market level was chosen. The appraiser does not create markets but researches them, and his or her primary research is based on documented prices, not opinions or sales offerings.

For example, if a jewelry item being appraised for estate FMV (probate) is a fine Art Deco brooch in excellent condition, the most common market for the brooch would probably be an auction. By diligent research of the auction market, the appraiser could doubtless build a valid and defensible report. Similarly, the most appropriate market for an out-of-style man's wristwatch with a worn and engraved case would be a scrap dealer.

The definition of fair market value is analyzed below. Every phase of this definition has been tested by the courts more than once.

Price at which Property Would Change Hands. What is being defined is the hypothetical sale price. It is obvious that an actual sale of the property would be the best indicator of the value, but if no sale is available, a hypothetical sale is used. All factors that are taken into consideration in hypothecating a sale are set out in the definition of fair market value. In general, a hypothetical sale is considered a sale for cash; any additional increase or decrease in the value that might result from special financing is not considered. For example, if money were borrowed to buy the property, the interest paid on the borrowed money is not considered part of the property's value.

Between a Willing Buyer and a Willing Seller. Exactly who are the willing buyer and seller? If the buyer does not want to buy and the seller does not want to sell, either no sale takes place, or the sale that does take place (such as a forced liquidation sale) would not be representative of fair market value.

Both Having Reasonable Knowledge of all Relevant Facts as of the Valuation Date. The appraiser works under the assumption that both buyer and seller have a reasonable knowledge of the facts concerning the items being appraised—for example, that both know

that the diamond is nearly flawless or that the carving is by Fabergé. If this is not the case, the sale is not determinative of value. The appraiser cannot be careless in this regard and must make sure that the appraisal document details the relevant facts on the valuation date. What the IRS calls the "valuation date," also known as the date of appraisal, identifies the market conditions that existed at the time appropriate for the function; in case of a probate FMV, it may be the date of death. In most cases, the executor will tell the appraiser what date to use, since the date of death is one date in an optional timeframe that can be chosen.

Marketplace. Marketplace is defined as the area in which the particular item is most commonly sold to the public. "Most commonly sold" and "public" are the key words in this definition. The courts have defined "public" as the greatest number of ultimate consumers of an item in its present form or condition buying for a purpose other than for resale. Types of markets include retail (to the ultimate consumer); wholesale; auction; collector; dealer to dealer; cutter; hobby; museum; scrap; and miscellaneous, depending on the jewelry.

The concept of marketplace also includes consideration of the location of the market. For example, if a wealthy person dies leaving a notable collection of jewelry, but her home is in a distant, remote part of the country, the cost of transporting the jewelry to a more accessible market for resale may be taken into account in the FMV appraisal. Conversely, there could be a reduction of appraised value if the collection is sold as is, where is.

It is useful to bear in mind that fair market value is a legal term, whereas market value is an economic concept. Fair market value often has special considerations for its determination, based on local legislation and rulings. In addition, the particular time requirements for disposition of the items may depend on supply and demand, and should be considered carefully. Fair market value applies when time is *not* of the essence, and the length of time needed for disposition of an item may vary from thirty to ninety days to over a year.

Appraisal Functions

Probate/Inheritance Tax Appraisal

Appraising in the area of *probate*, or estate appraisals, calls for specialized knowledge, experience, and willingness to go the extra effort in researching values. Errors in tax appraising for probate can result in penalties to your client and fines for the appraiser. The U.S. Treasury Department can also bar any ap-

praisers who are found deficient from providing future appraisals for tax purposes.

Estate (probate) appraisals are based on the fair market value of the items as of the testator's date of death, or at the alternate valuation date. The appraisal is necessary to determine inheritance taxes on the estate. Although the date of the testator's death is the most often used valuation date for probate appraisals, the executor of the estate has a several-month time period in which to dispose of the property. To achieve the greatest tax advantages for the estate, the executor may require the appraiser to use an alternate valuation date. When undertaking an appraisal of this type, discuss which date you are to use as the date of appraisal (valuation date) with the attorney or executor handling the estate.

An appraisal made in the course of administering an estate for inheritance tax purposes must reflect cash received from the items of the estate, based on actual liquidation figures. Should the estate wish to keep possession of the items, fair market value is applied for such items at the appropriate secondary retail market.

If an appraiser is requested to provide a marketable cash value in the appropriate marketplace, the appraisal should be labeled "marketable cash value," not estate or inheritance value. The IRS position is that if the lowest liquidation value is desired, the items should be sold for cash and the cash receipts declared. If keeping the items in the estate is desired, then the items should be appraised for fair market value at the secondary retail level in the appropriate market.

The sentimental value of an item to the owner does not affect its fair market value. To sanction this false belief results in undervaluation in estate appraisals.

Since inheritance tax laws may vary from state to state, candid discussions with the attorney handling the probate are urged. All federal estate taxes must be prepared in compliance with the Internal Revenue Code. See Publication #448, Federal Estate and Gift Taxes, September 1984 for guidelines to federal estate tax regulations. Federal tax rulings and revenue procedures are subject to change, so it is wise for appraisers to obtain a copy of the latest publication of regulations governing inheritance tax appraisals from the local IRS office before beginning an estate valuation.

Penalties may be applied to tax returns itemizing any property that is found to be 66⅔ percent or less of the "correct value." The penalty may not apply, however, if the undervaluation of an asset for gift or estate tax purposes results in less than one thousand dollars of tax underpayment. If the client is a private individual and not a corporation, the taxpayer may be subject to an additional tax of up to 30 percent of the underpayment and the appraiser may be subject to a thousand-dollar fine per offense.

The courts have long upheld the concept that an item has one and the same fair market value regardless of whether it is being appraised for a donation claim or estate tax liability. They have consistently supported the definition of fair market value discussed in the preceding section.

Use caution before assigning "no value" to any items you may encounter in the jewelry estate. "No value" can apply only to gemstones so tiny, broken, or abraded that they virtually cannot be recovered by repolishing or recutting. If you do assign "no value," be certain to make a full explanation in your appraisal. Most estates have a cache of worn and broken gold and silver mountings that can generally be assigned scrap value, or the melt price.

Collateral Appraisal

Jewelry that is tendered in place of cash for payment purposes is a form of collateral and, accordingly, the loaner may require an appraisal. Bank loan officers frequently ask for this type of appraisal when they want to determine the cash value that they can reasonably expect to receive, in the event the loan is forfeited, upon liquidation of the jewelry or gemstones. Collateral appraisals provide the fair market value of the items; however, banks need to know their options for quick disposition of the property, so you may wish to include a liquidation value as well. Your appraisal report should cover a full range of disposal options for the bank.

Divorce Settlement/Dissolution of Marriage

In the United States, there are nine states holding community property laws—Texas, Arizona, California, Idaho, Louisiana, Nevada, New Mexico, Washington, and Wisconsin—and three states with title regulations—Mississippi, Virginia, and West Virginia. The remaining states have equitable distribution of property statutes.

Community property states are those in which the personal property of the divorcing couple is divided equally according to its fair market value. In equitable distribution states, a judge awards each party a certain percentage of the total value of the combined holdings; the percentages vary according to the circumstances of the marriage. In title jurisdictions, property that is under one party's name remains his or her property, and the title cannot be affected under the matrimonial laws. If both parties are named on the deed or title, transferring title to one name and trading assets are two of the only ways to resolve the situation.

Divorce statutes are constantly in flux. Changes

may occur in your state's laws that may require explanation by an attorney. Consult your legal advisor before beginning work in this field.

There is hardly a divorce appraisal in which the subject of what belongs to whom and why will *not* arise. You are expected to know that the term marital property is used in states with community property and equitable distribution regulations. New York's definition is typical: marital property refers to all property acquired by either or both spouses during the marriage and before the signing of a separation agreement or the commencement of a divorce, regardless of the name in which the property is held. It applies to anything that the client acquires during the marriage, except for separate property which is defined as property acquired before the marriage or acquired by inheritance or gift from someone other than the spouse; personal injury awards; property acquired in exchange for separate property, not including any appreciation that is due partly to the other spouse's contributions; and any property that the parties designate in a prenuptial agreement as separate property.

Community property is another term for marital property and defines the entire estate. California's definition is typical: all personal property, wherever located, that is acquired during the marriage by either spouse while living in California is community property.

The reason all of the foregoing is important to you as the appraiser will become apparent once you have accepted the job of appraising a client's jewelry for division of common property, gone to their home, and discovered that you must evaluate seven hundred items of jewelry, half of which must be individually removed from a variety of jewelry boxes. If other personal property is involved, such as hardstone carvings, silver flatware, or silver holloware, you must act in your client's best interest and resolutely question each article's ownership.

Ask your client's attorney to give you clear direction on how he or she wishes you to distinguish between separate and community property at the time of the inventory of articles and on the appraisal report. Frequently, the attorney will direct you to appraise everything. He or she may be planning to categorize the items with the client after your report is finished. This is a good arrangement; you can then be sure that you have included all jewelry items of the estate in your report.

Handling divorce settlements requires a certain perspective. When you accept this type of work, you will often necessarily witness a drama of revenge, malice, and despair—needless to say, sensitive appraisers may suffer from this stress. Remember that although it is natural to have empathy for your client, it is your duty and responsibility as a professional appraiser to decline the role of advocate and remain impartial.

Divorce valuation is not for appraisers who cannot work quickly, efficiently, and obtain all the necessary information in one examination. The spouse demanding the appraisal usually has only one chance for outside experts to enter the home, so you must be prepared to assemble all the information you need in one visit.

Only a small percentage of the appraisals the average valuer is called upon to perform are for divorce, as the jewelry estate must be substantial enough for this service to become necessary. One judge estimates 10 percent or less of the divorcing population has jewelry estates large enough to justify the employment of an appraiser. In our materialistic, upwardly mobile society, this percentage may rise dramatically in the years to come.

Liquidation Appraisal

Liquidation appraisal value is value determined when an owner decides to convert jewelry items into immediate cash. The sale can be held under forced or limiting conditions and with time constraints, such as under court order or bankruptcy. Liquidation is the lowest measurable market, and results in the lowest net return to the client.

Since liquidation appraisals need research to determine what the client might expect to receive in a quick cash sale, the appraiser must obtain bid prices from several dealers who are in the business of buying and selling items similar to those being appraised. Executors and individuals seeking to liquidate usually have no idea what the items are worth; the appraiser is employed to identify, examine, inventory, and give a bottom-line figure (or estimate range) for which the items can be sold.

One market to research is the auction market. This represents the net sales price an item would probably realize at auction, minus fees and commissions. If the client has consigned goods to auction, he or she must also pay other charges: approximately 1 percent of the reserve price (the lowest for which the item can be sold) to insure the jewelry while it is in the hands of the auction house; and two hundred and fifty dollars for color photographs, or one hundred dollars for black-and-white photos of the item, to be used in the auction catalog. Most auction representatives concur that the reserve price can be figured at about 80 percent of the lowest presale catalog estimated price. This is handy information for the appraiser, who can then figure the lowest possible price an individual would take for an item.

The appraiser should not become too complacent about using auction prices however, because if the item has been auctioned at a small regional sale, there is usually no minimum reserve and the seller has no control over the outcome of the sale. Even at major auctions, anything can happen. The state of the economy or international problems can reduce the number of prospective bidders in a room. Conversely, bidding wars can spur the price of an item to unrealistic highs. An appraiser attempting to pinpoint auction values needs to proceed cautiously and do as much research as possible on events surrounding the sale of comparable items. Attending many auctions personally is the best way to gain an understanding of this market.

If the client wants to consign goods to a jewelry or gemstone retail outlet and wants to know what to expect in the way of value, the answer is that the client can usually expect to get 10 to 20 percent more than the current wholesale value of the items.

Comparison Appraisal

A client may bring in a jewelry or gemstone item to verify its identity and/or quality as claimed by the seller. Some jeweler appraisers will refuse to do such appraisals because they fear repercussions from their customers and colleagues if they provide appraisals that are too high or too low. Independent jewelry appraisers are without a vested interest in such cases and do not have this problem; they can render an ethical and professional appraisal based on careful research of the market in the valuer's locale without fearing any reprisals. Comparison appraisals usually reflect the jewelry at their most common retail-replacement price. When you undertake comparison appraisals, state the following limiting conditions verbally to your client and be sure that your appraisal form notes: "This price reflects the average current market price of a like or comparable item, which may be found in the average jewelry store, but not any one jewelry store in particular."

Estimate to Replace

An estimate to replace is used to establish the value of a previously undocumented item that has been lost or stolen. It is a hypothetical appraisal that is based on information supplied by the client, such as any photographs and the client's description of the item. Use the following disclaimer on your report: "This estimate to replace has been determined solely from the customer's information about the item. The appraiser did not personally inspect the subject jewelry."

Your report will be seen as more credible by insurance companies if you explain how you determined the stated values. State the procedures you followed and itemize, by date and name or title, the catalogs, wholesalers, and any other markets you have used for this estimate. If you are a jeweler, be sure to note in your report that the valuation you have supplied is an estimate of what you would charge to replace the item in your store, not an appraisal of market replacement.

Damage Report

A damage report expresses the difference in value that has resulted from breakage and estimates the cost of the removal, recutting, and resetting of the stone, as well as the value of the recut stone (loss of weight). In general, diamonds cost around one hundred to one hundred and twenty-five dollars per carat to recut. Consult with a gem cutter if you are not able to determine the exact weight loss involved in recutting. You must get a release of liability from your client if recutting the stone will be conducted through your facilities as most gem cutters will not accept liability for recutting stones.

A damage report should contain the following:

1. Purpose of the appraisal
2. Original value of the item
3. Current value as a damaged item
4. Weight loss of a diamond or colored stone that is expected to result from the recutting
5. Charge for repair to the item
6. Value of the item once repaired or recut (if gemstone)

The insurance company has the option to replace a damaged item with one like in kind; repair or otherwise restore the item to its condition immediately prior to the damage; provide a cash settlement covering the amount for which the property could reasonably be replaced with identical property; or simply provide the applicable amount of insurance. Generally, insurance companies opt for whichever of the above methods will cost them the least. A settlement that satisfies the client depends largely upon the individual insurance company adjustor and the local laws.

An important point for the appraiser to remember is that if a damage report relates only to the cost of repair of the damage to a stone, the report should state that the cost to restore the jewelry to new condition is *not* included. To restore the jewelry to new condition when only the stone is warranted is called a *betterment*.

Casualty Loss

In a casualty appraisal, the appraiser tries to determine the fair market value of a lost, stolen, or destroyed jewelry item that has not been previously documented. The Internal Revenue Service allows an income-tax deduction of some portion of the value of lost, stolen, or destroyed articles with a proper casualty loss appraisal. The allowable deduction for damaged items is the difference in fair market value before and after the damage to the item. For stolen or lost articles, the allowable is fair market value of the article before the incident.

There are IRS parameters that you need to be aware of, so it would be wise to check with the local district director before completing the appraisal, since regulations and interpretations change frequently. In any event, the IRS requires that the fair market value of the item just prior to loss be based on the original cost or the current market price, whichever figure is lower.

Donation Appraisal

On January 1, 1985, the 1984 Deficit Reduction Tax Act went into effect and life became both better and worse for gems and jewelry appraisers. Better for those who are complying with all the rules (as they probably were before the Tax Act) but definitely worse for the few unethical appraisers who were conducting charitable donation appraisals with a "sky is the limit" attitude. These appraisals were a gimmick pushed by stone gem sellers, who would set up the donation and provide inflated appraisals of the items being sold. In some cases, the reports were furnished to gem sellers by unscrupulous appraisers, who took a higher than usual fee to provide the inflated appraisals. The overevaluated appraisals brought the entire appraisal industry under the close scrutiny of the IRS, and the 1984 Tax Act was the result. It is a lengthy and somewhat complicated bill that not only increases penalties on taxpayers for donation overvaluations, but also regulates the appraiser as well as the kinds of appraisals it will accept, by imposing fines and/or barring unscrupulous appraisers from providing future tax-related appraisals.

A donation appraisal, as for a gift to a museum, university, or other nonprofit institution, should be based on fair market value. You should again consider the most common market for the articles, and accommodate the "willing buyer, willing seller" concept. The most common market will be the market having the greatest number of transactions, between willing buyers and willing sellers, of comparable merchandise.

Among other points, the bill has provisions for donations of an aggregate value of goods exceeding five hundred dollars but not five thousand dollars, and for donations of goods valued over five thousand dollars. The bill states that the valuation must be made by a qualified appraiser not earlier than sixty days prior to the date of donation. It must be prepared, signed, and dated by a qualified appraiser.

A separate qualified appraisal is required for each item of property that is not included in a group of similar items of property. Only one qualified appraisal is required for each group of similar items of property, but a donor may obtain separate qualified appraisals for each item of property.

The following information must be included in a qualified appraisal:

1. A description of the property in sufficient detail to enable a person who is not generally familiar with the type of property to ascertain that the appraised property is also the contributed property. A photograph of the property must be included as well.
2. The physical condition of tangible property must be described.
3. The date (or expected date) of contribution.
4. The terms of any agreement or understanding entered into or expected to be entered into by or on behalf of the donor relating to the use, sale, or other disposition of the property contributed.
5. The name, address, and taxpayer identification number (Social Security number) of the appraiser.
6. The qualifications of the appraiser, including his or her background, experience, education, and membership in professional appraisal associations. (One note: the IRS does not believe that special education or membership in a professional organization gives the appraiser uncontested approval.)
7. A statement that the appraisal was prepared for income tax purposes.
8. The date or dates on which the property was valued.
9. The method of valuation used to determine the property's fair market value.
10. The manner and date of acquisition of property by the donor or, if the property was created, produced, or manufactured by or for the donor, a statement to that effect and the date the property was substantially completed.
11. The specific basis for the valuation, if any, such as comparable sales.
12. The fee arrangement between the donor and appraiser.

Along with the appraisal report, you must complete and give to the client IRS Form 8283 for deductions of noncash charitable contributions. You must also complete section B, the Appraisal Summary part of the form, when the donated property exceeds five thousand dollars. You must also sign the form and certify that you are an independent appraiser, and that your fee is not based on a percentage of the property's value, since the IRS no longer accepts appraisals provided by appraisers who charge fees in this manner. Your signature makes you liable for civil penalties under section 6701(a) of the tax code.

To police the appraiser's work further, the IRS has Form 8282, which requires the donee to submit a statement to the IRS if the donated property is sold, exchanged, or traded within a two-year time period. This form is intended to check possible collusion between the donor and donee. However, it is possible that once the item is traded again, it may drop in value from your original appraised price. To protect yourself in the event that the IRS later asks you for information about your previous appraisal, keep records of substantiation so that you can prove that the market has since fallen. One example is the 1979–1980 peak market for "D" flawless diamonds selling for sixty-four thousand dollars per carat; the market later plunged to twelve thousand dollars per carat in 1985.

Can you use auction market prices when researching fair market value for a donation appraisal? Yes, if you can prove it is the most appropriate and common market. In 1986, Joseph W. Tenhagen was employed by the IRS to find the fair market value of a 48.20 carat natural alexandrite stone at the time of donation, December 1979. Tenhagen met the government's criteria for FMV by using the market-data approach of comparable gemstones. The auction and retail markets proved to be the most appropriate and common markets. The differences and similarities of comparable items were analyzed and correlated. Analysis included date of sale, size, amount of color change, clarity, cutting, and country of origin. The data reflected information obtained from eleven actual sales, two museum specimens, three stones that were offered (but did not sell) at auction, and sales information from three gemstone dealers with like stones for sale. Tenhagen established value and built a defensible document on the basic appraisal principle: research. His report can be found in the appendix. It is a good example of due diligence in using auction-recorded prices to establish fair market value for a donation appraisal.

Over the last five years, approximately three hundred cases of tax deductions for gem donations, claiming a total value of fifteen million dollars, have been reviewed by IRS personnel. In each case, the U.S. Tax Court defined the ultimate consumer, or end user, as the person buying the property, for a purpose other than resale, in its present condition in the most common market. The tax court had repeatedly held that if a recent transaction of the gems was in question, the price paid in the transaction was the best evidence of value, providing that no evidence existed that the price was extraordinary to the market. However, in several 1987 court decisions, the taxpayer was allowed to deduct *less* than he paid for the gem(s). The courts are no longer relying solely on the cost of the gems as the figure a taxpayer can use for a donation.

Table 2-2 lists ten representative cases decided from 1985 to 1987. Six were decided at the taxpayer's purchase price, not at the appraised value supplied by the taxpayer. In *Anselmo v. Commissioner*, the IRS offered to settle out of court at the taxpayer's purchase price plus an added 12 percent inflation sum; the other settlements ranged from slightly above the taxpayer's purchase price to below actual purchase price.

The IRS now asserts that only qualified appraisers may do tax-related appraisals. They define qualified appraisers as those who represent themselves to the public as appraisers of the type of property being valued, and who cannot be considered "excluded appraisers." *Excluded appraisers* include the donor; the donee; any party to the transaction in which the donor acquired the property (unless the property is donated within twelve months of the date of acquisition and the appraised value does not exceed the acquisition price); anyone employed by any of the named persons; and any person whose relationship to those involved in the donation would cause a reasonable person to question the independence of the appraiser.

You must declare on the appraisal that you meet the listed requirements, understand that a false or fraudulent overstatement of value of the property may subject you to a penalty for aiding and abetting an understatement of tax liability, and know that it may cause this and future tax appraisals that you perform to be disregarded. You must also question your client about the original cost of the item and provide extensive documentation. A thorough and detailed cover letter must accompany the appraisal, and must include the market information that was the basis of the evaluation for each item as well as references and comparable sales data. This reflects the effort of the IRS to prevent a person from buying in the wholesale market and selling or donating as a retailer. Before

you begin this type of donation appraisal, consult IRS publication 561, "Determining the Value of Donated Property" (revised November 1986) and also see publication 526, "Charitable Contributions."

Fear of Signing IRS Form 8283

To sign or not to sign this form has become a concern to many jewelry appraisers. Many, conscious of the substantial amount of paperwork involved in

Table 2-2. 1985 Court Decisions on Gemstone Donation Tax Shelters

Case and Trial Location	Taxpayer Donation and Cost	Tax Appraisal	IRS Stat Notice	IRS Appraisal	Published Court Date and Decision
Anselmo v. Commissioner Washington, D.C.	numerous parcels, 15,000	80,680	16,800	1) 7,900 2) 8,100	4/16/85 16,800
Robert C. Chiu v. Commissioner Washington, D.C.	tax year 1 (78) 2 @ 10,412 tax year 2 (79) 13 @ 22,039 tax year 3 (80) 28 @ 20,000	51,095 119,464 92,790	10,750 26,555 20,000	1) 5,919 2) 12,000 1) 44,571 2) 25,887 2) 20,974	4/15/85 10,750 4/15/85 26,555 4/15/85 20,000
Pliney A. Price v. Commissioner Washington, D.C.	parcel tourmaline 3,093 parcel sapphire 3,786	15,910 15,910	3,093 3,786	2,125	4/15/85 3,093 4/15/85 3,786
Ali A. Talabi v. Commissioner & *Chait Palantekin v. Commissioner* Washington, D.C.	tax year 1 (78) kunzite 21,943 tax year 2 (79) blue topaz 5,677	46,812 26,698	21,943 5,677	18,408 2,212	4/15/85 21,943 4/15/85 5,677
Chris B. Theodotou v. Commissioner Washington, D.C.	kunzite 2,641 opal 380 blue topaz 18,944	15,849 2,280 186,852	2,641 380 18,944	2,377 577 16,941	4/15/85 2,641 4/15/85 380 4/15/85 18,944
J & H Lampe v. Commissioner Dallas, Texas	9 @ 4,500	1) 22,023 2) 10,415	4,500	3,150	5/16/85 4,500
Dale B. Dubin v. Commissioner Washington, D.C.	topaz crystal 750 jade desk set 55,000	1,200,000 225,000	750 55,000	750 55,000	9/11/86 750 9/11/86 55,000
Clark R. Hecker v. Commissioner St. Louis, Mo.	8 tourmalines 5,100 9 mineral specimens 5,100	24,164 19,500	3,400 3,400	(av. of 2) 4,337 5,540	6/16/87 4,337 6/16/87 5,540
Edwin J. Cunningham, Jr. v. Commissioner St. Louis, Mo.	sapphire 4,000 pendant emerald/diamond 5,000 pendant garnet pendant 3,000	22,450 26,985 16,205	5,000 3,335 2,000	1)2,972 2)3,744 1)5,200 2)4,982 1)2,100 2)4,480	6/16/87 3,744 6/16/87 5,091 6/16/87 3,290
Leo J. Malone, Jr. v. Commissioner St. Louis, Mo.	rubellite tourmaline mineral collection yellowish/gr. 5,657 tourmaline pendant & ring 4,600	tax year (80) 27,500 tax year (81) 21,028	3,771 3,066	2,600 485 1)2,386 2)1,857 1)2,608 2)2,000 1)3,712 2)2,750	6/16/87 4,721 5,535 6/16/87

Note: Where appraisals were done by more than one appraiser, the numbers 1) and 2) are indicated. All figures are rounded to the nearest dollar.

doing appraisals for donation purposes, simply refuse such work. More serious, however, is the fact that signing the form renders the appraiser accountable for *all* statements made on the form. As Emyl Jenkins, a personal-property appraiser, points out, she is concerned that the IRS requires her to attest that all information given by the *donor* on the form is correct. She writes: "I now expect almost everyone to try to fudge just a little bit, especially when they're dealing with the IRS. I've concluded that IRS forms bring out the closet embezzler in most people" (Jenkins, 1986, 37).

Jenkins has raised a serious question. How can you protect yourself when asked to certify the truth of the donor's statement? One way is to hire an attorney to help you devise a statement to accompany each tax form you sign. The statement should, in part, declare that you cannot be held responsible for the donor's claim of when and how the item was acquired and the cost or adjusted basis for the gift.

Jenkins, who is a senior member of the American Society of Appraisers as well as an author and lecturer on personal-property appraising, has developed the following statement, which she attaches to every completed Form 8283:

> Donation of personal property by (donor's name) to (donee) on (date gift given): An appraisal to comply with IRS requirements for gifts with a value over $5,000.
>
> Accompanying is a complete description of the property donated by (donor's name) and my qualifications as an appraiser to make this appraisal. The fee for this appraisal was based on an hourly charge for the time the appraiser spent researching and preparing the appraisal, plus direct costs in the preparation of the appraisal document including telephone and incidental expenses to confer with other experts. This appraisal has been made for income tax purposes to accompany IRS Form 8283 and it is intended to provide the information required in Part II 2 (a) and (c), and II 3. The appraiser is not responsible for the information provided in Part II 2 (b), (c), and (d) of that form. The fair market value has been established by the use, in part, of published auction prices. The appraiser does not certify or warrant the accuracy of published auction prices, but maintains that such publications represent an accepted definition of "market" for the type of property described in this appraisal. The appraiser has no interest in the property appraised and is an independent contractor and not an employee of either the donor or donee.

Other Functions of an Appraisal

A *qualitative report* gives information about an item but does not include a statement of value. This type of report is used merely to establish or confirm identity and to describe gemstones, precious metals, and other jewelry components. A client might, for example, want to know whether certain gemstones are natural or synthetic, whether a stone has recutting potential, or might want to determine the country of origin of a jewelry item.

A *customs appraisal* is a report prepared for a client who wishes to take jewelry abroad and avoid any problems upon reentry into the United States. In the appraisal, you certify that the jewelry item is the property of the owner by providing the proper documentation—any serial numbers on the jewelry as well as a detailed description and a photograph of the item.

Limiting and Contingency Conditions for Appraisal Documents

The list below includes recommended limiting and contingency conditions to be attached to your appraisal report document as needed. Your actual document should be developed with the assistance of an attorney. You may wish to include several additional considerations to the report to meet any special circumstances. These statements should be in 8-point type or a larger size, depending upon legal requirements in your state. Remember, however, that you can limit your liability to disclose whatever prevented you from operating at a subscribed industry standard, but you cannot disclaim it totally.

1. Mounted stones are examined and evaluated only to the extent that the mounting permits.

2. All weights and measurements are estimates, unless otherwise stated.

3. Ordinary wear common to this type of item is not noted.

4. If the item is antique or out of style, say that the valuation is for the replacement of an item of similar size, type, and quality, not for an exact duplication.

5. Identification of metals and methods of constructions are determined only to the extent that the design permits.

6. If the take-in date is not the date of the valuation of the jewelry, distinguish the two dates clearly on the report.

7. If the appraisal has been prepared away from your normal working environment, state the location and make note of any working conditions that may have limited the proper examination and evaluation of the items, such as lighting or space limitations.

Also note any other factors that might affect the accuracy of the value conclusions.

8. Unless otherwise stated, all colored stones listed on this appraisal report have probably been subjected to a stable and possibly undetectable color enhancement process. Prevailing market values are based on these processes, which are universally practiced and accepted by the gems and jewelry trade.

9. No change in this appraisal report can be made by anyone other than the named appraiser; the appraiser will not be responsible for unauthorized changes.

10. Possession of this document does not confer the right of publication. This report may not be used by anyone other than the above-named client without written permission of the appraiser, and then may be used only in its entirety.

11. All value conclusions are valid only for the purpose stated.

12. It is understood and agreed that fees paid for this appraisal do not include the services of the appraiser for any other matter whatsoever. In particular, fees paid to date do not include any of the appraiser's time or services in connection with any statement, testimony, or other matters before an insurance company, its agents, employees, or any court or other body in connection with the property herein described.

13. It is understood and agreed that if the appraiser is required to testify or to make any such statements to any third party concerning the described property appraisal, applicant shall pay the appraiser for all time and services so rendered at appraiser's then-current rates for such services with half of the estimated fee paid in advance to appraiser before any testimony commences.

For fair-market-value appraisals, you might append the following contingencies.

1. The prices of subject items are estimates of their current fair market value in their present condition and within the existing local market. Primary research has been conducted in the following manner: (list marketplaces and prices analyzed to estimate value).

2. As used in this appraisal, "fair market value" is defined as the price at which such property would change hands between a willing buyer and a willing seller, neither being under compulsion to buy or sell and both having reasonable knowledge of relevant facts, in the most common market that is reasonable and appropriate for a purchaser who is the ultimate consumer of the property.

For estimate to replace appraisals, you may want to append the following limiting conditions. This appraisal sets value estimates at the current market value at which the appraised items may be purchased in a retail jewelry store engaged in the business of selling comparable merchandise, and does not necessarily reflect the price of any one particular jewelry store. Jewelry appraisal and evaluation is subjective, therefore estimates of value may vary from one appraiser to another and such variance does not necessarily constitute error on the part of the appraiser. This appraisal should not be used as a basis for purchase or sale of the items valued, and is only an estimate of the approximate replacement values of subject items at this time and in this locale.

Handling Insurance Replacements

You do not need to be a retail jeweler to expand your business by handling the replacement of gems and jewelry on insurance claims. By working as a broker, you will be in a good position to offer strong discounts to insurance companies and draw their business to you.

Insurance claims adjusters and agents need current information about replacement costs and the availability of jewelry they have on claim, so the first step is to contact them, tell them who you are, and explain how you can help them. Most will respond to you by contacting you for information at first. After working with you on several replacements, insurance representatives will probably begin sending you their clients for insurance appraisals.

While different insurance companies may have their own methods of handling claims, the basic procedures remain the same nation-wide. The chain of events leading to your involvement with the jewelry replacements is as follows:

1. A client gets a retail replacement "floater," "rider," or "schedule" on his or her insurance policy for an item of jewelry.

2. The client's jewelry is later lost, stolen, or damaged, and the client files a claim. If the article is stolen, the client must file a report with the local police before notifying the insurance company.

3. The claim goes to the Claims Department of the insurance company, bypassing the underwriter, who is no longer involved.

4. If the Claims Department believes that the claim is legitimate, it will want to give the client a replacement item of jewelry rather than the item's cash value. The insurance company would rather replace than "cash out" the item even if the company would save money by "cashing out." The reasoning is that if the article is replaced, it will

probably continue to be insured and the premium will be maintained.

5. The claims representative will want to replace the lost, damaged, or stolen article at a cost of at least 20 to 25 percent below retail. This is where you, the appraiser/insurance replacement specialist, come into the picture.

The claims representative, whom you have contacted earlier, calls and gives you details about the article to be replaced. You can use a quotation form such as the example shown in figure 2-1 to write down all the necessary information and work up your quote for replacement based on the description furnished by the agent. The agent will want a *written quotation,* the price for which you will deliver a comparable replacement article, according to the former insurance appraisal, to the client. You must quote the exact item by description; if it is a diamond, describe the four "C's" of color, cut, clarity, and carats.

After you have presented your quotation, you should get a letter from the insurance adjuster authorizing replacement. Make sure you have written authorization to replace before you start work. The cost of replacement (with the discount) is established between you and the insurance adjuster—do *not* discuss this with the customer. Ask the agent if there is a deductible and if local taxes are included or should be added.

If the item for replacement is a chipped or damaged diamond or colored gemstone, you must do a major damage report and review. If the damaged stone does not change dramatically in visual size after the recutting or repair, the client must accept the repair of the stone plus payment for the loss in value of the weight. The insurance company pays for cost of repair. If, however, damage to the stone is severe and the stone is estimated to become considerably smaller after recutting (insurance companies vary on the minimum acceptable size after recutting; consult with the agent), the company keeps the damaged stone and gives the client another of the same original size and quality. The insurance company then sells the smaller recut stone. If you are going to do quotations for diamond recutting, make sure you are proficient at this type of estimation, or consult with a diamond cutter. Protect yourself with the usual plots and photographs and explain to the client the risks of recutting the stone. A sample damage report form is shown in figure 2-2.

Authorization to Proceed

After the insurance claims representative receives your quotation and gives you the go-ahead to proceed with the replacement, you will either secure the item from your previously researched source or build a replacement (if you are a bench jeweler and able to perform this service), as you will have already stated. When the replacement item is ready, there may be yet another form for you to fill out completely and have the claimant sign, the customer satisfaction and insurance payment authorization form (fig. 2-3). Not all states require this but where it is used, its importance cannot be stressed too strongly—this form must be signed and returned to the insurance company before you can be paid for your services.

In Florida, for example, instead of a customer satisfaction form, the insurance company issues a two-party check with the names of the client and the insurance firm replacing the items. The cancelled check becomes an acknowledgment of satisfaction. If you are using a customer satisfaction form, have the claimant sign the form affirming that he or she is satisfied with the replacement jewelry. Next, fill in the percentage of discount extended to the insurance company below the retail replacement total. Include the amount due you at the bottom. If the client has paid you a deductible, as is the norm, subtract it from the total due. That bottom line is the amount the insurance company owes you for replacing the item. Sign the form and send the bill to the claims representative with whom you have been working.

Questions and Answers about Developing Insurance Replacement Business

Q. How can I get started?

A. Solicit claims representatives by mail, telephone, and by visiting in person. Invite insurance agents to your office or store and express your willingness to travel from your place of business to the claimant. If you wish to meet many claims adjusters in a short time, plan a seminar and invite agents to listen to you explain what you can do for them.

One Connecticut appraiser compiled a training manual for claims representatives, explaining common diamond and colored-stone terminology. He distributed the manuals at a seminar, and included in the booklet a list of questions for agents to ask claimants about lost items, as well as photographs to illustrate certain jewelry terms more clearly.

Q. What kind of mark-up margin should I allow?

A. The insurance replacement specialist's usual mark-up is about 20 percent above wholesale. If you really want to go after the business, go as low as you must over wholesale (but no lower than 5 percent) to get the job. Just make sure that you can deliver what you promise.

Q. Will the insurance company pay me to supply a quotation?

A. Yes. The average charge for a quotation is about thirty-five dollars, regardless of whether you do the replacement. But, as some will refuse to pay this fee if you contract for replacement of the jewelry, the matter of quotation fee must be settled between you and the adjuster when you are contacted to submit a written quote.

2-1. Sample written quotation for replacing an insured article.

COMPANY NAME
(Logo)

REPLACEMENT FORM

Date:_____

INSURANCE COMPANY:_____

ADDRESS:_____

CITY, STATE_____ZIP_____TELEPHONE_____

Adjuster's Name:_____

CLIENT:_____

ADDRESS:_____

CITY, STATE_____ZIP_____TELEPHONE_____

Policy #_____Coverage_____

Claim #_____Deductible_____

Article to Be Replaced: (Based upon descriptions furnished) Preliminary Estimate:

Estimated prices are current as of above date and subject to market fluctuations.

Quotation Authorized by:_____

2-2. Sample insurance damage report.

COMPANY NAME
(Logo)

DAMAGE REPORT

Prepared For: _____　　Regarding: _____

_____　　_____

_____　　_____

_____　　_____

Claim and Policy # _____

Type of Stone: _____

　Original Shape: _____

Estimated Weight Before Damage: _____ carat

　Present Weight: _____ carat (measured weight) (estimated weight)

Present Measurements: _____ x _____ x _____ x _____ x _____ mm

Description of Damage: _____

Recut Estimated By: _____　　　　　　[PLOT]

　Recut Time: _____

Recommended Recut Shape: _____

　Estimated Recut Weight: _____

　Weight Loss: _____

Estimated Recut Measurements: _____ x

_____ x _____ x

Estimated Quality Before Damage: _____ clarity/color

Estimated Present Quality: _____

Estimated Quality After Repair: _____

Estimated Value Before Damage $_____　　Estimated Present Value $_____

Estimated Recut Cost $_____ (retail)

Estimated Value After Repair: _____

Salvage Value $_____

　Date_____　　_____

　　　　　　　　　　　　　　　　　　Signature

2-3. Sample certificate of satisfaction form.

COMPANY NAME
(Logo)

Certificate of Satisfaction

Insurance Company: Insured: Policy No. _____

 Name _____ Name _____

 Address _____ Address _____

 City _____ State ____ Zip _____ City _____ State ____ Zip _____

 Attention: _____ Claim No. _____ Telephone _____

DESCRIPTION OF ITEM(S) TO BE REPLACED:

Items: Replacement Cost:

 Sub Total _____

 Sales Tax _____

 Total _____

This is to certify that the above facts are true and that the repair or replacement has been made to my satisfaction and in full settlement of its obligation under my policy shown above for said loss, I authorize my insurer to pay:

This certificate of satisfaction has been executed on the

_____ day of _____ 19 ____.

Company

Insured Signature

CHAPTER 3

Conducting the Appraisal

I counted the large balass rubies on the great throne, and there are about 108, all cabuchons, the least of which weighs 100 carats, but there are some which weigh apparently 200 or more. As for the emeralds, there are plenty of good colour, but they have many flaws; the largest may weigh 60 carats, and the least 30 carats. I counted about 116; thus there are more emeralds than rubies.

Tavernier, Travels in India, *1676*

Imagine that you are a gemologist or jeweler who is facing an appraisal of jewelry for the first time. The items are spread out in front of you and your refractometer, microscope, and other necessary tools are close at hand. You are ready to begin, but not sure where to start. The take-in form shown in figure 3-1 will help you proceed smoothly. The steps involved in appraising are as follows.

Initial Examination and Take-In

First, ask the purpose and function of the appraisal and find out how many items you will be appraising. (See chapter 2 for an explanation of the purpose and function of appraisals.) Explain your fee structure and obtain the client's approval to proceed. Next, fill out the client's name and address and the date and time of day on the take-in form. Itemize each piece to be appraised and list the client's estimate of the jewelry's value. If you plan to hold the jewelry overnight, place each item in a separate take-in envelope or plastic bag, mark the appraisal take-in form number on the outside of the bags, and number the bags in sequential order after the initial exam is finished.

Note any damage to stones or mountings on your take-in form and point this out to the client. Discuss the condition of each piece and show the client, under the microscope, any damage and/or needed repairs. This is the appropriate time to talk about the overall quality of the gemstones, indicating any particular aspects that may affect the value of the stones.

If the client does not know how to look for damage, show him or her how to use a loupe. You may make a friend and patron for life if you do so and explain what the client is viewing. Assure your client that when the jewelry is returned, he or she will have the opportunity to check the gemstones to ensure that these are the same gems brought in.

When you list the jewelry items on the take-in form, describe all stones generically. Never make a positive identification of metal or gemstones unless you have done the tests at that time. For example, write "one yellow metal ring containing one round faceted red stone and two near-colorless transparent stones. Shank stamped 14K."

Set a limit of liability in the event of loss, theft, or breakage on each piece taken in. Use a maximum of one to two hundred dollars unless your customer specifies a greater value on individual items.

Note any special instructions on the take-in form, such as "Do not clean ring; owner does not wish to lose patina."

Next, have your customer read, understand, and sign the take-in form, or, if you are a portable appraiser, the contract (fig 3-2). Follow the same procedure a storefront jeweler would in advising the client about damaged items or repairs that should be made before the appraisal begins. Make a note of these on a worksheet (a sample worksheet is shown in figure 3-3). Give the client a copy of the take-in form and notify him or her to present this copy in order to retrieve the jewelry later. If the jewelry is left with you, put it in your safe as soon as the client leaves until you are ready to begin work on the actual appraisal.

Advise the client of the various identification and testing procedures that you could perform, explaining both the risks involved in conducting the tests and the additional charges you will impose for the procedures.

Pearls and many colored gemstones—including golden sapphire, zircon, aquamarine, quartz, tanzan-

3-1. Sample appraisal take-in form.

COMPANY NAME
(Logo)

APPRAISAL TAKE-IN FORM

Name _____ Page _____ of _____.

Address _____ No. _____

City, State, Zip _____ Date Received _____

Telephone _____ Completion Date _____

Name on Appraisal _____ Appraisal Form (check one)

Address _____ Insurance _____ Estate _____

City, State, Zip _____ Other _____

Appraisal Type _____ Total Number of Items _____

 Estimated Fee _____

Item No.	Items	Customer's Declared Value

SERVICE AGREEMENT

"The description and value of the article(s) listed on this form are correct. By accepting said article(s) Customer agrees that neither the appraiser, its parent company, nor any of its employees or officers shall be responsible for the identification or condition of the jewelry or stones at the time of the receipt. I further agree that the responsibility for any damage or loss to said article(s) shall be limited to the actual cost to the appraiser and/or its parent company to repair or replace the article(s), and in no event shall said repair or replacement cost exceed Customer's evaluation as shown on this form. If Customer fails to list said value(s), the Customer agrees that the said value(s) of said article(s) do not exceed the sum of $100. I acknowledge that the above terms have been fully explained to me by the appraiser or a company employee whose name or initials appear on this form and that I agree to these terms and conditions."

Client's Signature _____

3-2. Portable appraisers should have their clients sign a formal authorization form such as this one before beginning the initial examination.

Authorization for Appraisal Service

In consideration of this Employment Agreement between _____

hereinafter referred to as the appraiser, and _____

hereinafter referred to as the employer, said parties _____
do hereby agree as follows:
The appraiser agrees to make a study of the property: _____

_____ located at _____

PURPOSE OF THE APPRAISAL

and to deliver () copies of a _____ report to the

employer on or before _____.

In return for said services and appraisal report, employer hereby agrees to compensate appraiser in the amount of
$_____, payable as follows: $_____ upon the signing of this agreement and the balance of
$_____ upon delivery of said report.

Should additional services of the appraiser be requested by the employer, his agent, his attorney, or the court, such as pre-trial conferences, court appearances, court preparation, etc., the employer agrees to compensate the appraiser at the rate of $_____ per hour provided such additional services are performed within one year after delivery of said report. In the event that such services shall be required more than one year after delivery of said report, the compensation shall be at the customary per diem rate charged by said appraiser as of that date.

The cost of preparing exhibits for court, photo enlargements, maps, etc., shall be borne by employer, and the appraiser shall, in addition to his compensation, be reimbursed by the employer for such costs advanced by the appraiser.

Payment for such additional services shall become due upon receipt of statement rendered by the appraiser.

It is further understood and agreed that if any portion of the above compensation or costs due to the appraiser becomes delinquent, the employer agrees to pay interest thereon at the rate of 10%_____ per annum on said account from the due date until paid, and further agrees to pay all costs of collection thereof, including reasonable attorney's fees, court costs, etc.

In the event that employer desires to cancel this authorization, written notice thereof shall be delivered to the appraiser, and it is agreed that the appraiser shall receive compensation from the employer for all services rendered at the rate of $_____ per day for the time actually spent prior to receipt of written notice to stop work plus all costs advanced in connection with said appraisal prior to receipt of such written notice.

I hereby accept these terms and conditions and order the appraisal to be made.

_____ _____
Employer/Fiduciary Date

Appraiser hereby acknowledges receipt of $_____ retainer.

_____ _____
Appraiser Date

3-3. Sample appraisal worksheet, for use with colored gemstone jewelry and other articles.

Appraisal Worksheet

JEWELRY TYPE: (Check) Woman's _____ Man's _____
 Ring __ Bracelet __ Brooch __ Chain __ Earrings __
 Necklace __ Other: _____
Measurements: Length _____ Width _____ Depth _____
Description: .

Containing Gemstones:

Information Reference Sources: (with Date)

COMPUTATIONS AND VALUATION

 Value: $ _____

No. _____
Client _____
Date _____
Appraiser _____
Date Due _____
Insurance ☐ FMV ☐

Metal (Circle)
Gold—Silver—Plat
White—Yellow—10K
14K—18K—Sterling
Weight, dwt/gram:

Stamped? Yes _____ No _____
Tested? Yes _____ No _____

Manufacture (Check)
Handmade _____ Cast _____
Die-Struck _____ Other _____
Hallmarks?

Style (Circle)
Antique Modern
Art Deco Can't Decide

Photo? _____
Plot? _____

INSTRUMENTS USED
Deluxe Mark V Gemolite
Eickhorst Gem Immersion Scope
Eickhorst Dialite
Diamondlite
UV-254-366 NM Mineralight
Duplex II Refractometer
Ceres Diamond Probe
Polariscope
Polaroid CU-5
Polaroid/35mm Microscope Camera
Master Color Diamonds
Specific Gravity Liquids
Thermal Reaction Tester
GEMPRINT
Metal Tester
Dichroscope
Spectroscope
Micro 2000 Digital Micrometer
Screw Micrometer
Leveridge Gauge
Proportion Analyzer
Mettler Diamond Balance H800C
Scientech SE300 DWT/CT Balance

ite, and Imperial topaz—are commonly subjected to a variety of color-altering enhancements before they are offered for sale. Approximately 75 percent of all colored stones sold in the average jewelry or department store are so treated, and the techniques range from low- or high-temperature heating to irradiation, staining or dyeing, and impregnation, among other procedures. Explain to your clients that if they do not want you to perform the additional testing, your report will reflect the assumption that one or more enhancement techniques may have been applied to the gem (especially sapphire or ruby). You are required, under a 1959 Federal Trade Commission directive, to disclose any or all gem treatments that you find in the items you examine.

Typically, your clients will be surprised and dismayed to learn that their gems may have been color enhanced. Try to explain to them that gem treatment is common practice, and that the purpose of the treatment is to improve the general desirability of the stones and, in some cases, their durability.

Appraisal Preparations

With the take-in form completed and all contracts and agreements signed, you are ready to begin the steps to valuation. Each step listed below is discussed in greater depth in the following text.

1. Clean the items if necessary and note on your worksheet any damage or special features that you failed to notice earlier.
2. Photograph the items to be appraised.
3. Identify, measure, or weigh the gemstones. Note on the worksheet all tests made to identify the gems. Itemize the equipment you used.
4. Analyze the metal fineness of the mountings.
5. Weigh and measure mountings and analyze the method and style of their manufacture.
6. Note hallmarks and stampings. Determine circa date, if possible.
7. Research the market and evaluate items accordingly.
8. Type or use a word processor to transfer all information from your worksheet to the final appraisal document. Plot the inclusions of major stones. Include photographs and be sure to define the ratios at which they were shot. List the reference sources you used, sign the form, and seal it.
9. File a duplicate copy of the appraisal in the client's folder.
10. Deliver, mail, or call the client to pick up the completed appraisal document.

Before you begin work on the inventory, pause to draw yourself together mentally and concentrate upon one item at a time. There is a tendency for appraisers to scan the job hastily and take in many impressions at once. Since you want to draw every possible ounce of information from each item, focus is important.

Excellent lighting conditions are required for working with diamonds and colored gems, because the degree of color observed by the appraiser is dictated by the light under which the stone is examined. Color researchers recommend using a light source that duplicates north daylight. The source is generally fluorescent light. Although fluorescent "daylight" fixtures do not exactly duplicate north light, they can produce a constant, uniform light. Two acceptable light sources are the fluorescent lamps Vita-Lite, made by Duro-Test Corporation, and Verilux, produced by the Verilux Corporation. The GE Chroma 50 lamp may also be used for color grading.

It is important to realize that all "daylight" fluorescent tubes are identical and that they are subject to manufacturing fluctuations. Look for a fluorescent lamp with a high color-rendering index, of about ninety. The index ranges from zero to one hundred, with one hundred equalling north daylight.

Since proper lighting may not be available in the client's home, office, or bank, some portable appraisers bring their own light sources with them.

Photographing the Jewelry

Photograph the items right away to allow for the time needed to develop the film and, if you are appraising off-premises, so you can restore the equipment to its carrying case, out of your way. Useful appraisal photographs can be obtained with both an instant-photo camera such as the Polaroid Close-up (CU-5) camera and with a 35mm single-lens reflex (SLR) camera. The Gem Instruments Corporation's PhotoStand combined with the Polaroid 100EE special instant camera is also economical and easy to use and ideal for grouping more than one item in a photo (fig. 3-4).

The advantages and disadvantages of using an SLR versus a CU-5 camera were weighed by Kay Manning Mays, a gemologist based in Seattle, in a pamphlet pocket guide she distributed in a recent meeting of gemologists. Mays evaluates the two systems as follows:

35MM SLR CAMERA

Advantages
- Better-quality focus
- More lenses, greater applications

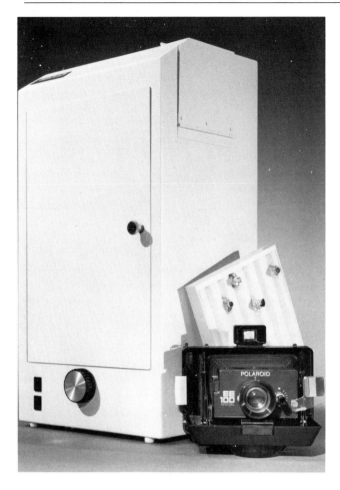

3-4. The Gem Instrument's PhotoStand and the Polaroid 100EE special instant camera. Both are good for appraisal photography. *(Photograph courtesy of Gem Instruments Corporation)*

- Easier to carry
- Negatives provide permanent record
- Better-quality finished product
- Longer-lasting prints
- Better color reproduction overall
- Ability to take magnified photos of inclusions

Disadvantages
- Mistakes are not apparent until the initial exam is over
- Having the film developed is time-consuming, requires some effort
- More complex to use than an instant camera

INSTANT-PHOTOGRAPH CAMERA

Advantages
- Instant results; mistakes are immediately apparent
- Easier to use than 35mm camera

Disadvantages
- No permanent record; no negatives are provided
- Color consistency not as great as with 35mm camera
- Equipment larger, more cumbersome
- Commercial-quality film not as widely available
- Fewer systems from which to choose
- Systems can be much more expensive than a 35mm camera

If you decide to invest in a 35mm camera and you are not an accomplished photographer, it is a good idea to pick up one of the excellent books on the subject, to give you more guidance than your owner's manual is likely to provide. The cost of a 35mm camera can range from two hundred and fifty dollars and up, depending on the sophistication of the equipment. Appraisal photographs will generally cost about 45 cents per shot, including film, processing, and printing—more for black-and-white prints, oddly enough.

In considering whether to use slide film or print film, bear in mind that whereas slide film will more closely duplicate the color of the gems, you will have to have prints made from the slides, requiring more time and expense. You may choose to use slide film only if it is important to verify the color of a gemstone in an appraisal. Print film offers the advantage of one-step development and may be suitable for many appraisals. Similarly, while the quality of photographs from a 35mm camera is better than instant photos, instant photos are usually good enough for appraisal purposes.

If you are interested in microphotography, the best film to use is 160 ASA Kodak Ektachrome professional film. It is good for shooting all gemstones but emeralds. Microphotography expert John I. Koivula cautions that film for microphotography must be stored in the refrigerator, and warns appraisers not to buy film that has not been taken from refrigerated storage at the time of purchase. He also recommends using Kodachrome 64 film for microphotography shots of emeralds.

The Polaroid system that shoots and prints automatically is called the Close-up 5. The cost is about two thousand dollars for the camera and for optional equipment that will allow you to shoot a subject at two or three times its actual size. The camera has a normal fixed ratio range of 1:1, or actual size—the ratio desirable for appraisal purposes. The unit is portable and has a built-in electronic flash ring light as its main light source, although other types of lighting may be used. For each degree of magnification, the camera has either a special frame or a viewfinder/rangefinder, making it easy to frame the subject and

get sharply focused pictures. The unit has its own power light source for indoor photography and has a full range of accessories. Although bulky, the camera can nonetheless be carried about by the portable appraiser. The unit looks impressive and adds to the image of a professional laboratory.

Use 668 or 669 professional film with a CU-5 Polaroid. The color shots will cost you about 90 cents per photo.

Arranging the Subjects

Depending upon how many items of jewelry you have to appraise, include one to six items per photograph. The number of items in a picture depends on the type of appraisal and size of the individual items. For instance, if you were appraising one hundred items for a divorcing couple, you would not need or want one hundred individual photos of the jewelry, but could photograph the items by category, grouping together rings, pendants, and so on. For a probate appraisal in which several heirs will eventually divide the estate, it might be more convenient for the heirs to have individual photos of the jewelry. Use a gray background for best contrast.

For an insurance appraisal, you can cluster items in a photo. The most effective way to do this is to use a ring box grooved for individual items. If you have three items in two rows, number them from top to bottom, left to right, to provide an easy crossmatch with the written report.

For insurance or divorce appraisals, this cluster technique will save you film while affording you a complete and accurate photo record of the jewelry. If there are only one or two jewelry items to appraise, it is neater and more professional to photograph them separately.

Cleaning the Jewelry

The jewelry will probably need to be cleaned. Most items will be covered with a film of skin oil and cosmetics that must be removed before you can make a thorough inspection of the gemstones.

Cleaning jewelry in a client's home or in a bank will require some creativity on your part. Cleaning tools you will need to carry routinely include a small bottle of any commercial jewelry-cleaning product such as Gem Kleener, a child's toothbrush, and a small bottle of Grease Relief or a similar grease-removing product.

Gem Kleener is distributed by International Gem Show, 4836 Rugby Avenue, Bethesda, Maryland 20814. It comes in a one-ounce plastic squirt bottle. Grease Relief can be obtained in most supermarkets.

Ask a druggist for an empty squirt bottle to carry this liquid. Do not overfill the container, as it takes only a little to do an adequate job.

You may also want to buy a compressed air product called Dust-off, used to clean camera lenses, slides, and delicate instruments. It can also be used to clean jewelry as long as the jewelry is not caked with grime.

As a responsible gemologist, you already know that many gemstones require special handling when they are cleaned. Diamonds can be cleaned in a steam or ultrasonic cleaner, but colored gemstones should *never* be put in an ultrasonic unit, and some species can also be damaged in a steam cleaner. Most colored gemstones have inclusions that can force internal cracks to the surface if the gems are subject to vibration. Emeralds, which are almost always oiled, will leach the oil if cleaned in an ultrasonic or steam cleaner and may emerge from the unit dull, grayish, and with every fissure in the stone announcing its presence. Emeralds can be reoiled if they are immersed in a vial of warmed cedarwood oil and the oil is kept warm for several hours or more; place the vial on top of a steam cleaner to keep the oil heated. To clean emeralds, use lukewarm water, baking soda, and a soft brush; do not rinse in alcohol.

Other stones that should not be cleaned in an ultrasonic or steam unit include jade, lapis, lazuli, amber, ivory, pearls, coral, and turquoise. Dyed lapis lazuli will leach its color, turquoise will turn green, and the others will suffer various misfortunes. Similarly, Indian corundum star stones should be kept away from steam and ultrasonic cleaners, as they are heavily oiled and, like emerald, will come out of the unit with every crack showing and color drained.

Avoid sudden changes in solution temperatures even when cleaning colored gemstones by hand. Tanzanite, aquamarine, peridot, and kunzite can all be damaged by exposure to sudden temperature variations.

Pearls. Be cautious when cleaning strings of pearls and beads. They may have weak strands ready to break with the slightest pull. If this appears likely, advise the customer to have the pearls restrung before you begin the appraisal, or obtain a release from liability for this hazard. Clean the pearls with a soft cloth, soft brush, and a paste of baking soda and water. Extra cleaning care should be given around the bead hole, as this is where most cosmetics will tend to accumulate and bead holes must be clean so you can investigate the thickness of the nacre. Strands of pearls and beads need to be supported with both hands after they have been cleaned and then left on a table to dry. Advise the client that the pearls must be left to dry for at least twenty-four hours, to allow

enough time for the string inside the bead holes to dry. Never clean pearls in ammonia; it will dissolve the nacre.

Diamonds. Dip ring in a solution of water, detergent, and ammonia, brush with a soft brush, rinse in alcohol, and dry. Of, if you want to clean diamonds the way the professionals do, boil a small amount of mild soap flakes and a little ammonia in two cups of water. Put the diamond ring in a wire tea strainer and swish it in the hot suds for a few moments. Let the ring cool and then dip it in alcohol to cut the soap scum. Place it on a paper towel to dry. Do not boil the diamond if the jewelry contains any colored stones.

Mother-of-Pearl. Wash in a solution of a small amount of powdered whiting and cold water. Do not use hot water or soap. (Whiting is a very fine preparation of chalk that can be bought at paint stores.)

Ivory. An expert in valuing ivory netsukes suggests that soaking in milk is an effective way to clean ivory.

Glued-in Stones. Stones that are obviously glued into place should not be cleaned unless you have supplies available to reglue them. Do not clean foil-backed stones of any kind, including cabochons and faceted stones. These are frequently found in costume as well as antique jewelry.

Lockets. These should be handled with care, especially antique hair lockets. Hair lockets are made of plaited, woven, and curled hair, and should never be cleaned! Not only would you damage the hair, but antique items must not be cleaned or the patina on the metal will be destroyed.

Enamelled Jewelry. Enamelled pieces should be handled carefully as they may contain soft enamel, which can easily be washed out. Examine the piece first to see whether it has any soft enamel—the soft enamel will appear dull under magnification. Hard enamels are usually safe enough to clean by hand, but you should avoid the ultrasonic cleaner at all costs.

Charms. Some charms may contain paper prayers, booklets, or folded paper money. Check contents carefully before you start cleaning.

Watches. Unless you are an experienced watchmaker, do *not* attempt to clean a watch. To clean a watch successfully requires removing the movement and leather or fabric bands. Also, many watches are not waterproof; it is better to appraise them in as-is condition and save yourself a possible lawsuit for negligence.

Identifying, Measuring, and Weighing Gemstones

Examining gemstones, calculating their weight, and grading gems for color and clarity is what gemology is all about and the point at which real jewelry appraising begins. In most appraisals, gemstones, whether diamonds or colored stones, are the greater portion of the value of the item, although there are exceptions to this rule.

All gemologists, no matter how experienced, will sometimes come across a gemstone that they cannot positively identify. This situation calls for a consultation with another gemologist or gemological laboratory. If you are not sure of a gem's identity, don't guess. Advise your client of the identity problem and defer the appraisal until you can resolve the matter. In some cases, mountings may restrict positive identification and removing the gem from the mounting may be all that is necessary to solve the problem. Be sure to get a waiver of liability from your client in writing before you proceed.

Diamonds

Measure diamonds with a Leveridge gauge and write down the specific data. Make a special diamond appraisal worksheet to use for all major diamonds so that you do not forget to include any important tests. See the sample form shown in figure 3-5.

On the diamond appraisal worksheet, note the shape of the stone; the color, graded against master diamond grading scales; the clarity, graded under magnification; a plot of the inclusions for all diamonds of one carat or more; and the quality of the cut. Also note any unusual inclusions and other reasons you had to assign the grade you did to the stone. Finally, note any damage to the stone, both on your worksheet (under "Miscellaneous") and on the worksheet plot.

There are several grading systems in use today to describe diamond color, clarity, and other characteristics such as finish, proportion, and so on. The GIA system is the most widely used in the United States, but is not the only system. Figures 3-6 and 3-7 show comparison grading systems employed world-wide. To ensure that your appraisal will have gradings recognizable to any concerned party, use terms that have been carefully defined and widely published. If, however, you find it more convenient to use other grading plans, comparison bars should be included on your report to the more popular and universally understood terms.

Cutting Styles

Standard cutting styles are illustrated in the appendix. Several styles have been designed recently that contain more facets than the brilliant cut. The purpose of these more complicated cuts is to achieve a greater degree of brilliance in the finished gemstone. Some of the fancy cuts are the *jubilee cut* (80 facets);

3-5. Sample diamond appraisal worksheet.

Name_____ Job #_____

Address_____ Date_____

City_____Zip_____ Date Due_____

Shape and Cut_____Loose_____Mounted_____

Weight_____Estimated_____Measured_____
Diameter
 or Table
Dimensions_____Depth_____Measurement_____
 length and width

Depth Percentage_____

Table Diameter Percentage_____

Girdle Thickness_____

Finish
Girdle Surface_____

Symmetry_____

Culet_____

Polish_____

Miscellaneous_____

Clarity Grade_____ Proportion Grade_____ Finish Grade_____

Color Grade_____ COMMENTS:

Fluorescence_____

Base Price per Carat_____

Base Price per Stone_____

Est. Replacement Cost (retail)_____

Engraved Diamond #_____

Gem Print #_____

List Instruments Used:

COLOR: **DIAMOND GRADING SCALE (GIA)**

D E F G H I J K L M N O P Q to Z
 Fancy
 Yellow
COLORLESS NEAR COLORLESS TRACE COLOR VERY LIGHT YELLOW LIGHT YELLOW

CLARITY
 Industrial
 Bort
F
L VVS₁ VVS₂ VS₁ VS₂ SI₁ SI₂ I₁ I₂ I₃
 Very Very Very Slightly Slightly Imperfect
 Slightly Included Included
 Included

3-6. Color grading standards for diamonds.

	GIA [USA]	Hong Kong	AGS [USA]	Scandinavia 0.50ct & over	Russia	France	Great Britain	Switzerland
Mounted stones appear colorless — Small mounted stones appear colorless	D	100	0	RIVER	RAREST WHITE	BLANC EXCEPTIONNEL	FINEST WHITE	RIVER
	E	99.5						TOP WESSELTON
	F	99	1	TOP WESSELTON	FINEST WHITE	EXTRA BLANC	FINE WHITE	
		98.5						
		98						WESSELTON
	G	97.5						
		97	2					
	H	96.5		WESSELTON	WHITE	BLANC	WHITE	TOP CRYSTAL
		96	3					
	I	95.5		TOP CRYSTAL	FINEST CRYSTAL	BLANC NUANCÉ	COMMERCIAL WHITE	CRYSTAL
		95	4					
	J	94.5		CRYSTAL	COMMERCIAL WHITE	LÉGÈREMENT TEINTÉ	TOP SILVER CAPE	
		94	5					
	K	93.5						
		93						
	L	92.5	6	TOP CAPE	FINEST CAPE	TEINTÉ	SILVER CAPE	TOP CAPE
		92						
	M	91		CAPE	CAPE		LIGHT CAPE	CAPE
		90	7					
	N	89						
	O	88		LIGHT YELLOW	COMMERCIAL CAPE		CAPE	
		87	8					
	P	86						

the *king cut* (86 facets); the *magna cut* (102 facets); the *royal cut* (154 facets); the *radiant cut* (70 facets); the *quadrillion* (70 facets); and the *barion cut* (62 facets). The *Trillion* is a patented triangular brilliant cut diamond, with 50 facets—41 including the table and culet, plus nine girdle facets.

Old European- and Old Mine-Cut Diamonds

Many clients will ask your advice about having their old diamonds recut. They will want to know how they can release the presumably finer stone that is now "trapped" within the existing stone, and whether the recut stone is likely to be of fine quality. In general,

3-7. Clarity grading standards for diamonds.

GIA [USA]	Scandinavia	Exchanges	Russia	Alternate W. Europe
FL	FL	PURE	10X CLEAN	IF
IF	IF	PURE	10X CLEAN	IF
VVS1	VVSI1	PURE	10X CLEANISH	VVSI
VVS2	VVSI2	VVS	10X CLEANISH	VVSI
VS1	VSI1	VVS	10X VERY SLIGHT	VSI
VS2	VSI2	SI	10X VERY SLIGHT	VSI
SI1	SI1	SI	10X SLIGHT; EYE CLEAN	SI
SI2	SI2	PIQUE	10X SLIGHT; EYE CLEAN	SI
I1	PIQUE 1	PIQUE	VERY SLIGHT TO EYE	PIQUE 1
I2	PIQUE 2	PIQUE	SLIGHT TO EYE	PIQUE 2
I3	PIQUE 3	PIQUE	MARKED TO EYE	PIQUE 3

the only old-cut diamonds you should consider advising your client to recut should fall into a better color grade than KLM and should have a very high clarity grade. This may rule out most of the old-cut stones you may see, which are likely to be Dutch White (KLM colors).

Normally, a stone is not recut with weight retention in mind. However, old mine-cut diamonds tend to lose about 35 percent of their existing weight when recut because of their square lines, and old European-cut diamonds tend to lose about 15 percent. This is not a hard-and-fast percentage, however; some "old miners" have been known to lose as much as 60 percent of their original weight without any great improvement in appearance, whereas some old European-cut stones have been improved in appear-

ance with only a slight reworking and 10 percent loss of weight (figures 3-8, 3-9, and 3-10).

If you have any difficulty in assessing old cuts, try to get instruction from a cutter. An experienced cutter can give you more information in a brief session than you might obtain from an entire day spent digging information out of reference books.

Some old mine-cut diamonds are almost like rough diamonds in terms of shape. You can learn to assess their probable quality when recut by checking the stones for strain under a polariscope. Strain can cause serious damage to a stone in the recutting process. Knotted material may also be uncuttable, and most cutters will not agree to handle such stones.

Some companies deal routinely or exclusively with old-cut stones, and are excellent sources of informa-

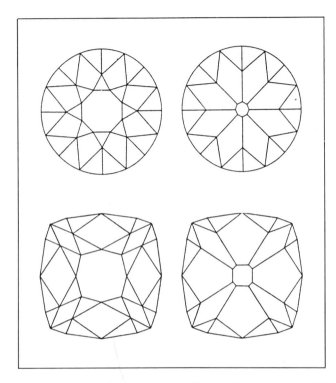

3-8. *Top row:* Old European-cut diamonds. *Bottom row:* Old mine-cut diamonds.

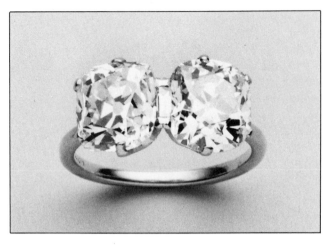

3-10. Fine quality old mine-cut diamonds in a woman's ring. *(From the Lynette Proler Antique Jeweller's Collection)*

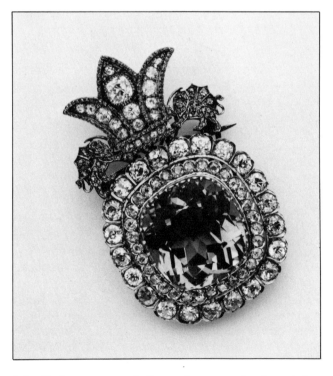

3-9. Citrine quartz and diamond presentation brooch has cushion-cut citrine in the center surrounded by approximately seventy-two old European-cut and several rose-cut diamonds. *(Photograph © 1986 Sotheby's, Inc.)*

tion on both recutting and pricing. One well-known firm is D. Atlas & Company, 732 Sansom Street, Philadelphia. David Atlas cites overestimation of color grade as the mistake most frequently made in estimating the potential quality of stones to be recut. He explains that the leakage of light through the large culets reduces color concentration and can make the color grade seem higher. Also, he warns: "Platinum prongs can make JK colors look like HI colors, and it's easy to be three color grades too high." He recommends that extreme care be taken in evaluating old miners in antique Georgian jewelry with sealed backs, noting that "the stones look large but are usually thin. Bruted (frosted) girdles instead of polished ones will cause the stone in the jewelry to look whiter than it really is." Atlas also explains that an old-cut diamond with an R or S grade color should be treated in the opposite way from the norm, and should be turned into a fancy cut to improve it to the fullest extent.

Atlas has a "Rule of Ten" test that he believes will help gemologist appraisers calculate the probable weight lost in recutting. First, make a list of all "repairs" that must be made to the stone. For old mine-cut diamonds, award ten points for *each* necessary repair: girdle; pavilion refaceted; crown refaceted; pavilion depth; crown depth; and shape surgery. For old European-cut diamonds, award ten points each for repairs made to the girdle, crown, table, culet, and pavilion (lower girdle facets). If you can add up as much as 50 points for an old mine-cut diamond, cutting weight loss will probably be about 60 percent. For old European-cut diamonds, you may lose 30 percent or more weight in recutting, with the average weight loss at 10 to 20 percent.

Colored Gemstones

First, identify the material. Is it synthetic or natural? Is it color enhanced? (See table 3-1.) Are there any unusual treatments, such as glass-filled inclusions? Make a note of these, and incorporate the following steps in your regular examination routine.

1. Color. Evaluate the stone in terms of *hue* (the basic color); *intensity* (the strength of the color); *tone* (how dark or light the color is on a scale of black to white); and *color distribution,* if irregular (such as the zoning in sapphires).
2. Clarity.
3. Cut. Evaluate in terms of shape and quality.
4. Take the size of the stone in millimeter measurements and carats.
5. Note whether the stone is transparent, translucent, or opaque.
6. Note any nicks, cracks, damage, or unusual properties of the stone.
7. Plot the inclusions of important stones.
8. List the instruments used in the examination.

Color and Clarity

Color is the name of the game in assessing colored gemstones, and its intensity is the number-one factor affecting the price; it can be as much as 80 percent of the value of the stone. Examine the color of the subject stone under normal daylight, fluorescent, and incandescent light to determine the extent of color alteration, which occurs when the light source is changed. Fluorescent light intensifies the color of blue sapphires; incandescent does the same for rubies. Grading color is subjective and the appraiser should note clearly on the report the type of illumination used to examine the gemstones.

At the present time, there is no international manual for color grading standards accepted by all gemologists, appraisers, or the jewelry industry at large. Of the several color-communications systems on the market, the three most widely used are: Gemological Institute of America's ColorMaster; Howard Rubin's GemDialogue; and the American Gemological Laboratories' Color/Scan.

All color-communications systems agree on the essential components of color: hue, saturation (intensity), and tone. All operate on a matching process but each system uses a different medium for sample color presentation.

GemDialogue, which has been adopted by the American Gem Trade Association as its official color communication system, works with twenty-one transparent color sheets and three modifying sheets called *color masks.* Each color sheet contains ten blocks of color, each of a different strength, from very pale to very dark. First, match your stone to the correct sheet, then find the right lightness or darkness. If matching involves the use of an intermediate color sheet, then the strongest color becomes the main or primary color and the weaker the overlay or secondary color. The GemDialogue system does not grade colors, it identifies and describes them.

Clarity is graded by GemDialogue as an average of the number of inclusions seen by the naked eye and through a 10x loupe: flawless, VVS1, VVS2, VS1, VS2, all invisible to the naked eye; SI1, SI2, seen with difficulty by the naked eye; and I1, I2, I3, and I4, easily seen with the naked eye.

Color/Scan is marketed by the American Gemological Laboratories, located in New York. The system has been described by its inventor, C.R. Beesley, as a substitute for master stones. Basically, it uses 2- × 6-inch cards with six ovals simulating gemstones on each card. The ovals are metallized surfaces applied to a Mylar-based film and embossed with a facet pattern that simulates the facet reflections of a cushion or oval-cut stone. A series of optical filters placed over the film determines the hue of the sample. Tone is found by using cards that simulate different levels of stone darkness. To describe a stone, match it with the appropriate color card, select the most appropriate oval on that card, and decide on tone by using tone cards, which are matched as the color cards are.

Color/Scan also has guidelines for grading clarity. The grades are FI (free of inclusions); LI1 and LI2 (lightly included); MI1 and MI2 (moderately included); HI1 and HI2 (highly included); and EI1, EI2, and EI3 (excessively included). Both Color/Scan and GemDialogue are portable systems that are easy to learn and use (figs. 3-11 and 3-12).

Not so portable is the Gemological Institute of America's ColorMaster machine (fig. 3-13). This instrument is used in the GIA's color grading course and although GIA maintains the language of its system works without use of ColorMaster, it is more easily understood by seeing the machine in action. ColorMaster gives a numbered readout from the mixture of red, green, and blue that makes up the color of the gemstone being viewed on the machine with comparison to an actual stone. To operate the machine, the user first establishes an initial identification of the stone's color by choosing the closest matching hue from the ColorMaster workbook, which contains samples of thirty-one reference hues. Then the user selects tone and saturation and dials this numbered code into the ColorMaster while the gem being evaluated is placed in built-in tweezers under the screen. Adjustments in hue, tone, and saturation can be

made on the screen until the user is satisfied that the color is a good match.

The GIA Color Grading Course also teaches clarity grading, which is based on three types depending upon whether the stone is almost always inclusion-free or almost always included. Grades descend from

Table 3-1. Common Gemstone Treatments and Detection Tests

Gemstone	Treatment	Test	Reaction/Result*
Aquamarine	Heat	None	Not applicable
Chalcedony	Dye	Spectrum/spectroscope Chelsea filter	Shows broad absorption bands Blue and green dyed material shows pinkish filter reaction
Corundum Sapphire	Heat Surface diffusion	Ultraviolet fluorescence Immersion in methylene iodide	Chalky green fluorescence Shows blotchy color zoning and evidence of a thin color layer
Ruby	Heat	Ultraviolet fluorescence Magnification	Not distinguishable with limited testing May see glassy fractures or changes in the structure of the inclusions
Emerald	Oiling Dye	Ultraviolet fluorescence Magnification	Oil may fluoresce yellow Dye may be seen in fissures
Ivory	Dye	Magnification	Color (dyed to improve color)
Jadeite: Green	Dye	Spectrum/spectroscope	May show 4370 A.U. line; 6300–6700 broad band proves presence of dye
Lavender	Dye	Magnification	Dye concentration in cracks
Lapis-lazuli	Dye Wax	Acetone Magnification/hot point	Discoloration of the swab Sweating effect of wax with hot point held to stone
Opal	Plastic Smoke	Hot needle/hot point Magnification	Extreme softness of material; acrid plastic odor Unnatural color confined to surface
Pearl	Dye	Diluted solution of nitric acid	Discoloration of swab
Quartz	Dye Heat	Magnification None	Unnatural color, chatoyant band Undetectable
Topaz	Irradiation	Fade test *may* work	Treatment is often unstable and gemstone is subject to fading
Turquoise	Paraffin or plastic	Hot point/hot needle	Acrid plastic odor if treated with plastic; if wax treated, will show sweating effect when hot needle is held 1mm from stone
Zircon	Heat	None	Not applicable
Zoisite (Tanzanite)	Heat	None	Color probably does not occur in nature; when the naturally brown zoisite is heated, it turns blue

* Reaction or result will be present if gemstone has been treated.

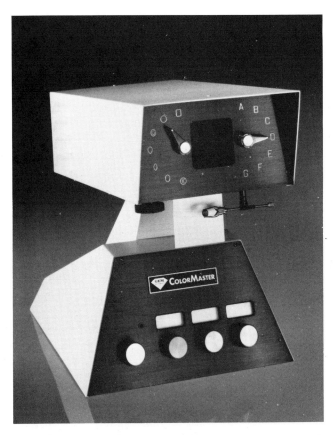

3-11. The ColorMaster color-matching system. *(Photograph courtesy of Gem Instruments Corporation)*

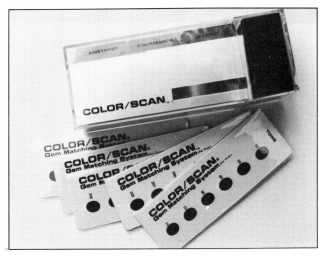

3-13. The American Gemological Laboratory's Color/Scan gemstone description and color-matching system.

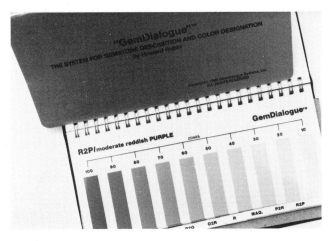

3-12. The GemDialogue gemstone description and color-matching system, devised by Howard Rubin.

VVS (minute inclusions visible only under a 10x loupe) to VS1, SI1, SI2, I1, I2, I3, to a bottom déclassé grade (stones with inclusions so numerous that the entire stone is no longer transparent).

Whatever color and clarity grading method you use, be sure to explain it on your report and include a chart, if necessary, to communicate grading to the reader. Since there are no universally accepted and used clarity grading systems, appraisers unfamiliar with the methods noted above may wish to base their assessments on examination with the naked eye and with a 10x corrected loupe, as most gem dealers do. A majority of dealers base clarity grading on the obviousness of the inclusions and surface defects to the unaided eye, even if magnification is used to locate flaws. They judge clarity by the size of inclusions and surface blemishes; the type of inclusions and surface blemishes; the number of inclusions and surface blemishes; their location; and expected consequences from the inclusions, such as whether a cleavage will work up to the surface of the stone.

Cut

A well-cut stone will have good proportions, a clearly defined outline shape, a centered culet, good finish, and a medium girdle. Most faceting styles can be classified as brilliant, step, or mixed cuts. Brilliant cuts have facets that radiate from the table or culet to the girdle. Step cuts have concentric facets. These styles can be adapted to almost any shape. While it is true that better-proportioned gems are generally a little higher in price, the make of colored stones has only a slight effect on their overall value. Appraiser and colored-gem expert Joseph Tenhagen says that most colored gemstones have a 70 to 80 percent pavilion depth. That's a lot. The cutter tries to obtain as much yield as possible from the rough. Generally speaking, gemstones cut from inferior materials are usually found in lower-cost or promotional jewelry.

"In this category," Tenhagen says, "are those stones cut so shallow that there is little or no life in the center of the stone and they exhibit a window; you can see through the stone [as you could] through a pane of glass." Stones that are lumpy or cut with unbalanced outlines and outrageous pavilion bulge also fall in the lower-cost category and appropriate discounts should be factored into your valuation. When describing the cut, mention any carving or drilling. An exception is a fantasy-cut stone, which has its own set of standards.

Analyzing Metal Fineness

Testing kits for analyzing metal fineness are available from major jewelry supply houses. Each consists of a wooden box with five plastic bottles of prepared balanced acids and a black basalt block for testing. The liquid is used on a clean surface of the block and is not mixed with other liquids or water. The bottles dispense the acid one drop at a time; it should be kept tightly closed when not in use to prevent spillage or evaporation.

To test a metal, first ensure that the surface of the mounting is dry and clean. Make a long streak of metal on the black testing stone surface. Press hard into the surface of the mounting under test to ensure that any plated covering is penetrated and the underlying base metal is smeared on the testing stone. Next, apply a small drop of the appropriate liquid onto the streak and study the reaction very carefully. The liquids are marked 18, 14, 10, S, and P. After finishing the test, clean the waste from the surface of the testing stone. When the stone is dry, it is ready for reuse.

Testing Gold, Silver, and Platinum

Gold. Start by applying a drop of the liquid marked 18. If the gold is 18K or higher, the streak will remain for at least five seconds. Count off the time. If the test streak disappears immediately, the gold jewelry is of a lower karat fineness and you should restreak the stone and apply the 14 liquid. The 14 liquid requires ten seconds to react. If the streak disappears in fewer than ten seconds, the gold is not 14K and you should repeat the test with 10 liquid. The 10 liquid also requires ten seconds to react.

Silver. If the liquid S turns the trace on the test block a milky white, the jewelry in question is sterling silver. If the trace remains intact, disappears, or turns green, this indicates some other metal.

Platinum. It takes one minute for the liquid marked P to affect the trace on the test stone. If the streak is still in place at the end of one minute, you can consider it platinum. The streak will turn gray if the item is gold. On silverplated or base metals, the streak will disappear.

Some appraisers and jewelers still like using a kit containing gold test needles, a testing stone, and acids for testing metals. This system requires practice for good results. In this test kit you have three one-ounce ground-glass-stoppered bottles in a wooden box. These are not portable and the acid can be easily spilled. The bottles should be kept upright since the acid is dangerous, corrosive, and toxic. If the contents are accidentally spilled on your fingers or hands, the area should be flushed immediately with plenty of cold water. In the kit, pure nitric acid is used for testing 10K gold or less. Aqua regia—a combination of one part nitric and three parts hydrochloric acids, in which gold is soluble—is used to determine fineness from 18K up. Gold from 14K to 18K should be tested with a mixture of one part hydrochloric acid, forty-nine parts nitric, and twelve-and-one-half parts distilled water.

The test needles are a keychainlike arrangement of metal "fingers" tipped with gold from 4K to 20K. Testing begins when you take the keychain of needles and make a streak on the testing stone of 18K, 14K, and 10K. Below these streaks, add a streak from the item of jewelry you are testing. With a drop of liquid on the glass dropper, draw the liquid across the streaks in a straight line and compare the fade time of the 18K and 14K with the fade time of your jewelry streak. If both your jewelry streak and one of the gold needle streaks do not disappear, the karat content of the jewelry in question is the same as the test streak it matches.

The kit does not include test needles for platinum or silver but a platinum streak tested with nitric acid will exhibit slow fading (a few seconds), and a platinum streak tested with hydrochloric acid will exhibit extinction with a brownish surface float. A silver streak tested with nitric acid will have slow to quick extinction; tested with hydrochloric acid, the silver will show extinction with a white powdery float.

The appraiser should know that some 14K gold alloys will first give a greenish reaction similar to brass and then a normal 14K gold reaction. It should never be assumed that the quality marks found on an item of jewelry are correct, especially on items of foreign manufacture. Some foreign manufacturers start with 18K gold, but owing to the contamination of solder or another base metal, the final quality can drop as low as 8K. Also, there have been instances of manufacturers stamping any metal as 14K or 18K without regard to gold content. If it is impossible to reach

different parts of the mounting or finding (as in layered construction) but the *majority* of the mounting checks out as stamped, then it is acceptable to write on your report: "The portion of the mounting that cannot be assayed because of its construction appears to be (whatever quality the rest of the item has been assayed to be)."

Use caution in appraising class rings, as they sometimes have double metals. A 10K gold overlay on a base metal is not uncommon. Plating may cause you some problems with correct assaying unless you take care to obtain a rub that bites beyond the plating. Similarly, rhodium plating on white gold or silver may react just as platinum or high karat gold would, and rings stamped 14 without the K usually have inner protective bands of 14K gold, but the remainder of the ring may be another metal. Assay wedding bands without quality marks carefully. These may test 14K but may actually consist of a gold overlay on copper or stainless steel.

The heft of a jewelry item will provide another clue to its metal content. Some chains and bracelets of foreign manufacture may be marked as 14K or 18K, but prove in the final analysis to be gold-plated silver. These will have a certain heaviness or lack of heaviness that will alert you that the stamping may be false. Sometimes an item's clasp may be genuine gold but the band or chain will be plated. Conversely, you will find 14K chains and bracelets with gold-filled or -plated clasps. In these cases, the original clasps usually have been replaced. In general, do not make any assumptions based on face value. Test each item.

Gold teeth are often encountered in estate appraisals. They are usually about 16K, or .666K fineness.

Gold Content and Stamping

The Federal Trade Commission has ruled that the terms *gold* and *solid gold* can only be used to refer to *fine gold;* that is, gold of 24-karat quality. By law, gold articles must be marked to reflect their karat content accurately. Gold stamped 14K is correctly stamped as *plumb gold.* The stamp 14K means that the gold in the article weighs $14/24$ of the total weight of the item, the remaining weight being composed of other metals mixed with the gold, such as nickel, zinc, copper, or silver. A plumb-gold ring stamped 14K will not be less than 14K gold because of any base-metal soldering added in manufacture. On articles manufactured after June 1962, the karat mark must also be accompanied by the name or trademark of the person or concern who has applied the gold marking. See table 3-2 for a breakdown of the gold content of karat alloys.

Quality marks provide other clues as well. For ex-

Table 3-2. Gold Content of Karat Alloys

Gold Percentage	Karat
100.00	24
95.83	23
91.67	22
87.50	21
83.33	20
79.17	19
75.00	18
70.83	17
66.67	16
62.50	15
58.33	14
54.17	13
50.00	12
45.83	11
41.67	10
37.50	9
33.33	8
29.17	7
25.00	6

ample, the stamp 10K O.B. means that only the outer band is composed of 10K gold; a 10K I.B. stamp has gold only on its inner band.

Gold Filled, Gold Overlay, Double d'Or. These articles have a layer of 10K or better-quality gold mechanically bonded to all significant surfaces. This layer of gold must be at least $1/20$ of the total metal weight. The typical quality mark is $1/20$ 12K GF.

Rolled Gold, Rolled Gold Plate, Plaque d'Or Lamine. The difference between this and a gold-filled article is that the quality of karat gold in a rolled-gold item may be less than $1/20$ of the total metal weight. The typical quality mark is $1/40$ 12K RGP.

Gold Electroplating. These articles have the least amount of gold deposited upon another metal by the use of chemicals and electricity. Thickness is measured in millionths of an inch. In the United States, a gold electroplate of at least 10K fineness and at least seven millionths of an inch thick may be called gold electroplate. A gold electroplate at least one hundred millionths of an inch thick may be called heavy gold electroplate. A typical quality mark would be 10K H.G.E.

Vermeil. Vermeil jewelry contains gold electroplated over a sterling-silver base.

Liquid Gold. Sometimes called *gold-washed* and *gold flashed,* this is a solution of chemicals, including 12 percent gold used as a surface decoration, that is literally painted on, then fired to 1004 degrees Fahrenheit.

The following list provides the gold qualities commonly used in jewelry produced in these countries:

- Austria: 14K, 18K
- Belgium: 18K
- Denmark: 8K, 14K, 18K
- France: 18K, 22K
- Germany: 8K, 14K, 18K
- Greece: 14K, 18K, 22K
- Italy: 18K
- The Netherlands: 8K, 14K, 18K
- Norway: 14K, 18K
- Portugal: 19K
- Spain: 18K
- Switzerland: 9K, 14K, 18K
- United Kingdom: 9K, 14K, 18K, 22K
- United States: 10K, 14K, 18K
- Hong Kong: 14K, 18K, 24K
- Japan: 8K, 14K, 18K, 22K
- South Africa: 9K, 10K, 14K, 18K, 22K

The Platinum Group

Six metals form the platinum group: platinum, palladium, iridium, rhodium, ruthenium, and osmium. They are always found together in their natural state and have certain characteristics in common. All but osmium have been used in jewelry. Palladium, next to platinum, is the most extensively used and is brilliant white in color. It is a precious metal in its own right and often described as the twin sister of platinum, which it closely resembles. Palladium, however, is much lighter in weight than platinum. Articles made of platinum alloys and one or more of the related metals, of at least $985/1000$ parts platinum where solder is not used, and $950/1000$ parts platinum where solder is used, can correctly be marked and described as platinum. If the alloy contains $750/1000$ parts platinum and the alloy represents at least $50/1000$ parts of the entire article, both dominant metal names must be used together on the stamping, such as iridium platinum or ruthenium platinum. Both iridium and ruthenium are used to harden platinum. Rhodium, seldom used to harden platinum alloys, is used with ruthenium to harden palladium alloys. Rhodium is also used to plate silver and white gold to prevent tarnish. Osmium alloys are used for compass bearings.

The complete and official text regarding all federal regulation of trade practice, commercial standards, and stamping of precious metals can be found in the U.S. Federal Registry's *Guides for the Jewelry Industry* publication, which is available in the libraries of most major cities or from the Federal Trade Commission in Washington, D.C. Some of these rulings affect how an appraiser may describe the various metals, so it is a good idea for you to obtain a copy of this report.

Silver Content and Stamping

Sterling silver is defined as an alloy of at least $925/1000$ parts silver, the other parts being such base metals as copper, nickel, tin, and antimony. Sterling has also been called *solid silver*, but it actually contains $75/1000$ parts of metal other than silver. The term sterling does not signify the weight or gauge of the article, as a sterling-silver item, such as a bracelet, can be very light or thin.

Silverplated. A silverplated item is made of base metal with silver electroplating. The thickness of silver on electroplated items may be only about $1/100,000$ of an inch. If an article has an alloy containing not less than $900/1000$ parts fine silver, it is called *coin* or *coin silver*.

Nickel Silver or German Silver. Items marked with either of these terms are alloys containing *no* silver. When used as a base for silverplated ware, it usually consists of 65 percent copper, 5 to 25 percent nickel, and 10 to 30 percent zinc.

Colored Gold

We all know that gold comes in two colors—yellow and white. Sometimes we see various shades of yellow gold, from dark to light and even rose. More and more designers and manufacturers are turning to an amazing rainbow of colored golds for attention, shock value, and to offer something new. If you are curious or have had questions from your clients about the alloys involved in the party-colored golds, see table 3–3.

Peter Gainsbury, design and technology director at the Goldsmiths' Company in London, says that some of the colored golds are not what they seem. He asserts: "Black gold is a contradiction in terms, blue gold is a myth, and purple gold is not a metal." Gainsbury has made studies that prove black gold to be only a film of black copper or nickel oxide on an alloy surface, or a surface coated and colored in the same way a plating solution would coat and color.

The British Assay Office will not permit the use of the term "blue gold." Blue gold, Gainsbury claims, is nothing new—the term can be found in old textbooks as 18K gold iron alloy. He says that the blueness may be the result of the development of iron oxide film on the surface of the alloy, as is the case for "black gold." Blue watch dials, we are told, are produced either by coating the gold surface with a transparent blue lacquer, nickelplating the gold dial and chemically coloring the nickel, or implanting cobalt atoms into a gold alloy surface to produce a blue color.

Table 3-3. Content Breakdown of Colored Gold Alloys

Color/Karat	Alloy Content
Bright yellow, 22K	91.67% 24K gold; 5% fine silver; 2% copper; 1.33% zinc
Bright yellow, 18K	75% 24K gold; 9.5% fine silver; 15.5% copper
Medium green, 18K	75% 24K gold; 5% fine silver; 20% copper
Very deep green, 18K	75% 24K gold; 15% fine silver; 4% cadmium; 6% copper
Deep rose, 18K	75% 24K gold; 25% copper
Pink, 18K	75% 24K gold; 5% fine silver; 20% copper
Bright red,* 18K	75% 24K gold; 25% aluminum
Bright purple, 20K	83.3% 24K gold; 16.7% aluminum
Blue, 18K	75% 24K gold; 25% iron
Gray, 18K	75% 24K gold; 8% copper; 17% iron
Black, 14K	58.3% 24K gold; 41.7% iron
Brown, 18K	75% 24K gold; 18.75% palladium; 6.25% fine silver
Orange, 14K	58.33% 24K gold; 6% fine silver; 35.67% copper

*Tends to be brittle.

Purple gold exists, Gainsbury points out, but it is not a metal. It is obtained by melting together a mixture of 75 percent gold and 25 percent aluminum, but the result—instead of being an alloy—is a chemical compound of gold and aluminum that has few of the essential properties of a metal.

Weighing, Measuring, and Noting the Manufacturer

The weight of the item is a convenient way to evaluate gold and silver jewelry. It helps you distinguish between thin- and heavy-gauge metal jewelry, and whether the item is hollow or solid metal.

If you need to determine only the weight of the mounting of an item containing gemstones, use this formula:

1. Note the total weight of the item in grams.
2. Calculate, from measurements, the total gemstone weight in carats.
3. Convert carat weight into grams with the formula: carat weight × 0.2 = grams.

4. Deduct this gemstone gram weight from total gram weight of the item.

Another formula for computing the net weight in pennyweights of metal in mounted goods: net weight = gross weight minus carat weight × .13. If the identity of the stone is unknown, use an estimated specific gravity of 3.00.

Weigh chains separately from any pendants that hang upon them. The labor required to produce chains reflects a much smaller percentage of its total price. Charms that are soldered on bracelets and cannot be removed can be weighed by resting the charm(s), one at a time, on a pennyweight scale while you hold the bracelet in your hand and support your arm on a counter or desk. You should list the value of each charm on an insurance replacement appraisal. Make sure that the client has a complete list by design and style in case replacement is needed. The total weight of the charm bracelet can be determined by subtracting the total weight of charms from the total weight of the bracelet and charms.

When taking measurements, list the overall size of the item in millimeters or inches. Use a small tape measure and do not include the clasp when you take the total measurement of a necklace. A millimeter gauge should be used to establish the widths and depths of chains, bracelets, watch bands, rings, brooches, earrings, and so on. If you are working with a strand of pearls or beads, note the length of the strand and count the number of beads or pearls. Use a millimeter gauge or a pearl gauge to obtain the size of beads or pearls and note the figure on your worksheet.

Construction Analysis

Examine each item of jewelry to determine the type of construction. Is it handmade, cast, die struck? A combination? Knowing the construction is important because the cost of handmade jewelry is higher than that of similar pieces cast from wax patterns or die struck. Chains that are mass produced by machine cost much less than those that are hand assembled and finished.

Cast jewelry usually shows pits and rough areas in the small recesses on the underside of jewelry, where polishing is difficult. Open pit marks, cavities, and stressed areas reveal that an item was hastily cast. Pinpoint holes indicate porosity, another sign of careless casting undertaken without consideration for detail. In cast jewelry, you will also find small cast settings; intricate work will not look quite finished.

Handmade jewelry items will normally show a different color of solder in the joints: even well-con-

structed items often reveal small areas of solder. Although handmade jewelry will normally have a higher value than other construction, if the piece has been poorly made and finished it may be less valuable than an item cast and finished with care. "Handmade" does not necessarily mean "quality." If an item looks as good on the inside as it does on the outside, you probably have a hand-constructed piece or a die-struck item finished by hand. Handmade and hand-finished jewelry may show deeper and uneven cuts, overlapping or incomplete cut ends, which do not join other parts of a design, layout lines on the back sides, or tool marks. Other signs of poor workmanship include file marks that should have been polished out and obvious, pitted solder joints.

Note the condition of filigree jewelry in particular. There is a big price difference between hand-cut and cast filigree jewelry. Learn to detect the differences and, if possible, enlist the aid of a bench jeweler to help you.

Die-struck jewelry is formed by pressing metal into dies and is usually mass produced. Stamping is a two-step process. The item is first stamped into the metal and then the shape is cut out. Much inexpensive gold jewelry, especially pendants and earrings, are made by these methods. Die-struck and stamped items are characterized by a bright finish in the small recesses. Die-struck items are frequently heavier than are their cast counterparts because of the denser metal used in the manufacturing process.

Flashing, the slightly raised or overlapped metal that exists on the back side of punched-out jewelry, is a typical clue to machine-finished work. Often you will find the pressed-in look of the design showing on the back side of the jewelry. It is also important to note the finish of the jewelry on the appraisal report. See the appendix for a glossary of finishing terms.

Evaluating Chain Construction

Pay particular attention to chains when you are evaluating the construction of items in an appraisal. They are quite popular and abound in most jewelry collections. See figures 3–14 through 3–18 for illustrations of twenty-seven popular kinds of chains.

Run the chain through your hands. How does it feel? Are there rough edges? You can cut your finger on a badly finished chain, for which the manufacturer sacrificed labor to achieve a certain price. A rough-edged chain was most likely mass produced and sold for a low retail cost.

Check the chain for flexibility. Many cheap chains are stiff. Does the chain kink up when handled or worn? Watch the complexion of the diamond cutting to see whether there are *chatter marks*, the small grooves or jumpy ridges that indicate the machine

did not run smoothly over the gold, and show that the manufacturer used shortcuts. Check the corners of hexagonal chains to see whether they are beveled. This simple technique makes the chain smoother to the touch and whispers "better quality" to the appraiser. On rope chains, there should not be a gap between the two lengths wrapped around each other; if there is a gap, it will cause the chain to hang badly on the neck. Examine the ends of chains to see how they were made; machine-made chain is cut off a long spool. Is each chain end capped to give it a clean look, or are the ends simply pressed together? Finally, look at the clasp. Is it a spring ring of good quality and the right weight for the chain?

Nomenclature for Jewelry Findings, Mountings, and Chains

It cannot be stressed too often that correct description is essential to proper documentation. If you do not know how to describe the various parts of a jewelry piece, how can you convey to your client or to a third party what the items look like? Furthermore, are you describing the piece with the same terminology your peers use?

Findings are the small metal components used by jewelers to make or repair various articles. Mass produced by machine, findings include bolt rings, gallery strips, settings for stones, brooch catch plates, and

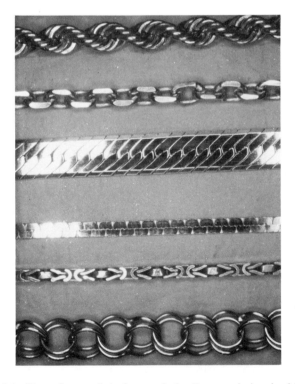

3-14. *Top to bottom:* Spiral rope chain; Boston chain; double herringbone chain with beveled edge; zipper chain; king chain; double-link curb chain.

links for cufflinks. When made by hand, these are sometimes called *fittings*. In describing mountings, be sure to include the following information:

1. Whether the item is for a man or woman
2. Type of article
3. Metal, metal fineness, and metal color
4. Method of manufacture and manufacturer's marks
5. Style or motif
6. Metal finish
7. Metal weight

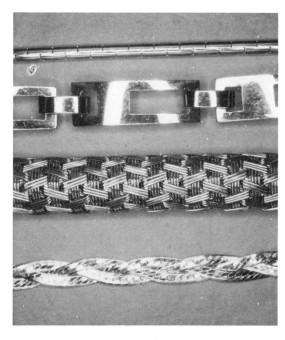

3-15. *Top to bottom:* Round c chain; buckle chain; basket-weave chain; braided and beveled herringbone chain.

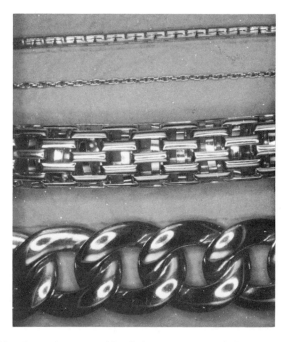

3-17. *Top to bottom:* Cable chain; spun rope chain; French-link chain; round disc chain.

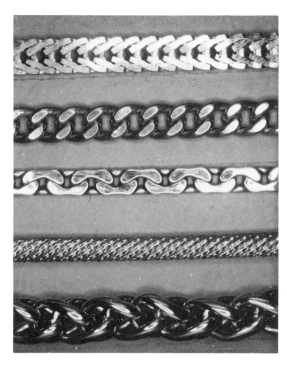

3-16. *Top to bottom:* Foxtail chain; curb-link chain; c-link chain; round mesh chain; ultra-link chain.

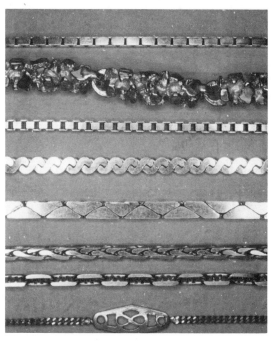

3-18. *Top to bottom:* Mirror chain; nugget chain; box chain; serpentine chain; cobra chain; wheat chain; stirrup chain; infinity chain.

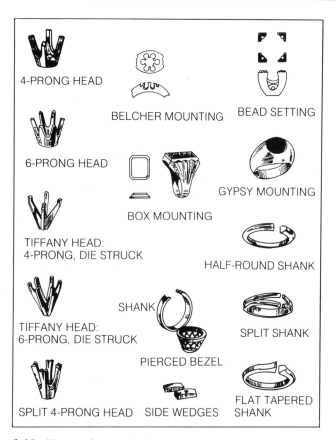

3-19. Nomenclature for ring heads, mountings, settings.

Rings manufactured by more than one process, such as die-struck and hand-assembled rings, should be described in terms of their composition, manufacturing method, and assembly. For items containing a number of gemstones, report the number, cuts, types, measurements, weights, and analyses of all stones. Common findings, mountings, and chains are illustrated in figures 3-19 through 3-22.

Trademarks and Hallmarks

Trademarks identify a particular manufacturer. A trademark can be a monogram (two or more letters alphabetized according to the first letter on the left); designs without letters; company names; or numbers. Trademarks have been used for hundreds of years and in the beginning consisted of pictures, designs, or trade symbols to help the illiterate identify the source of a commodity. When the early guilds of Europe were established and the reliability of an artisan's product was of prime importance, the trademark came into use as a method for guilds to trace the makers of certain items, to ensure that proper standards were being met. This use of trademarks stil holds today; quality is associated with a manufacturer's trademark. The National Gold and Silver Stamping Act (last revised in 1981) requires

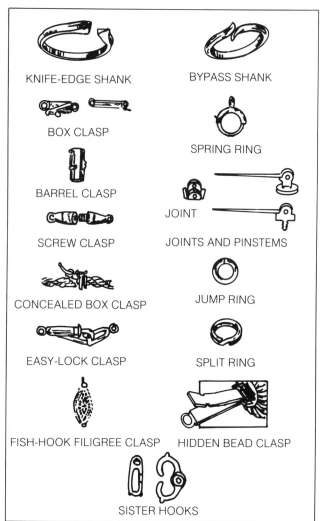

3-20. Nomenclature for clasps, shanks, joints and pinstems, hooks, and ring closures.

manufacturers of jewelry and precious metals to stamp their trademarks next to the quality marks of their goods. Trademarks must be registered in the United States Patent and Trademark Office.

For the appraiser, trademarks and stamped marks offer one of the few ways to establish the provenance of any particular jewelry item. A good reference source for trademarks is the Jewelers' Circular Keystone *Brand Name and Trademark Guide,* which lists over eleven thousand names and symbols used by nearly five thousand makers of jewelry. The *Canadian Jeweller 1988 Trade Mark Index,* a comprehensive directory of Canadian jewelry trademarks as well as brand names of other precious-metal products from around the world, is equally impressive. This index of trademarks currently registered with the Canadian government includes jewelry and silverware marks and the brand names of watches, clocks, giftware, and accessories. The directory is updated annually.

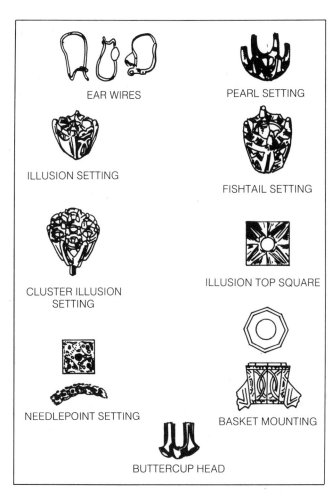

3-21. Nomenclature for settings, ear wires, and heads.

Hallmarks

The systematic marking of gold articles began in 1300 in England, when a law was introduced to protect the public against the fraudulent use of adulterated gold and silver by dishonest smiths. Originally, all wares were marked in London and at first only one mark, a leopard's head, was punched into gold and silver. Later, other marks indicating quality, place, date, and maker came into use. Today, almost all countries use some form of hallmarking on gold articles.

Standards used by other countries and marked on *gold* items include the following (not a comprehensive list):

- Argentina: .750, .500
- Australia: 9, 12, 14, 18, 22
- Austria: $^{986}/_{1000}$, $^{900}/_{1000}$, $^{750}/_{1000}$, $^{585}/_{1000}$
- Belgium: $^{500}/_{1000}$
- Bulgaria: $^{920}/_{1000}$, $^{840}/_{1000}$, $^{750}/_{1000}$, $^{583}/_{1000}$, $^{500}/_{1000}$, $^{330}/_{1000}$
- Canada: 9, 12, 14, 18
- Czechoslovakia: 9, 14, 18

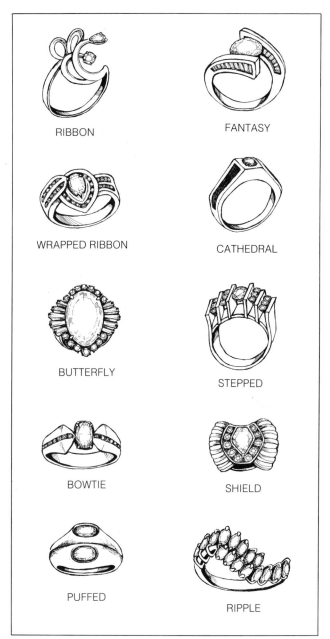

3-22. Mounting styles.

- Egypt: 12, 14, 15, 18, 21, 23
- Finland: $^{969}/_{1000}$, $^{750}/_{1000}$, $^{585}/_{1000}$
- France: 18, 20, 22
- Hungary: 14, 18, 22
- Ireland: 9, 14, 18, 20, 22
- Israel: 9, 14, 18, 21
- Italy: $^{750}/_{1000}$, $^{585}/_{1000}$, $^{500}/_{1000}$, $^{333}/_{1000}$
- Japan: $^{375}/_{1000}$ to $^{1000}/_{1000}$
- Malta: 9, 12, 15, 18, 22
- Netherlands: $^{585}/_{1000}$, $^{750}/_{1000}$, $^{833}/_{1000}$
- Norway: 14K, 18K
- Poland: $^{375}/_{1000}$, $^{500}/_{1000}$, $^{583}/_{1000}$, $^{750}/_{1000}$, $^{960}/_{1000}$

- Portugal: $^{800}/_{1000}$ (minimum legal standard) Watches may be .583 or .750
- Romania: $^{375}/_{1000}$ to $^{958}/_{1000}$
- Soviet Union: $^{583}/_{1000}$, $^{750}/_{1000}$, $^{958}/_{1000}$
- Sweden: 18K, 20K, 23K
- Switzerland: 14K, 18K
- Tunisia: $^{583}/_{1000}$, $^{750}/_{1000}$, $^{840}/_{1000}$, $^{875}/_{1000}$
- Turkey: 12K to 22K
- Yugoslavia: $^{583}/_{1000}$, $^{750}/_{1000}$, $^{840}/_{1000}$, $^{950}/_{1000}$

Also see table 3-4 for a list of some gold hallmarks used in England and Ireland. For in-depth information about gold and silver markings and hallmarks as well as complete dates, town lists, and maker's marks, consult Tardy's *Poincons d'Or et de Platine* and Tardy's *International Hallmarks on Silver*. Both are listed in the bibliography.

In Great Britain, sterling silver is indicated by a lion passant. Britannia silver is $^{958.4}/_{1000}$ parts fine silver and the rest base metal. The quality mark for this alloy is the Lady Britannia, seated with a shield and spear.

French silver that is marked with a crab is $^{800}/_{1000}$ parts fine silver. Marked with the head of Minerva in an octagonal shield, the silver is $^{950}/_{1000}$ parts fine silver.

Irish sterling silver is marked with a crowned harp or with the Hibernia, the seated figure of a woman with a small harp in her hand and a spray of palm leaves. In Scotland, sterling silver is indicated either by a thistle or a thistle with a lion rampant.

In the Soviet Union, silver marked 84 and 88 is of a quality below sterling; silver marked 91 indicates a quality slightly above sterling.

Conducting Market Research

Jewelry items that are stamped with the name of the manufacturer and the production number of the article, as is often the case, will present few problems to the appraiser in obtaining a retail replacement cost. By contacting the manufacturer and giving the details of the item and the production number, the appraiser is usually able to obtain the manufacturer's wholesale price. By applying the retail mark-up that is most commonly used by the average fine jewelry store in his or her geographical locale, the appraiser can then determine the retail replacement price.

If, on the other hand, you do not know the manufacturer, the firm is out of business, or comparables are unavailable, one of the most expedient ways to price the item at retail replacement is to use the cost approach—what some appraisers called the "bricks-and-mortar" breakdown of an item. Take the intrinsic

Table 3-4. Gold Hallmarks of Ireland and Great Britain

Irish Hallmarks	Quality	Date of Usage
Crowned harp	22K	1784–1975
916	22K	1975–present
Plume of feathers	20K	1784–1975
English Hallmarks		
Crown over 22	22K	1844–1975
Crown over 18	18K	1798–1975
15.625*	15K	1854–1932
12.5*	12K	1854–1932
9.375*	9K	1854–1932
750*	18K	1973–present
Uncrowned king's head	18K	1808–1815

*These will be found with a lowercase *e* in a square shield followed by a leopard's head in a circle.

parts (the weight of metal and gemstones), multiply their respective weights (per karat and per carat) by the current wholesale costs, add any other factors, such as setting and/or labor charges, and then add a retail mark-up. You will end up with the average cost of a new reproduction.

To find the value of a ring that weighs 5 dwt. and is stamped 14K, multiply the current price of gold (say, $400) by .585 (14K) and divide by 20 dwt. (there are 20 pennyweights per troy ounce of gold). This formula will give you the price per pennyweight of gold on any particular day if you use the most current price of gold. The pennyweight price is then multiplied by the weight of the ring to obtain the intrinsic value of the gold ring.

The intrinsic value figure is multiplied by 1.5, the average manufacturer's mark-up. (Mark-up can be as high as 2.5 for some items—see the *Other Considerations* section below.) The price you have will be the approximate wholesale selling price for most cast rings and for some die-struck rings. The formula is as follows:

Current gold price × gold fineness ÷ 20 (dwts. per gold oz) × weight of item × 1.5 (mfg. mark-up) = wholesale cost to average jeweler.

To determine the wholesale cost of sterling silver in jewelry items, use the above formula, substituting the current price of silver and using .925 for metal fineness. For fine silver, use .999 for metal fineness.

For platinum, use the above formula, substituting the current price of platinum and using .950 for metal fineness. After multiplying by the 1.5 percent manufacturer's mark-up, add an additional 20 to 30 percent to the total sum, to reflect the fact that platinum is labor-intensive and requires additional heating and more preparation.

Other Considerations

Different manufacturers' mark-up percentages will be used in the above formula, depending on the amount of work required to produce the item and the value of the gold or other metal. To determine manufacturer's mark-up for an article that is very intricate or a one-of-a-kind cast, multiply the intrinsic gold or other metal content by 2 or 2.25, to account for the time required and the wax model making. For very heavy gold items, multiply the intrinsic gold content by at least 2.5 to determine mark-up.

For two- or three-color gold, multiply the intrinsic value of the gold by approximately 2.2 to determine mark-up; use a slightly higher factor for die-struck jewelry. Some designer jewelry may be marked up as much as 2.75 percent. It is best to contact the manufacturer of the item if possible.

Setting and Labor Costs

You need to be familiar with setting and labor costs to make accurate calculations when you use the cost approach to valuation. Visit a jewelry repair company in your area and ask for a copy of their price list. If there is no jewelry repair company in your immediate area, use the following compilation of average prices charged at keystone in the Houston area at the time of writing. See table 3-5 to obtain a quick computation of plumb gold at current gold prices.

Table 3-5. Cost of Plumb Gold Content by Pennyweight

$ per troy oz. of gold	$ value per dwt. (rounded off to nearest 5¢)						$ per troy oz. of gold	$ value per dwt. (rounded off to nearest 5¢)					
	9½K	10K	12½K	14K	17½K	18K		9½K	10K	12½K	14K	17½K	18K
300	5.95	6.25	8.45	8.75	11.00	11.30	510	10.10	10.65	14.35	14.90	18.65	19.15
310	6.15	6.45	8.70	9.05	11.30	11.60	520	10.30	10.85	14.60	15.15	19.00	19.50
320	6.35	6.70	8.95	9.35	11.70	12.00	530	10.50	11.10	14.90	15.45	19.35	19.90
330	6.55	6.90	9.25	9.65	12.05	12.40	540	10.70	11.30	15.20	15.75	19.70	20.30
340	6.70	7.10	9.55	9.90	12.40	12.75	550	10.90	11.50	15.45	16.00	20.10	20.65
350	6.90	7.30	9.80	10.20	12.80	13.10	560	11.10	11.70	15.70	16.30	20.45	21.05
360	7.10	7.50	10.10	10.50	13.15	13.50	570	11.30	11.90	16.00	16.60	20.80	21.40
370	7.30	7.75	10.40	10.80	13.50	13.90	580	11.50	12.10	16.30	16.90	21.20	21.80
380	7.50	7.95	10.70	11.10	13.90	14.30	590	11.70	12.30	16.60	17.20	21.60	22.20
390	7.70	8.15	10.95	11.35	14.25	14.65	600	11.90	12.50	16.90	17.50	22.00	22.60
400	7.90	8.35	11.20	11.65	14.60	15.00	620	12.30	13.00	17.40	18.10	22.60	23.20
410	8.10	8.55	11.50	11.95	14.95	15.40	640	12.70	13.40	17.90	18.70	23.40	24.00
420	8.30	8.80	11.80	12.15	15.35	15.80	660	13.10	13.80	18.50	19.30	24.10	24.80
430	8.50	9.00	12.05	12.50	15.70	16.15	680	13.40	14.20	19.10	19.80	24.80	25.50
440	8.70	9.20	12.35	12.80	16.10	16.50	700	13.80	14.60	19.60	20.40	25.60	26.20
450	8.90	9.40	12.65	13.10	16.45	16.90	720	14.20	15.00	20.20	21.00	26.30	27.00
460	9.10	9.60	12.95	13.40	16.80	17.30	740	14.60	15.50	20.80	21.60	27.00	27.80
470	9.30	9.80	13.20	13.70	17.15	17.65	760	15.05	15.90	21.40	22.20	27.80	28.60
480	9.50	10.00	13.50	14.00	17.55	18.00	780	15.45	16.30	21.95	22.80	28.50	29.30
490	9.70	10.25	13.75	14.30	17.90	18.40	800	15.85	16.70	22.50	23.40	29.20	30.00
500	9.90	10.45	14.05	14.60	18.25	18.80							

Reprinted with permission of Jewelers' Circular-Keystone.

AVERAGE SETTING COSTS

Diamond setting, melee, prong, needlepoint:
- Up to 4 points $8.00
- 5 to 12 points 10.00

Diamond setting, flat plate, bead, bright cut:
- Up to 4 points $10.00
- 5 to 12 points 12.00

Center, Women's, prong or needlepoint:
- .01 to 12 points $10.00
- 13 to 24 points 12.00
- 25 to 49 points 14.00
- 50 to 74 points 18.00
- 75 points to 1 carat 22.00

Center, Men's, flat plate, bead, and bright cut:
- .01 to 10 points $16.00
- 11 to 24 points 19.00
- 25 to 49 points 24.00
- 50 to 74 points 32.00
- 75 points to 1 carat 38.00

Handmade initials, per letter: $30.00

Center heads, illusion or prong (includes setting):
- .01 to 10 points $45.00
- 11 to 25 points 50.00
- 26 to 50 points 55.00
- 51 to 75 points 65.00
- 76 points to 1 carat 80.00

Heads, 4 or 6 prong (includes setting):
- .01 to 5 points $30.00
- 6 to 10 points 36.00
- 11 to 21 points 39.00
- 22 to 50 points 46.00
- 51 to 75 points 60.00
- 76 points to 1 carat 68.00

Side plates for melee (includes setting):
- Single stone $26.00
- Each additional, to .05 12.00
- Each additional, over .05 14.00

Claw and bezel setting:
- 7 × 5mm, 8 × 6 mm, 10 × 8 mm $12.00
- 12 × 10 mm, 12 × 14 mm 14.00
- 12 × 16 mm, 14 × 16 mm 16.00
- 18 × 13 mm 18.00
- 20 × 15 mm 20.00

Bezels (includes setting):
- 10 × 8 mm $48.00
- 10 × 12 mm 50.00
- 12 × 14 mm 58.00
- 12 × 16 mm 62.00

Miscellaneous:
- Gold safety chain $32.00
- Fold-over catch, 14K 30.00
- Gold spring ring, 14K, small 10.00
- Gold ring, soldered 10.00
- Figure-eight catch 42.00

Engraving:
- Hand engraving, minimum charge $10.00
- Hand engraving, per letter 1.75
- Machine engraving, minimum charge 8.00
- Machine engraving, per letter .50

Pearl and bead stringing:

Knotted:
- 15″ to 18″ long $15.00
- 18″ to 24″ long 18.00
- 24″ to 36″ long 20.00

Unknotted:
- 15″ to 20″ long $10.00
- 20″ to 24″ long 14.00

A Manufacturer Talks about Price

Speaking at the International Society of Appraisers meeting in San Francisco, Los Angeles jewelry designer and manufacturer Moshe Pereg discussed the cost of manufacturing fine jewelry. "Machine-made chain," Pereg said, "not polished, is sold for two to three dollars above gold value per pennyweight (at wholesale)."

Pereg, one of the founders of the Jewelry Manufacturers Guild, a national association of fine jewelry manufacturers, also offered these hints for valuation: "In evaluating an item of jewelry which would be less than a thousand dollars but signed with a well-known name such as Cartier, add 20 to 30 percent over the normal retail. On some designer jewelry, even doubling the value on cost of estimate would be appropriate."

When valuing platinum items, take into consideration the high cost of alloying and the high loss factor in clean-up, which is greater than for gold. Pereg also advised appraisers to double the cost of the labor for platinum articles. He noted that the cost of platinum alloy is at least double the cost of 14K gold metal. Pereg explained that platinum castings require a lot of hand finishing but that the platinum mounting will wear three times longer than a comparable gold

mounting. "Figure," he said, "a hand-made platinum ring to sell at approximately one hundred dollars per pennyweight at wholesale."

In evaluating one-of-a-kind items, Pereg stressed, the replacement price must reflect the time, effort, labor, and design of the craftsperson. "Be as reasonably high as it is possible to be," he offered, "to be able to replace it with another one-of-a-kind item if needed."

Research Sources

Where will you research the jewelry you are valuing? Have you a clear idea of where to look and whom to call for information? Keep records of all the research you do on items, and list the people and companies you contact and the information gathered on your appraisal worksheet.

Market data research sources include:

- Retail stores carrying like merchandise
- Wholesale jewelers who sell like merchandise
- Auction houses
- Jewelry trade shows
- Gem and mineral shows—an excellent but often overlooked source of information
- Manufacturers
- Casting houses and findings companies
- Jewelry designers (individuals)
- Books and trade magazines or periodicals
- Price guides directed at specific markets, such as diamonds, colored stones, pearls
- Your own records
- Computer telecommunications networks with access to historical records and/or current prices of gemstones and precious metals
- Museum catalogs and special exhibits

Using Price Guides

Almost every jewelry appraiser will use or at least consult a price guide at some point. A price guide can be a book on antique jewelry, an auction-house catalog listing the estimated pre-sale prices of the articles to be auctioned, the wholesale price lists of jewelry manufacturers, or the price lists of specific items, such as diamonds and colored stones that are privately sold by subscription.

Price guides have one thing in common. The prices stated can and do fluctuate and should be used only as guides, and not as gospels, of price. Industry price guides are *not* valid primary sources of market value. Primary research is information based on established, substantiated prices (the mode of prices most frequently occurring in the marketplace), not on opinion or prediction. Gemstone price guides are largely

hypothetical, based on one individual's opinions or calculations of future prices. Moreover, price guides generally give the dealer's asking price, not the actual selling price. To be accurate, ethical, and legal, the appraiser must use verifiable sales data.

Price guides do have a place in the appraiser's reference library, however, and can be used as tools to establish, through comparison, a range of prices to which the appraiser adds specific data and makes final value judgments based on individual items and local markets.

Every appraiser should keep records of the prices of gemstones and jewelry they appraise, as well as the dates and sources of these prices. No other tool is as handy or dependable as your own records, which are also valid as a body of substantiated information that you can use to verify your appraisal document in court. The idea is now new—appraisers and jewelers have been making notes about sales and levels of pricing at gem shows and jewelry markets for years. If you find that it is too time-consuming to take notes at gem shows, consider using a microtape recorder. You can murmur unobtrusively into a recorder jewelry descriptions, sales transactions and prices, and your impressions of the various styles and designs. Transcribe the information into your notebook when you return to your office.

If you are establishing a range of prices from auction catalogs, be cognizant of the many variables that can affect the final sale price. Damage or needed repairs are not always disclosed, and provenance is rarely guaranteed. Furthermore, auction catalog photos cannot be relied upon to give a true idea of a gem or jewelry piece, as photos are shot from only one side and angle. Of course, if you are able to inspect the auction articles personally, the piece can be used as a point of reference *if* you can be sure that the hammer price reflects value in the market and is not unduly high or low because of the auction time, place, location, attendance, and so on. Remember that using a similar item in an auction catalog does not in itself provide enough description or information about quality and condition to be used as the sole comparable piece for the item you are appraising.

If you are using auction prices to help establish fair market value, remember that FMV data must come from sales of comparable items to the ultimate consumer—the end user of the property. Many auctions are attended by dealers who are presumably buying for resale. If a dealer is the purchaser, an item's hammer price may not be used to establish fair market value. Auction prices are useful, however, for items most commonly sold to the public. These include antiques, period pieces, and designer jewelry. For do-

nation appraisals and fair market values used for estate purposes, the hammer price alone—not including buyer's or seller's commission—is used.

The following price guides are available by subscription:

1. *Rapaport Diamond Report,* 15 West 47th Street, New York, NY 10036.
2. *Gemwatch,* American Gem Market System, 1001 Country Club Drive, Moraga, CA 94556.
3. *The Guide,* Gemworld International, 5 N. Wabash, Suite 1500, Chicago, IL 60602.
4. *GPR* (Gemstone Price Reports), c/o UBIGE S.P.R.L., 221 Avenue Louise, 1050 Brussels, Belgium.

Which Retail Mark-Ups Should Be Used?

Average mark-ups work in principle but not always in practice, where retail selling prices are often discounted in competitive markets. Furthermore, mark-ups fluctuate, depending on general business conditions and the economy.

Jewelers say that they use few formulas to determine their mark-ups, but vary mark-up according to the individual article. Some cite these reasons for mark-up variables: higher or lower demand for a particular item; keen competition; jewelry that simply looks better and can support a higher mark-up; jewelry that has been bought at a lower rate and can be marked up high—even a gut feeling about how an article may sell. Cash-flow problems can also cause a jeweler to alter the mark-up he or she commonly uses.

None of these explanations would seem to help the appraiser very much. However, it has been shown that jewelers generally stick to the mark-up that they have established. Once you know how the jewelers in your area tend to mark up their stock—get a mode based on jewelers' prices in your market region—you can build you own ratio chart. A list of average mark-ups used across the United States is provided in table 3-6. The table was compiled by the National Association of Jewelry Appraisers and was based on a member survey with 1,801 item responses. Respondents

Table 3-6. Breakdown of Percentage Mark-ups by Geographical Area

Percentage Mark-up for the West			
Wholesale Price Range	Jewelry Mountings	Colored Stones	Diamonds
All	100–150%	100–150%	100–150%
$ 1–250	100–150%	100–150%	100–150%
$ 251–500	100–150%	100–150%	100–150%
$ 501–1000	100–150%	100–150%	100–150%
$ 1001–2500	100–150%	100–150%	100–150%
$ 2501–5000	100–150%	50–100%	100–150%
$5001–10,000	50–100%	50–100%	50–100%
over 10,000	——	0–100%	0–50%
	MELEE Diamonds	Colored Stones	
All	100–150%	200–250%	

Percentage Mark-up for the South			
Wholesale Price Range	Jewelry Mountings	Colored Stones	Diamonds
All	100–150%	100–150%	100–150%
$ 1–250	100–150%	100–150%	100–150%
$ 251–500	100–150%	100–150%	100–150%
$ 501–1000	100–150%	100–150%	100–150%
$ 1001–2500	50–100%	100–150%	100–150%
$ 2501–5000	50–100%	50–100%	50–100%
$5001–10,000	50–100%	0–100%	50–100%
over 10,000	——	0–50%	0–50%
	MELEE Diamonds	Colored Stones	
All	100–150%	100–150%	

Percentage Mark-up for the East			
Wholesale Price Range	Jewelry Mountings	Colored Stones	Diamonds
All	100–150%	100–150%	100–150%
$ 1–250	100–150%	150–200%	100–150%
$ 251–500	100–150%	100–150%	100–150%
$ 501–1000	100–150%	100–150%	100–150%
$ 1001–2500	100–150%	100–150%	100–150%
$ 2501–5000	50–150%	100–150%	50–100%
$5001–10,000	50–100%	0–150%	0–100%
over 10,000	——	0–50%	0–50%
	MELEE Diamonds	Colored Stones	
All	100–150%	100–200%	

Percentage Mark-up for the Midwest			
Wholesale Price Range	Jewelry Mountings	Colored Stones	Diamonds
All	100–150%	100–150%	100–150%
$ 1–250	100–150%	100–150%	100–150%
$ 251–500	100–150%	100–150%	100–150%
$ 501–1000	100–150%	100–150%	100–150%
$ 1001–2500	100–150%	100–150%	100–150%
$ 2501–5000	50–100%	50–100%	50–100%
$5001–10,000	50–100%	50–100%	50–100%
over 10,000	——	0–50%	0–50%
	MELEE Diamonds	Colored Stones	
All	100–150%	200–250%	

were asked to indicate mark-ups used as a percentage over cost, as an add-on margin. The data shown in tables 3-7, 3-8, and 3-9 were reprinted from *Jeweler's Circular-Keystone* magazine and represent a wide response on the part of the jewelry industry to a December 1983 survey conducted by the magazine. The tables are included for general reference purposes, and should be used as a basis for comparison only.

Table 3-7. Retail Jewelry Mark-ups

Jeweler's Cost	From Stock			From Memo		
	Retail Range	Retail Median	Mark-up	Retail Range	Retail Median	Mark-up
$25	$40–$100	$60	2.4X	$30–$100	$55	2.2X
100	$125–$450	225	2.25X	$110–$450	210	2.1X
250	$475–$950	550	2.2X	$275–$950	500	2.0X
500	$900–$2000	1100	2.2X	$550–$2000	1000	2.0X
750	$1200–$2800	1575	2.1X	$825–$2800	1500	2.0X
1000	$1500–$3000	2000	2.0X	$1100–$3000	2000	2.0X
2500	$3750–$7500	5000	2.0X	$2750–$6250	4500	1.8X
5000	$6000–$15,000	8500	1.7X	$5000–$11,250	8000	1.6X
10,000	$11,000–$22,000	15,000	1.5X	$11,000–$22,000	15,000	1.5X
25,000	$27,000–$58,000	35,000	1.4X	$27,500–$58,000	31,625	1.26X
50,000	$51,000–$116,500	60,000	1.2X	$51,000–$116,500	60,000	1.2X

Table 3-8. Retail Watch Mark-ups

Jeweler's Cost	From Stock			From Memo		
	Retail Range	Retail Median	Mark-up	Retail Range	Retail Median	Mark-up
$25	$32–$75	$50	2.0X	$37–$75	$50	2.0X
50	$65–$100	100	2.0X	$75–$100	100	2.0X
100	$130–$250	200	2.0X	$150–$250	200	2.0X
150	$195–$300	300	2.0X	$225–$300	300	2.0X
250	$325–$600	500	2.0X	$375–$600	500	2.0X
300	$390–$600	600	2.0X	$400–$600	600	2.0X
500	$550–$1100	1000	2.0X	$550–$1250	1000	2.0X
750	$975–$1500	1500	2.0X	$1125–$1500	1500	2.0X
1000	$1300–$2000	2000	2.0X	$1500–$2000	1950	1.95X
1500	$1950–$3000	3000	2.0X	$2200–$5500	2950	1.97X
2000	$2600–$4000	4000	2.0X	$2800–$8500	3500	1.75X
2500	$3250–$5000	5000	2.0X	$3500–$9000	4375	1.75X

Table 3-9. Retail Mark-ups of Loose Stones

Jeweler's Cost	From Stock			From Memo		
	Retail Range	Retail Median	Mark-up	Retail Range	Retail Median	Mark-up
$25	$48–$125	$60	2.4X	$48–$125	$61	2.44X
50	$97–$250	125	2.5X	$97–$250	120	2.4X
100	$195–$500	240	2.4X	$195–$500	220	2.2X
250	$400–$1250	550	2.2X	$400–$1250	500	2.0X
500	$800–$2750	1075	2.15X	$800–$2500	1000	2.0X
1000	$1400–$5000	2000	2.0X	$1100–$5000	2000	2.0X
2500	$3000–$12,500	5000	2.0X	$2750–$12,500	4500	1.8X
5000	$6000–$20,000	8500	1.7X	$5500–$20,000	8000	1.6X
10,000	$11,000–$20,000	15,000	1.5X	$11,000–$20,000	14,500	1.45X
25,000	$27,500–$55,000	35,000	1.4X	$27,500–$55,000	32,500	1.3X

Computers and Telecommunications

High technology has reached to the jewelry business. Industry analysts estimate that between a fourth and a third of retail jewelers now use some form of computerization, whether an in-house computer, a network connected to a mainframe, or a computer service. Computer equipment is suddenly commonplace in the jeweler's office and the appraisal laboratory. Although manufacturers claim that proper equipment and programming can help the jeweler and appraiser have a more efficient business, a majority of the jewelers find inventory control to be the most important task that their computer performs.

Computer equipment and software programs may or may not be fully compatible with other brands. If you believe you have a need for a computer, begin looking at options and find out how different brands and programs can be integrated to serve you best. It may comfort you to know it is now cheaper to make a mistake in choosing computer equipment than it was a few years ago. Personal computer set-ups that cost five thousand dollars in 1982 have dropped to a thousand dollars.

Your decision to buy or use a computer for your business should depend on the computer's potential to increase your productivity and profits. Do not rush into a decision before you consider exactly how a computer system can help you. Do you want it to be able to file, write letters and appraisals, keep inventory, and receive data by phone? Determining the scope of your work is an important first step in planning your purchase. Too many people act without design only to find they have bought equipment that does not meet their requirements.

Second, the most difficult part of buying a computer is not selecting the unit or choosing the software, but learning how to use it. Some companies include several hours of hands-on training for those who buy their components, and a few independent companies conduct special day and night school classes for a fee. For those wishing in-depth instruction, classes are held year-round in local community colleges all over the country.

If you have already considered the pros and cons and decided you want electronic help, begin with the essential pieces of hardware: processor with plenty of memory (at least 128K to accommodate future expansion); a keyboard; a color monitor; a wide carriage printer; a surge protector; and a software program. If you want to communicate with other people or sources of information, you will need a modulator-demodulator, or *modem*. It works through the telephone lines, but requires a program to make it operative. A program that permits communications with source data may be included with the purchase, or you may use independent communications software.

The software you select should meet your needs. The software program for a manufacturing jeweler is entirely different from that needed by a retail jeweler. Appraisers will use only a token few of the programs available to retailers. Actually, what the appraiser really needs is a computer with software programming that offers quick access to current prices of gems and jewelry; historical data on gems and precious metals; and verifiable market values—in short, a computer linked to a telecommunications network. *Telecommunications* refers to the passing of information from one computer to another through a modem over the telephone. When hundreds of computers or terminals with modems are linked to a *mainframe*—or mass storage system—and pool their knowledge, it becomes a *network data base*. To gain access to this information network, you need a computer password that is given when you sign up as a subscriber to a telecommunications program. For the appraiser, this is a dream come true. Networks provide instant access to market transactions with verifiable data for the latest sales of gems and jewelry. Since you can print out the current prices as of the appraisal date, this method is a more accurate guide to prices than price lists or price guide books updated weekly, monthly, or semiannually. Printout pages offer better proof than verbal calls to dealers because you have an actual record of current sales of comparable items instead of an opinion of what an item will sell for, or the price at which a comparable item is offered for sale.

The largest telecommunications network for jewelers in the world is the American Gem Market System (AGMS), 1001 Country Club Drive, Moraga, C.A. 94556. When you *interface*, or interact, with a corporate mainframe computer, you gain access to information from subscribers all over the world. If you wish, you can have personal link to gem dealers in such far-away places as Bangkok by pushing the right buttons. Another communications network, not a computer system but a teletype-like service, is Polygon Network, Inc., 121 Dillon Mall, P.O. Box 1885, Dillon CA 80435.

A telecommunications network is a quantum leap into the future of information dissemination. The network's central computer keeps track of the tens of thousands of trading transactions that occur among members—retailers, wholesalers, importers, manufacturers, cutters, and appraisers. It reports on goods that are in demand and in supply, as well as average prices and overall price trends. The fact that the reports are based on actual sale—not asking—prices is what makes the service so valuable to appraisers. An-

other plus to using a network is that the appraiser can eliminate a lot of legwork and standardize appraised prices on diamonds and colored stones.

For those with computers, the addition of a modem will allow access to a network data base. If you do not have a computer and do not want one, you can use a *terminal*, which looks like a computer but has no computational ability (fig. 3-23). The terminal is "dumb" and relies on the computational ability of the mainframe. Using a terminal is easy and requires no computer programming knowledge. After the initial set-up is complete, using the terminal is a lot like using a push-button telephone. If you attach a printer, you can get hard copy, or printed data, to keep for future reference.

These are not the only services offered by telecommunications networks. Whereas some computer software programs have individual capabilities to gather and analyze gemological data, separate programs are usually needed to handle a variety of demands. By contrast, a telecommunications network such as the one offered by AGMS does it all. It can provide colored stone and diamond grading on line; current gemstones and precious metals prices; gemological identification programs; historical prices for diamonds, colored stones, and precious metals; inventory search, through millions of dollars worth of goods—the combined inventory of all subscribers—for needed gemstones; a forum to buy and sell; latest technical information in the gem market; a bulletin board to post notes to other members; and other interesting options.

Even so, the most urgent reason for the appraiser to consider telecommunications is the more credible reports that can be made, based on the current actual sales prices. Access to indisputable market sales data can be a tremendous advantage for the appraiser.

3-23. Easy access to a database of price information with the use of a terminal with a built-in modem. *(Photograph courtesy of American Gem Market System)*

Comparing Notes with Foreign Colleagues

Sharing and comparing appraisal techniques and methodology is both interesting and educational. Since no one appraiser has all the answers (or has thought of all the questions), there is plenty of room in this field for more efficient, creative, and inspired appraisal methods and grading systems.

We asked a few colleagues in Canada, France, Australia, and South Africa how they interpret value and their anwers yielded some interesting information. Each appraiser was sent color photographs of an emerald and a diamond ring together with all details needed for its evaluation (figs. 3-24, 3-25, and 3-26). They were asked to tell us what the item would appraise for in their country and give us the arithmetic used to determine the final price. The response was good, but we were surprised by the extreme variations in price.

Paris

This is the procedure for valuing the ring used by our Parisian gemologist appraiser. She wrote: "Fourteen karat gold is illegal in France, so I had to use eighteen karat gold." She also noted that the diamond grade is commercial quality in France.

7.76 grams of gold × 80F = 620F	($88.00 US)
2 full-cut diamonds, 0.10 carats each:	
355F each = $50.00 (each) × 2	= $100.00
1 0.12 carat emerald round cut,	
approximately 50F	= $ 7.00
1 emerald-cut low-intensity, emerald	
300F/carat ($42/carat US) × 3.5 cts.	= $147.00

Adding up the parts:

Gold,	620F
Diamond,	710F
Small emerald,	50F
Large emerald,	1050F
	2430F

"When pricing for retail," the gemologist wrote, "I would mark it up approximately three times, therefore the price of the piece of jewelry would be about 1041.00 in U.S. dollars." She added, "I wouldn't be suprised to find this piece of jewelry in a jewelry store at that figure."

Alberta, Canada

At the time of the project, the exchange rate was 1.4 Canadian dollars for 1 U.S. dollar, and the Canadian federal taxes were 22 percent.

3-24. The ring appraised in the international survey is a woman's 14K yellow gold ring, size 7, cast mounted and weighing 7.76 grams. It contains one 3.5 carat emerald-cut natural emerald, center-set in prongs, that is heavily included, transparent, and a low-intensity medium green color containing gray. (No color grading system was used for the large emerald.) The ring also contains two full-cut .10 carat round brilliant diamonds of I/J color with a GIA clarity of VS2. The last stone is a round, faceted, .12 carat emerald of commercial quality. It is transparent, moderately included, and a medium green color. The ring was photographed at three times its actual size.

3-25. Appraisal survey ring, photographed at 3:1 ratio.

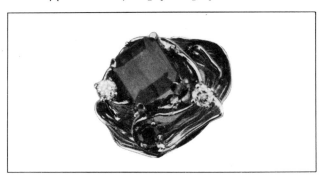

3-26. Appraisal survey ring, photographed at 3:1 ratio.

Mounting

Cast mounting, 7.76 grams	
14K yellow gold @ $75 grams.	$582.00
Three (3) heads @ $15 each =	
$45 + 1 handmade head @ $50.	95.00
Total *retail* Canadian	$677.00

Gemstones

Two (2) round brilliant diamonds	
.10 ct each VS2 − I/J	
Current prices $650 per ct × .20 =	$ 130.00
One (1) round-cut emerald,	
.12 ct $400 per ct × .12	48.00
One (1) 3.5 ct transparent emerald,	
low intensity, heavily included.	
$700 per ct × 3.5 cts	2450.00
Total *wholesale* for gemstones	$2628.00

Mark-up

The $2,628 gemstone cost × 2.5 mark-up	$6570.00
Plus mounting:	677.00
Grand total in Canadian dollars	$7247.00
(U.S. dollars, $5,176.43)	

This appraiser reported that a 2.5 mark-up on larger items is normal; with 3.5 mark-up on smaller items up to approximately $5,000.

A Victoria, British Columbia, gemologist had this to say about mark-up variations in Canada: "This is a complex area and I marvel when I see three-time mark-ups because in this region appraisers universally use the following guide:

$3500: Keystone	$5–10,000: 60%
$3500–5000: 75%	$10,000 up: 50%

"On older pieces being appraised for estate retail, some appraisers add 20 percent more for difficulty in finding a comparable item."

New South Wales, Australia

The Australian gemologist participating in this exercise declined to give prices for the article of jewelry we were researching, but did offer a step-by-step breakdown of the methods used when she figures value.

1. Cast pieces require the following assessment: metal cost, plus casting charge, plus cleaning-up labor cost, plus setting cost, plus polishing and plating.

It may be necessary to add a proportion of the original model cost, but this cannot be entirely ascertained and will not be of significance unless the casting is from a small production run.

When all required costs have been compiled, the base cost of the jewelry mounting can be determined. At this time it must be remembered that the base cost is seldom what is charged for a mounting. All manu-

facturers are entitled to a percentage of profit for their effort and organizational abilities. This will vary among manufacturers from 15 percent to 33 percent with the average at 25 percent. It is probably wise to allow for this in addition to mounting cost, as there will also be an overhead component in manufacturing, which is included. This may, however, be covered in some manufacturers' charge-out rate for labor; jewelers and assemblers charge from $20 to $23 per hour for work, the actual workman makes from $5.41 to $6.28 per hour (Australian dollars).

2. Add up the cost for hours spent in casting the mounting plus the cost of the 7.76 grams of 14K gold. Total up the cost for gem setting: ($2 each for the diamonds, $10 for the large emerald and $4 for the small emerald).

3. Add up all costs and totals and figure in the mark-up percentages. The normal mark-up varies from 2.5 and up, with most using a sliding scale according to the value of the total cost.

4. Add the tax for the final total valuation.

Even though we did not learn the price of the ring suggested for the project, we gained a good insight into the appraising procedure of our Australian colleagues!

Harare, Zimbabwe

"In Zimbabwe, we have developed a special color/clarity/quality scale for Sandawana emeralds," writes our appraiser. "This system, in brief, works by putting the emeralds into different categories:

K: Deep bright green—exceptional, clean
L: Fine lively green—minor inclusions
M: Good clear green—inclusions clearly visible to naked eye
MN: Slightly dark green—inclusions visible immediately
N: Green beryl borderline
O: Very dark included material (cabochon)

By the description given of the emerald in the subject ring, and by studying the photograph, I placed this emerald in the split grade of N/O with the price per carat $400."

Methodology: 3.50 ct emerald	
× $400 per carat	$1400.00
.20 ct diamonds @ $2200/ct	440.00
.12 ct emeralds @ $200/ct	24.00
Estimated current replacement cost of handmade mounting 7.76 grams, 14K gold	796.00
Total value, current replacement in *Zimbabwe dollars:*	$2,660.00

Our correspondent points out that 20 percent sales tax must be added, and "the current retail replacement value that we work on here is the same as your insurance value."

U.S. Appraisals

The following information about jewelry evaluations was compiled by the Association of Women Gemologists, based on a member survey utilizing one-hundred-fifty item responses.

The survey questionnaire included photographs of jewelry items and details of their manufacture and the gemstones. The survey asked for retail-replacement value to see if any standard pattern of pricing emerged either by state or by region. They hoped to determine the appraisal price gap that exists on an article of jewelry from coast to coast.

The responses showed that prices are contingent upon the standard regional mark-ups, geographic locations, current market demands, local strength of supply, and regional economic conditions.

The items appraised included a woman's diamond ring, a woman's diamond and ruby ring, a woman's diamond antique wristwatch, a gold antique locket, a modern gold and colored-gemstone ring, and a European designer necklace (fig. 3-27).

Item one: Woman's 14K gold and diamond ring. The 14K yellow gold ring is of cast construction, weight 7dwt. Mounting in a wave motif contains sixteen full-cut round brilliant diamonds: 8 @ 0.03 ct each; 6 @ 0.05 ct each, 2 @ ¼ ct each. All diamonds are VS2; color I.

Texas & Oklahoma	NYC & Northeast	Northwest & Alaska	Calif. & West
$1,895*	$1,600	$2,802.80	$2,695
$2,360	$1,800	$2,535	$1,100
	$1,800		$1,770
	$1,280		$1,800*

* Numerous identical figure responses in these regions are not repeated on the table.

Item Two: Woman's diamond and ruby pear-shaped ring. The 14k yellow gold die-struck mounting, 5 dwt., with pear-cut genuine ruby set in the center in a 3-prong head. Ruby weight: 1.12 ct. The medium reddish purple, moderately included ruby, is surrounded by thirty-four tapered baguette and twenty-one round brilliant diamonds. The baguettes have a total estimated weight 1.82 cts. Clarity is VS2, and color I/J. The twenty-one round brilliant diamonds have a total combined weight 1.05 cts. Clarity is VS2, and color I/J.

Texas & Oklahoma	NYC & Northeast	Northwest & Alaska	Calif. & West
$6,500	$7,000	$7,707	$6,849
$6,060	$5,500	$10,160	$9,605
	$5,800		$2,350
	$4,548		$3,500

Item Three: Woman's antique-style diamond wristwatch. This platinum, rectangular geometric motif wristwatch is Art Deco style and circa 1920. Platinum weight 7 dwts., including movement. The case is set with sixty-six round full-cut diamonds @ 0.02 carats each; and two marquise-cut diamonds—1 @ 0.47 cts and 1 @ 0.46 cts. Clarity is SI1, and color I. The diamonds' total estimated weight, 2.25 cts. The watch has no brand name on the dial. It is in running condition. There is some black onyx trim on the case.

Texas & Oklahoma	NYC & Northeast	Calif. & West	
$3,200	$4,300	$4,840	$2,000*
$3,800	$5,750	$2,250	$2,000
$5,200	$3,677	$5,261.88	
	$3,625	$1,900	

* In some cases, where numerous identical prices from the same region were returned on the survey, they have not been individually reported in these results.

Item Four: Antique locket, circa 1890. Woman's 14K gold oval antique locket, weight 10 dwts. Late Victorian style with cannetille work on the front and a 1½ inch oval. Hinged side opens to reveal compartments for two photographs.

Texas & Central	NYC & East	Calif. & West	
$800	$625	$600	$450
$500	$625	$600	$690
$45	$300	$610	
	$600	$350	

Item Five: David Webb 18K yellow gold ladies' ring. One 18K yellow gold cast ring, signed Webb. Gold weight, 17 dwt. Modern style with three rows of full-cut round billiant diamonds pavé set in platinum in the center; seventeen diamonds each row. The diamonds are 0.02 cts each. Bezel-set on the ring are: one cabochon ruby approximately 1 ct, medium red with moderate inclusions; 1 cabochon emerald, medium green with moderate inclusions, approximately 1.30 ct. A black onyx band is centered around the ring showcasing the platinum and diamonds.

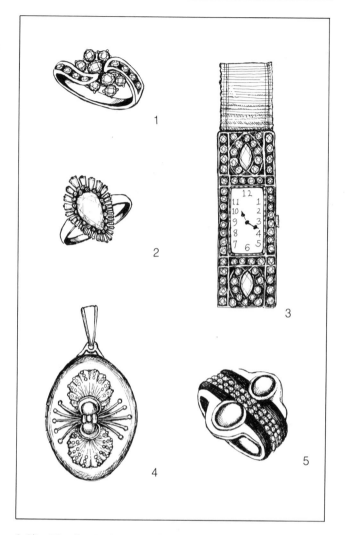

3-27. The five U.S. survey items.

Texas & Central*	NYC & East*	Calif. & West*	
$8,550	$4,500	$13,770	$18,000
$6,150	$4,550	$3,000	$18,000
	$6,500	$8,850	
	$9,800		

* At least a dozen appraisers from each region said that they would not value this ring without contacting the manufacturer. That, of course, is an appropriate posture. The company listed this ring in its catalog for a suggested retail price of $6,900.00. The lesson learned is you cannot use the cost approach on this type of jewelry. Check with the company for replacement.

The European designed necklace was refused by all appraisers. Each participant pleaded an inability to place value upon the item without first contacting the manufacturer for replacement price guidance. That is an appropriate and sound procedure.

CHAPTER 4

RESEARCH AND ANALYSIS: HOW TO ESTIMATE VALUE

A competent appraiser is also a good investigator, searching through libraries and other information sources to document an item's worth. Charts, tables, formulas, and guide books are all part of the appraiser's arsenal of research and analysis. However, an appraiser must beware of falling into the complacent use of only one reference source or value table. No single book, chart, table, or reference is comprehensive enough to cover all market variables.

The tables and references that follow will provide the appraiser with the basis of a good reference library. They should, however, be viewed only as additional and useful tools for the appraiser.

Pricing Old-Cut Diamonds

Few old European-cut or old mine-cut diamonds are actually recut in the commercial marketplace, but they are invariably evaluated as if they will be. The Gemological Institute of America has always in-structed students to evaluate old-cut diamonds by estimating recut weight to ideal proportions, even though there may be no real intention to recut the stone. Accordingly, gemstone appraisers follow the same principle for valuing old-cut diamonds. However, while one appraiser may see many old-cut stones and one appraiser may see few, both will have difficulty finding reliable market pricing information.

The price reference shown in table 4-1 was compiled by D. Atlas and Company in 1986–87 for their use in buying and selling old-cut diamonds. The table shows a matrix of current base-price information for various sizes, colors, and clarity grades of old-cut diamonds. The numerals signify the per-carat price and include a minimum charge of one hundred dollars for recutting, so the appraiser need not discount for that service. The chart is helpful in finding the approximate liquidation value of old-cut diamonds according to the Atlas system. This is important information for the appraiser. In knowing the ap-

Table 4-1. Current Market Value of Old European- and Old Mine-Cut Diamonds

Color	Clarity IF to VVS₂*					Clarity VS₁ to VS₂*					Clarity SI₁ to SI₂*					Clarity I₁				
	Carat					Carat					Carat					Carat				
	.50	.75	.95	1	2	.50	.75	.95	1	2	.50	.75	.95	1	2	.50	.75	.95	1	2
D–E	2800	3165	3690	5700	8100	2100	2590	2915	4000	5900	1700	2110	2235	2700	4200	1300	1630	1745	2200	2800
F–G	2300	2685	3110	4300	6300	1900	2300	2620	3400	5000	1500	1820	2040	2500	3600	1100	1435	1550	2000	2600
H–I	1800	2200	2430	3200	4400	1500	1915	2135	2600	3600	1200	1535	1745	2200	2900	900	1245	1355	1700	2400
J–K	1200	1630	1845	2200	3100	1100	1435	1650	2000	2800	800	1150	1360	1800	2100	700	1055	1165	1500	2000
L–M	800	1150	1260	1500	2000	700	1055	1165	1300	1700	600	860	970	1100	1500	500	765	870	1000	1300

*Numerals represent per-carat prices in dollars. Color grades in italics indicate low bias. Compiled by David Atlas, D. Atlas & Company. Reprinted with permission.

proximate liquidation value of the goods among dealers, the appraiser can calculate a more accurate wholesale value or retail replacement value.

To determine the liquidation value of old-cut diamonds, Atlas offers this formula:

Base price × estimated recut weight × 40% to 70% = Approximate liquidation value in a quick interdealer sale.

For example, if you were using the price chart to find the value of an old cut diamond, you would multiply $2,600 (the base price of an H, VS$_2$ stone) by 1.20 (the estimated recut weight) to obtain a figure of $3,120. Next, you would multiply $3,120 by 50 percent to obtain the approximate liquidation value asked among dealers. In general, use a percentage between 40 and 70 percent, choosing a higher percentage for more desirable goods with better color and clarity, and using a lower percentage for imperfect, off-color stones. Last, to obtain the wholesale value of any particular stone, multiply the liquidation price by a factor of 1.5.

When supplying retail replacement appraisals for insurance purposes on jewelry articles with old mine-cut and old European-cut diamonds, give two figures on your report. Figure the cost of the old cut stones replaced with comparable old cut stones and give the price of a replacement diamond of modern cut with the same color and clarity grades of your old cut diamonds. State these figures separately on the appraisal and indicate clearly that you are providing dual values for complete protection of the client, in case of loss or damage of the gemstones.

Be certain that you know the difference between an old European-cut and an old mine-cut diamond and can explain the distinctions to your client.

Phenomenal Gems

Some jewelry articles and gemstones have their own inherent set of value factors, including such phenomenal gemstones as star, change-of-color, and cat's-eye stones. All appraisers would like to possess an easy formula to apply to these items for evaluation, but unfortunately, no such formula exists. Many special articles must be judged on the merits created by their uniqueness and place in the consumer market.

When giving value to phenomenal stones, the following questions must be answered.

CAT'S-EYE STONES
1. What is the sharpness of the eye?
2. How well is the eye centered?
3. Is the opening and closing of the eye distinct?
4. Does the stone exhibit a "milk and honey" effect?
5. What is the pavilion bulge factor?
6. Is the stone opaque? Translucent?
7. Are there any internal cracks or gas inclusions that could endanger the stone?
8. Are there external blemishes?

STAR STONES
1. Is the star centered?
2. How many legs are there? Are they straight or wavy?
3. How sharp is the star?
4. How much weight is below the bezel?
5. Does the stone have belly bulge?
6. What is the bottom of the stone like? Is it chipped or cracked?
7. How good is the contrast between the star and the background?

CHANGE-OF-COLOR STONES (Alexandrite, Sapphire, Garnet)
1. What colors show under various lighting sources?
2. Is the stone cabochon-cut or faceted?
3. How much weight is below the girdle?
4. Is the stone transparent, translucent, or opaque?
5. If you shine a penlight through the stone, does it reveal any internal cracks or gas inclusions that may endanger the stone?
6. What is the clarity?
7. Are there external blemishes, scratches, or abrasions?
8. What is the degree of color change?
9. How good is the contrast of change?

All cabochon-cut stones should be examined under a single overhead light beam, such as a penlight, and moved from side to side under the light for good observation of the star or cat's eye.

Fantasy-Cut Gemstones

The German term used to describe a fantasy-cut gemstone is *freischleiferi*, or free cutting. Two German master cutters of this highly acclaimed avant-garde style are Bernd Munsteiner and Erhart Jung. Figures 4-1 and 4-2 illustrate examples of their work.

Fantasy-cut stones are unique, nearly three-dimensional in effect; each stone refracts and reflects light at a different angle. Jung and Munsteiner angle and place grooved cuts, curves, and straight planes to achieve total reflection of light. The fewest possible facets are used to obtain the effect. All are one-of-a-

4-1. Green fantasy-cut 14.22 carat tourmaline by Bernd Munsteiner. *(Photograph by Lary Kuehn)*

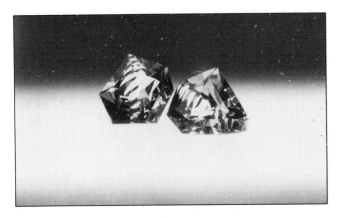

4-2. Pair of fantasy-cut citrines, 12.61 carats each, by Erhard Jung. *(Photograph by Lary Kuehn)*

kind pieces and impossible to automate, although the Japanese are copying the cuts. One key to recognizing gems from the wheels of the master German cutters to the Japanese knock-offs is the ability of the Germans to achieve an incredibly high quality of polish. Attention to detail requires twenty-five to thirty hours of labor per stone. Munsteiner's studio alone is able to turn out only a thousand to fifteen hundred gemstones per year. Since the stones are not cut in standard sizes, jewelry mountings must be custom designed to fit the stone's size and aesthetics.

Bernd Munsteiner is the most famous gem cutter in the capital of gemstone cutting, Idar-Oberstein, West Germany. He has been called a "cutter's cutter," and is admired because he is a master of traditional cutting techniques as well as a breaker of tradition with his freestyle cutting. "Jewelry should develop to fit the times," he has been quoted as saying. Since 1985, Munsteiner has signed his gemstones with three triangles or the letters BM, either on the girdle of the stone or on one of the facets near the girdle. His signature alone will guarantee that his gemstones will command a higher market price in years to come. For the moment, however, appraisers are as interested in the weight estimation of a set fantasy-cut stone as in authenticating the cutter. What does one do about a formula to estimate weight? A survey of dealers who sell the stones and designers who use the cut in their work failed to turn up any standard formula that would give an accurate estimate of weight.

Gem dealer Lary Kuehn of Dallas is a wholesaler of gems cut by both Jung and Munsteiner. When the formula problem was presented to him, he supposed the best method would be to use the standard formula that would best apply to the stone if it were cut in the normal manner—that is, if it were a rectangle, emerald, oval, or so on. Then, approximately 20 percent should be deducted from that estimated weight. Kuehn cautioned that this "formula" is only a supposition, however: "As far as I know, no formula has been published for fantasy-cut gemstone weight estimation."

Once you can get an estimate of the weight, how do you price these stones? "By keeping in mind the uniqueness of this cutting and the fact that they are all hand-cut," Kuehn suggests.

Fantasy-cut gems must be individually valued against work by the same cutter and cannot be compared to the work of other artists or to material of similar color or similar species. Using a per-carat basis to calculate this highly specialized form of gemstone art is impossible and will lead to undervalued goods.

Kuehn said that a tourmaline of good commercial green color and of about 10 carats in weight normally would sell for one hundred and fifty to one hundred and sixty dollars per carat wholesale. In comparison, if the same stone, same color, same weight, same clarity grade were Munsteiner-cut, Kuehn stated that it would sell for around three hundred and fifty to three hundred and seventy-five dollars per carat wholesale.

Ivory

Ivory has been sought after, cut, polished, sold, bartered, and coveted since the earliest times. Ivory jewelry will surely cross your desk from time to time, and your first thought will be: Is it fake or real? Great imitations have existed for decades.

The characteristic crosshatching (sometimes called crossgraining) effect of elephant tusk ivory makes it the easiest ivory to identify. Crosshatching may be difficult to locate on small items, requiring determined examination. Both mammoth and mastodon

ivory tusks can still be found in part (figs. 4-3 and 4-4). These ancestors of the modern elephant had ivory tusks varying in color from creamy white to rich dark brown, or sometimes steely gray. Mammoth and mastodon tusks also have a crosshatch line, but much of the ivory found is useless owing to cracking and calcification that have occurred over the years. However, many new jewelry crafters like using this material because it is pliable and easily worked. Tusks that have been buried next to phosphate of iron are normally bluish or greenish; this ivory is known as *odontolite*. You may also encounter ivory from other animals such as walrus, whale, boar, shark, bear, elk, camel, beaver, and hippopotamus. Vegetable ivory—not a true ivory but from the ivory palm *Phytelephas macrocarpae*, which produces tagua nuts—handles, cuts, works, and ages in the same manner as animal

4-3. Small section of mastodon ivory, showing crosshatching and resting on another section of elephant ivory tusk.

4-4. Close-up view of ivory crosshatching.

ivory. Tagua-nut ivory was an especially popular medium for buttons, thimbles, needle cases, bracelets, pendants, belts, and scarf pins in the late 1800s. Factories producing vegetable ivory buttons were established in England and France about 1862 and two years later in Massachusetts. You may find many estate items carved from vegetable ivory.

Shirl Schabilion, gemstone dealer and collector of vegetable ivory, says that tagua-nut ivory can be identified by its distinctive wavy, circular grain, which resembles moire taffeta or watermark silk. Once you see this pattern, you will find it easy to identify vegetable ivory, which is the only ivory that shows this unusual, recognizable pattern.

Animal ivory in mint condition has a mellow, warm, translucent appearance, almost as if it had been soaked in oil. Very little suggestion of grain is seen. Asiatic ivory is a denser white than African ivory, is coarser in texture, and yellows easily. Ivory from Africa is characterized by its translucency and the fact that it bleaches whiter with age.

Inform your client who has ivory that heat is the chief enemy of this material. If your client wants to know how to clean it, recommend the method of soaking the ivory in milk, then dipping the ivory in a mild soap-flakes solution and scrubbing it with an old toothbrush.

The factors that govern value in ivory are color, translucency, polish, workmanship, and condition. Ivory bead necklaces range in wholesale price as follows:

- 4mm beads, 16″ to 18″ strand: $15
- 8 to 10mm beads, 16″ to 18″ strand: $25
- Carved, graduated beads, 18″ strand: $40
- Round, graduated beads, 30″ strand: $80

Bangle bracelets that are simple in style sell from twelve to twenty-five dollars each wholesale.

Jet

The heyday of the jet jewelry industry was in the 1870s, when two hundred to three hundred miners of jet were employed in the area around Whitby, England. Mining began there in about 1840 and ceased in 1920. Unless antique jewelry appraising is your specialty, you will probably not encounter much jet jewelry.

Jet is a variety of brown coal known as *lignite*. Because of its somber color, the material was used to make mourning jewelry and was popular in the Victorian era. It can be confused with such imitations as vulcanite, bog oak, Bakelite, and black glass, which is also called *French jet*. The conclusive test is a hot nee-

dle, which in jet produces a smell of burning coal. A hot needle used on Bakelite will result in a smell of phenol, or carbolic acid; vulcanite tested with a hot needle has the unmistakable smell of burning rubber. Bog oak is a fossilized wood and shows a woody structure; since it is easily identified by sight, testing is not necessary. French jet is also not difficult to identify, since glass is cold to the touch, and both heavier and harder than jet. It cannot be scratched with a pin and a hot needle produces no effect.

The factors that govern value in jet jewelry are as follows:

- The purity of the black color
- The degree of freedom from inclusions of other minerals, especially pyrite and sulphur
- Absence of cracks
- High polish (a dull polish diminishes the value)
- The degree of the jet's density, compactness, and hardness—the more dense, compact, and hard, the more valuable

Jet has been used to produce a variety of jewelry items, including necklaces, bracelets, crosses, pendants, and hair ornaments. Carvings, picture frames, cane heads, and related articles were also made of jet.

Examples of retail prices for assorted jet items are as follows:

- Cross pendant, 4¼″ × ¾,″ circa 1860: $99
- Cross, 2½″ × 4″: $99
- Necklace with carved beads, 12mm, 18″ long: $140
- Necklace, carved 12mm beads, 23″ long: $140
- Necklace, round graduated beads, 27″ long: $87
- Necklace, faceted beads, 19″ long: $60
- Necklace, oval carved beads, 18″ long: $80
- Earrings with 2″ × ¾″ jet dangles, circa 1860: $110
- Earrings with jet dangles having pin shell cameo centers, 2¼″ × 1″: $110
- Locket/pendant, 2″ × 1¾,″ circa 1870: $100
- Bracelet, 8″ long with carved chain links: $100

Coral

Coral has been a popular jewelry medium since antiquity. Its widespread use as a material of personal adornment has been duly noted by such peripatetic adventurers as Marco Polo and Jean-Baptiste Tavernier. Thirteenth-century explorer Marco Polo noted the use of coral for fashioning idols in Asian temples and the popularity of coral has hardly waned through subsequent centuries.

Much coral comes to Japan and Taiwan for processing from the Midway Island area, and some Mediterranean coral is also imported to Taiwan for processing. Mediterranean coral has long been held by experts to be the finest. Modern travelers to Italy will surely bring back jewelry from the coral-cutting center at Torre del Greco near Naples for you to appraise, and you will see this coral in shades from white to deepest red.

Coral is seldom confused with any other material except plastic, and is usually found in either cabochon-cut stones or beads. There are several different shapes of beads indigenous to Italian coral: round; tubular (small cylinder shapes); *spezzati* (small, rough nuggets); *cupolini* (small pieces of straight branch coral); basic nuggets; *fabrica* (large, chunky nuggets); and *frangia* (long, straight, curved pieces of branch coral). These shapes are illustrated in figure 4-5. Figures 4-6 and 4-7 also show products of the Italian coral carver's art.

Color is the main value factor of coral. Oxblood-red coral is the most expensive, followed by salmon,

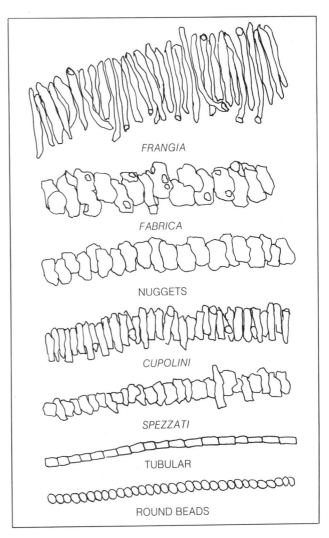

FRANGIA

FABRICA

NUGGETS

CUPOLINI

SPEZZATI

TUBULAR

ROUND BEADS

4-5. Assorted shapes of Mediterranean red coral beads.

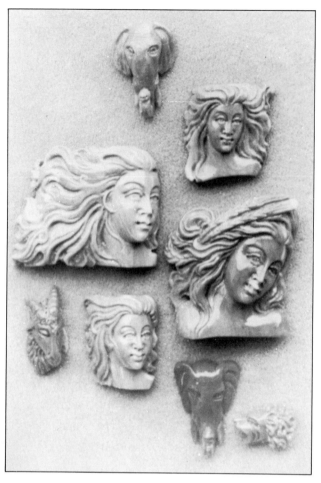

4-6. These Italian coral carvings range in color from angel skin to deep oxblood, and vary from ½ inch to 2½ inches in size. *(Photograph courtesy of Timeless Gem Designs)*

4-7. Mediterranean red coral worked by Italian carvers. The carving is 70mm wide and weighs 94 grams. *(Photograph courtesy of Timeless Gem Designs)*

angel-skin, white, and black coral. Most experts also consider intensity and uniformity of color to be major factors. Cleanliness is another value factor. The material must be compact and free of spots, cracks, inclusions, or holes of any kind. The cleaning of any organic substance such as coral, shell, or mother of pearl should be undertaken gently and carefully. Do not use solvent of any kind, as it will attack the material. Instead, use a weak, detergent-and-water mixture to remove grime, followed by a careful rinsing.

Coral is often dyed to color enhance it. To detect the presence of dye, use a drop of nail-polish remover on a cotton swab and test the underside of the coral. If color comes off on the swab, the coral has been dyed. To test for genuine coral, place one drop of a bland acid such as vinegar on the coral carefully. If the coral is genuine, the acid will cause the coral to effervesce.

Coral polish should be excellent. Some traders may mask poor coral by using wax to produce a shine, so be alert. Strands of coral beads should be uniform in bead size, unless the necklace is of graduated beads, and the material should have no holes or blemishes. Bead holes should be drilled directly through the middle of the beads so that they lie on the neck properly. Round bead necklaces are the most expensive of the coral necklace shapes, and vary in price according to color and grade. The wholesale price of some round-bead coral necklaces is as follows:

Red Coral
- 4mm beads, 16″ strand: $50–85
- 6mm beads, 16″ strand: $100–200
- 8mm beads, 16″ strand: $450 and up

Pink Coral
- 4mm beads, 16″ strand: $25
- 6mm beads, 16″ strand: $65
- 8mm beads, 16″ strand: $125–175
- 8mm fluted beads, 18″: $375

White Coral
- 4mm beads, 16″ strand: $10
- 6mm beads, 16″ strand: $25
- 8mm beads, 16″ strand: $35

Salmon Coral
- 4mm beads, 20″ triple (twisted) strand: $180

Amber

Amber is the condensed sunshine of a pine forest. Some say it is a fragment of eternity, for it is fossilized tree resin thirty to sixty million years old. Amber's warm golden color has been popular since the Stone Age and it has always been an excellent material for beads. Although you will probably see only amber

beads to appraise, contemporary jewelry designers are now putting amber to use in rings, bracelets, pendants, and earrings. The material is soft but durable. Caution your customer to handle amber with care and not to wear it in the swimming pool (where chlorine will be present) or put it in an ultrasonic cleaner. To clean amber, wash it with mild soap and water and polish it dry with a soft cloth. Sometimes the luster of amber can be restored by polishing it with a soft cloth saturated in olive oil, then rubbing with a soft cloth to remove the excess oil. Under no circumstances should solvent ever be used to clean amber—solvent can dissolve the soft material. Avoid excessive heat and hot water in cleaning amber.

Amber is very light in weight and always warm to the touch. Colors range from bright "banana" yellow to deep rose.

Amber ranges in clarity from opaque to transparent and is found with or without inclusions. A product known as reconstructed or pressed amber (sometimes called *amberoid*) is made by melting small pieces of amber and compressing them into blocks by hydraulic pressure, usually with the addition of linseed oil. The blocks are then stained in various colors and shaped. Pressed amber turns white when it is old and is less valuable than natural amber.

Antique amber is prized by collectors who enjoy the aged reddish or brownish colors. However, appraisers should be aware that some specimens may not be what they seem and may have been artificially aged by immersion in salt water for several weeks.

Warnings about amber treatments and substitutes were being given as early as the sixth century A.D. Much of the amber jewelry from the late nineteenth and early twentieth centuries is really Bakelite, celluloid or casein, all synthetic resins. Testing is essential.

The hot needle test is commonly used to distinguish genuine amber from its many plastic imitators. Celluloid beads will emit an odor of camphor and celluloid may even adhere to the needle point. Bakelite and other plastics will give off an acrid odor when touched wth a hot point while genuine amber gives off a "piney" odor. A touch of the hot point to casein will produce the odor of burned milk. In *Amber, Golden Gem of the Ages,* Patty Rice provides a useful clue in distinguishing imitation from genuine beads —examining the bead hole. Since amber is softer than most plastics, Rice says, the constant rubbing of the string in old bead necklaces will eventually erode the amber near the bead hole, and edges will chip as the beads rub together. She claims that even beads made of Bakelite that have been strung for sixty or seventy years or more will still have clean smooth bead holes.

Genuine Baltic amber is of premium value because of its increasing scarcity. Baltic amber ranges in color from white to near black; most is yellow, gold, or light brown, with clarity varying from transparent to opaque (fig. 4-8). The material takes a higher polish than other amber and is considered to be the finest in the world.

Inclusions in amber are a matter of personal preference. Some amber dealers believe that organic inclusions, such as leaves or insects, add value to the amber, especially if the inclusion is exactly centered in the material. If the appraiser has such material to value, using individual comparables priced in the current wholesale market is the only logical approach. Value factors for amber include color—fine golden and translucent reds are the most valuable; size; transparency; flawlessness or, conversely, exceptional inclusions; and intensity of color.

Reynolds and McNear, two amber dealers based in San Rafael, California, list the following wholesale prices in their catalog:

- Rough beads, graduated, 25″ strand: $21
- Baroque beads, clear, 22″–27″ strand: $87.50–150
- Oval beads, clear and graduated, 32″ strand: $150
- Rectangular-shaped beads with baroque spacer, clear material, 30″ strand: $125–150
- Double-strung, choker-style (triple bib), 16″–18″: $97.50
- Baroque beads, clear: $162.50–225
- Hand-faceted beads, 22″ strand: $100
- Baroque, angular, dark beads, 22″–25″: $100
- Baroque beads, clear 23″–30″: $162.50–225
- Baroque beads, clear and opaque, 26″–35″: $70.–150

4-8. Baltic amber from the collection of Reynolds McNear, San Rafael, California. The large amber nugget in the center has an entombed cockroach. *(Photograph courtesy of Reynolds McNear)*

- Round beads, hand-shaped, 26″ long strand: $125
- Russian reconstituted round beads, graduated and uniform, various lengths: $50.–125
- Heart-shaped pendants, clear and opaque: $9 each
- Necklace of clear, 6-sided faceted beads, 17½″: $175
- Necklace, clear and butterscotch colors, 20″: $200
- Amber specimens with insect inclusions are base priced at $5.00 per gram and $25.00 per insect with adjustments for rarity, visibility, and other factors

Opal

Are you aware that an international nomenclature for precious opal exists? There is also an Opal Society International in the United States, founded by Bob and Josie Griffith of the Arizona Blue Fire Opal Company in Phoenix. The Opal Society has between fifteen and thirty-five members at any given time, and is a networking organization for dealers and collectors of opal who wish to further their knowledge and education about the precious gemstone. Although it is not connected with the Australian Opal Society, publisher of the international opal nomenclature, it subscribes to all the grading rules of the Australian society and information is willingly exchanged between the groups. The Opal Society is located on the Griffiths' two hundred and eighty acres of blue-based opal, and offers abundant material for members who wish to learn the finer techniques of cutting.

The rules for valuing opal, as might be expected, center on color. All grading of the precious solid material is done by the naked eye under an incandescent tungsten lamp that emits at least 100 watts of white light. For clarity grade, a 10x magnifying lens is used.

Black opal is the most valuable when it has an excellent, high-quality spectrum of colors. In descending order of value, the remaining opal colors are semi-black, boulder opal, black crystal opal, white crystal opal, and white opal. Each type is modified in value by the amount and type of spectral colors present, as well as by the pattern and distribution of the spectral colors in the central body color. Clients who have opals will often ask you whether they should soak the stones to keep them from cracking. There are several theories regarding the storage of opals, including soaking them in water, mineral oil, or glycerine, but none has been proven effective and the techniques may even damage the opals. The water in some localities contains minerals that may react and discolor opal unpleasantly after several weeks; and opal kept in mineral oil or glycerine will develop a hard-to-remove film of grease.

The value factors for judging opal include its size in carats, colors, transparency, shape, and flawlessness. When describing an opal in your appraisal report, note the predominant color of the opal, the background color, other colors that are visible, and the distribution as well as intensity of the opal colors. (See the appendix for a glossary of opal terms.) In addition, shine a penlight through the stone from the back of the gem and examine it for cracks and flaws.

To order the booklet *International Nomenclature for Precious Opals*, write to the Griffiths at Arizona Blue Fire Opal, P.O. Box 23049, Phoenix, AZ 85063.

Jade

The romance of jade appeals to many Western jewelry buyers. Jade expert John Y. Ng, who is based in Los Angeles, reports that while certain demand factors of jade are cultural or traditional, the essence of jade value is its beauty. As he sees it, the elements that make up beauty in jade are: color, texture, translucency, shape, size, and polish.

The finish of jade beads as well as how they have been matched or graduated in size are equally important. Jadeite cabochons are usually priced by the stone rather than by the carat. Although the costliest jadeite is green, this is not the only valuable color. Next in order are mauve or pale violet, red, yellow, white, and black. Unfortunately, black is the most easily dyed color. Without using a fade test, there is no reliable way to recognize stones that have undergone a subtle treatment. When given adequate exposure to sunlight, however, treated stones will soon fade. As a general guide, Ng suggests that a natural stone will show areas that are heavier in color than others, whereas a dyed stone will show an even color. You may also be able to spot telltale accumulations of dye along any fissures, cracks, or grain boundaries.

There is no set way to price jade. Supply and demand plus dealers' costs and how much color they recover from the raw material combine to make jade prices fluctuate. Appraisers should use the following examination tips when determining type of jade and quality:

1. Shine a penlight on top of the stone or examine it in a well-lighted area in the shade or under cool daylight. Note color, tone, and texture.
2. Focus a penlight under the stone to check the degree of translucency and look for cracks or color mottling.
3. Look for even shape, good cutting, and excellent polish.
4. Consider the belly of the stone. A flat belly is acceptable; a hollowed-out one is not.

In their book *Jade for You,* John Ng and Edmond Root offer a complete grading system for jade. They explain that the jadeite cabochon-cut stone is the most desired for jewelry use.

Other recent wholesale prices for jadeite jewelry are:

Solid, one-piece jadeite bangles, 8mm–10mm wide, 1¾″–2″ inside diameter:
- Black: $100–600
- Multicolored: $600–5,000
- Lavender: $100–4,000
- Light green: $150–2,000
- Imperial green: $5,000 and up

Jadeite segmented bangles with 14K yellow gold fittings:
- Green: $150–300
- Four colors: $125–250
- Black: $125–200

Jadeite pendants, carved:
- Multicolor: $50–250
- Lavender: $100–350
- Medium green: $500–1,000
- Imperial green: $1,000–3,000

Jadeite bead necklaces, 8mm–12mm beads, 18″ length, complete with 14K clasp:
- Multicolor: $50–150
- Yellow or red: $100–800
- Lavender: $100–2,500 and up
- Light apple green: $150–1,000 and up
- Fine green: $1,000–10,000 and up

Color-matched items of jewelry, such as matched pairs or multiple matched pieces, should be priced 30 percent higher or more, even though the shapes may not be identical.

Pearls

Many factors combine to stimulate consumer interest in pearls from time to time, primarily influenced by fashion: Pearls are either in fashion or in eclipse. Currently, pearls are in style, and with their classic beauty and range of sizes and shapes on the market, the appraiser will have many opportunities to invoke his or her special training in pearl evaluation.

Regardless of size or weight, the foremost consideration in judging salt-water cultured pearls is roundness. The rounder, the better. Any sign of elongation reduces the price of the pearl. Other factors to judge value include:

Luster. The pearl should have luster, which makes it shine like a mirrored ball. To determine luster, the appraiser should look at the pearl by the light of an overhead fluorescent light. On a pearl with high luster, the light will appear as a thin, curved line. On low-luster pearls, the light will look fuzzier and more diffused.

Color. This is a matter of personal preference, but most of the world's pearl fanciers like a pearl with a slight rosé cast. Pearl body colors can be pink, black, light cream, medium cream, dark cream, white, blue, gray, silver, gold, and yellow. The overtones on pearls are like blush powder on a woman's face; they affect the surface color. There are three overtones: rosé, blue, and green, with blue as the least common and rosé as the most common. With the exception of black pearls, the more rosé overtone color present, the higher the pearl value. The more green overtone present, the lower the value.

Pearls should be placed on a grayish background before they are graded for color. North daylight is the ideal grading light, but overhead fluorescent light will do. Never grade pearls under incandescent light.

If you have gold color pearls to appraise, you will notice that a top gold pearl will look a lot like 22K or 24K gold. Yellow pearls range in color from a "melted butter" look to the hue of a legal-size yellow tablet. Beware of pearls that have been dyed bright colors: inspect both cultured and freshwater pearls for dye. Cream-colored, green, and yellow pearls are often dyed to seem rosé. Look inside the pearl drill hole. If it has been dyed, the drill holes will usually appear unnaturally red. Similarly, the string will look slightly pink if the pearls have been dyed. Another clue is that dyed pearls will fade. Figure 4-9 shows a twisted necklace of white cultured pearls and dyed black cultured pearls.

Cleanliness. Blemishes in cultured pearls, as with other gems, reduce value. Cracks, spots, blotches and what is called an "orange peel" effect are found. Inspect carefully, because some companies have made a practice of stringing poor and good pearls together to make the strand look better than it is.

Nacre. According to GIA, nacre thickness is the most difficult category to judge in cultured pearl grading and appraising. The standard method is to rotate the strand near a light source and observe to what extent a blinking effect occurs, and to look down the bead hole for a cross view of the nacre. An ideal nacre thickness is ½mm on each side. The mother-of-pearl bead is about 60 percent of the production. To see the nacre, tilt the pearl so that the drill hole is angled at between 12:00 o'clock and 2:00 o'clock placement. The nacre deposit appears as light colored and is somewhat transparent.

Size. Size also affects value. Prices rise sharply for

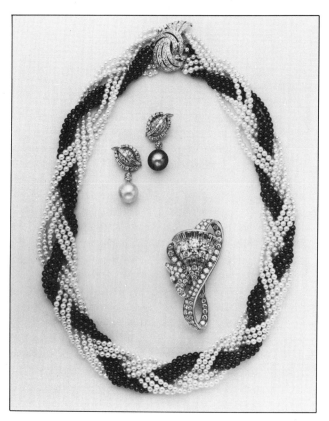

4-9. A twisted, multistrand 18-inch white and dyed-black cultured pearl necklace with 14K white gold and diamond clasp. *Center left:* A pair of natural button-pearl and diamond earrings. The white pearl measures 11.6 × 9.9mm; the black pearl measures 12 × 10.5mm. The platinum mountings feature ten baguette and forty-four round and single-cut diamonds. *Center right:* Platinum and diamond clip. Total weight of the diamond, 14.8 carats. (*Photograph © 1986 Sotheby's, Inc.*)

each 1mm change in size, especially over 7mm. Example: An 18 inch strand of wholesale, commercial-grade 6mm pearls may cost one hundred and twenty-five dollars; the same strand in wholesale, extra-fine quality could cost six hundred and twenty-five dollars while the same length in 8mm may be two hundred and fifty dollars (commercial) to eighteen hundred dollars (extra fine). The most popular sizes of cultured pearls are from 4mm to 6.5mm.

- Choker: 14"–16" long
- Princess: 17"–18" long
- Matinee: 20"–24" long
- Opera: 28"–30" long
- Bib: Necklace with more than three strands
- Rope: 45" up (also called *lariat* or *sautoir*)

Pearl necklaces are in either graduated size, in which the smaller pearls are close to the clasp and the largest pearls are at the center, or uniform size, in which nearly all pearls are equal in size. The unit of measure for pearls is *momme:* 18.75 carats (3.75 grams) = 1 momme.

South-Sea Pearls

When valuing South-Sea pearls, use the same criteria used to value Japanese cultured salt-water pearls, but keep in mind that spot-free South-Sea pearls are very rare gems. South-Sea pearls can cost from five hundred to twenty thousand dollars per pearl and from nine thousand to one hundred and fifty thousand dollars per strand wholesale. South-Sea pearls grow to be quite large, generally from 12mm to 14mm. The 16mm and 17mm South-Sea pearls are so rare that it is almost impossible to have a necklace containing only pearls of this size. Graduated strands may have a 2mm to 3mm difference in size from the center pearl to the ends of the strand. The typical South-Sea pearl necklace is 18 inches long.

Natural Pearls

Natural pearls are rare and becoming more rare with each passing decade, given the pollution of the world's waters and other factors. To appreciate the rarity and exceptional value of fine natural pearls, consider that their equivalent in value is a strand of perfectly matched fine Burmese natural rubies. At the peak of their popularity between 1895 and 1930, a strand of natural pearls could cost as much as 1.5 million dollars. American natural pearls were as treasured as those from the Orient, and in the early 1920s, Tiffany's assembled two necklaces that sold for over a million dollars each, and a hundred that sold in the range of a hundred thousand dollars each. If you have natural pearls (verified as such by X-ray) and are trying to get some idea of current pricing, research the major auction-house catalogs. Natural pearls appear with some frequency in their jewelry catalogs. In October 1983, Christie's sold a short choker of natural pearls, graduated in size from 10.2mm to 15.2mm at the center for three hundred seventy-four thousand dollars. They had estimated the sale price to range from two hundred and twenty thousand to two hundred and forty thousand dollars. A pair of natural pearl button earrings sold at Sotheby's in 1985 for two thousand eight hundred and sixty dollars.

Although all natural pearls have, by industry tradition, been called *Oriental* pearls, the Federal Trade Commission has narrowed the definition and ruled that only natural pearls fished from the Persian Gulf can rightfully be called Oriental.

Freshwater Cultured Pearls

These can be divided into three categories: Biwa, Chinese, and American. The mantle tissue (irritant) of freshwater cultured pearls is 95 percent of the final product. How are they different from saltwater cultured pearls? Colors are light, medium, and dark orange, purple, lavender, violet, and multihued. Many freshwater pearls are iridescent and might be baroque, flat, or elongated instead of round. There are usually low-luster areas on portions of the pearls. Most are sold on the basis of weight alone. The majority are from Lake Biwa, Japan, and have fullness, sheen, and texture on all sides of the pearl. The average Chinese freshwater pearls are domed, have a flat bottom, and an irregular sheen and texture. This devalues them since it is impossible to conceal irregularities while wearing them. To evaluate the quality of the pearls, lay them on white tissue paper. The paper will provide sufficient contrast to define color and luster.

There are two American freshwater-pearl farms in Tennessee, and growers are making plans for farms in other states. The first harvests have been limited, but growers remain enthusiastic about future yields.

Imitation Pearls

Imitation or simulated pearls have been around for centuries, long before the existence of cultured pearls. Plastic, glass, and shells are used to create these pearls, and a substance made of fish scales is often applied to the surface, giving the pearls a lustrous, nacrelike appearance. Majorica pearls are simulated pearls that are often mistaken for cultured pearls. Majorica strands range in price from twenty-five to seventy-five dollars in the better department stores. To tell the difference between these imposters and cultured pearls, rub the suspect pearl against the bottom edge of your upper teeth; cultured and natural pearls have a coarse, gritty feel, whereas simulated and imitation pearls are smooth.

Keshi or Seed

The saltwater, occasionally freshwater, keshi or seed pearls are the tiniest pearls available. They are frequently the size of a poppy seed and are often used in multiple-rope strands.

Mabe

Mabe, or mobe, pearls are a form of blister pearl, grown on the shell of an oyster. The pearls are dome-like and frequently measure up to one inch in diameter. They are usually used in earrings, rings, and other jewelry where a flat back is desired. Prices of mabes range from sixteen dollars for a 10mm pearl to about seventy-five dollars for one approximately 20mm; 14mm, a popular size, is about thirty dollars each.

Pearl Masters

Master grading strands of cultured pearls can be purchased from dealers who have developed their own grading systems, using a particular pearl trader's goods.

A master pearl grading strand is available from James S. Seaman, Midwest Gem Lab of Wisconsin, 1335 S. Moorland Road, Brookfield, WI 53005. This company offers seven 2½-inch strands with price lists for three hundred seventy-five dollars. They also offer a quarterly updated list by subscription. Pearl prices (necklaces and loose pearls) are updated regularly in *The Guide*, a subscription price guide from Gemworld International, Inc., 5 North Wabash, Chicago, IL 60602.

Table 4-2 offers the appraiser a guide to the quality of saltwater cultured pearls. The chart should be used only as an indicator of quality and combined with the appraiser's research and first-hand knowledge of value characteristics.

Writing the Pearl Report

On your appraisal report, be certain to note the following value factors for strands of pearls:

1. Whether the strand is uniform or graduated.
2. Whether the strand is single, double, or triple (fig. 4-10).
3. The number of pearls and their size in millimeters.
4. All quality information on the pearls.
5. The overall length of the pearl strand or bracelet.
6. The metal fineness and style of the clasp, if any, and any gemstones and/or pearls set in it.
7. Note whether the drill holes in the pearls are centered. Off-centered drill holes convey sloppy and hurried workmanship and lower the value of the pearls. The best way to spot off-center drilling is to lay the strand out in front of you on a desk or counter and, holding each end of the strand, roll it toward you. Off-center drilling will make badly drilled pearls wobble and easy to spot.
8. Use the correct nomenclature for the shape. Pearls are reported in the following shapes: seed, three-quarters, half, rice, oval, drop, long drop, long stick, flat, twin, triangle, round, semi-round (or off-round), egg, semibaroque, baroque, button, twin, top, circle, and bridge.
9. If the pearls have been verified as natural by X-ray, note when and where the verification took place.

Table 4-2. Cultured Pearl Quality Determination

Quality	Cleanliness	Color	Cultivation*	Luster	Shape
Gem	Nearly 100% spotless	Rosé, white-pink, silver-pink, white-silver	Thick, even layers, silky smooth	Mirrorlike glow	Round in all
Fine	Very few spots	Cream rosé, rosé, white-pink, silver-pink, white-silver	Heavy, even layers	Bright, glassy look; bright surface sheen	Round in most
Top commercial	Few spots	Rosé, white-pink, silver-white, white-light green, pink, white	Medium to heavy even layers	Bright luster, bright surface	Round in most to very slight off-round
Better commercial	Few to some spots	White-pink, white to light green, pink, white	Medium layers	Average brightness	Round to slight off-round
Commercial	Spots	White to yellow	Thin, uneven layers	May have slight brightness	Round to slight off-round to semibaroque
Promotional	Spotty to very spotty	Chalky white to dark brown and yellow	Very thin, not evenly layered	Little if any; usually very dull	Round to baroque

* Nacre thickness.

Source: Cultured Pearl Association of America.

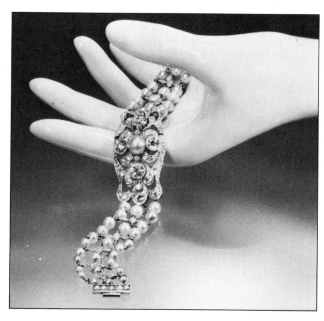

4-10. This estate article of platinum, natural pearls, and old European-cut diamonds can be worn either as a bracelet, or, by adding an extension, as a choker. Total diamond weight approximately 3½ carats. *(Photograph courtesy of Lary Kuehn)*

Answers to Questions Your Clients Will Ask About Pearls

Q. How long does it take a pearl to grow?

A. Pearls require from three to seven years, depending upon the size and quality desired and part of the world in which they are cultivated. Most cultured saltwater pearls on the market today are only in the water three years—sometimes less.

Q. Will wearing my pearls make them look better?

A. Regardless of what you have read or been told, pearls do not improve by being worn.

Q. What material should be used to string pearls?

A. For durability and beauty, pearls should be strung on silk cord, which should be knotted to protect from loss in case of strand breakage.

Q. How do I clean my pearls?

A. Do *not* use commercial jewelry cleaners, ultrasonic or steam cleaners. Remove any concentrations of dirt, make-up, or grease with a fingernail or a soft tissue. Soak the pearl strand for ten to fifteen minutes in a lukewarm, nondetergent solution such as Ivory or Woolite. With a complexion brush, scrub the knots and around the bead hole. Do not

scrub too vigorously or the nacre could be damaged. Rinse pearls in clean, lukewarm water for at least ten minutes. After washing, it is vital to support the pearl strand with *both hands* when picking it up to keep it from stretching or breaking. Pat the strand with a paper towel or cloth to absorb water, arrange it in a circle with the clasp closed, and lay it on a towel to dry at room temperature. Drying time will take at least twenty-four hours; it takes this long for the string in the drill hole to dry completely.

Bead Necklaces

Beads are worn in all countries and are among the oldest items for bodily adornment. Beads have been used in religious ceremonies and to indicate status. Beads are always fashionable; the appraiser will see strands of the most precious and the most outrageous materials. Pearls are the fashion favorites of all time, but amber, lapis lazuli, turquoise, coral, and jade intrigue generation after generation with their mystical beauty.

Beaded necklaces are available in many materials and shapes—spheres, ovals, cylinders; beads may be plain-surfaced or faceted. Frequently they are carved.

From an appraisal standpoint, the most inexpensive are smooth spherical beads, because they can be mass-produced and are sometimes finished by tumbling them in polishing barrels; many other shapes must be done by hand. Faceted beads are available from Germany, Japan, and India. The bead prices depend upon the accuracy of the faceting, with the best work being done in Germany. The most expensive beads are those made from the most expensive gemstones (rubies, sapphires, emeralds) and are partly or wholly carved and/or faceted.

Many necklaces of fine opal beads have come onto the market in the last few years. They are sold by the carat with prices ranging from an 18-inch strand of strong blue and green flash of 377 carats at ten dollars per carat wholesale, to a 16-inch strand of top color and red flash beads, 3mm to 6mm at sixty dollars per carat (for 57 beads) wholesale. With some materials, such as opal, emerald, and ruby, it is difficult to find beads of the same color and flawlessness. The larger beads of more costly material are more difficult to match and therefore more expensive.

Beads made from materials available in abundance, such as tigereye, quartz, lapis lazuli, and malachite, are more easily matched and are less expensive, because supply is sufficient to meet the demand.

Many types of chalcedonic quartz are dyed to imitate more costly gemstones, especially lapis lazuli and turquoise. The lapis imitations are sometimes called *Swiss lapis* or *Italian lapis*. Always check lapis beads for signs of dye. If you suspect the beads have been dyed inform your client immediately and get permission before you test. A quick and simple test is performed with a cotton swab dipped in fingernail polish remover. If the swab shows blue coloring after dabbing at a bead hole, the material is dyed.

Problems deciding whether or not you have genuine lapis or its substitute sodalite can be resolved with the hydrochloric acid test. Carefully place one drop of the acid in an unobstrusive spot on the bead. Genuine lapis will immediately emit the odor of rotten eggs. Wipe this spot off quickly; if left too long, the acid will erode the finish of the lapis.

When judging the quality of the beads and bead necklaces and writing them up on the appraisal report, observe and list the following:

1. Type and quality of the material.
2. Workmanship. Are the beads round or faceted? If they are faceted, square, or octagonal, are the planes flat with uniform polish? If they are round, do they have any flat spots? Grade them as you would a cabochon for round beads and a faceted stone for faceted beads. List their measurements in millimeters.
3. Closeness of the match in the material which has patterns and color variations. Note if the strand is uniform or graduated in size.
4. Note the accuracy of the bead sizes in uniform strands and the accuracy of the smooth taper in graduated-size beads.
5. Quality of the drilling. Are all the holes drilled exactly through the center of the bead? Beads inaccurately drilled do not hang well; this is immediately noticeable when the necklace is worn. Drill holes that were not finished smoothly and correctly around the edges may also rub against the cord and cause the necklace to break.
6. Is the strand knotted?
7. If other materials are used with the beads (gold spacers, etc.), note type and fineness of metal.
8. Note the polish on the beads. Is it bright and even?
9. Finally, note the strand length and clasp.

Also record the number of beads on the strand and list any phenomena such as *adularescence*, the floating, billowing blue to white light the stone may exhibit when turned. The formula for computing bead weight, accurate within 2 percent of actual material weight, is:

$$\text{Diameter}^3 \times \text{S.G.} \times .00259 = \text{Carat weight.}$$

Rare and Collector Gems

The pricing of rare gemstones is little understood. Although the value of any gemstone is determined largely by its color, clarity, carat size, cut, and historical desirability, the basis for pricing rare stones has a twist—the degree of rarity dominates all other factors. Since a large and continuing market demand cannot be met, a systematic tracking of the market and market value is not possible. In this situation, every transaction is a one-of-a-kind deal.

The price of rare gemstones is determined by what the seller thinks the market will bear at the time of sale; the price is usually set by comparing known sales of similar material. If no such sales exist, and if there is not much similarity between the stone in question and the closest comparable recent sale, the price is set and subject to negotiation. As appraiser, you should make an effort to acquire data through reading, attending gem shows and sales, canvasing rare stone dealers, and even building your own collection of rare stones, even if the collection must be very small at first. Collectors and dealers of rare stones are a closely knit group of individuals; unless you can join the group of collectors, you may find it difficult to get price information upon which you can rely.

Availability as a criterion for value is very important. You may have customers with gemstones of such rarity that virtually no established price guidelines exist, because not enough of the particular stones are traded. Some stones are so rare that they are of interest only to collectors who may pay very high prices. These stones must be valued on an individual basis, using the actual price paid by the customer as the best indication of market value; this, in effect, sets the price and the value.

Is Bigger Better?

Appraisers should be aware that a huge stone is not automatically more valuable if no commercial demand for it exists. In theory, as the size of the stone increases, so does the price per carat—all other factors being equal—but this is true only to a point. In other words: How big is too big?

If a stone is suitable only for museum display, and its main asset is sheer volume (which gives the stone its color), the appraiser must use the "highest and best use" approach to value. For gems and jewelry appraisers, the concept of "highest and best use" is the reasonable and most probable use that will support the highest present value of the item. This is further defined as the most physically possible use; legally permissible use; financially feasible use; and the most productive use. The appraisal report should include proof that no other use for the item can produce greater benefit, and must also contain a complete identification of the property. In all FMV cases, the appraiser must explain on the report how the current state of the market relates to the highest and best use; how the size and rarity of the material relates to value; and the general and current supply and demand. For example, the appraiser must be able to prove that an existing doorstop-sized gemstone is attractive and rare enough to find a home in a museum, and address the issue of whether a museum can be found that would accept it.

There is a danger of misusing the word "highest" to mean either the biggest in size or the highest in quality. There is a point at which gemstone size actually lowers the value. For example, a study by the American Gem Market System has shown on a correlated weight-and-price chart that aquamarines become less marketable and drop in price as they increase in size. At approximately the 10 carat size, a small percentage drops off the current price per carat; when the stone reaches the 60 carat size and larger, it is worth about half the current price per carat.

Two Are Better than One

Would a pair of matched stones be priced higher than a single stone? Yes and no. A lot depends on the kind of material as well as the quality match of the stones and their size. This is a research and judgment call. Obviously, a pair of carnelian cabochon-cut stones in a pair of earrings would not command a higher price than normal because carnelians are common and not much in demand. A pair of chrysoberyl cat's-eye stones (matched in quality and size) would bring a premium. A price list of faceted rare gems is given in table 4-3.

Synthetic Gemstones

If your clients plead that their stones cannot be synthetic because they belonged to their grandmother, tell them that even the ancient Egyptians developed artificial gems, and that these played an exalted role in those days. In fact, lists of precious materials from that time show imitation lapis lazuli prized above gold and used to pay tribute to the Pharaohs. The thought that the stone was not natural was trivial compared to its beauty.

Who puts the value on synthetic gemstones and why do some man-made stones soar in price while others drop in value? The most stably priced synthetics are luxury synthetics: Ramaura rubies, Chatham-Created emeralds, sapphires, and rubies, Kashan ru-

Table 4-3. Price List of Rare Faceted Gems*

Stone	Size**	Shape	Carat Weight	Price
Sphalerite yellow/brown	12.8 × 7.8	Octagon	6.60	$247.10
Cuprite	9.7 × 7.2	Oval	3.89	182.05
Wulfenite blue	3 × 2.7	Octagon	.23	32.29
Apophyllite	9 × 5.3	Octagon	1.11	135.06
Chrysoberyl	9.8 × 6	Octagon	2.20	133.85
Rhodochrosite	13.2 × 7.2	Pear	2.96	249.35
Cuprite	20 × 15	Oval	20.28	1,370.30
Labradorite	7.5 × 5	Rectangle	1.03	217.50
Spinel rose	8 × 4.5	Oval	1.48	658.24
Moldavite	22.5 × 7	Oval	18.69	296.00
Rhodochrosite	16.4 × 8	Oval	5.81	869.00
Fluorite rose	15 × 12	Antique Cushion	10.55	371.36
Phosphophyllite green	6.8 × 5	Oval	.61	295.50
Scapolite purple	9 × 6	Pear	1.14	120.00
Beryl red	7.5 × 3	Rectangle	.40	360.00
Benitoite	6.5 × 5.7	Pear	1.10	660.00
Boleite	3.6 × 3.4	Rectangle	.47	112.00
Senarmontit	2.3 × 2.8	Emerald	.20	60.00
Phenakite	7.1 × 6	Cushion	1.14	150.00
Cassiterite	4.1 × 2.5	Rectangle	.41	54.00
Herderite	3.8 × 3.5	Freeform	.14	45.00
Prehnite	12.8 × 10.5	Emerald	6.99	245.00

* This price list was based on a single source (a Midwest dealer of rare stones), and is provided only for comparison purposes.

** In millimeters.

bies, and Gilson opals. How will the appraiser value these? By recognizing that all synthetics are not created equal. Much of the value has to do with the manufacturing process. Melt-grown and pulled crystals are simple and fast methods used to create products quickly. Because technology and labor are less significant factors in developing these stones, they are very inexpensive, wholesaling from thirty cents to two dollars per cut carat. On the other hand, flux-fusion and hydrothermally grown stones require a slow growth process that imitates the natural growth and takes up to a year. In addition, vast amounts of electric power are needed to maintain their special growing environment and only expensive platinum crucibles can be used as growth chambers. Luxury synthetics are therefore costly due to high production cost and high risk.

The rational procedure for the appraiser seeking value on synthetic gems is to use the cost approach, first identifying the synthetic generically (that is, flux-fusion, hydrothermal, and so on) and then grading the stone. All synthetics have quality grades. Master grading stones are available from the manufacturers of synthetic materials.

Tables 4-4 and 4-5 provide keystone price lists of stones from J. O. Crystal Company; table 4-6 provides keystone prices from Chatham Created Gems; table 4-7 provides keystone prices for Kashan Created rubies; and table 4-8 gives keystone prices for Gilson Synthetics. Table 4-9 provides a chronological guide to the development of synthetic gemstones, including the various processes and manufacturers. Table 4-10 lists the common identifying characteristics of synthetic stones.

Table 4-4. Ramaura Ruby, J. O. Crystal Company, Keystone List of Prices per Carat

Carat Size	Gem Grade	Fine	A	B
.16–0.85	$330	$220	$180	$100
.86–1.50	360	250	200	100
1.51–1.99	380	280	230	100
2.00–2.99	420	300	240	100
3.00–3.99	460	360	290	150
4.00–4.99	480	400	320	150
5.00–5.99	530	420	340	150
6.00–6.99	560	440	350	150
7.00–7.99	630	460	370	150

Gem: Free of inclusions.
Fine: Slight inclusions.
A: Moderate inclusions.
B: Included; table clean.

Table 4-5. Regency Created Emeralds; J. O. Crystal Company, Keystone Price List per Carat

Carat Size	Gem Quality	Fine Quality	A Quality and Cabochons
0.12–0.85	$330	$200	$130
0.86–1.50	360	230	130
1.51–1.99	380	260	150
2.00–2.99	420	280	170
3.00–3.99	460	330	210
4.00–4.99	480	370	240
5.00–5.99	530	380	250
6.00–6.99	550	400	260
7.00–7.99	620	430	280
8.00–8.99	720	440	290

Table 4-7. Kashan Created Rubies

Carat Size	Grade	Faceted	Cabochon (per carat)
1.00 up	4A	$400	$150
1.00 up	3A	$300	$120
1.00 up	2A	$200	$80
1.00 up	1A	$150	$50–60
Below 1C	4A	$300	
Below 1C	3A	$250	
Below 1C	2A	$150	
Below 1C	1A	$120	

Table 4-6. Chatham Created Gems; Keystone Price List per Carat for Emeralds, Ruby, Blue Sapphire, and Padparadscha

Carat Size	Gem Quality	Fine Quality	A	B
.12–1.50	$430	$290	$160	$90
1.51–1.99	480	350	190	90
2.00–2.99	530	380	210	90
3.00–3.99	580	450	260	90
4.00–4.99	600	500	300	90
5.00–5.99	660	520	320	90
6.00–6.99	690	550	330	90
7.00–7.99	780	580	350	90
8.00–8.99	900	600	370	90

Cabochons, A quality in all sizes, $160.00 (keystone) per carat. Gemstone identification kits are available from Chatham Created Gems, 210 Post St., San Francisco, CA 94108.

Table 4-8. Gilson Synthetic Emeralds

Carat Size	Grade	Keystone per Carat
Up to 4 Carats	3-Star	$360
Over 4 Carats	3-Star	Specially Priced
Up to 4 Carats	4-Star	$440
Over 4 Carats	4-Star	Specially Priced

Table 4-9. Chronology of Synthetic Gemstones

Date	Gemstone	Process	Manufacturer	Reference
Chrysoberyl				
1970s	ALEXANDRITE	Flux	Kyocera (Inamori)	N.80,246
1973	ALEXANDRITE	Flux	Creative Crystals	N.80,246; E.79,145
1979p	CHRYSOBERYL Cat's-eye	Floating Zone	NIRIM	JGSJ.80,3
1982	ALEXANDRITE	Floating Zone	Suwa Seikosha	G&G.84,60
Corundum				
1885	RUBY	Melt	Geneva	N.80,42
1891p	RUBY	Flux	Fremy & Verneuil	F.1891
1905	RUBY	Verneuil	Verneuil	N.80,27
1910	SAPPHIRE	Verneuil	Baikovsky	N.80,66
1918	RUBY	Czochralski	Union Carbide	N.80,87;E.79.52
1947	STAR CORUNDUM	Verneuil	Linde	N.80,75
1957*	RUBY	Flux	Chatham	C.Pers.Com.,85 L.J.1959
1958	RUBY	Hydrothermal	Bell	E.70,53

Table 4-9 continued.

Date	Gemstone	Process	Manufacturer	Reference
1969	RUBY	Flux	Brown (Kashan)	E.79,81; JofG.85,469
1971	CORUNDUM	EFG	Tyco Laboratories	E79,55;N.80,90
1974	BLUE SAPPHIRE	Flux	Chatham	C.Pers.Com.,85
1974	CORUNDUM	Czochralski	Kyocera	T.Pers.Com.,85
1980	PADPARADSCHA SAPPHIRE	Flux	Chatham	C.Pers.Com.,85; G&G.82,140
1980	RUBY	Flux	Knischka	Zts.80,155
1981	RUBY	Flux	Ramaura	O.Pers.Com.85; G&G.83,130
1983	CORUNDUM	Flux Overgrowth on Verneuil seed	Lechleitner	Zts.83,207
1983	CORUNDUM	Floating Zone (ruby, pinkish orange, blue)	Suwa Seikosha	G&G.84,60
1984	STAR RUBY	Verneuil	Kyocera	T.Pers.Com.,85

Diamond

Date	Gemstone	Process	Manufacturer	Reference
1955	DIAMOND	High Pressure	Bell	N.80,173 or 186
(1985)	DIAMOND	Low PT	Va Poly Tech	Nature85No6025 220
(1905)	DIAMOND	Low PT	Burton	Nature85No6025 220

Diamond Simulants

Date	Gemstone	Process	Manufacturer	Reference
1948	RUTILE	Verneuil	National Lead; Union Carbide	N.80,211
1955	STRON. TITANATE	Verneuil	National Lead Co.	N.80,213-17
1960	GARNET—YAG & GGG	Flux	Bell	N.80,249
1968	GARNET—YAG	Czochralski	Bell	N.80,223
1975	GARNET—GGG	Czochralski	Bell	N.80,345
1976	CUBIC ZIRCONIA	Skull Melting	Aleksandrov et al.	N.80,232

Emerald

Date	Gemstone	Process	Manufacturer	Reference
1938	EMERALD	Flux	Chatham	C.Pers.Com.,85
1960	EMERALD	Hydrothermal	Leichleitner	N.80,149
1961	EMERALD	Hydrothermal	Linde	S.81,297; JofG.65,427
1963	EMERALD	Flux	Gilson	S.81,297
1964	EMERALD	Hydrothermal	Linde	N.80,150 S.81,297
1979	EMERALD	Hydrothermal	USSR	G&G.85,79
1979	EMERALD	Flux	USSR	G&G.85,79
1980	EMERALD	Flux	Lens Lens	JofG.80,73
1981	EMERALD	Flux	Seiko	RJ.4/19/84,16
1981	EMERALD	Hydrothermal	Regency (Linde)	LJ.79,Cover
1985	EMERALD	Hydrothermal	Biron	AG.82,344; G&G.Fall,85

Quartz

Date	Gemstone	Process	Manufacturer	Reference
1950	QUARTZ	Hydrothermal	Bell; Clevite Corp.	N.80,102
1974	CITRINE	Hydrothermal	USSR	N.80,116; G&G.79,227
1975	AMETHYST	Hydrothermal	USSR	N.80,117; G&G.79,227
1975	AMETRINE	Hydrothermal	Sawyer Research	N.Pers.Com.,85

Table 4-9 continued.

Date	Gemstone	Process	Manufacturer	Reference
Spinel				
1910	SPINEL	Verneuil	Paris	N.80,210
1969p	SPINEL	Flux	White & Wood	E.79,54
Other Gem Materials				
1972	TURQUOISE	Ceramic	Gilson	N.80,262
1974	OPAL	Multi-Step Settling	Gilson	N.80,258
1976	LAPIS	Ceramic	Gilson	N.80,264; G&G.79,227
1977	OPAL—Essence Glass	Precipitate	Slocum	N.80,276; G&G.79,227
1978	CORAL—Imitation	Ceramic	Gilson	N.80,276; G&G.79,227
1984	JADEITE	High Pressure	General Electric	G&G.84,244
1984	OPAL—Imitation-F	Multi-Step Settling	Gilson	JofG.84,43

Abbreviations for Reference List

AG	= *Australian Gemmologist*	JofG	= *Journal of Gemmology*
C	= Tom Chatham, personal communication, 1985	LJ	= *Lapidary Journal*
CI	= *Chemistry and Industry*	N	= Kurt Nassau, *Gems Made By Man*, 1980
E	= Dennis Elwell, *Man-Made Gemstones*, 1979	Nature	= *Nature*
F	= Edmond Fremy, *Syntheses du Rubis*, 1891	NIRIM	= National Institute of Research in Inorganic Materials
G&G	= *Gems & Gemology*	O	= Judith Osmer, personal communication, 1985
G&S	= *Gold und Silber*	RJ	= *Retail Jeweller*
J	= Gary Johnson, personal communication, 1985	S	= John Sinkankas, *Emerald & Other Beryls*, 1981
JCG	= *Journal of Crystal Growth*	T	= Ken Takada, personal communication, 1985
JGSJ	= *Journal of the Gemmological Society of Japan*	Zts	= *Zeitschrift der Deutschen Gemmologischen Gesellschaft*

Dates

Date = appeared in quantity on market.

(Date) = Experimental work produced results.

p = date reported by publication.

*More than 30 different processes for flux growth developed for research purposes.

Compiled by Dona Dirlam, Research Librarian GIA.

Table 4-10. The ABCs of Synthetic Stone Detection*

Stone	Maker	Method	Common Identifying Characteristics
Alexandrite	Creative Crystals (Concord, Calif.)	Flux	Strong short-wave red fluorescence, platinum crystals; flux inclusions; color change: bluish-green to reddish-purple, sometimes dissimilar to natural stones
	Inamori (Kyocera, Japan)	Not disclosed	Very clean and therefore suspect; strong short-wave red fluorescence; color change: blue-green to purple, dissimilar to most natural stones
Amethyst	Russian; Japanese	Hydrothermal	Possible seed plate; "bread crumb" inclusions; possible liquid inclusions resembling fingerprints; all other properties the same as natural, thus making this material extremely difficult to detect. Note: the Russians also make synthetic citrine

Table 4-10 continued.

Stone	Maker	Method	Common Identifying Characteristics
Emerald	Chatham (San Francisco, Calif.) Gilson (Geneva, Switzerland)	Flux	Low refractive index; long-wave red fluorescence; flux fingerprints and other inclusions; wispy veils
	Regency	Hydrothermal	Low refractive index; long-wave red fluorescence; hydrothermal inclusions; seed plate; 2-phase "nail-head" inclusions perpendicular to seed plate
	Biron (Western Australia)	Hydrothermal	Refractive index closer to natural; no long-wave red fluorescence; hydrothermal inclusions; seed plate
	Lechleitner Distributed through (Idar Oberstein, W. Germany)	Hydrothermal	Synthetic emerald overgrown on faceted natural colorless beryl; crazing between natural and synthetic layers of the material; faint long-wave red fluorescence
Garnet YAG (yttrium aluminum garnet)		Czochralski	Not true synthetic garnet since natural garnets are silicates; colorless variety used as diamond imitation; see-through effect; refractive index: 1.83
GGG (Gadolinium gallium garnet)			Used as a diamond imitation; high specific gravity (7.02); low hardness (7); see-through effect; refractive index: 1.97
Lapis lazuli	Gilson (Geneva, Switzerland)	Ceramics	Specific gravity is lower than natural stone; material is more porous than natural
Opal	Gilson (Geneva, Switzerland)	Precipitation	Not truly a synthetic; magnification reveals "chicken wire" or "lincoln log" structure absent in natural
Ruby		Flame fusion (Verneuil)	Curved striae; gas bubbles; strong red fluorescence
	Kashan (Austin, Tex.)	Flux	"Rain"; flux fingerprints; "Comet tail" inclusions; parallel growth layers that meet at an angle but do not intersect; fractures and healed fractures
	Chatham (San Francisco, Calif.)	Flux	Residual flux; platinum crystals; growth and color zoning; transparent, near colorless crystals, sometimes with rounded corners; strong short-wave red fluorescence
	Inamori (Kyocera, Japan)	Czochralski (suspected)	Phantom smoke wisps under oblique fiber optic lighting; very strong short-wave red fluorescence
	Ramaura (Redondo Beach, Calif.)	Flux	Residual unmelted flux, often appearing as sulphur-yellow globules; flux fingerprints ranging from flat to wispy; growth and color zoning

Table 4-10 continued.

Stone	Maker	Method	Common Identifying Characteristics
	Knischka (Steyr, Austria)	Flux	Dense, white cloud-like areas; irregular color zoning; distinct 2-phase inclusions; flux inclusions, including platinum crystals; spherical and elongated gas bubbles; some cut stones with original natural ruby seed may contain natural inclusions
Sapphire Blue; fancy colors		Flame fusion (Verneuil)	Short-wave chalky blue fluorescence; Plato test with crossed polaroid filters reveals strain within stone; curved striae and gas bubbles (difficult to see in pink and orange stones)
"Alexandrite"		Flame fusion	This synthetic color-change corundum is commonly mistaken for alexandrite; strong short-wave red fluorescence; color change: bluish-purple to purple, totally dissimilar to natural alexandrite; curved striae; gas bubbles
Linde Star Sapphire	Union Carbide (Danbury, Conn.)	Flame fusion	"L" trademark on back of cabochon; curved striae; gas bubbles; star: too straight, too good to be true; under 40-60x magnification: needles that comprise star are not distinctly visible, as opposed to those in natural stones; short-wave chalky blue fluorescence
Pink, orange "padparadscha"	Inamori (Kyocera, Japan)	Czochralski (suspected)	Very strong short-wave red fluorescence: phantom smoke wisps under oblique fiber optic lighting
Pink	Kashan (Austin, Tex.)	Flux	See ruby, "Kashan"
Spinel		Flame fusion	Not truly a synthetic; usually very distinctive fluorescence; cross-hatch anomalous double refraction in the polariscope; refractive index: 1.73 (higher than natural spinel); sometimes made into triplets using green cement to look like emeralds (these stones are easily identified with spectroscope)
Turquoise	Gilson (Geneva, Switzerland)	Ceramics	No iron line in spectroscope; "tapioca" effect under high magnification

* Reprinted courtesy Modern Jeweler and GIA's New York Gem Trade Lab.

JEWELRY FROM ANTIQUITY TO THE MODERN ERA

A piece of fine antique jewelry is not only an ornament; it is art. It tells a story and offers a glimpse into the life-styles of people who lived a long time ago. For the appraiser to interpret the significance and place values on antique jewelry requires connoisseurship in the cultures, social customs, and fashions of the era.

Values seem to be constantly rising for items in this field due, in part, to high collector demand, which is generally greater than the supply. The public mania for buying antique and estate jewelry was vividly demonstrated in the April 1987 sale of the Duchess of Windsor's jewels by Sotheby's in Geneva, Switzerland. Bids came from twenty-three countries, and this was the biggest jewelry auction in history. The auction was originally estimated to bring in 7 million dollars and the final figure was 45 million, not including a 10 percent buyer's fee.

For the appraisers who are challenged by this area of jewelry, some basic requirements include an exhaustive knowledge of the materials used in antiquity to determine if their use was technically possible at the time proposed for a subject item, and of the preference during any given era for a particular kind of jewelry, design, motif, or gemstone.

Jewelry Antiquities

There is a fascinating category of jewelry so obscure and specialized that obtaining any value information is difficult to impossible. The class is called jewelry antiquities. Hand-wrought, sometimes wondrously detailed fragments of other civilizations, these ancient gems and jewelry treasures are most often seen in museums—protected from the light, elements, and the public in glass display cases. There is a small collector's market for jewelry antiquities, and various pieces are auctioned with some regularity in New York and in Europe. Putting a value on these objects can be one of the most challenging and frustrating jobs ever undertaken by the appraiser.

To begin with, you cannot assume that all you must do is canvas museums and ask curators for price ranges. Most museums will not allow their staff members to quote values. Even during the "heirloom" or "discovery" days when the public brings items into the museum, the articles are only identified and dated, not valued. In fact, on a recent tour of the Asian Arts Museum in San Francisco, the appraisers in the group were warned by the leader of the tour not to embarrass themselves or the curator by asking the specific worth of any of the display items. Somebody did anyway, but the curator gracefully circled the question and stepped over to another exhibit.

To the appraiser, the question of value is legitimate; there should be guides that allow the worth of an object to be estimated, regardless of its age or historical importance. Over the period of a year, correspondence was sent to twenty-five museum curators and antiquities collectors requesting guidelines in assessing the value of ancient jewelry. From all parts of the world, the reply was strikingly similar: "Almost impossible to answer." Most museums declined to answer; some attempted to convey their own convoluted formulas; and a few individuals gave considerable attention to the questions and returned some reasonable, thoughtful, and practical answers.

René Brus, noted goldsmith, jewelry historian, and collector from the Netherlands, said that value depends partly on who the collector is. For Western collectors, Early European jewelry and items from the Middle Ages will be much more desirable than jew-

elry from Far Eastern and Asian countries, whereas Asian collectors search for objects from their own civilizations. When asked about royal jewelry, Brus said,

Coronation objects are so rare, and in some countries so sacred, that almost none will be for sale and therefore no value can be fixed to them. I do know that the small crown of Empress Eugenie of France was valued by one of the leading auction houses for five million dollars, which was far beyond the value of the materials, which were gold, diamonds and emeralds.

From London, antiquities expert Richard Digby explains:

[In] valuing medieval pieces, we must first start with the appearance, and then the quality of manufacture including design and the gems that are used. Also, a lot of early jewelry has ancient Roman or Greek cameos, intaglios, and other carvings, which in themselves can be valuable, so to value a piece for insurance is very much an educated guess. Moreover, if the item can be worn without being damaged or recognized by ordinary people as being ancient and possibly very valuable, this helps make the item expensive, because it doesn't look valuable.

Alfred M. Brown, a glyptic arts collector from California, has this to add:

The monetary value of such things is rather arbitrary, depending mostly upon who has what and who wants it badly enough to pay for it. I have friends who have private collections of gems and seals and they are as savvy as any of the dealers. The false inflation of prices [in this field] has been brought about by unscrupulous dealers who will buy anything regardless of the price or quality. Who can say such masterpieces as an engraved scaraboid by Epimenes is worth X amount of dollars without knowing the market? More often than not, we are talking about a few carats of chalcedony, not infrequently of inferior quality or condition, engraved with obscure figures, letters, or symbols. Curiosity or treasure, investment or work of art—it all depends upon the personalities involved, the times and the place.

In short, supply and demand, authentication, and knowledge of the marketplace are essential factors in appraising jewelry antiquities. This is confirmed by a former California museum curator:

Values for jewelry antiquities are established by the current market. The market is made up of private collectors and museums. Prices may vary greatly due to a number of factors: the rarity of the object in relation to others known of its kind; how long it has been on the market; the materials used in its fabrication; and the quality of craftsmanship.

At last! A curator has committed to value factors that we can write down on paper, understand, and follow. A former staff member of the J. Paul Getty Museum in Malibu, California, was also willing to assist in researching market data sources by offering the following suggestions:

The museum curator can provide the names of individuals who make it their business to buy and sell such material and assist the appraiser in determining the culture and historical period to which the piece belongs. This description is essential in the valuation process. Major auction houses, such as Sotheby's and Christies, include ancient jewelry in their special catalogs of antiquities art objects (ancient Near East, Egyptian, Greek, Roman, Byzantine, Medieval). Looking for comparatives in these catalogs is a good place to begin establishing current prices. Some dealers in the United States specialize in this sort of material and provide catalogs of their sales. Most of them advertise in specialized magazines such as *Connoisseur*, *Ornament*, and *Apollo*.

How can one prove the antiquity of a jewelry item? There is no lab analysis comparable to the Carbon-14 test used in archaeology. An ancient appearance can be deceptive: Corrosion of metals can be induced, as can accretions or patinas. Circa-dating these items is so difficult and requires so much specialized expertise that it is incumbent upon the appraiser to get as much help as possible. There is a lot of disagreement, even among experts in this field, on what constitutes proof of provenance, circa-dating, and identification.

There are fakes and forgeries in jewelry antiquities. Some date to the eighteenth and nineteenth centuries, when the archaeological style was in vogue, and some can be traced to the Renaissance. As one museum curator warned: "Assume that anything can be and is copied or forged, with or without the intent to deceive." This curator appended a very interesting postscript to her letter: "As investments, [jewelry antiquities] are the least secure of any jewelry objects."

Use the following guidelines in judging jewelry antiquities:

1. The current market prices (for comparable items)
2. The rarity of the object, in relation to others known of its kind
3. The length of time it has been on the market
4. The materials used in construction
5. The quality of the craftsmanship
6. The supply and demand for this type of article
7. The condition of the object

For this market, the *correlation analysis* technique is used to help establish value. Simply put, in this technique, the similarities and differences of the item being appraised are measured against any and all comparables. The appraiser contrasts and collates comparable items until enough of a parallel exists for the appraiser to make a value determination.

Antique Jewelry

Valuing antique jewelry scares some appraisers, but this aspect of jewelry valuation is neither sacrosanct nor impossible to learn. Intense study of the specialized markets, acquisition of detailed references, concentrated research, good judgment, and common sense are all that is required.

Most of the jewelry your clients will call antique will not really be antique items, which must be at least one hundred years old. The jewelry will likely fall into one of these three categories: heirloom, collectible, and old junk. However, you must be able to distinguish among the three groups and translate their characteristics into value.

A few excellent books on antique, vintage, and collectible jewelry, which include price guides, are listed in the *Using Price Guides* section of this chapter. Those wishing to acquire knowledge of this field in a more formal way can take a correspondence course, written by Jeanenne Bell and offered by the Indiana University School of Continuing Studies, called "The Appraisal of Antique and Period Jewelry."

In addition, you can get valuable hands-on experience by attending antique-jewelry seminars and trade shows. One three-day seminar devoted exclusively to the development of expertise in this field is held at the University of Maine at Orono every July. Sponsored by Dr. Joseph Sataloff, a collector of and writer/lecturer on antique jewelry, the event has brought dealers, curators, collectors, and others interested in the subject together for the last decade.

To identify and assess the value of antique items, complete the following steps:

1. Determine the materials and construction technique.
2. Learn the styles typical of the period and evaluate the item's artistic merit.
3. Learn the hallmarks or maker's marks.
4. Become familiar with the types of gemstones and cuts used during specific periods.
5. Determine the desirability of the item.
6. Establish the condition of the item.

Gaining expertise takes time. Reading the following brief reviews of period jewelry will not, of course, make the appraiser an expert in these specialized fields of study. Rather, the discussion is intended to pique the interest of appraisers who may have shunned these areas of valuation, and to provide an overview of the subject. The periods of style discussed in this next section include:

- Georgian 1714–1830
- Victorian 1837–1901
- Edwardian 1901–1914
- Arts and Crafts 1890–1914
- Art Nouveau 1895–1915
- Art Deco 1920–1930
- Retro 1940–1950

Georgian Jewelry: 1714–1830

Antique jewelry cannot be separated from the social and economic trends of its time. During the eighteenth century, British jewelry was greatly influenced by foreign fashion, particularly that of Italy and France. England's political power was increasing throughout the world, and the country was prosperous: A middle class sprung up for the first time in history; greater numbers of people became interested in travel and art; and jewelry was much in demand.

Georgian jewelry was almost entirely made by hand, and is distinguished by its craftsmanship. The art of faceting gemstones was being developed at this time, and diamonds with twenty-four to fifty-six facets are characteristic of this period. Finely engraved metal work, mostly of 18K gold, was common, and *cannetille*, an intricate wirework, was also very popular. Jewelry styles were almost exclusively of flowers, leaves, and other natural subjects, and diamond jewelry was often decorated with such motifs as sprays of foliage, feather plumes, leaves, ribbons, flowers, and birds. Convertible jewelry, such as bracelets that joined to form a necklace, or a stomacher that could be disassembled to become several

brooches and a pair of earrings, are also characteristic of the period. Georgian jewelry is also marked by *en tremblant* articles, which moved or trembled when worn, usually as hair ornaments. Necklaces from the early Georgian period were fitted with loops at either end to hold ribbons that were used to tie the necklace onto the wearer. Rings with stones set in silver with high-karat gold backings and gold shanks are also typical of the Georgian era. Most gems were set with closed backs. As the Georgian period progressed, engraved gemstones and intaglios became popular. And, during the last part of the eighteenth century, cabochon-cut gemstones were the rage.

Paste gemstones were common, and appraisers should be careful to verify the authenticity of all pink gemstones in Georgian jewelry. Developed in France, paste is a high-quality lead glass faceted and polished like a genuine gemstone. In 1766, a London craftsman named John Tassie came up with his own formula for making good-quality paste gemstones; some people still refer to these as *tassies*. Colored paste was a very popular substitute for such gemstones as ruby, emerald, sapphire, garnet, and pink topaz. Russian pink topaz was especially popular during this time, and pink glass was often used instead of the real thing. Paste opals were also manufactured, using colored foil to imitate the colors of opal. Figure 5-1 illustrates a late Georgian necklace in 18K gold with pink topaz and pearls.

From 1706 until about 1814, the ancient city of Pompeii was under excavation, and the discoveries made there captured the imagination of jewelry designers as well as of the public. Jewelry in the shape of rams' heads, pieces with mosaics of ancient temples, and other designs echoing the artifacts found at Pompeii became popular. Enamel jewelry was also stylish. An important clue to dating these pieces is that only the front of enamel jewelry made during the Georgian epoch was fired; the backs are either plain or engraved.

Victorian Jewelry: 1837–1901

The Victorian period began with Queen Victoria's accession to the throne and ended with her death in 1901. Victoria adored jewelry and her influence over the development of styles was felt for more than seventy years. There are three discernable phases within the Victorian epoch: the Romantic period, which lasted until 1860; the Grand period, which continued until 1885; and the Late Victorian period, which ended in 1901.

The changes in jewelry style that mark the three periods reflect the British Empire's increasing pros-

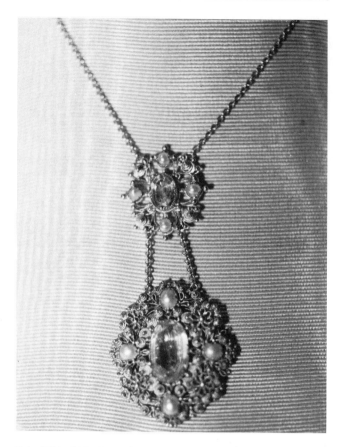

5-1. This 18K Georgian necklace is enhanced by fine cannetille wirework and set with genuine pink topaz and natural pearls. *(Photograph courtesy of Lynette Proler Antique Jewellers, Houston)*

perity and progress. However, there is no exact division separating one period from the next. Some styles continued to be popular in one region after the trend had faded in another area, and the styles tended to overlap. Appraisers should be aware that fully marked and stamped Victorian jewelry is rare, for the British government did not require jewelers to use markings during the nineteenth century. Firsthand knowledge and market research are necessary for the appraiser to be able to distinguish among jewelry of the different periods.

Romantic Period: 1837–1860

The fall of Napoleon and the inception of the Industrial Revolution set the stage for social change. More middle-class families were joining the professional class, and the taste in jewelry was toward naturalism and sentiment. As the necklace shown in figure 5-2 illustrates, jewelry love messages, often with natural themes, were taken seriously. Popular materials included jet, tortoise-shell, malachite, amber, agate, turquoise, and coral. Motifs were mostly stars,

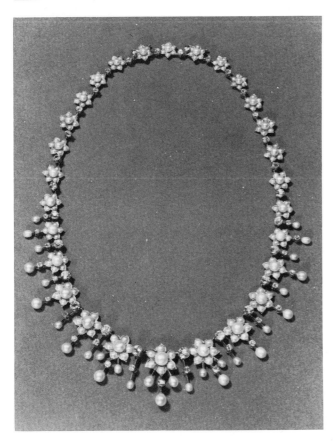

5-2. Romantic-era Victorian necklace, circa 1860, is of old mine-cut diamonds and natural pearls in 15K yellow gold. *(Photograph courtesy of Lynette Proler Antique Jewellers, Houston)*

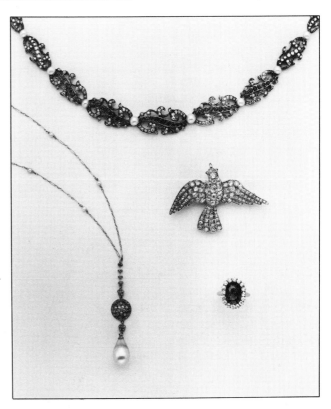

5-3. Jewelry from the Grand Victorian period. *Left:* Natural pearl and diamond pendant with rose-cut diamonds, platinum chain 18 inches long. *Top:* Gold and silver scroll-link necklace 16 inches long with pearls, demantoid garnets, and old European-cut diamonds. *Center:* Gold and silver brooch in bird motif, set with one hundred and eight old mine-cut diamonds. *Right:* Late Victorian 18K gold ring with alexandrite and sixteen old European-cut diamonds. Gemstone weight, 4½ carats. *(Photograph © 1986 Sotheby's, Inc.)*

crosses, bursts of garnets, twigs, leaves, and branches. Around 1840, delicate seed-pearl jewelry came into vogue, and studying flower lore was fashionable.

Grand Period: 1860–1885

Archaeology affected jewelry design, especially the neo-Etruscan style that dominated jewelry fashion for many years. This jewelry was primarily the work of the Castellani family of Rome, and was shown in England in 1862 at the International Exhibition. The style, characterized by little gemsetting, high standards of goldsmithing, and small areas of enamelling, set a trend.

During this phase of Victorian jewelry, black glass began to be used as a substitute for jet, and the terms became interchanged. The most popular motifs were horses, dogs, birds, insects, horseshoes, and snakes (fig. 5-3).

From the jewelry of this era you may find items of bloomed gold, a type of matte finish produced by acid treatment. The gold discolors easily, so the trend was short-lived. Lava and hardstone cameos as well as in-

taglios, with elaborate beadwork mountings and intricate metal decoration, were in style.

Gloria Lieberman, head of the antique jewelry department at Skinner Auction House in Boston, advises appraisers to consider whether the Victorian jewelry under appraisal can be worn in public today. If the answer is yes, then the piece has increased value.

Late Victorian Period: 1885–1901

There was a great difference between the commercial and aesthetic styles popular during this time. With the opening of the great diamond mines, diamonds became more widely available and were all the rage. At the same time, novelty jewelry—the reverse painted crystals—holiday souvenirs, hair jewelry, miniature portraits, and mourning jewelry were popular. Other jewelry items common in the Late Victorian period include stickpins, bar brooches, narrow

bangles, open bangles, and star-shaped settings for gemstones. Popular gemstones were cabochon-cut moonstones, amethysts, opals, and emeralds.

There are some important maker's marks found on jewelry from the Victorian era. ACC and CC are both marks used by Fortunato Pio Castellani and his son, Alessandro Castellani. The CC is interlaced and back to back. Carlo and Arthur Giuliano used C & AG as their mark; Giacinto Melillo, an apprentice of Giuliano, signed his work GM. John Brogden's work is signed JB.

Edwardian Jewelry: 1901–1914

The Edwardian era was the short but sweet period before the beginning of World War I. Lavishness and ostentation mark the jewelry of this style. In 1903, the marquise-cut diamond was popular and the *lavalier*, a small, delicately styled pendant necklace, usually set with one or more gemstones and/or pearls, came into vogue along with the lighter, softer, post-Victorian clothing that was being worn. Platinum became the metal of choice, and jewelers were fashioning delicate patterns using the saw-piercing method of construction that distinguishes jewelry made between 1909 and 1914. Typical of the decoration is *milgraining*, a line of globular projections of metal applied by a tool around a setting holding a gem, or around the outer edges of a jewelry article (fig. 5-4).

Women wore their hair in the fashionable pompadour, decorating this hairstyle with diamond combs and *fourches*, large, tortoise-shell hairpins. Tiaras and large brooches were also in demand.

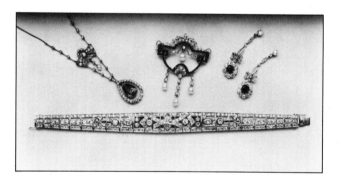

5-4. *Top left:* French Edwardian-era lavalier with violet pear-shaped sapphire and Oriental pearls set in platinum and milgrain bezel set with diamond. *Top center:* French brooch circa 1900–1925 with Oriental pearls and sapphires set in platinum. *Top right:* Late Victorian English pendant-style earrings of old European-cut and rose-cut diamonds with drop and bow platinum settings. *Bottom:* Platinum and diamond bracelet of very high quality. Total weight approximately 9 carats. (*Photograph courtesy of Lynette Proler Antique Jewellers, Houston*)

One of the favorite motifs of the era was the bow, but instead of being formal it was a relaxed, casual motif. King Edward, for whom the era is named, was married to one of the great beauties of the day, Alexandra. Because green stones were Edward's favorite, the demantoid garnet is seen in much of the jewelry of the time; Alexandra favored the amethyst, which was also used extensively in jewelry.

Arts and Crafts: 1890–1914

The Arts and Crafts movement was a brief period of revolt by artisans and craftspersons against mechanization. The academic backlash originated in England, where craftspersons organized around the principle that all jewelry should be made by hand. The movement was doomed because of the expense involved in the labor of handmade jewelry and because Arts and Crafts jewelry was never popular with the majority of the public.

A leading jeweler craftsman of the time was Charles Robert Ashbee. His mark turns up in jewelry of this period from time to time as CRA GOH Ltd. Other craftspersons whose marks you may find include Nelson and Edith Dawson (ND in an ivy leaf); Arthur Gaskin (AJG); Edgar Simpson (name in a circle); and Liberty & Co. (LY & Co. in a triple diamond).

Silver was the metal of choice. The most popular gemstones were turquoise, moonstone, fire opal, amethyst, and peridot. Most gemstones were cabochon cut and bezel set. The appraiser should use caution in judging this work because there is a tendency to overvalue handmade items. High standards of judgment should continue to be used, including assessing the quality of the materials and work.

Art Nouveau: 1895–1915

The Art Nouveau movement in art, architecture, and design began in the latter years of Queen Victoria's reign and lasted until World War I. Some of the jewelry motifs common in this era were popular both before and after Art Nouveau. The jewelry of the period followed three schools of design: new art, craft, and traditional. Each influenced the others and melded into some beautiful and unforgettable works. Sinuous lines are characteristic of this style, as is the use of natural images: motifs of graceful insects, maidens with long flowing tresses, sunbursts, crescents rendered in wavy whiplash curves, lizards, and snakes (figs. 5-5, 5-6, 5-7). Art Nouveau borrowed heavily from Japanese work, which was widely admired.

Nontraditional materials such as horn and glass were used in jewelry during this period, and designers mixed valuable gems with inexpensive ones, such

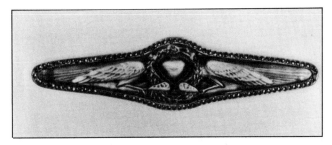

5-5. Rare Art Nouveau brooch signed by René Lalique. *(Photograph courtesy of Charterhouse & Co.)*

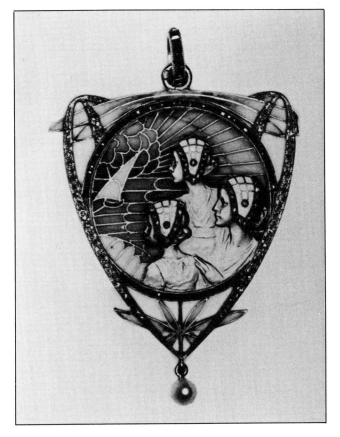

5-6. Pliqué-à-jour enamel and diamond brooch by Masriera. *(Photograph courtesy of Charterhouse & Co.)*

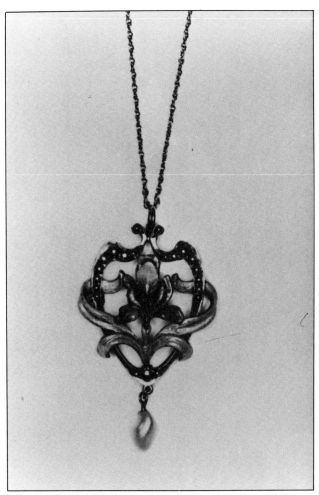

5-7. Enamel and seed-pearl pendant. *(Photograph courtesy of Charterhouse & Co.)*

as ivory with horn. Amber, garnet, and agate were used for lower-priced jewelry and silver jewelry was in demand. Enamel-work techniques were of special interest to designers, especially translucent plique-à-jour enamel, which was used to create the popular stained-glass effect (fig. 5-8). Jewelry took on an iridescent finish and dreamlike design fantasies were produced.

Cultured pearls made their first appearance in long necklaces and chokers during this era. Platinum jewelry became popular and settings were often chased or engraved. Although most of the fine work of the period was made by hand, it became more common

to incorporate machine-made parts into jewelry as the century ended.

One of the most widely heralded goldsmiths of this era was Peter Carl Fabergé, court jeweler to the last czars of Russia. His legendary work was conducted until 1918. Be cautious about attributing jewelry to Fabergé or to his workshop unless you can authenticate the works positively. The Fabergé signature is shown in figure 5-9.

Art Deco: 1914–1935

Art Deco is the style of jewelry that predominated between the two World Wars. It was named after the great Paris Exhibition of 1925, *L'Exposition Internationale des Arts Décoratifs et Industriels Modernes.*

Art Deco is a bold, geometric style that emerged as a reaction against the pale color and fluid lines of the Art Nouveau period. The look is a straight, clean line with the curve of the previous period's jewelry replaced by the angle. Art Deco jewelers borrowed heavily from Asian, Islamic, Indian, African, and

5-8. The 18K diamond and pearl Art Nouveau pendant is decorated with pliqué-à-jour enamel and is in its original fitted box. *(Photograph courtesy of Lynette Proler Antique Jewellers, Houston)*

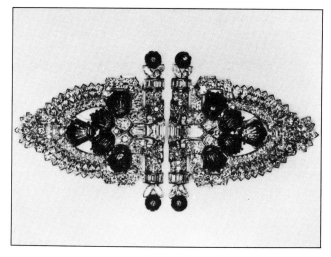

5-10. Art Deco ruby and diamond clips, circa 1925. *(Photograph courtesy of Charterhouse & Co.)*

ФАБЕРЖЕ

5-9. The Fabergé signature.

Egyptian motifs. The opening of King Tutankhamen's tomb in 1922 instituted a strong Egyptian trend in jewelry.

Art Deco jewelry was dramatic, bold, brassy, and exciting. The jewelry was finely crafted—even the costume pieces. Of particular note are platinum diamond clips (used in pairs), brooches, and jabot pins, which featured diamonds, sapphires, rubies, and emeralds in one piece of jewelry (figs. 5-10 and 5-11). Colorful and eclectic, these creations have become known as "fruit salad jewelry" in collector circles. Appraisers will find long, dangling jade earrings, straight-line bracelets (many with synthetic gemstones), carved emeralds, and lapel watches for both men and women to be representative of the era's jewelry. The jeweled "cocktail" wristwatch also became fashionable.

The principal theme during the period was move-

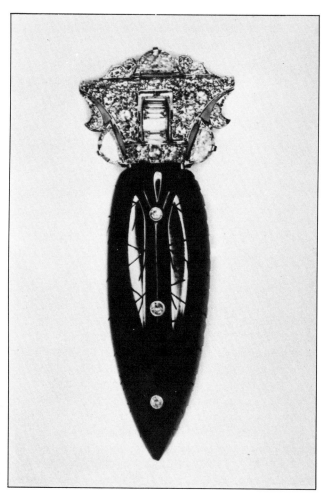

5-11. Art Deco diamond and onyx leaf brooch signed by Fougery. *(Photograph courtesy of Charterhouse & Co.)*

ment. Common jewelry motifs include airplanes, cars, trains, ocean liners, and running greyhounds.

Along with the precious jewelry came a surge in the use of nonprecious, less expensive stones and materials, such as coral, onyx, and enamel. For the first time, costume jewelry became as important as fine jewelry and man-made materials were widely used. In 1908, a Belgian-American chemist, Leo Hendrik Baekeland, created a plastic intended for electrical installation purposes. He named it *Bakelite* and promoted it as "the material of a thousand uses." Bakelite molded nicely into bangle bracelets resembling ivory or wood and, by the early 1920s, an eclectic jewelry collection in horse, bird, small-animal, and fruit motifs was being produced from the polymer material.

Bakelite jewelry was popular from the 1920s through the early 1940s. Costume-jewelry designers used it for everything—from bangle bracelets to brightly colored jewelry ornaments shaped like animals, vegetables, and insects. Bangles were very popular and are among the most often found articles today. The colors of Bakelite jewelry are incredible—bright, cheerful, and bizarre yellows, reds, oranges, and greens. Polka-dot patterns and stripes predominated, and pastel-colored Bakelite is rare.

Bakelike jewelry has enjoyed a resurrection in the 1980s, and is now often priced at a hundred times its original cost, which ranged from a few cents to a few dollars.

The carved pieces of Bakelite jewelry generally will show some unpolished tool marks in the recesses of the item, while the new molded jewelry remains glossy all over and exhibits mold seams. Intricate floral and geometric motifs are common to the old Bakelite jewelry items, but the new plastics rarely have such a degree of craftsmanship.

In valuing fine Art Deco jewelry, look for the following factors:

1. Maker's name. Important jewelry pieces are always signed, as are important paintings and sculptures. The most famous and prolific jewelry designer of the Art Deco period was Louis Cartier; other distinguished designers and jewelry houses of the period include Van Cleef & Arpels, Mauboussin, Boucheron, Fouquet, Dusausoy, Chaumet, Sandoz, Marchak, and LaCloche (fig. 5-12).

2. Quality. Workmanship and materials play a significant role in determining value. Top designers always used first-class materials.

3. Condition. Check for damage and for signs of repair, such as fresh soldering, as well as for replacement or substitute materials.

4. Overall design. Not all pieces by the same designer are of the same caliber. Learn to distinguish

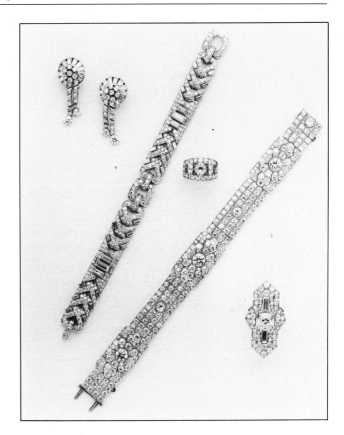

5-12. *Top left:* Trabert & Hoeffer, Mauboussin, platinum and diamond ear clips, circa 1930. Total weight, 4½ carats. *Center:* Platinum and diamond bracelet, circa 1930. Total weight, 12 carats. *Center right:* Diamond and sapphire platinum ring, circa 1920. Total weight of diamond, 2.2 carats. *Right:* Bracelet by J. E. Caldwell & Co., circa 1930. Total weight of diamond, 29.5 carats. *Far right:* Cartier platinum and diamond ring, circa 1930. Total weight of diamond, 5½ carats. *(Photograph © 1986 Sotheby's, Inc.)*

good from fine, and fine from exceptional. The only way to gain this expertise is to do time-consuming research in this field, and to handle and examine as much of the jewelry as possible.

5. Motif. Floral-designed Art Deco jewelry is invariably of greater value than is jewelry with a geometric design.

Retro Jewelry: 1940–1950

As recently as 1970, jewelry from the 1940s and 1950s was being sold for scrap value. Trends change, and jewelry from this period has now become collectible. Spokespersons from major auction houses say that the price of this jewelry is on an upward climb and it is believed that the trend will not peak for several more years. Intrinsically, this jewelry is not as valuable as Art Deco jewelry, which featured detailed workmanship and the use of more precious stones.

The drama and distinctiveness of the designs account, in part, for the popularity of Retro jewelry. The pieces are bold, oversized, and called gaudy by some. An almost three-dimensional look—left over from the popular Cubist movement in art—identifies the style. Rose gold with a high polish is typical, as is the heavy use of aquamarine, ruby, and citrine (figs. 5-13 and 5-14). Classic Retro motifs include ballerinas, bows, and large link chains and rings with dramatic, scrolled shanks.

Post-Retro Jewelry

According to dealers who buy hundreds of lots of estate and antique jewelry yearly, the newest trend, jewelry from the 1950s and 1960s, is already underway. Dubbed "Atomic Moderne" by some and "early Harry Winston" by others, the jewelry style is characterized by a multitude of diamond-and-platinum rings and brooches designed in a waterfall motif, as well as the popular irradiated diamond cluster pieces.

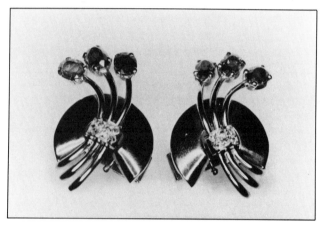

5-13. Retro modern gold ear clips with diamonds and multicolored stones. *(Photograph courtesy of Charterhouse & Co.)*

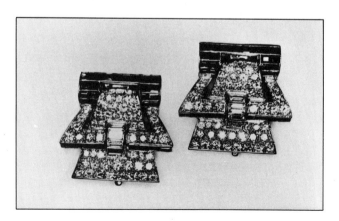

5-14. Retro modern ear clips. Mixtures of aquamarine, topaz, amethyst, and ruby were common in Retro jewelry. *(Photograph courtesy of Charterhouse & Co.)*

Consider that the furniture, pop-culture relics, and fashions from the 1950s and 1960s are enjoying renewed popularity and remember that jewelry follows fashion's lead.

To keep up with innovations in style, appraisers should be aware of what art and craft galleries and museums are exhibiting, and start now to build a reference library of jewelry styles, motifs, prices, and manufacturers of the era, while material is still readily available.

Examining and Evaluating Period Jewelry

After you have circa-dated an item of antique jewelry to your satisfaction, follow these standards toward making final evaluation:

1. Examine the item under magnification and note any apparent wear, repairs, materials, construction, and design on your worksheet.

2. Acid-test the metal. Do not accept the markings at face value and remember that the karat fineness helps suggest a date of manufacture. (See the *Chronological Guide to Dating Period Jewelry* in this chapter.)

3. Note hallmarks, maker's marks, or touchmarks. Either draw them on your worksheet or photograph them if you have a macro lens on your camera.

4. Identify any gemstones, noting whether they are "right" for the period. Replacement stones lower the value of the piece.

5. Determine the weights of stones and note their quality.

6. Examine the workmanship again and make sure that the item is not a "married" piece of jewelry (two items of jewelry made into one).

7. Consider whether you can be sure it is not a reproduction. Carefully inspect the back of the item for important clues that signal reproduction, such as porosity or a wrinkled look in the metal. Both indicate the item was cast, typical of reproduction jewelry.

8. Check the findings and clasps. Are they "right" for the period? Have they been repaired or replaced? A pin back or earring wire dating from another period will reduce the value of the item by two-thirds. Figure 5-15 illustrates the findings commonly found in various antique and vintage jewelry. For example, pin backs vary during different periods; safety catches did not appear until 1910; and hinges can be significant—the earliest type of hinge consisted of three small pieces of tubing.

9. Does the item have enamel? If so, is the enamel in good condition?

10. Is it a micromosaic? If so, it is complete with no pieces missing?

11. If item is part of a set, are all the pieces present?

12. Should it be a pair of something? During the

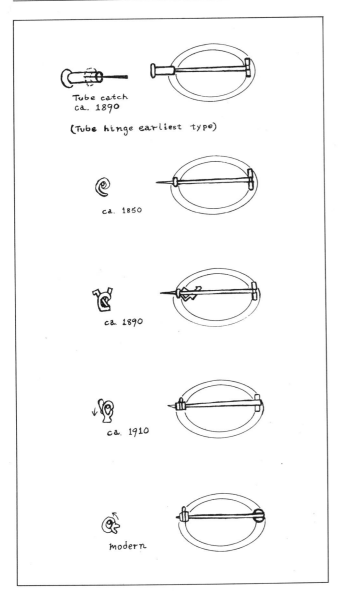

Tube catch
ca. 1890

(Tube hinge earliest type)

ca. 1850

ca. 1890

ca. 1910

modern

5-15. Findings commonly used on antique and vintage jewelry.

Victorian era, women commonly wore bracelets in pairs. A pair is more valuable than one; ditto earrings. Breaking up a set can destroy one-half to one-third of its value.

13. Are the prongs or bezel settings smooth? If they are rough or catch clothing or skin, they may have been changed.

14. Look at the chains. Are they smooth and supple when you run them through your fingers? Stiff chains signal section repairs. Also, inspect the links for wear, especially near the clasp; a worn-out chain is worth only intrinsic value. Look at the clasp; an original will frequently be hallmarked, which will give a higher value than a replaced one.

15. Are there any solder repairs? The presence of lead solder on antique jewelry reduces the value of the piece by 50 percent. Heat can destroy patina and cause irreparable damage to foil, cameos, and jet jewelry.

16. Do you have the original fitted box? This can add 20 percent to an item's value.

17. Look at the stones. Stones in a nineteenth-century piece will be well cut; those in a sixteenth-century piece will not. Modern stones such as tanzanite will not be found in antique jewelry, unless the original stone has been replaced. Jewelry made before 1900 should have natural pearls; Mikimoto was sending cultured pearls into the marketplace by the turn of the century and even won a medal for a pearl exhibition at the 1904 St. Louis Exposition.

18. Look at the safety chain. Victorian bracelets had a safety chain with a safety-pin attachment. Other antique bracelets had a small hook on the safety chain and no spring ring. Poorly soldered, especially lead-soldered, safety catches can reduce value up to 50 percent.

Alterations made to original articles are common. Pins or clips have often been turned into pendants. Look for the joining of two sections from different periods. As an appraiser, you are accustomed to judging quality in jewelry; use the same trained eye to detect changes such as these mentioned.

If the antique jewelry under appraisal needs repairs, advise your client that it takes a highly skilled specialist to do the job. Electric soldering is the best repair method. Enamel cannot be heated, and foiled stones will be charred and ruined by a sloppy repair job, which can devalue an item by as much as two-thirds.

When writing up the report, note any embellishment found on antique jewelry items, since any engraving on the item can add to or detract from the value, depending on the purpose of the report. For instance, if a bangle bracelet is apraised for insurance-replacement purposes, add the cost of any engraving and/or message inside the bracelet. If, however, the item was appraised at fair market value, the engraving would decrease the item's value. No one else would want a bracelet with this exact name or message.

Antique jewelry is correctly valued in relation to a comparable: the market-data approach. The cost of replacing the article with a comparable one may be higher or lower than the cost of remaking the item, but you cannot use the cost approach technique to appraise antique jewelry accurately. In addition to using comparables for replacement values, the appraiser needs a good current knowledge of supply and demand of like items within the appraiser's market region. This information can be collected only

through personal research among antique jewelry dealers in the appraiser's local area. However, you should remember that almost all appraisers tend to *overprice* antique jewelry.

Provenance

Provenance is one of the most compelling reasons for your client to enter the world of antique jewelry collecting. Even before the great auction boom of the late 1970s, historic jewelry brought historical prices. Christie's auctioned two pearl-and-diamond earrings in Geneva in 1969. Although the quality of the pearls and the design were not especially noteworthy, the proof that the earrings were three hundred and fifty years old and once belonged to Henrietta Maria—daughter of Henry IV of France and Marie de Medici; sister of Louis XII; and wife of Charles I of England—attracted hordes of collectors, dealers, and museum directors. Three portraits, by Van der Helst, Netscher, and Voet, exist in which Henrietta Maria can be seen wearing the earrings.

If the client has any documentation of authenticity, or letters from previous owners claiming a pedigree on a piece of jewelry, append these to the appraisal report.

Telling a Reproduction from a Genuine Antique

Is it old or merely a reproduction? The answer has become tougher to resolve in the last few years because many companies are reproducing antique jewelry. Furthermore, once these items have been in the market for a few years, their genesis becomes even harder to determine. The field of antique jewelry reproduction has existed for centuries, with copies ranging from highly sophisticated works of skilled craftsmen to mass-produced examples that do not have the correct appearance of age, quality of design, or workmanship. Over the centuries, various techniques have been surreptitiously used to "age" jewelry. One method is to immerse gold metals in a weak acid or lye solution to impart an aged look; gemstones have been purposely chipped or scratched with emery or sand to give them the appearance of many years of use.

Some suggestions for distinguishing between the genuine article and reproduction jewelry include the following:

1. Use a good loupe and a strong light source.
2. Look for porosity (surface pits and bubbles), which denote that the item was made from a mold—a common method of mass-producing reproductions.
3. Note whether the prongs or shanks of rings show

wear. Look at the links and clasps on bracelets and necklaces for signs of wear.
4. Reproduction jewelry, when new, has the fresh tone of new gold while antique jewelry has a slightly warm tone consonant with the patina of gold antiquities.
5. A cast reproduction item will not have the finely detailed decoration or engraving of old jewelry as ornamentation will have been molded in with the casting.
6. Leftover pieces of gold from the casting procedure can often be found in the corners and edges of reproduction jewelry.

If you cannot tell for certain, get a second opinion from a knowledgeable colleague. Recognizing the limits of your knowledge and getting help when needed will keep you out of trouble.

Quality Factors of Enameled Jewelry

When writing your report on enameled jewelry, note the type—translucent or opaque—in your description. Color and technique are also important and can affect value.

The common enamelling techniques are *cloisonné, champlevé, basse-taillé, plique-à-jour, taille d'épargne, niello, grisaille,* and *guilloché.* Two other techniques encountered rarely are *en résille* and Limoges. *En résille* is a base glass or rock crystal upon which fine, hairlike lines are incised to form the design. The pattern is lined with gold, and the cells filled with soft, low-fire opaque or translucent enamel. Limoges enamelling is done without the aid of separate cells. Enamel is applied all over the metallic (usually copper) surface, one layer nearly drying before the next one is applied; the entire surface is then fused in one firing.

Note whether the enamel has strong and pure color and if care has been shown in the selection of the color combination. Mention whether the design is cleanly and clearly carried out and whether the metalwork is cleanly executed and free from excess solder or other evidence of careless workmanship. Note the polish; it should be a high luster. Fire-polished items can be recognized by the lack of a truly flat surface and betray an inferior piece. Mechanical polishing produces a comparatively flat and beautiful surface.

A few clues to age: If an enameled item purported to be Art Nouveau has concave cloisons, be suspicious. The enamel in the cloisons of old pieces is absolutely level. Furthermore, in old Italian and Portuguese pieces, each block of enamel in the cloisons is shaded in color; in newer items there is no shading.

Chronological Guide to Identifying Period Jewelry

1798: 18K gold standard introduced in English jewelry.

Before 1800s: The backs of stones in jewelry were closed because tools had not yet been developed for the proper faceting of stones. As cutting tools became available, the backs on stone settings began to be opened.

1835: First class rings (West Point).

1840: Gold electroplating process developed. The majority of necklaces had closures in front.

1854: 9, 12, and 15K gold jewelry introduced in England.

1868: Demantoid garnets discovered.

1870: Kidney wires first used in earrings. (These are still in use today.) Long chains and long pendants with no plain surfaces were common. All surfaces were ornately chased or engraved with trivial all-over designs. Novelty jewelry includes birds, flowers, insects, moths, butterflies, and heads of females.

1880: Small stud and pearl earrings and choker necklaces popular.

1885: The first ruby synthetics came into use. Diamonds were used on nearly all articles.

1860–1880: Dangling, neo-Etruscan–style earrings in vogue.

1890: Threaded stud earrings in style. Although still used today, they are smaller in diameter and the nut is lighter weight. Platinum first used in jewelry at this time. Platinum was first discovered in the fourteenth century, but a torch hot enough to work the metal comfortably was not developed until the 1890s.

1890–1915: Gold and platinum often used in the same item.

1880–1900: Colored golds popular: pink, yellow, and green gold combined in the same item.

1900: First cultured pearls appear in jewelry.

1903: Kunzite discovered by Dr. George Frederick Kunz in California.

1903: Marquise-cut diamonds and baguettes came into vogue.

1906: Law passed in U.S. that gold content must be stamped in jewelry.

1909: Screw-back earrings developed.

1910: First synthetic sapphires and spinels came into use.

1912: White gold developed.

1920s: "Invisible" settings popularized.

1938: Emerald synthetics developed by Chatham.

1940: Clip-back earrings in style (still used today).

Using Price Guides

There is a line from a song in the Broadway musical *The Music Man* about selling to the public: "You've got to know the territory." That applies to valuing antique jewelry, too.

You must know your own regional markets, as well as the national and—ideally—international markets of supply and demand. Price guides for antique jewelry should be used *only* as guides, not as fully accurate prices. Both Sotheby's and Christie's conduct auctions several times a year, and issue illustrated catalogs with realized prices.

Consult the following for identification and value guidance: *Official Price Guide to Antique Jewelry*, by Arthur Guy Kaplan; *Answers to Questions about Old Jewelry*, by Jeanenne Bell; *The Price Guide to Jewellery*, by Michael Poynder; *Antique Jewellery and Watch Values*, by Diana Scarisbrick; and *Sotheby's International Price Guide*, edited by John L. Marion. These five books are listed in the bibliography.

Cameos

Cameos are one of civilization's oldest art forms. Engraved gems—cameos and intaglios—evolved from the development of seals about 6500 B.C. in Mesopotamia, where they were used to authorize documents, seal goods, trademark, and tax products.

Egyptians wore scarab seals around their necks with their signature on the underside of the scarab. The Romans, however, are responsible for bringing cameos into their finest and most prolific epoch. They introduced designs of family portraits, erotic fantasies, animals, and gods. With the decline of the Roman Empire, the cameo's popularity also fell, and not until the Middle Ages were engraved gems revived as popular talismans.

During the fourteenth century, cameos and intaglios were revered and the Medici family and other collectors made the importance of the gem soar. When banded agate was discovered in Germany in the sixteenth century, cameo production increased substantially and popularity continued until well into the early Victorian period, when Queen Victoria herself became an ardent shell cameo collector. The Italians, already exceptional carvers, were ready for the craze with mass production of locally available shells.

The word *cameo* literally means "raised above." This carving in relief is executed in a variety of shells and hardstones, coral, lava, glass, and jet.

Today, cameo production is carried out chiefly in Italy and Japan. The Italian cameos are generally found in coral, shell, and hardstones such as onyx and chalcedony. Many cameos are still crafted by hand, but automation has crept into the industry and

ultrasonically carved cameos are now being mass produced. In Japan, most cameos for jewelry are machine-carved from Brazilian agate. One machine can produce five pieces in one day, while it takes three or four days to carve one piece by hand.

The Japanese are manufacturing well-defined hardstone cameos for pendants, brooches, earrings, rings, cuff links, buckles, and clasps for string ties. Prices for cameos set in mountings range from two hundred and forty dollars to four hundred dollars wholesale; unset cameos sell for one hundred to two hundred and fifty dollars wholesale, with the smallest sizes for rings priced at approximately fifteen dollars.

Some exceptionally finely cut cameos are being imported into the United States from Idar-Oberstein, West Germany. These pieces can be distinguished from the machine-carved counterparts easily because their finish is better and details finer. A few of the German carvers, including the notable Erwin Pauly, sign their work, which enhances the value of the gemstone. German cameos are produced in a variety of hardstone materials by a body of master carvers who turn out truly artistic work. By special commission, lifelike portraits such as the one pictured in figures 5-16 and 5-17 are being created. These pieces cost about two hundred and fifty to nine hundred dollars wholesale.

Although there are slightly different rules for judging antique and contemporary cameos, all are examined under 10x magnification with a strong light to expose any cracks or breaks in the material. Since gemstone carving is an art form, it must be evaluated as one by judging composition, proportion, subject, detailing, finishing, and craftsmanship. Appraisers can use the following guide to estimate value of contemporary carved cameos:

1. Material. Identify the material used in the cameo and remember that hardstone is more valuable than shell. Examine the material to determine if the piece has been dyed or color enhanced. Is the cameo hand carved or machine made? Is it one piece or a composite?

2. Detail. Study the engraving. The composition, subject, and quality of craftsmanship should combine to point up the artistic quality of the cameo. Hair should have a hairlike texture; skin should look like skin.

3. Signature. On finer pieces, the artist's signature is almost always applied either to the front or the back. The signature may be prominently and boldly displayed or hidden in clothing folds or locks of hair.

If you are unsure of your ability to judge the artistic merits of cameos, remember that the finest workmanship is generally used on top-quality material by the most experienced engravers. Careful study of mu-

5-16. The owner and model of the cameo shown in figure 5-17. (*Photograph courtesy of Timeless Gem Designs*)

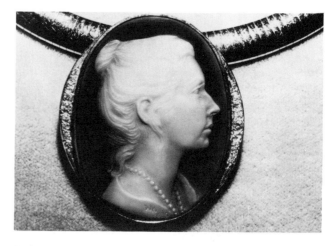

5-17. This strikingly accurate chalcedony cameo portrait of the owner illustrates the quality of craftsmanship achieved by German master cameo carvers. (*Photograph courtesy of Timeless Gem Designs*)

seum collections for comparison of craftsmanship and materials will enhance your ability to judge quality.

German master carver Gerhard Becker has some firsthand knowledge about judging cameo quality: "In most cases craftsmanship is more important than the material used," he insists. "A fine craftsman can turn any rock into an art object, while an unexperienced carver may destroy the finest material. Carving quartz," he said, "is more difficult than carving agate, while lapis lazuli, topaz and corundum all require separate techniques."

Explaining further, Becker said an agate cameo carved in a layered flat-relief technique, such as the one shown in figure 5-18, is a much more difficult exercise than carving a cameo from thick layered material. He also stressed the importance of the surface finish and proportion of the carved motif to the stone as combining factors that point out the carver's expertise. The handsome cameos shown in figure 5-19 are fine examples of the cameo engraver's artistic abilities. In appraising antique cameos, all of the rules for appraising contemporary cameos apply as well as the three following:

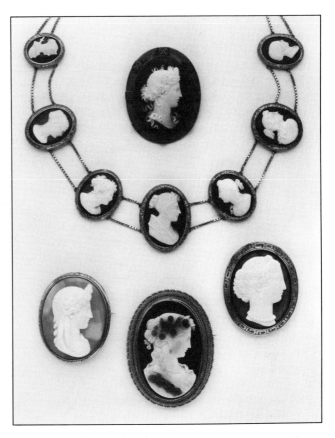

5-19. *Top center:* Gold and hardstone sardonyx brooch from the mid nineteenth century. The gold frame is embellished with small square panels decorated with foliate motifs in blue-black enamel. *Center:* Mid-nineteenth-century necklace composed of seven oval-shaped black-and-white agate cameos. All set in frames carved with foliage and joined *en esclavage* by double box-link chain of later date, approximately 15 inches long. *Bottom center:* Sardonyx cameo brooch with rope-twist frame. *Bottom left:* Beige and white hardstone cameo brooch in gold frame engraved with scrollwork. *Bottom right:* Mid-nineteenth-century gray-and-white agate cameo brooch within gold frame decorated with key fret motif. *(Photograph © 1986 Sotheby's, Inc.)*

1. Depth of carving. Deeply carved cameos are desirable and more valuable than shallowly carved ones. Lava particularly lends itself to this rare, fine, deep detailing. Examine the cameo for wear because this may indicate its age.

2. Period of origin. Examine the design theme as a possible clue to its time of production. Remember, provenance adds value.

3. Subject. The subject or subjects may add value. Scenes, full-face and full-length figures, carvings of men and children, and identifiable portraits are all less common and thus more valuable.

When researching the price of antique cameos, consider current comparable item prices from antique dealers along with auction prices.

5-18. This three-layer carved agate shows the mastery of German cameo detailing. *(Photograph courtesy of Gerhard Becker)*

Class Rings, Fraternal Jewelry, and Religious Jewelry

Class Rings

Class rings made their debut in 1835 when the cadets of the U.S. Military Academy at West Point began wearing heavy gold signet class rings. The rings displayed a school insignia and the motto, "Danger Brings Forth Friendship," as well as the graduation date. They were made to individual order and, as the story is told, one cadet set a pebble from West Point's old parade ground as a stone in his class ring. In the West Point class of 1837, the eight-dollar gold class ring was especially noteworthy because of the intaglio carnelian gemstone used. Later, other colleges, high schools, and West Point graduating classes agreed upon uniform rings struck from a standard die. The all-metal signet style ring was also changed to a purely ornamental gemstone-set ring.

Class rings then remained pretty much unchanged until the nonconformist period of the 1960s and 1970s, when the military was scorned by so many young people and class rings changed dramatically. The uniform ring passed out of style and manufacturers started offering a variety of styles to the graduates. Fashion rings—a smaller, thinner class ring—have surged in popularity since they were first introduced in the mid 1970s. However, the traditional heavier ring is still sought by many teens, especially boys who insist on the traditional style with square stone.

Class rings are made in a variety of metals: 10K, 14K, and 18K gold; stainless steel; celestrium; trillium; yellow aurora; and white lustrium—all nonprecious metals. Major manufacturers of class rings are: ArtCarved Class Rings, Inc.; Balfour; Gold Lance Corporation; Jostens, Inc.; and R. John Ltd. Their average retail price for a high school ring starts at about sixty dollars and escalates to over four hundred dollars for a college ring.

Price guides for replacements can be obtained from many class-ring manufacturers, and they should be consulted on a per-item basis. Each one has slightly different charges and options.

Class rings and military-service rings are judged and valued according to the following standards:
1. Metal, fineness, and weight.
2. Identity and quality of gemstones, if any.
3. Optional features. These are important since they increase the costs. Optional features include enamelling, custom-made theme side panels, special gemstones, pierced shanks, and inscriptions. Options are numerous and at customer request, special dies can be made, which increase the price further.

Service Awards

In a separate but related category are service awards and corporate-incentive jewelry awards. Recognition jewelry is produced by all the manufacturers listed above, as well as such others as Bulova Watch and Seiko Time Corporation. These awards are sold through jewelers to businesses. Jewelry given your client as a sales incentive, service award, honor award, or retirement gift is often of precious metal and set with gemstones. For an appraisal, the item is handled as is any other fine jewelry; however, when figuring replacement price, consultation with the manufacturer or jeweler selling the item is highly recommended. Special dies, design, or handwork that add to the final price may have been used, and may not be readily apparent to the appraiser.

Fraternal Jewelry

The association ring is a symbol of the desire for mass companionship. Its use as a badge of fellowship has been going on for a very long time. You will find fraternal rings mentioned in the records of heraldry and ancient orders of knighthood, in which the ring played a stellar role as a symbol of membership. One of the first recorded accounts (quoted in Remington, 1945), refers to an English knight who was given a symbolic ring in A.D. 506. Rings have been used as heraldic emblems and in coats of arms throughout all kingdoms in Europe. In ancient days the ring was called an *amulet*.

Lodge and fraternal rings and pins are not so romantic today as in times past, but still symbolize people bound by religion, social, financial, or civic interest.

The following list, which is by no means comprehensive, is of major fraternal organizations and intended to be a useful starting point for appraisers seeking more information about such jewelry:

- The Loyal Order of Moose
- The Free and Accepted Masons
- The Benevolent and Protective Order of Elks
- The Knights of Malta
- The Knights of Pythias
- The Independent Order of Odd Fellows
- The Knights of the Maccabees
- The Improved Order of Red Men
- The Fraternal Order of Eagles
- The Woodmen of the World
- The Independent Order of Foresters
- The Knights of Columbus
- The Knights Templar of the United States and Canada
- The Royal Arcanum

- Phi Beta Kappa
- Alpha Delta Phi
- Alpha Sigma Phi
- Omega Delta
- Phi Gamma Delta

The rings for these organizations and their auxiliaries are varied in metal, manufacture, and style, but most are of gold. Many are set with diamonds and other precious stones or enameled in jewellike colors. Some vary according to membership within the association. The Freemasons have at least two dozen types of Masonic rings, each representing a different degree of the main organization.

As with the class-ring manufacturers, complete listings of those who deal exclusively in fraternal jewelry can be found in the *Jeweler's Circular-Keystone Directory*. Some manufacturers have easily identifiable lodge and fraternal symbols in their catalogs, so you can make accurate identification of the lodge jewelry you may be appraising. The following are determining factors in valuing fraternal jewelry:

1. Metal fineness, weight, and type.
2. Precious stones, enamelling, or other applied decoration.
3. Condition. Has the jewelry been repaired and if so is the enamelling damaged? Reenamelling an item requires removing all existing enamel, recutting the areas to be reenamelled, and then applying the new enamel—a costly process.
4. Special designs, artwork, or logo. Custom work requires special dies, and is therefore more expensive.

Religious Jewelry

Interest in religion is reflected in gold and silver jewelry: it might be called faith on a chain. Religious jewelry is popular and fashionable, particularly among young adults. A metropolitan newspaper, quoting recent results of a survey of Christian and Jewish religious gift shops, declared that religious jewelry is finding a great niche market. For one Texas jewelry manufacturer, James Avery, it has become a 17.5 million-dollar-a-year business. Avery is regarded as one of the foremost religious jewelry designers and producers in the United States. A staff of five hundred and fifty employees keeps the jewelry moving to consumers all over the world. The jewelry is stamped with his three-candle logo and JA. Prices range from ten dollars to two thousand dollars, with most items listed at less than one hundred dollars retail.

An appraiser needs to be familiar with the symbols used by all faiths and religions. With a working knowledge of the symbols and what they represent, you can interpret the religious jewelry and artifacts you may be called upon to value. These may include chalices, mezuzuhs, Hanukah lamps, menorahs, gem-set Torahs, gem-set croziers, scrolls, communion and ceremonial plates, Kiddush cups and beakers, crosses, rosaries, crucifixes, miraculous medals, seals and talismans, etc. Different styles of Christian crosses are illustrated in figures 5-20 and 5-21. Jewish symbols frequently used in jewelry and charms are identified in figure 5-22.

Judaica

The field of judaica is a discipline unto itself. The determining value factors for jewelry or religious items in this category are:

1. Age of the item. Eighteenth-century and earlier European silver is in demand and given a higher value.
2. Hallmarks.
3. Condition.
4. Size.
5. Provenance.

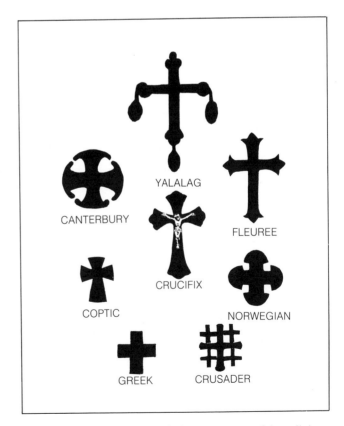

5-20. Various styles of Christian crosses used in religious jewelry.

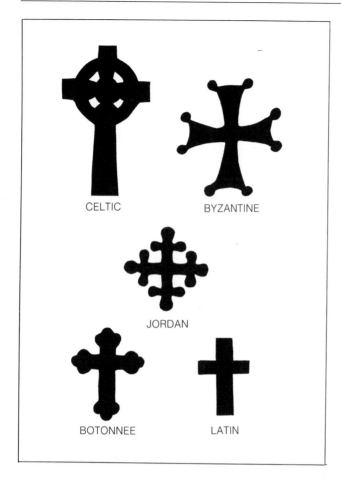

5-21. Further examples of Christian crosses used in religious jewelry.

5-22. Jewish symbols used in religious jewelry.

Many modern mass-produced Jewish jewelry items such as chais and mazel-tov charms are gem set. The items are valued in the normal way for precious metal content and gemstones. Chains should be weighed separately from the medals.

Comparable items of contemporary jewelry can be found in catalogs from manufacturers engaged almost exclusively in producing this jewelry. The annually updated *Jewelers' Circular-Keystone Directory* has complete listings of these manufacturers and their current addresses.

If an object of adoration such as a chalice, Torah, or icon falls to you for valuation, you can also conduct research in catalogs from the major auction houses. Companies handling religious goods, sacred vessels, and vestments also have catalogs. Pursuing catalog sources often leads to documentable replacement prices.

American Indian Jewelry

The commercial Indian jewelry craze began in the 1920s, when the Harvey House restaurant chain opened during the great days of rail travel in the United States. At first, Indian jewelry was simply sold as curios in the restaurants for patrons touring the west. Earrings and thin, small bracelets stamped with arrows and bows and containing oval pieces of turquoise were most in demand. Heavy Indian jewelry was not popular until about 1925, when the classic squash-blossom necklaces were first brought to the tourist market. The squash-blossom craze lasted until 1940, when they were discontinued by the Indian artisans for requiring too much work and too much turquoise.

In the 1920s and 1930s, the concho belt changed from a simple silver belt to a belt with turquoise stones not only in the buckle but also turquoise in the *butterfly*—the spacer between the conchos. The tourist jewelry of that era is highly collectible today.

In the years following World War II, many Americans traveled across the country and, on their trips to the Southwest and other areas inhabited by American Indians, discovered that "traders" had rooms full of the Indians' old personal jewelry, which the "traders" called "pawn pieces." Most of these are jewelry items the Indian people made for themselves and pawned for two reasons: they needed money, and it was a safe storage place.

As a result of the popularity of the pawn pieces, a host of "trading posts" sprang up in the Southwest. During this time, which extended to the early 1950s, turquoise was named, for sales purposes, after the mines in which it was found: Bisbee, Castle Dome, Nevada Green, and others. The names have become

so standardized over the years that they now have little to do with the mines or even the original color of the turquoise. For example, Bisbee turquoise originally had a brown matrix. The Bisbee that is mined today has no brown matrix, although the mine is still active; it has a high blue color. Today's turquoise is mostly treated with plastic bonding, chemical vapor penetration, paraffin, or some other stabilizing agent to help the material retain its bright color. Your clients may ask you about their turquoise items that have changed from blue to green over the years. You can reply that natural, untreated turquoise will *always* turn green after a few years owing to the porous nature of the material. There is nothing available to bring back the original blue color. It has been estimated that only about 25 percent of mined turquoise can be used without treating.

Although some American Indians continued to handcraft silver jewelry in the 1960s in the traditional way, their work was not widely popular until the late 1960s and early 1970s, when the craze for Indian jewelry reached such proportions that it makes Indian traders today yearn for the "good old days." As near as can be pinpointed, the craze for the jewelry started on the West Coast, when film stars began wearing turquoise and silver. The demand for the jewelry was so great that it was soon being produced in Mexico, Taiwan, and the Philippines. The market became glutted, and by 1981 the supply was high but the demand was gone.

Some good and fine artistic work has emerged from the era. A few of the exceptionally talented American Indian silversmiths used their profits to develop new concepts and techniques in American Indian jewelry design. The result is that now there are two kinds of jewelry for sale. The first category includes signed, hand-made silver and gold jewelry, often set with turquoise, lapis lazuli, and even diamonds. These are contemporary in design, unlike the original American Indian jewelry. The second category includes production-work Indian jewelry—Navajo, Hopi, and Zuni—which is characterized by new designs in silver and the use of more stones.

Navajo jewelry is distinguished by its simplicity and sparing use of turquoise or other stones. The Navajos are silversmiths. Their famous squash-blossom beads are not symbols of fertility—a romantic notion perpetuated by traders—but adaptations of Spanish ornaments, which were shaped like pomegranates. The dangling *najas*, crescent shapes, were also borrowed from the Spaniards, who in turn had adapted the shape from African charms used to ward off the evil eye.

The Zunis learned how to work silver from the Navajos, but their primary interest is lapidary. They are stonecutters and stoneworkers. In Zuni-designed jewelry, metal serves primarily as a support for colored stones. Designs are often so ornate that little silver is visible.

The Hopis used turquoise sparingly and their contribution to Indian jewelry and the most popular styles was developed after 1930. They use an overlay technique in which two sheets of silver are sweat-soldered together. The top or overlay has a cutout design, and the area directly beneath the design (on the bottom silver) is oxidized, creating a contrast between bright and dark silver. Traditional Hopi designs were drawn from pottery decoration.

The Santo Domingo Indians are known for making fine beads called *hishi*. Turquoise, clam, and other shells are drilled, strung together, and rolled over to produce smooth and round edges. This tribe also includes silver in their necklaces.

Elements in valuing old Indian jewelry include the following:

- Age
- Patina
- Workmanship
- Weight of the silver
- Quality of the stone, if any
- Classic design. The simplicity of design was one factor that made American Indian jewelry valuable to non-Indians.

Elements in valuing contemporary Indian jewelry include:

- Metal(s), fineness of metal(s), and weights
- Signature
- Quality
- Wearability. Some pieces are simply too large or heavy to be worn comfortably.

In your report, use the terms "like Zuni" or "like Navajo" to indicate style and design unless you can specifically classify the item by signature. Use correct nomenclature. The parts of a squash-blossom necklace are the beads, the trumpets (squash blossoms), and the *naja* (the U-shaped center dangle).

Some well-known signatures that increase the value of the jewelry include the following. *Navajo:* Francis James, Helen Long, Jimmy Bedoni, Mary Morgan, Lee Yazzie, Andy Kirk, Eddie Begay, Sam Begay, John Hoxie, and Leroy Hill. *Zuni:* Lambert Homer, Sherman Yuselu, Virgil Benn, Shirley Benn, Lucille Quam, Lon Jose, Kirk and Mary, Dennis Edaakie, Lee and Mary Weebothee. *Hopi:* Charles Loloma, Lawrence Saufkie, Victor Coochwytewa, and Duane Maktima (who is of both the Hopi and Laguna tribes).

Santo Domingo: Charles Lovato, Paul Rosetta, Harold Lovato, and Sedelio F. Lovato. Other signatures that you may see include David Tsikewa, Mary Tsikewa, Edna Leki, Veronica Nastacio, Larry Golsh, Charles Pratt, and Preston Monongye.

In the late 1970s, the price of Indian jewelry increased tenfold, according to Colonel Douglas Allard, only to drop dramatically some five years later. A bracelet that cost sixty dollars in 1968 cost six hundred dollars in 1978 and one hundred and fifty dollars in 1986. Large squash-blossom necklaces and fancy concho belts, selling for five thousand dollars in the 1970s sold for twelve hundred dollars each at auction in 1986. Most concho belts, squash-blossom, coral, and turquoise necklaces currently sell in the five hundred to twenty-five-hundred dollar retail range if they are signed items.

The 1930s thin silver bracelets stamped with arrows and similar motifs that originally sold for six to eight dollars each were worth sixty to one hundred dollars in 1986. They have become collectibles. These bracelets contain approximately two ounces of silver each and must be judged individually. In the 1950s, some commercial jewelry manufacturers began reproducing the Depression-era designs in nickel, silver, and plastic—beware of these reproductions; they are worth intrinsic value only. There is a lot of counterfeit American Indian jewelry still on the market. The Indian Arts and Crafts Association has attempted over the last several years to require labeling on foreign counterfeit American Indian–style goods. In 1985, more than two hundred American Indian artisans, backed by two Congressmen, filed a class-action request with the U.S. Customs requiring clear, indelible, and permanent labeling on the imitation jewelry. They would like all such imported items to be marked "imported." This, of course, would help appraisers assess the true value of this jewelry and determine whether it is genuine.

According to an *Albuquerque Tribune* article published on July 10, 1987, the Senate has passed an amendment designed to promote the export of Indian arts and crafts. The measure authorizes the Secretary of Commerce to make grants to pay for trade missions, promotional programs, surveys, and other market-development activities for Indian jewelry, art, and crafts. The Senate also passed a second amendment that would make it illegal to import counterfeit Indian jewelry, art, and crafts unless the imports are indelibly marked with the country of origin. As of this writing, the class-action request made to the U.S. Customs in 1985 is still pending.

For price guides of American Indian jewelry, see Sotheby's illustrated mixed-tribal auction catalogs. Indian items are also auctioned by Christie's, Butter-fields of San Francisco, Waddington's of Toronto, and Spinks of London. Up-to-date catalogs and price guides are mentioned in *American Indian Art Magazine*, 7314 E. Osborn Drive, Scottsdale, AZ 85251.

In addition, contact the following organizations:

- Sioux Indian Museum and Crafts Center, P.O. Box 1504, Rapid City, SD 57009.
- Southwestern Association on Indian Affairs, Indian Market, P.O. Box 1964, Santa Fe, NM 85704.
- Southern Plains Indian Museum and Crafts Center, P.O. Box 749, Anadarko, OK 73005.
- Indian Arts & Crafts Board, c/o U.S. Department of Interior, Room 4004, Washington, DC 20240.
- Indian Arts & Crafts Association, 4215 Lead S.E., Albuquerque, NM 87108.

Ethnic Jewelry

Each social culture has its own interpretations of fine jewelry, which may frequently be opposed to what Americans consider "fine." Appraisers often have complete collection and/or single items of ethnic jewelry to valuate as part of estates for probate, divorce, or insurance. How are these items handled and what criteria are used for value? Folk jewelry is an area in which the appraiser without experience in appraising jewelry of a particular culture, may place too high or low a value on the article.

Although it is not necessary for you to attempt to be an expert on jewelry from all cultures, the better informed and the more widely read you are, the more accurate your valuation will be. Build a reference library of books on ethnic jewelry as well as catalogs from major auction houses, museums, and rare-book dealers. Check the bibliographies of these reference works to find further sources of information.

In appraising ethnic jewelry, determine the following factors:

1. Culture of origin, such as Bedouin, Peruvian, Islamic, or Balinese, for example.
2. Purpose of the jewelry (other than decorative), if any.
3. Condition and age.
4. Material and fineness of metal if the piece contains metal. The material need not be a precious metal for the jewelry to be valuable in this category.
5. Craftsmanship and execution of design. The basic techniques of design are universal; only applications will differ. Recognize and list *repoussé*, *cloisonné*, embossing, and other techniques. These will often help to identify the country of origin.

6. Wearability of the item. Does the clasp work properly? Are there any broken or missing parts?
7. Provenance. Can it be authenticated?
8. Whether the item is a single piece or part of a collection.
9. Hallmarks, maker's marks, or other stampings.
10. Popularity of the item. Was it part of a fad or a trend? Trendy jewelry is almost always better made than fad items. The appraiser must be able to recognize particularly desirable objects.

It is important to be able to distinguish between the style of the jewelry and its actual country of origin. Many jewelry articles are produced in the style of another country or culture, and there are many reproductions of stylistic transitions. What the appraiser is concerned with are the actual items of jewelry produced in any particular country. Comparables in pricing Bedouin, Philippine, Moroccan, African, or other ethnic jewelry can be difficult to find. A creative approach is called for to obtain current prices and/or comparable item prices. The following market resources may be of help:

1. Catalogs, including those published by auction houses, museums, and various airports. In particular, try Sotheby's London catalogs, which cover jewelry from all cultures; catalogs published by the Metropolitan Museum of Art (New York), and the Smithsonian Institute; and catalogs from Saudi Arabian Airlines, Amsterdam Airport, and Shannon Airport. Also try the Spink & Son of London catalog of Islamic jewelry.

2. Popular magazines and trade journals, including *Smithsonian, Ornament, Connoisseur, Antique World,* and *Lapidary Journal,* under the headings "Finished Jewelry" and "Miscellaneous," for catalogs offered by dealers from Sri Lanka to Haiti, Mexico to Chile. Research your public library for other specialty publications.

3. Major metropolitan cities often have full-scale ethnic communities that can be fertile hunting grounds for the appraiser researching prices. Try ethnic church bazaars as well as crafts fairs. If there are no ethnic communities in your area, perhaps there is an import specialty store.

4. Trade/gems and mineral shows. Call foreign trade commissions and visit their trade shows as well to get the names and addresses of companies that publish catalogs. Art galleries, too, often have showings of jewelry as well as artwork from other cultures.

5. Retail and other stores. Don't overlook clothing boutiques that concentrate on foreign styles. They often hold trunk shows of jewelry, which are announced in local newspapers. Also, try canvassing local pawnshops for comparable items. If the jewelry you are appraising is trendy, try upscale department stores—they usually stock a few items in their "costume jewelry" department, where non-gold jewelry is sold.

Mexican Jewelry

If you believe all Mexican jewelry is made of heavy silver and decorated with Aztec motifs and green and black stones, you are wrong. That primitive style was developed for the tourist industry during the 1920s and has become the equivalent of American costume jewelry.

The contemporary silver and gold jewelry of major Mexican cities today is not very different from jewelry found in New York or Rome. The fine jewelry sold in the cities is international in scope and style and will offer few evaluation problems to the appraiser.

What may present a dilemma, however, is pricing the jewelry produced in small workshops all over Mexico and mostly made by hand. Such work is done with traditional and simple tools, ranging from crude silver work containing colored glass to finely wrought gold jewelry set with precious stones.

Mexicans are lovers of tradition. In many villages, ways of living have changed little over the generations. A woman may still wear the exact style of earrings her grandmother wore. These would be crafted by the village silversmith in the traditional designs the smith has used season after season. There are villages where the jewelry styles are the same as they were four hundred years ago. In Mexico, each village has its own style of decoration. Frequently the materials indigenous to the area and the primary means of earning will inspire the jewelry motifs, materials, and style used. For example, the village of Pátzcuaro is located on a lake and fishing is the main source of income. If you want the necklace with small silver fish that is famous in Pátzcuaro, you must go there, find the local artisan who makes the necklace, and buy it. Chances are he or she is the only one in Mexico who makes exactly that style.

Even more traditional are the earrings worn by the women in the six villages surrounding Pátzcuaro. Again, each village has its own design—and you can tell where a woman is from by the earrings she wears.

Mexico produces about a third of the world's silver and consequently has plenty of raw material to work. A large quantity of silver jewelry is still made today in and around the famous silver center of Taxco. Most Mexican silver items are stamped .925, sterling. These are required by law to be $^{925}/_{1000}$ parts silver. Some Mexican silver jewelry is stamped as high as .980 because many craftspersons like to make their own alloys. The beauty of .980 silver is that it has a soft patina and is resistant to tarnish.

Mexican jewelry is typically characterized by simple forms; naturalistic motifs, such as flowers, vines, birds, and butterflies; religious motifs; and movement. Most pieces have separate parts that move, such as bells, pendants on chains, or have fringe decoration, as on dangling earrings.

The artistic merits of much of the silver jewelry crafted in Taxco during the 1920s and 1930s has resulted in the development of a small but serious collector's market. The heavy cuff bracelets, highly stylized with swirling or geometric designs, are currently priced at several hundred dollars in the U.S. market. Suites of silver jewelry, hand made and without stones, can be found priced at a thousand dollars and up. These escalating prices are the result of a combination of intrinsic value, artistry, and maker's marks. Maker's marks, some of which are listed below, contribute significantly to the value of a particular item:

Maker's Name	Mark
Frederick Davis	F inside a D
William Spratling	W joined to an S
Antonio Castillo Jorge Castillo	Los Castillo Taxco, written in a circle around an eagle
Enrique Ledesma	Ledesma, written in two conjoined ovals
Antonio Pineda	Antonio Taxco, written in a crown design
Hector Aguilar	HA, joined in a circle
Felipe Martinez	Piedra y Plata
Ysidro Garcia	Maricela Mexico, in a circle
Margot de Taxco	Margot de Taxco, in a square
Bernice Goodspeed	Sterling B Taxco, in a circle
Salvador Teran	Salvador, cursive writing in a rectangle
Ricardo Salas Poulat	Matl Salas, cursive writing in a square

European Designer Jewelry

Jewelry crafted by European designers has a special appeal. Most of the people who purchase from the salons of Bulgari, Buccellati, Boucheron, Chaumet, Mauboussin, and others view the articles as investments in good taste as well as fine jewelry.

Some of the most beautiful styles come from the hands and minds of European designer jewelers. The mystique surrounding foreign designed and manufactured goods is somehow mixed with perception of superior quality and historical reputations. Putting a value on this jewelry presents a few extra problems to the appraiser.

The good news is that most European designer jewelry of high quality is signed by the maker; many pieces are also marked by numbers and letters on the mounting to indicate the city of manufacture and the total weight of the gemstones contained in the item. The appraiser should begin by making a careful survey of the inside, underside, and backside of each jewelry article, writing down all symbols, hallmarks, and numbers.

A Bulgari spokesperson in New York said that documenting the purchase of a designer article is like establishing a pedigree: "The jewelry is in the same category as a fine painting. If you have all the documentation surrounding its purchase, the item will be more valuable in the long run." It seems clear that the appraiser should ask the client immediately whether a sales receipt, appraisal report, or any other documentation given with the jewelry at time of purchase is available.

The most important point in evaluating European status jewelry is that an accurate replacement figure cannot be obtained by determining the cost of the components. The appraiser must research an item at its place of manufacture. One reason that the bricks-and-mortar approach will not provide an accurate replacement valuation is that some jewelry houses hire designers on contract basis. We cannot know if the designer charged a hundred dollars an hour to produce the jewelry or twice that amount.

To illustrate just how far off appraisers can be in determining price, a study of the replacement cost of an 18K yellow gold necklace, set with diamonds and rubies by Bulgari, was conducted by the Association of Women Gemologists in 1986. The actual item was purchased in Paris for twenty-six thousand dollars in 1985, discounted from the asking price of thirty-five thousand dollars. The survey revealed that most appraisers used the cost approach for insurance replacement, and were thousands of dollars short of what the necklace actually sold for in France. Furthermore, these appraisers grossly underpriced the cost of replacing the item in this country. According to Bulgari spokespersons, replacing the item with an identical one in New York would cost forty-four thousand dollars.

The first rule in evaluating European designer jewelry for retail replacement is *call the company*. Speak with a knowledgeable individual, explain what you are appraising, and let the representative lead you through the steps necessary for proper and documentable replacement price. The best-known firms all have salons in New York or Los Angeles. If you

are searching for fair market value, catalogs of major auction houses are reservoirs of information for sales of similar European designer items (fig. 5-23).

Bulgari has salons in Rome, Geneva, Monte Carlo, Paris, Milan, Tokyo, and New York. Examples of Bulgari jewelry are illustrated in figures 5-24, 5-25, and 5-26. One of the unique aspects of Bulgari is that everything sold by the firm is made by the firm; there are no outside commissions made by others and signed by Bulgari. Therefore, it is either Bulgari jewelry or it is not. In jewelry currently manufactured by the firm, you will find the letter C and four numbers stamped on items that are hand-made in the New York workshop. Jewelry cast in one of the three Bulgari workshops in Rome is stamped with the letters BD followed by four numbers. Write down each number and letter before you call Bulgari for consultation. Bulgari has been stamping its jewelry with serial numbers and their name for the past twenty-five years. Before that, they used the name only; prior to that, the jewelry was merely stamped .750. The Italian company has been in business for over a hundred years, and has maintained very careful records of clients and purchases. They will help you with a replacement price if you tell them when and where the jewelry was purchased; provide the name and address of the customer; give them the letters and numbers on the jewelry; and submit written authorization from the client to release information to you.

Extra care should be taken in researching and evaluating the work of these contemporary designers and jewelers: Cartier (Alfred Durante is the only Cartier designer whose individual initials have ever been al-

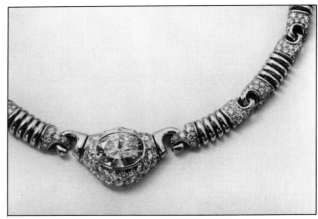

5-24. Bulgari 18K necklace with center bezel-set yellow diamond of 8.38 carats; 353 round diamonds with a total weight of 2.89 carats; and ten baguette diamonds with a total weight of .96 carats. *(Photograph courtesy of Bulgari, New York)*

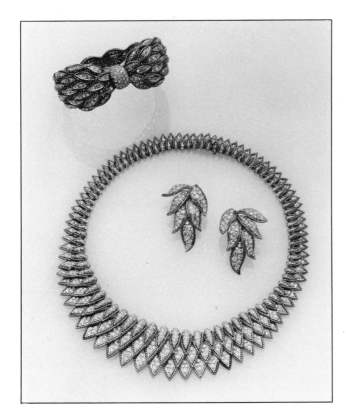

5-23. Eighteen-carat gold, platinum, and diamond necklace signed by Van Cleef & Arpels is pavé set with 747 round and single-cut diamonds, with a total weight of approximately 20 carats. The 18K platinum and diamond ear clips signed by Van Cleef & Arpels have 140 round diamonds with a total weight of approximately 7 carats. The bangle bracelet of 18K gold, platinum, and diamond, with a total diamond weight of approximately 5 carats, is not attributed to any designer or jeweler. *(Photograph © 1986 Sotheby's, Inc.)*

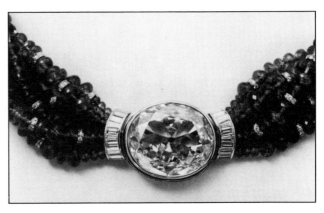

5-25. Bulgari multistrand necklace set with sapphire beads (total weight, 6.2 carats); with bezel-set yellow sapphire in center (total weight, 94.63 carats); thirty-two baguette diamonds (total weight, 5.08 carats); and 224 round diamonds (total weight, 23.25 carats). Fittings are 18K. *(Photograph courtesy of Bulgari, New York)*

lowed to appear next to the Cartier name on single pieces); Van Cleef & Arpels; Tiffany & Co. (Paloma Picasso and Jean Schlumberger); Travert & Hoeffer; Trabucco; Capello; and Ivo Misani (figs. 5-27 through 5-29).

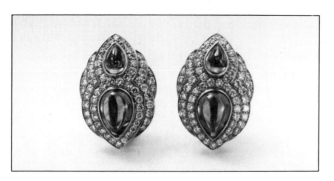

5-26. Bulgari 18K yellow gold, blue sapphire, and diamond ear clips. The pear-shape sapphires weigh 10.53 carats, and the twenty-four round diamonds have a total weight of 2.53 carats. (*Photograph courtesy of Bulgari, New York*)

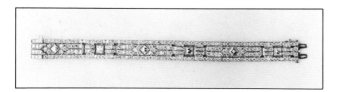

5-27. Platinum and diamond bracelet by Tiffany & Co. The rectangular and square links center five square-cut diamonds weighing approximately 3.75 carats and set throughout with 252 round diamonds weighing approximately 10.5 carats. (*Photograph © 1986 Sotheby's, Inc.*)

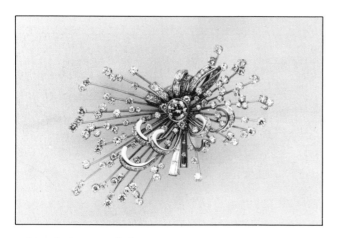

5-28. Platinum and diamond starburst brooch by Trabert & Hoeffer, Mauboussin, centering one collet-set light brown diamond weighing approximately 2 carats and surrounded by 208 round and single-cut diamonds (one missing), and by six baguette diamonds. Total weight, approximately 15 carats. (*Photograph © 1986 Sotheby's, Inc.*)

Fakes and reproductions can be found in all markets, including that of fine European designer jewelry. Become familiar with the work of the individual jewelers. You must know how to identify quality to be able to tell a knock-off from the genuine article. Bulgari jewelry is widely copied, but fakes will be revealed by their incorrect proportions as well as by their relative crudity. A genuine Bulgari will be harmonious in every detail, with every stone precisely set. You will find this trait to be true of all fine designer jewelry.

Jewelry from New-Wave Designers

Jewelry is an exciting business. Each generation of designers and goldsmiths innovates new styles and trends, and the appraisers must be aware of these.

Perhaps the best way to keep up with new jewelry artists is to attend trade shows. Jewelers of America sets aside its New Designers room at its New York show to feature some of the latest pieces. What you will see may be a revelation: the designers are well trained in their craft, have imagination, and are dar-

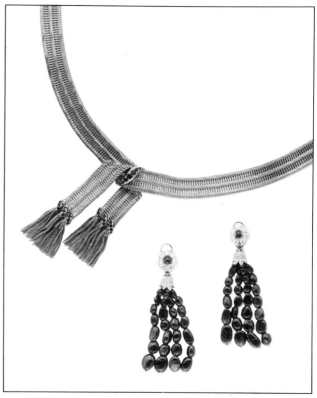

5-29. A pair of ruby bead, emerald, and diamond ear clips in platinum and gold by Van Cleef & Arpels. The Van Cleef & Arpels 18K gold and ruby lariat necklace has thirty-one small round rubies and weighs approximately 60 dwt. (*Photograph © 1986 Sotheby's, Inc.*)

ing in their use of materials and techniques. Some young designers already have their own lines of jewelry in galleries or stores around the country. Many have won national and international design awards. All instill a joyful and fresh look to jewelry design.

It is not easy to value this work, but standard guidelines do apply. Ask yourself the following questions. Is the item signed? Is the quality excellent? Is the finish in harmony with the style and does it help make the appearance complete? Is the material a precious metal or an exotic one? Are the stones natural or synthetic?

When you first examine the item, consider whether the artist has put any thought behind the design and/or gem material. You cannot use old ideas and methods to evaluate this designer jewelry. Instead, you should proceed more as an art appraiser. Compare the jewelry to similar works by the artist and check how well these items have been selling. The work must be marketable before the item can receive its full value potential.

For information about jewelry designers, contact the Society of North American Goldsmiths (SNAG), 6707 North Santa Monica Blvd., Milwaukee, WI 53217. This organization has the names of more than five thousand members on file and can offer insights into a particular designer's position in the market.

It is expected that art-as-jewelry will be a major trend for many years. One reason is the bold new use of three progressive, colorful elements, known as *refractory metals:* titanium, niobium, and tantalum. When the materials are heat treated or run through an electrical bath, they display a spectrum of colors—lush tropical greens, blues, magentas, and purples. Because these metals can endure extremely high temperatures, they cannot be commonly soldered, and require more innovative techniques to hold gemstones and findings. Accents such as 14K gold, silver, and gemstones must be mechanically riveted or wrapped onto the exotic metals or must be suspended from holes pierced in the jewelry. It is this intricacy of craft that has attracted these media to many of the new designers. The ultimate cost of the item is based on the degree of craftsmanship required. A pair of titanium earrings can cost as little as ten dollars retail, whereas an intricate necklace incorporating silver and gold may retail for as much as five hundred dollars.

Even designers not attracted to the refractory metals are employing new and unusual finishes on their jewelry. Some are discovering and using interesting metal techniques from Asian and other cultures. A Japanese style called *mokume gane,* or layers of metal, has found followers among the new-wave designers.

Most new-wave designers are vague on the subject of how appraisers should value their work. A few, like Ann Marie Montecuollo, Jewelers of America's 1985 New Designer of the Year, are realistic and candid about pricing. She charges fifty to one hundred dollars per hour for labor, and determines the cost of the article by adding to the intrinsic value of the material a 10 to 35 percent mark-up, the cost of labor, and an additional 50 percent mark-up. If the item is very special, Montecuollo adds a further 10 to 20 percent mark-up. She sells her work through her own company, Line of Gold, in Santa Rosa, California. All Montecuollo's work is stamped with her maker's mark.

Examples of Montecuollo's "production" work are shown in figures 5-30, 5-31, and 5-32. Montecuollo

5-30. Jewelry from the designer collection of Ann Marie Montecuollo, item #129. *(Photograph courtesy of Line of Gold)*

5-31. Earrings from the collection of Ann Marie Montecuollo, item #225. *(Photograph © 1986 Tom Wachs. Reprinted courtesy of Line of Gold)*

5-32. Tourmaline bead necklace with removable pin. Item #517 from the collection of Ann Marie Montecuollo. *(Photograph © 1986 Tom Wachs. Reprinted courtesy of Line of Gold)*

5-33. Frank Trozzo's jewelry sculpture Technocat. The sculpture is actually a suite of jewelry, all parts of which can be worn, as shown in figure 5-34.

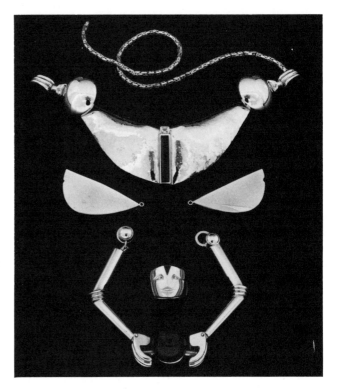

5-34. Technocat becomes a ring, earrings, a bracelet, and a necklace. (Photograph © 1986 Tom Wachs)

5-35. Frank Trozzo's crossover link bracelet in 18K white and yellow gold has a sculptural look. *(Photograph © 1986 Tom Wachs. Reprinted courtesy of Frank Trozzo, Aurum Gallery)*

explained that all these pieces were priced approximately thirty dollars per pennyweight at three hundred dollars gold; diamonds were priced with a 20 to 30 percent mark-up. All quotes are wholesale.

Some other designers say they mark their work up from 35 to 50 percent over the cost of material and labor, with gemstones marked up from 10 to 35 percent over the designer's cost.

Jewelry from such designers as Frank M. Trozzo has to be priced on individual basis, since much of it is one-of-a-kind items combining art forms; for Trozzo, combining sculpture with jewelry. He is the owner and director of two contemporary jewelry galleries—Aurum Galleries—in the San Francisco Bay area. With training in Europe and the United States, he is noted for unusual designs like his "Technocat." This work was featured at a Pacific States Fair in 1986, and is a jewelry sculpture made from six ounces of 18K yellow gold, adorned with precious stones and black South-Seas pearl (fig. 5-33). It may look like a sphinx but is actually a suite of jewelry: the head is a ring; the wings are earrings; the forearms and paws holding the black pearl fold into a bracelet; and the body and hind legs open to form a necklace.

Even though Trozzo has been called a technical innovator by his peers and by jewelry trade journals, he also does pieces that are more traditional. His crossover link bracelet is a new style combined with an old (figs. 5-34, 5-35).

Countless new designers sally forth into a competitive jewelry marketplace each year. The American Gem Trade Association selects some of the best-of-the-best designers in their annual Spectrum Awards competition. Figures 5-36, 5-37, and 5-38 illustrate the top three 1986 award winners.

Costume Jewelry

Most appraisers won't touch it. "Junk" or "scrap" is their quick response when asked their opinion of costume jewelry. Some, of course, are correct in their assessment because most costume jewelry has little or no intrinsic value.

Few owners of the flashy baubles will seek you out to make an insurance appraisal; if they do, they will often be dismayed to find that the cost of an appraisal is more than the item is worth. However, costume jewelry is one of the hottest fields of collectibles: one man's junk is another man's treasure.

Since the field of collecting costume jewelry is growing, you may well be called upon to assess the value of a collection for probate. Although you will not need many gemological skills, you will need to use your judgment and experience as an appraiser. If you do not understand that this is viable merchandise with its own market and set of value factors, your assessment will be inaccurate, perhaps by thousands of dollars.

Gloria Lieberman of the Skinner Auction House in Boston says that the work of a group of costume jewelry designers and manufacturers has become collectible to the point of a cult following. She cites Schiaparelli, Chanel, Coro, Trifari, Miriam Haskell, Krementz, Carnegie, Hobé, and Eisenberg. She states that prices for these items vary from one region of the country to the other, with collectors paying the highest prices in California. Two of the most sought-after pieces are pins from the 1940s: One is an American flag decorated with colored glass or enamels and worn on the lapel; the other is a Scotty dog. The popularity of the American flag pins seems reasonable enough, since there was a war on at the time of its manufacture and many collectors are nostalgic. But Scotty dog pins? Lieberman explains that Presi-

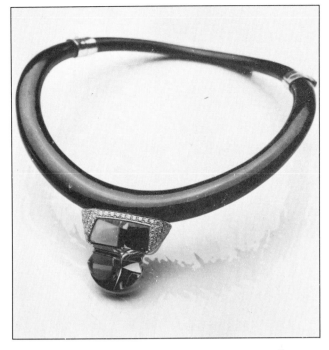

5-37. This necklace by Cornelis Hollander won second place in the 1986 AGTA Spectrum Awards. The solid black jade collar is fitted with 14K gold and adorned with a Munsteiner-cut 45.68 carat ametrine. Total diamond weight, 1.42 carats. *(Photograph courtesy of Cornelis Hollander)*

dent Roosevelt had a Scotty dog at the White House during the 1940s and that the antics of the little fellow were frequently reported in the press and enjoyed by the public. Scotty dogs were the favorite breed during that administration.

Retail prices for collectible costume jewelry range from ten dollars to more than three hundred dollars per item. A Trifari necklace made in 1943 with an original price of fifty-five dollars is now selling for

5-36. First-place winner of the 1986 AGTA Spectrum Award by Jean-Francois Albert, Bosshard & Co. Ring is 18K with 1.42 carat diamond, 4.06 carat rhondolite garnet, and 3.93 carat tanzanite. *(Photograph courtesy of Lary Kuehn)*

5-38. This third-place AGTA Spectrum Award winner by José Hess is a pin/pendant combination in 18K gold with cushion-cut green tourmaline set between two pear-shaped pink tourmalines. Total weight of the tourmalines, 15.57 carats. *(Photograph courtesy of Lary Kuehn)*

approximately two hundred dollars. Rhinestones are a hot item, with most pieces hovering around the fifty-five to eighty-five-dollar mark—more than three times what they sold for when they were brand new!

Items retailing for two to three dollars during the 1940s will now be found marked twenty-five dollars and up. What makes the differrence? It depends upon the item's visual appeal; whether the stones are hand-set or glued into the mountings; whether the metal is sterling or base metal; an whether the piece is marked with the manufacturer's name. If the jewelry is in the original box, its value increases considerably.

Flea markets, thrift shops, house and garage sales, and, surprisingly, major antique shows are good places to research value. Dealers in antique shows, especially those held in shopping malls, are reporting increased sales in this category. Some auction houses handle the more desirable items. Of course, in advance of all trends are harbingers of the news, so a few cost guides are already on the market. For further help in identifying costume jewelry and learning more about this field, see *Collecting Rhinestone Jewelry*, by Maryanne Dolan; *One Hundred Years of Collectible Jewelry*, by Lillian Baker; *Collectible Costume Jewelry*, by S. Sylvia Henzel; and *Fifty Years of Collectible Fashion Jewelry: 1925–1974*, by Lillian Baker. All include price guides and are listed in the bibiliography.

VALUING WATCHES, COIN JEWELRY, CARVINGS, AND OTHER ARTICLES

Vintage and Contemporary Wristwatches

The difficulty in appraising antique and modern wristwatches is the time it takes to get information about the product. Some of the most important data in your personal price-and-research records will be the notes you accumulate on watches. To keep from spending an inordinate amount of time looking for comparable watches, set up some file folders marked with the names of major makers—Audemars Piquet, Baume & Mercier, and so on. In these folders, keep every scrap of price information you can find about individual watches from newspaper advertisements, jewelry trade journals, and upscale consumer magazines. Even though the prices become outdated, you will have a record of styles and the names of the stores carrying those particular brands so that you may more easily scout the market for comparable items and current retail prices.

Major auction houses issue catalogs of watches, but getting watch catalogs from manufacturers themselves is difficult. Why this should be such a problem is unclear, but unless you are a retail jeweler who has business with a specific watch manufacturer, it will be difficult, if not impossible, to get a current catalog for your reference library. If you are doing appraising in a jeweler's store, the jeweler will usually not be averse to letting you browse through the watch catalogs he or she receives.

Some companies have catalogs that you can obtain for a small fee, and you can also order special flyers with style and retail-price information from some watch manufacturers. Look for these flyer advertisements in fine magazines such as *Vogue* or *Town and Country*.

Modern Wristwatches

Some of the most popular and sought-after wristwatches for both men and women are by Patek Philippe, as illustrated in figures 6-1 and 6-2. The 18K

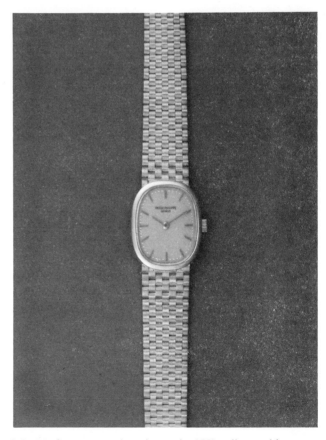

6-1. Modern woman's wristwatch, 18K yellow gold quartz Ellipse by Patek Philippe. *(Photograph courtesy of Henri Stern, New York)*

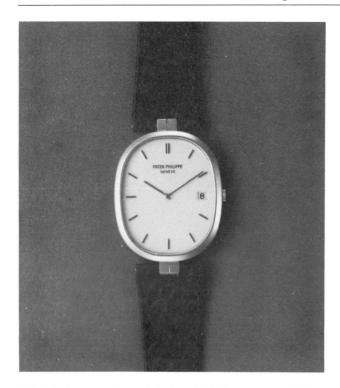

6-2. Modern man's watch by Patek Philippe: quartz Ellipse, 18K gold, and leather band attachment. *(Photograph courtesy of Henri Stern, New York)*

watches are all individually handcrafted works of art. Other status names are Audemars Piguet, Baume & Mercier, Brequet, Cartier, Concord, Corum, Piaget, Rolex, Tiffany, Universal Genevé, and Vacheron & Constantin. Become familiar with the trademarks and hallmarks of the various important watchmakers— their names raise the value of the watches. There are those who advocate opening the backs of watches to count jewels and to remove the movement to weigh the case. This is a mistake and entirely unnecessary in normal appraisal practice. Unless you are a qualified watchmaker, you can seriously damage the watch by attempting to open the back. And, except for complicated watches such as those by Patek Philippe, movements play a small part in the value of the modern wristwatch. Instead, the most important factors include:

- Name on the dial
- Condition of the case and movement
- Metal and metal fineness
- Case style
- Features (day/date, moon phase, etc.)
- Precious or synthetic stones
- Movement: jeweled, quartz, or other
- Bracelet attachment

A complete appraisal of a modern watch should include all the following information as well as a photograph of the timepiece:

1. Description of the case style and a record of the case serial numbers. (Case styles are illustrated in figure 6-3.)
2. A description of the hour and minute-hand style (fig. 6-4).
3. Movement serial number, if it can be obtained from the client's records, not by opening the back.
4. A description of the gemstones, colored lacquer, or other decoration on the dial and case.
5. The weight of the watch (including movement) in pennyweights.
6. A note of any engraving on the case.
7. A description of the attachment.

Check and note whether the watch is in running condition; this is often overlooked. Some gray-market watches—trademarked watches imported into the United States by channels other than the manufacturer's authorized U.S. distributors—have no valid warranty in this country. Many, in fact, cannot be

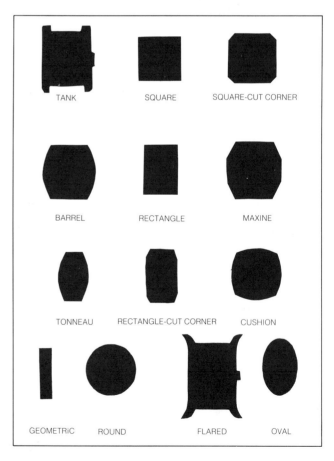

6-3. Wristwatch case styles.

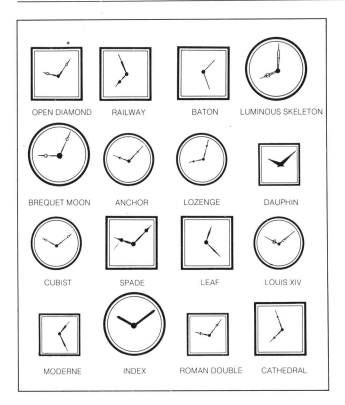

6-4. Wristwatch hand and minute styles.

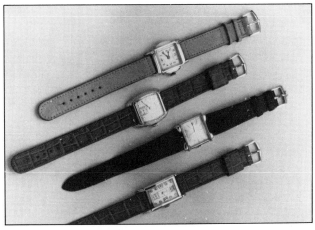

6-5. Four watches dating from 1925–1940. (*Photograph courtesy of Lynette Proler Antique Jewellers, Houston*)

repaired because no compatible replacement parts or accessories are available. If you have a gray-market wristwatch for appraisal, and you can determine it without doubt, state this on your report. For new wristwatches, your area jewelers' mode of 20 to 25 percent off the manufacturer's suggested retail price is commonly used as replacement value for insurance purposes.

Vintage Wristwatches

Researching value for vintage wristwatches could become your life's work, as it seems there is a market with well-defined standards. In actual practice, however, much depends upon trends, fads, and collectors. The following factors determine value in vintage watches:

Style. Fads and trends determine the style at any particular time and that affects value. Figure 6-5 illustrates the great appeal of the men's flared, cushion, and tank-style wristwatches.

Utility. Because a wristwatch is useful and enjoyable to wear, it is a top item to collect. Watches that were expensive originally will always be in demand. Junk watches will always be junk.

Metal. All materials, from platinum to stainless and plastic have been used in watch cases. The intrinsic value of the case metal is the *only* value of some

watches, but watches with top brand names and platinum and/or gold cases are worth more than the weight of the metal.

When you are assessing value of older watches, look at the dial first. Does it need to be refinished? Refinishing can cost a hundred dollars or more. Does the dial have any missing or damaged figures, scratches, or dents?

Examine the case for signs of wear. Is it bent, dented, or worn? Are the spring-bar holes worn? On gold-filled watches, inspect the high edges of the case to see if the brass shows through. In addition, look for engraved initials or a dedication on the watch case; engraving lowers fair market value.

Old watches that you have to appraise may have been recased but it is very difficult to tell a recased movement from the original. Watch experts believe that if you can establish that a movement has been recased, the value of the watch will drop dramatically.

In vintage watches, the original winding crown should be in place. This is especially important on Patek or Rolex watches. Deduct value if the crown has been replaced. Add value for hinged lugs, curved or enameled cases, two-tone gold cases, numerals on the bezels, numerals on an enamel bezel, and Art Deco–style numerals on the dial (fig. 6-6).

The watch bands or bracelets of vintage watches are usually worth only a small premium over the intrinsic value of any precious-metal content. Added value is given *only* if the bracelet or attachment is in pristine condition (fig. 6-7). Exceptions are made for exotic skin bands on original and signed Patek, Rolex, or Cartier watches.

Comic-characters watches, alarm watches, chronographs, repeaters, and calendar watches are valued slightly above liquidation. The original box and guar-

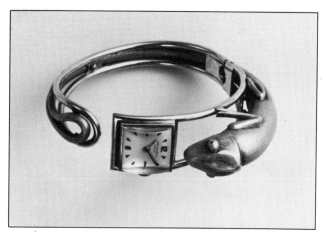

6-6. Woman's wristwatch from the 1940s with unusual chameleon bracelet and case in 18K gold with silvered metal dial. The Patek Philippe signature on the dial, unusual design, and pristine condition add value to the watch.

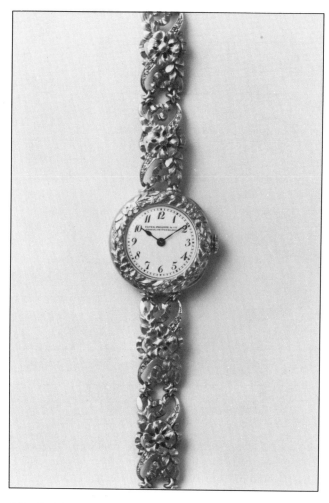

6-7. Early 1900s woman's wristwatch of 18K gold, chased and inlaid with rose-cut diamonds, with a white enamel dial and blued steel hands. The wristwatch's rare design, perfect condition, and Patek Philippe logo on dial add value to its appraised price.

antees greatly enhance the value of a wristwatch. The more valuable the watch, the greater the value of the box and papers.

Private-label or contract wristwatches are found with the jeweler's name on the dial, movement, or case. These watches were used primarily for advertising.

If you would like to expand your expertise in valuing contemporary and antique wristwatches, join your local and/or national Horological Association to obtain information and special education. The newsletters and publications they send will help keep you informed of price changes in this field.

Keep in mind that vintage watches are secondhand goods. When you do insurance appraisals, do not price these as new replacements. Vintage watches are valued for the cost of replacement with a comparable-quality wristwatch. Discuss this with your clients. If they want you to provide a new replacement price, perhaps you should give both values to cover yourself as appraiser. In terms of fair market value, some watches that retail for a thousand dollars will have an FMV of a hundred dollars. Determining fair market value of vintage watches requires the appraiser to do focused research. Survey prices from antique dealers and auction catalogs. Other market resources are *Charterhouse & Co.,* 16835 Kercheval, Grosse Pointe, Michigan, 48230; and *Vintage American and European Wristwatch Price Guide,* by Sherry Ehrhardt and Peter Planes (see the bibliography).

Spotting Imitation and Counterfeit Wristwatches

Imitation and counterfeit luxury watches can be a serious problem for the appraiser. Unless you are an experienced watchmaker, you do not want to open the back of a wristwatch to see the movement, and yet this is where it is easiest to detect whether a watch is genuine. If the watch is of a brand that is often counterfeited and you have any grounds to suspect the item's authenticity, it may be smart to have the movement inspected by a watchmaker before you complete your report. If you fail to do so and remain skeptical about a watch's authenticity, indicate in your appraisal that you did not confirm the movement, the reasons you did not confirm, and why you are suspicious.

A lecturer offered the following tips on detecting counterfeit watches at a Gemological Institute of America Gemfest. The spelling of the trade name is often a giveaway. Genova for Genevé, Omeca for Omega, 3enrus for Benrus; Longine for Longines. Look closely at the style of the script of the brand

name. Become familiar with the styles of maker signatures. Genuine Rolexes are illustrated in figures 6-8 and 6-9. Check the logo and make sure it is correct. You will find fake Rolexes without crowns or crowns that are the wrong size. The Rolex crown on the Italian gold band is a different size from the crown on the Swiss gold band. The Greek-letter logo that dignifies Omega is not recognizable on the counterfeits.

Check the metal. Do not trust karat stampings. Gold-filled and gold-plated watches are common in bogus watches. Acid testing is the only reliable means of authenticating metal. Genuine stainless-steel and gold Rolex bands have a number on the underside of the band; the last two digits indicate whether the gold is 14K or 18K mixed with stainless steel. Also, the

gold finish is not very good on some of the imitation 18K gold bands. Look especially near the lugs and at the end of the rows of metal for poor finishing.

Heft is another clue to fake watches, but you must have handled a lot of genuine watches of the brand to be able to detect the difference. The Rolex man's Presidential model, for instance, has a certain heaviness that is not present in a counterfeit. Phony stainless-steel and gold Rolex models are much lighter in weight than the genuine; this lightness will be immediately apparent upon inspection. Stainless-steel snap-on backs also reveal fake Patek Philippe and Piaget tank-type watches; the movements of these imitation-brand watches are quartz, and only selected watches in the Patek line are quartz.

Check any gemstones that mark hours on the dial. Frequently, a diamond on a genuine watch dial will be prong-set; counterfeit watches often have glued-in stones.

A helpful tip shared by jewelers and appraisers who know fine Rolex watches is to look at the second hand. A genuine Rolex Oyster Perpetual second hand moves four times per second, whereas on the

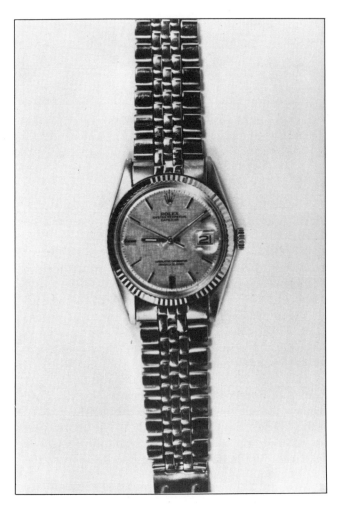

6-8. One of the most frequently counterfeited watches is the Rolex brand. Pay attention to the weight of the watch; check the logo for correct spelling and type style; check crown design for correct size. Look at the finish on the bezel and watch attachments. Be certain the dial has all the information it is supposed to contain, such as Rolex Oyster Perpetual Datejust.

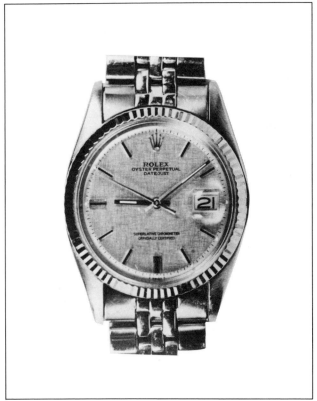

6-9. To spot a counterfeit Rolex, check the second hand closely. A genuine Rolex Oyster Perpetual second hand moves four times per second, while the imitation moves once per second.

counterfeit Rolexes, the second hand moves only once per second. The Rolex Oyster Perpetual is one of the most frequently knocked-off brands and one that you must be most careful in examining. In general, only the most popular brands and styles are counterfeited.

Pocket Watches

The appraiser must have experience and expertise in handling pocket watches before attempting an evaluation. A knowledgeable jeweler can quickly learn to differentiate among poor, medium, and high quality pocket watches, but it takes actual hands-on experience to understand how value standards operate for pocket watches.

Although the subject is both antique and modern pocket watches, "modern" in this context refers to pocket watches made until 1960. Makers of luxury Swiss watches such as Patek Philippe who are still in business have their own set of value standards and guides. These watches must be individually researched for value with like brands and styles.

To appraise the majority of pocket watches, follow these procedures:

1. Note whether the item is a man's pocket watch or woman's pendant watch.

2. Write whether the watch is a hunting case, or covered dial, model; an open-faced style; a pair case (two cases); or a form case in the design of a flower, cross, shell, ladybug, fan, or so on (figs. 6-10, 6-11).

3. Determine whether the watch is working and if the functions—(the repeater mechanism, moon phase, calendar, and so on) are working. The more functions the watch has, the greater its value.

4. Establish which metal was used to manufacture the case. Some watches, even though gold-filled, chrome, nickle, or silver, may be valuable if the case and movement are original.

5. Determine the case condition. A case of 14K or 18K gold in mint condition will be of higher value than a case that shows wear. What is the condition of the case—pristine, mint, extra fine, average, fair, or scrap? On a hunting-case watch, note the condition of the hinge—is it worn? Can you determine whether the case is original? Note how the case is decorated: *repoussé*, engine-turned, enameled, or any other technique. List any initials or dedications engraved on the case. Engraved words or letters reduce value if the appraisal is for fair market value. If the appraisal is for insurance replacement value, describe any fancy engraving or dedications and add this cost to the estimate. Hand engraving is expensive.

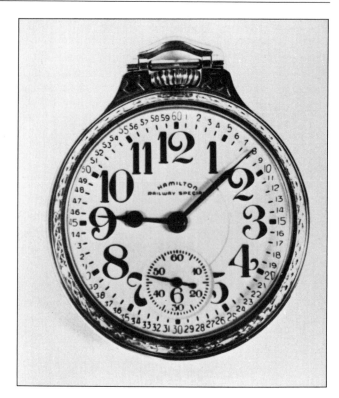

6-10. Open-faced railroad watches were very accurate timekeepers. Many can still be found in estate appraisals. (*Photograph courtesy of Charterhouse & Co.*)

6. Size. A couple of systems are used to gauge size. The Lancashire Gauge is the most commonly used system; you can buy it at your local watchmakers' supply house. The gauge has two sides. The American watches use size 8, 12, 16, and 18. European watches are measured in *lignes;* that is, 2, 3, and 4 lignes. The size of a watch is determined by measuring the outside diameter of the face. Most books about watches print reference gauges for easy judgment of watch sizes, which you can use if you do not have a proper gauge.

7. Look at the dial and note the condition. Is it chipped or does it have any hairline cracks? Both will reduce value. Is the dial porcelain? Note the style of the hour and minute hands, as shown in figure 6-12, and whether the numerals are arabic or roman. Is there color on the dial? Are there photographs on the dial? Is it single or double sunk? Does it have subsidiary secondhands? Is the crystal pristine, broken, or missing?

8. Movement. This is as important to a pocket watch as color is to colored gemstones. From the movement you can determine the type of plates used (three-quarters, full, or bridge); the type of balance; the winding type (stem-wind, key-wind, or lever set);

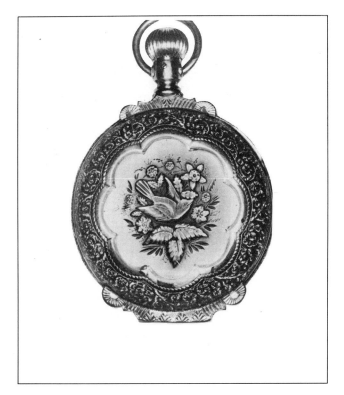

6-11. Hunting case pocket watch in pristine condition with ornamental cover. Very desirable to collectors. *(Photograph courtesy of Charterhouse & Co.)*

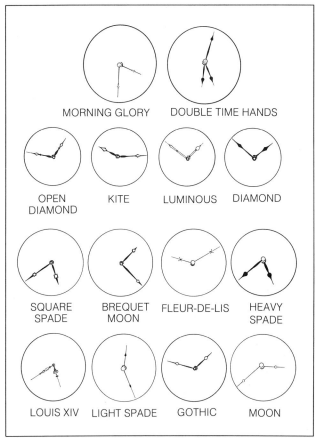

6-12. Hour- and minute-hand styles for pocket watches.

the number of adjustments; the number of jewels; the presence of *damaskeening* (the process of applying ornate designs on metal by etching—this adds value to the watch); and the serial number of the movement. Note on your report every number and word you see on the movement of American-made watches. The serial number is used to determine the year it was made; manufacturers' serial numbers correspond with the years of production. Low serial numbers are more valuable than high ones.

You can usually date European and English pocket watches by referring to the signature of the maker on the movement and using either Britten's *Old Clocks, Watches and Their Makers* or the G. H. Baillie work, *Watchmakers and Clockmakers of the World* as reference sources for dates during which various manufacturers were in business. If you encounter a name that you cannot find listed in any reference, chances are that the name is either the importer or the jeweler, not the manufacturer. Studying the characteristics of the movement will also help you determine the date of the watch.

Provenance is a difficult area to establish on pocket watches, with the possible exception of those made by

Patek Philippe. This company, which was founded one hundred fifty years ago by French watchmaker Adrien Phlippe and Polish nobleman Count Antoine de Patek, maintains detailed records of its timepieces. If you can provide the movement number, case number, and description of the watch, the company will send you the history of the piece, including its date of manufacture, date sold (and to whom), and any repairs conducted through the company. In short, you will receive everything you need to make a positive provenance record, which adds value to the object.

Stampings

The hallmarks of foreign gold cases will usually be legitimate indications of the karat quality, but beware of foreign cases that are stamped 18, especially if this is the only mark you can find on the watch. Acid tests may confirm that the karatage is actually only 8K to 10K. Similarly, American cases stamped with the manufacturer's hallmark, with the mark of the U.S. Assay Office, or the marks 14K and 18K will usually be correct, although in some cases, the mark 14K

refers only to the gold filled part of the case. Test the case to be sure.

In 1924, the U.S. government prohibited the use of the guarantee terms on watch cases. If you see the guarantee terms 5, 10, 15, 20, 25, and 30, or the word *permanent*, you are looking at gold-filled material, not solid gold. Case companies began to use the markings 14KGF or 10KRGP to indicate the actual qualities of case metals.

Silver-color cases may be marked *silveroid*, *silverine*, *silverode*, or *silverore*. These are trademarks for white metal cases that are not silver but a combination of copper and manganese. Sometimes these are marked "guaranteed for 100 years."

Dating American Pocket Watches

1870s: Damaskeening appeared on pocket watches in the late 1870s.

1879: First appearance of 14K and 18K multicolor gold cases.

1910: Multicolor gold cases no longer made in the 16 and 18 sizes; smaller sizes continue to be produced.

1924: Government prohibits further use of the guarantee terms 5, 10, 15, 20, 25, 30 years. After 1924, manufacturers marked cases 10K, 14K gold-filled, and 10K rolled gold plate.

Dating European Pocket Watches

1635: Enamel dials used
1640: Pair cases used
1687: Minute hands used
1697: Hallmarks used
1700: Jewels used in movements
1774: Dust caps used
1820: Keyless winding instituted. Widely popular after 1860.

Two examples of the modern watchmaker's art are the Patek Philippe skeleton pocket watches shown in figures 6-13 and 6-14. These extraordinary timepieces are destined to become the heirlooms of tomorrow. How will the twenty-first-century appraiser value these items? By the same standards we use today: Beauty, rarity, demand, supply, condition, and age. At a recent auction in Geneva, a blue enamel and diamond pocket watch, dated 1650, decorated with figures and flowers by watchmaker Jehan Cremsdorff of Paris, sold for more than 2 million dollars. Only four or five comparables exist.

Handling a Hunting Case Pocket Watch

Do not embarrass yourself as an appraiser by failing to learn the correct way to handle a pocket watch.

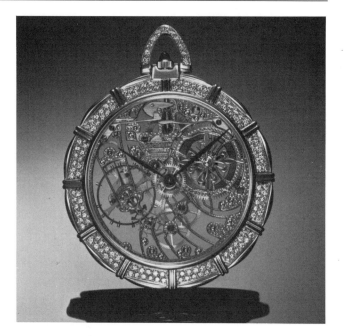

6-13. Contemporary Patek Philippe pavé-set diamond skeleton pocket watch. This commissioned watch took fifteen months to create.

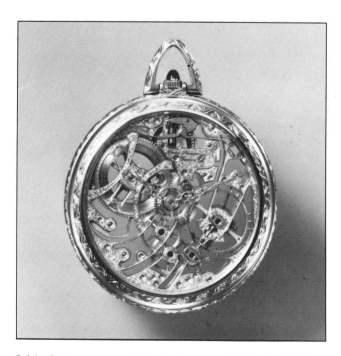

6-14. Contemporary 18K skeleton model Patek Philippe pocket watch.

Collectors who have such watches know instantly if you are abusing their property by careless or incorrect handling. It brands you as an amateur.

Hold the watch in the right hand with the bow or swing ring between the index finger and thumb. Press on the crown with the right thumb to release the cover over the face. Never snap the cover or push

in the middle of the cover to close the watch. Instead, hold the watch in the palm of your hand, press the crown to move the catch in, close the cover, then release the crown. This will reduce wear on the soft gold rim and catch and keep from damaging the cover.

For watches with a screw-on front and back such as the railroad models, hold the watch in the left hand and, with the right hand, turn the bezel counterclockwise. While removing the bezel, hold carefully to the stem and swing ring so you do not drop the watch. Lay the bezel down and check the dial for cracks and other signs of damage. Look at the lever to see that it will allow the hands to be set. After examination, replace the bezel and turn the watch over. While holding the stem between the left thumb and index finger, remove the back cover. If it is a screw-on back cover, turn it counterclockwise. For a snap-on cover, look for a lip on the back and use a pocket watch-knife to lift the back off. Do *not* attempt any of these moves unless you have been personally shown how to proceed by a watchmaker.

Appraising pocket watches is a sub-specialty of the gems and jewelry discipline. If you feel you are not qualified in this area, turn the item over to a colleague who has the necessary expertise. Even antique pocket watches have their fakes and counterfeits.

For identification and price guides, the following publications may be helpful: *The Complete Guide to American Pocket Watches* by Cooksey Shugart and Tom Engle; and *American Pocket Watch Identification and Price Guide,* by Roy Ehrhardt. Both are listed in the bibliography. By joining the National Association of Watch and Clock Collectors (513 Poplar Street, Columbia, PA 17512), members receive a bulletin with historical information about watches and clocks and a periodic newsletter devoted to buying and selling announcements.

Coin Jewelry

Three factors combine to determine the value of any coin: rarity, demand, and condition. Coins of numismatic quality are rarely found in jewelry. Collectors of numismatic coins are generally sophisticated enough to realize that once a coin is mounted in jewelry, it loses value based on its wear and exposure to damage. Age alone has little effect on the value of a coin, and many appraisers make the mistake of conferring special value on old coins.

When you have coin jewelry to appraise, one of your first impulses may be to clean the jewelry. Do not do it! Coins should be left in their existing condition, and no attempt should be made to alter their appearance by cleaning or polishing. Never test the

metal content of gold coins—the rub on a touchstone could reduce the value of a collectible coin.

To appraise precious metals, you need a working knowledge of world coin values. It would be useful to become a member of your local numismatic society and learn differences in grading coins. As a member, you would also receive newsletters and bulletins with current coin prices and information on general supply and demand. If, however, you have no opportunity to join a coin club or attend meetings or lectures, there are several books that provide helpful general information: *Handbook of United States Coins: Dealer Buying Prices,* by R.S. Yeoman; *Green Coin Book,* by Robert Friedberg (with additional information and revisions provided by Arthur and Ira Friedberg); *Standard Catalog of World Coins,* by Chester L. Krause and Clifford Misher.

Rarity is the most important factor in determining coin value, since without rarity the other two criteria are of minor significance. A rare coin is one that may be struck in a limited quantity for a certain period; struck in only one year; one of the few surviving coins of a large number originally struck; or a rare coin that may have been uncirculated and is now considered scarce. *Demand* is the real indicator of the coin's place in the market because no matter how rare it is, it cannot be sold for a price matching its rarity unless demand exists for the item. *Condition* is the state of preservation of the coin. As gemstones are desirable without chips, nicks, or cracks, coins in the finest condition (those that are shiny and showing no signs of wear) are most desired by collectors. Coins and commemorative medals incorporated in jewelry are generally worth bullion value plus about 3 to 4 percent.

Follow these standard steps when appraising coins:

1. Establish country of origin, metal, denomination, and date.
2. Determine whether the coin jewelry is authentic, counterfeit, token, commemorative, or of private issue.
3. Note condition (coins in jewelry will probably be either very good or good).
4. Note the weight of the coin (alone if possible, or in the mounting as part of the total weight).
5. Provide coin measurement in millimeters.
6. Describe the mounting and appraise as you would normally appraise any precious-metal jewelry.

Most appraisals of coin jewelry that you will be asked to do will concern retail replacement for insurance. You can get the current prices of many foreign and United States coins from the daily newspaper market listings. Internationally known foreign and

domestic coin dealers, such as Manfra, Tordella & Brookes, have buy-and-sell price sheets based on current gold prices; many domestic and foreign coins of contemporary vintage are listed. Silver coins in well-circulated condition are considered bulk coinage and sold as silver scrap.

Coin Gradings

These are the general characteristics defining the different coin grades:

- *Fair:* Designs and lettering identifiable. Quite worn.
- *Good:* Legends, design, and date are clear.
- *Very Good:* Features clearer and bolder, better than good.
- *Fine:* Circulated coin with little wear. All legends should be clear.
- *Very Fine:* All details and relief are sharp; only the highest surfaces show wear.
- *Uncirculated:* Never circulated, regular minting. Toning or tarnish may show on older issues.
- *Proof:* Coins specially struck for collectors. These usually have a mirrorlike surface, although sandblasted and matte finishes are produced for some proof series.

The American Numismatic Association has a certification service for the authentication and grading of coins. Appraisers uncertain about the potential numismatic value of any gold coin can get help from the ANA.

The American coin jewelry trend accelerated when the Gold Bullion Coin Act of 1985 authorized the minting of the first general-circulation U.S. gold coins since 1933, and is expected to continue. The series of four gold coins contains the following amounts of pure gold: one ounce for the fifty-dollar coin; one-half ounce for the twenty-five-dollar coin; one-quarter ounce for the ten-dollar coin; and one-tenth ounce for the five-dollar coin. Jewelers can expect to pay about 3 percent above spot gold price. See table 6-1 for a list of the coins jewelers sell.

Love Tokens

Love tokens, interesting articles of jewelry and a popular art form, are currency coins that have been erased and especially engraved on one side. Their history goes back, reportedly, as far as the Middle Ages, and they were quite popular in Europe in the sixteenth century. Also popular in the United States for about forty years, beginning in 1870, they went into a decline after the federal government made it illegal to deface currency in 1909.

Table 6-1. The Coins Jewelers Sell: Cost to Retailer from Dealer*

Coin	Country	Fineness	Gold Weight	Diameter	Price
$20 St. Gauden	USA	.900	.97 oz.	34mm	$591.
$20 Liberty	USA	.900	.97	34	556.
$10 Indian	USA	.900	.48	27	485.
$10 Liberty	USA	.900	.48	27	232.
$5 Indian	USA	.900	.24	21	268.
$5 Liberty	USA	.900	.24	21	168.
$2.50 Indian	USA	.900	.12	17	204.
$2.50 Liberty	USA	.900	.12	17	222.
50 peso	Mexico	.900	1.2	37	431.
20 peso	Mexico	.900	.48	27	175.90
10 peso	Mexico	.900	.24	22.5	90.50
100 corona	Austria	.900	.98	37	339.
4 ducat	Austria	.968	.44	39	165.80
1 ducat	Austria	.968	.11	19.6	42.90
Maple leaf	Canada	.999	1.	33	358.
Panda	People's Republic of China	.999	1.	32	368.20
Panda	People's Republic of China	.999	.50	27	190.40

* Based on gold at $344.50 per ounce. Prices change daily based on spot gold prices.

Love tokens were commonly engraved with initials, monograms, scenes, or messages. Messages can be charming: *Baby, 5-9-86;* sentimental, *Annie 6-29-88;* or to the point, *Jeweler,* as on those used for advertising purposes. Many of the coins you will see are dated 1876, the year of the U.S. Centennial celebration. Many engravers were present at the New York World's Fair, plying their trade to the mass of souvenir hunters.

Engravers, however, were not the only ones to produce love tokens. This ancient art is ascribed to lonely sailors, soldiers, and prisoners. Amateur craftsmen and artists began carving messages, names, or initials and pictures of houses, boats, and birds. Some crude primitively scratched coins are called *pin hole* or *punchwork* tokens. More artistically finished love tokens were usually by jeweler engravers who ground one side of the coin flat for engraving (sometimes both sides) and used enamel, glass, gemstones, and often an overlay effect to enhance their designs.

Gold coins with initials cut out of other gold coins

(often a different color gold), intertwined and soldered onto the base coin are beautiful and have the look of finely engraved initials.

Jewelry love tokens include brooches, necklaces, bracelets, stick pins, and cufflinks. Young women of the Victorian era liked to collect as many love tokens as possible from their sweethearts; it was a visual display of a young woman's popularity.

Gail B. Levine, a graduate gemologist and collector of love tokens, recommends the following factors to help appraisers determine prices for the coins:

- Condition of the coin and date
- Craftsmanship of the engraving
- Message or scene on the coin

Dual-sided pieces bring the highest prices. Special scenic coins command a greater premium, and messages that relate to historical events add value. Levine gives this list of love tokens rating from commonly found (less valuable) to most desirable (more expensive):

- *Initials*—plain, fancy, elaborate, combination with scene or date: seven dollars and up.
- *Monograms*—plain, fancy, elaborate, combination with scene or date: ten to twelve dollars and up.
- *Names*—plain, fancy, elaborate, combination with scene or date: fifteen to eighteen dollars and up.
- *Scenes*—flowers, birds, animals, landscapes, seascapes, people, trains, ships, guns, religious emblems: twenty dollars and up.
- *Dual pieces*—both sides smoothed off with monograms or initials with combination sayings, date or scenic: twenty-five to thirty-five dollars and up.
- *Historical*—Centennial, World's Fair, patriotic, political: fifty dollars and up.

Add value to the coin if they have any of the following: enamel, cut-out designs, gemstones, relief-carved designs, or any combination of these.

Coins with love messages command the top price, followed in value by pornographic/erotica, historic, Masonic, funeral remembrances, contest awards, identification tags, anniversary, birth, and wedding coins. Belt buckles are the most expensive of jewelry love tokens, followed by shirt studs, hat pins, earrings, spoons, buttons, cufflinks, watch fobs, brooches, necklaces, stick pins, bracelets, pendants, pocket pieces, and charms. Figures 6-15 and 6-16 illustrate two pieces of love-token jewelry.

Coins that are most *desired* (making a love token most expensive), descending to least expensive are: the twenty-dollar gold piece; copper and nickel

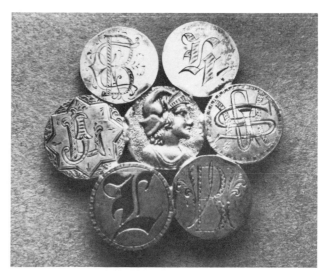

6-15. A love-token brooch made from dimes with fancy lettering. *(Photograph courtesy of Gail Levine)*

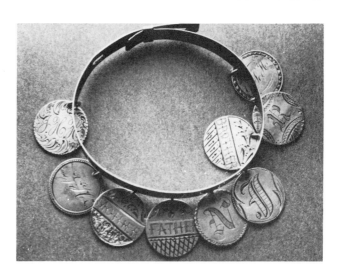

6-16. Love token bangle bracelet—a memento made from dimes. *(From the Gail Levine collection)*

pieces; large cents; twenty-cent pieces; five-dollar gold pieces; Morgan and trade dollars; the 2.25 dollar gold piece; three-cent silver coins; the dollar gold piece; silver dollar; half-dollar; half-dime; quarter; and the dime. A dollar gold piece with one side planed off and the name "Ella" engraved was recently quoted for one hundred and fifty dollars retail in a coin shop.

If you have love-token jewelry to appraise, research coin shops, coin shows, flea markets, antique shops, and antique shows; occasionally, one will turn up at an exhibition in a gem and mineral show. Local coin clubs can inform you about coin auctions, which may be of assistance in comparable pricing.

Erotica

Erotica has always been a part of the arts, from exquisitely executed tomb paintings to contemporary vulgar jewelry and *objets d'art.* Today's gemstone and jewelry dealers say there is a solid group of collectors for these items. There are antique items in this category but they seldom reach the public market because they sell briskly among collectors.

Objects of erotica are found in Oriental ivory netsukes and East Indian jewelry, Ashanti gold weights, pre-Columbian jewelry and art, love-token jewelry, and among the gold and silver jewelry of the "flower children" movement of the 1960s.

In ancient Egyptian and Roman jewelry, many articles were decorated with erotic motifs, with a phallus used on amulets, rings, and brooches. In *An Illustrated Dictionary of Jewelry,* Harold Newman reports that erotic motifs were carved on cameos of the Hellenistic era and the Renaissance period. Erotica is also found in the jewelry of Peru, Japan, and Germany. Pornographic buttons were made in eighteenth-century France, Japan, and India. Also, erotic automatons—watches with a mechanism that cause figures on the dial or under the cover to move or rotate—were produced for the East Indian market.

Much of the jewelry is or was created for ritualistic charm use, for religious rites, as love charms, and so on, but the purpose of some was simply to please or excite. Consequently, some are only obscene novelties.

Ivory is a favorite medium for carvers of erotica. A complete collection of antique carved netsukes can be measured in value only by what the last collector actually paid for them. They are rare. The new netsukes, explicitly sexual, are priced at retail about 50 percent higher than their plain counterparts of similar size. Many of the new ones are in color and it should be noted this is a twentieth-century variation. The value factors in determining price are the same as in carvings:

- Material
- Depth of carving and craftsmanship
- Intricacy of detail
- Polish and finish

The appraiser can figure that a three-inch-high ivory netsuke (without color) new, but nicely carved and finished, will be valued at approximately one hundred dollars wholesale.

Ashanti weights, which were used to weigh gold dust, can still be found in the market and will often be presented for appraisal. The originals sold for up to one hundred dollars retail. Ashanti reproductions now on the market retail for about five dollars each. They are crudely made and finished. Even if you have never see any of the original weights with their primitive kind of beauty, you cannot mistake the overwhelming ugliness and vulgarity of the new reproductions.

At the height of the hippie era in the United States, cast silver and gold erotic jewelry was plentiful. Most of the jewelry was mass produced, poorly cast, and cheaply finished. To value it, apply the same standards used to appraise other metal items: fineness of metal; weight of metal; workmanship; method of manufacture; and finish.

Love tokens with erotic scenes are still around, but collectors buy them so quickly at coin shows that you may not have time to catalog current prices. Silver coin erotic love tokens are priced at thirty-five dollars and up; gold coin prices begin at about one hundred and fifty dollars and go as high as the market will bear.

To antique erotica jewelry and carvings, add these additional value factors:

- Rarity
- Market demand
- Circa date
- Signature (some Japanese and Chinese netsukes were signed)
- Partial or complete collection (value is added for a complete over a partially assembled collection)

Carvings

Many of the carvings you will be asked to appraise will be part of a classification known as tourist-trade or airport art. These are popular hardstone carvings of jade and its imitations—serpentine, quartz, and agate—representing likenesses of Kwan Yin, phoenix birds, eggs, frogs, and snuff bottles. Most will have been purchased from gem and mineral dealers, gift shops, boutiques, or Asian markets. These items retail from ten dollars for a more or less oval malachite egg to three hundred dollars for a 6¼-inch-high green serpentine jar with lid on a wooden stand. The serpentine jar is masquerading as a fine carving, but the discerning eye will appreciate that it is nothing special. The hallmarks of these commercial carved objects are their crude shaping, lack of detail, and glasslike polish. The dazzling polish is intended to divert your attention from the obvious poor quality of the carving.

Mass-produced carvings from Hong Kong, Taiwan, and China arrived in the wake of the introduction of power tools and crass commercialism to Asia. Where an apprentice in China used to spend ten

years learning his craft, he now spends only four. It was estimated recently that new factories in Beijing employ up to ten thousand men and women in this industry. Given the ocean of goods spilling onto the market, how does the appraiser tell the fantastic from the feeble? These are some standard guidelines:

1. Look at the carving in the same way you look at colored gemstones and judge its hue, tone, and color saturation.
2. Judge the appropriateness of the material to the subject.
3. Evaluate the luster or polish.
4. Look for an absence of undercutting, chips, and cracks.
5. Check the detailing. An excellent and expensive carving is finely detailed and finished on the front, back, and even on the base.
6. Look at the stand. Fine carvings deserve well-made and -fitted stands.

These are the basic criteria used to judge all hardstone carvings with additional value factors varying according to specific materials.

Jade Carvings

It is difficult to date jade. An authentic ancient piece would have come from a scientifically excavated tomb, but few jades on the market today have such provenance. Nevertheless, you will have clients bring you jade carvings they believe are ancient and ask your assessment and authentication.

If the item is said to be Chinese pre-1784 jadeite, be suspicious. The year 1784 marked the resumption of trade between China and Burma and the time when jadeite was introduced to China. The Chinese used only nephrite imported from Turkestan for carving until jadeite was introduced. Not until after 1880 did Chinese craftsmen start using jadeite for large ornamental pieces, and green jadeite censers, bowls, and vases were neither produced nor on the market until the turn of the twentieth century. Graduated necklaces of jadeite were not crafted in China earlier than 1900, and then they were made for Westerners, stylistic copies of the pearl necklaces popular at the time.

If you firmly believe that the jade carving you are appraising is antique, carefully examine it to see if raw edges or uneven texture is present, or if the engraved designs have loose ends. Since many antique jades were carved as ritual objects for divine forces, it was believed that each object must be absolutely perfect. The cutting of such objects was not rushed; each design was a model of perfection. Not all old jade is good jade, however, so do not be misled just because

an object is old, or by the fact that compared to latter-day mass-market carvings, the old designs look less faulty and less crude. Chinese antique jade carvings purported to be from the Ch'ien Lung period (1736–1795) will have no sharp corners and no raw edges, no matter what the subject executed by the carver, for during this period the art of gemstone carving reached its zenith in China.

These are general standards for judging jade carvings. First, examine all carvings under 10x magnification for quality, the main consideration. The better the jade quality, the higher the price of the carving. The toughness of jade makes it the ideal carving medium, with the finest quality jade generally used for cabochons or small carvings used in jewelry, and less costly grades of jade used for larger ornamental items. For carvings and cabochons of the same color and quality, the cabochon will command the higher price because of its higher luster. An exception is a one-of-a-kind carving.

Next, consider the following basic factors:

1. Is it jadeite or nephrite?
2. Color.
3. Translucency, texture, and finish.
4. Size of the finished object.
5. Is there effective use of shading and different colors in the host material to highlight the subject of the carving?
6. Look for uniformity of color versus pattern. Patterns may be multicolored, swirled, speckled, or mottled. A combination of colors and markings determines the desirability of patterned jade.
7. Have all the scratches been worked out? Is the carving clean and distinct?
8. Is the polish uniform? Be aware that there is a waxing process used by Asian craftspersons that involves soaking the item in molten wax and then buffing. This results in a very high polish.
9. Are fractures or other undesirable inclusions present? Both metallic and crystalline inclusions affect the price and lower the value.
10. Oxidation of the material lowers the value.
11. Does the piece have aesthetic appeal? Even if a piece is technically perfect, if it looks like a monstrosity, it may have little marketability.

If the jade carving you are appraising scores 100 in all the mentioned positive factors, consider whether its country of origin can be established beyond all reasonable doubt. If so, then value should be added.

Some jade experts believe that there is another, intangible factor which must be considered in valuing jade carvings. They think that an object should evoke some emotion from the beholder, even if it is just

admiration of the coloration. In the *Standard Catalog of Gems*, author John Sinkankas says that sophisticated collectors frequently judge gemstone carvings on the basis of "message, or appeal to the sensibilities. . . . If the message is weak, trivial, or nonexistent, artistic value declines to the point an object is judged only on ornamental or utilitarian value" (Sinkankas, 1968, 220).

When collecting jade prices, the appraiser should note the prices of both commercial-quality and fine-quality carvings at gem and mineral shows, art exhibitions, and related events. The magazine *Arts of Asia* lists important jade pieces sold at international auctions, and includes color photographs of the items, the auctioneer's estimates, and the actual selling prices.

Opal Carvings

To judge the value of an opal carving, first obtain its weight and multiply that amount by two. Kim Hurlbert, a Los Angeles dealer of opal carvings, explains that the rough, uncarved opal material is sold by the carat and that at least 50 percent of the original material is lost during carving. Estimating the cost of the uncarved material can be the starting point for your valuation. Keep in mind that this cost will vary according to the quality of the material. Other considerations in judging opal quality include color, degree of transparency, and workmanship. A fine play of color will determine over 50 percent of the final value. In addition, the more transparent, fine, and detailed the carving, the more valuable it will be.

Also, note the quality of the workmanship. Is the carving detailed? Is it finished correctly and polished all around? Does the carving show as well from the back as from the front? If so, then it has the mark of a fine crafter.

For price lists contact: Timeless Gem Designs, 606 South Hill St. Suite 302, Los Angeles, CA 90014; or, Opals International, Ltd., 7300 N.W. 23rd St., #401, Bethany, OK 73008.

Ivory Carvings

Much erroneous information about ivory carvings is circulated throughout the appraisal community. One lecturer to a group of jewelry appraisers made the statement that there are no archaic ivories because of the nature of the material. This is quite wrong, as the Walters Art Gallery, which houses one of the world's great collections of antique ivory objects, would be quick to point out. The Baltimore gallery has over eleven hundred ivory articles carved in the round and in relief and ranging in date from 4500 B.C. to A.D. 1900. The collection is extraordinary, comprising more than four hundred Far East-ern ivory netsukes as well as ancient Egyptian, Hellenistic, Roman, Minoan, Greek, and Etruscan period masterpieces.

In the Middle Ages, ivory was a favorite carving medium for important liturgical objects, many of which have survived. Ivory carvings from the Gothic period include mirrorback articles and jewelry boxes as well as diptychs and triptychs. Ivory was also a favorite material for carving and jewelry during the Art Nouveau period.

While it is true that few antique ivory carvings may be seen outside of museums, you need to know that these do exist and avail yourself of any opportunities for viewing. In seeing antique ivory at its finest and in observing genuine patina, you will not as easily be fooled by artificially aged ivory.

Color does not prove age nor does it identify ivory. While some ivories remain white, others age and darken to a color ranging from brown to mahogany. However, because it is commonly believed that all antique ivories darken, it has become standard practice in many countries to "age" ivories artificially by darkening them. Favorite methods used to age ivory include heating it under fire and burning incense on it, or soaking the ivory in coffee, tea, tobacco juice, or other substances that stain. One way to age ivory prematurely is with potassium permanganate. It will not fade and remains brown until it is sanded off. Similarly, because most old ivory develops cracks, new ivory is frequently heated to a high temperature and then plunged in cold water until it begins to crack and supposedly resembles aged ivory.

As a gemologist, you know that crosshatch markings identify elephant ivory. However, if the markings are absent, this does not necessarily mean the material is not ivory. Since many substitutes for ivory are on the market, positive identification of the material is the first order of business. Bone is the material most often confused with ivory and at first they do look similar. Bone, however, has some major differences. First, bone is hollow along its entire length and is a hard, white material without the soft, warm touch of ivory. Also, bone has tiny dots (capillary openings) that make it easy to distinguish from ivory. Horn, another ivory substitute, can be identified by its fibers. Artificial ivories include *ivoryite*, made of ivory or bone chips mixed with a resin and molded; *galolith*, a molded curd product known as *casein;* and celluloid, an early plastic invented in France about 1860 (and sometimes called French ivory) and popular in the 1930s. A clue to distinguishing celluloid is its lines, which wrap around the object, whereas lines in genuine elephant ivory cross. When valuing an item you believe is elephant ivory, consider that the elephant tusk is solid only along one-third of its

length (fig. 6-17). The most expensive items are carved from the solid part. Turn the item over and inspect the bottom. If it is hollow, has a hole, or has a hole that is capped, this is an indication of a lesser-priced item. Larger items are more expensive in general because they must be carved from larger tusks that cost more per kilo. Each increase in the size and weight of a carving raises its value. An analogy might be made to a 2-carat diamond that is worth more per carat than a 1-carat diamond of the same quality.

In today's market, the most valuable carvings are Japanese, if they can be authenticated (fig. 6-18). Next on the value scale are Chinese carvings, followed by Hong Kong copies of finely carved Japanese ivory carvings, if proven as Japanese copies (figs. 6-19 through 6-21). Standard Hong Kong mass-produced carvings are at the very bottom of the price list, joined by ivory carvings from India and Africa. These, according to ivory trader Edward J. Tripp, are not very salable in the United States. Ivory antique pieces like the billiard balls shown in figure 6-22, he says, are in a price class of their own.

What about damage—does a damaged carving have no value? Absolutely not, says Edward Tripp. If the damage does not detract from the overall carving, value it as you normally would and discount it 50 percent. "If damage to the carving is too extensive to be repaired," he states, "the item is worth only 5 percent of its normal value, or roughly the intrinsic value of the ivory."

Ivory chess sets are common items for valuation. Solid chess sets are priced 20 to 25 percent higher than are hollow ivory chess sets. Hollow sets have a cap on the bottom of each playing piece. Tripp claims that chess sets were commonly underpriced in terms of their fine ivory material until 1970, so if you are appraising a set that is several generations old, you may wish to take the former undervaluation into account when assessing current retail replacement. Explain the big price jump to your client.

Factors to be considered when valuing ivory carvings include the following:

1. What is the grade of the ivory: clean, cracked, damaged, or rotten?
2. Can you find crosshatch markings or nerve endings? (Nerve endings, large or small, are revealed as black dots.)
3. Is the item well carved, with details on both front and back?
4. Is this a rare subject or antique item?
5. Is the item signed? Netsukes are frequently signed, but signatures are reproduced for the mass market and should be authenticated by experts.

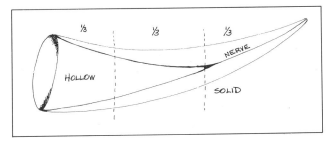

6-17. Elephant tusk ivory is solid for one third of the length. The most expensive carvings come from the solid portion.

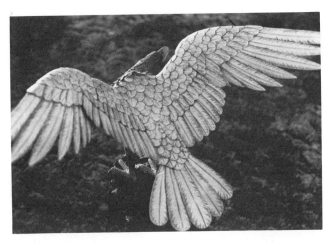

6-18. An exquisite sample of the ivory carver's art. This early Japanese carving, circa 1920, on a three-foot express base, has a wing span of 29 inches. (*Photograph courtesy of Edward J. Tripp Co.*)

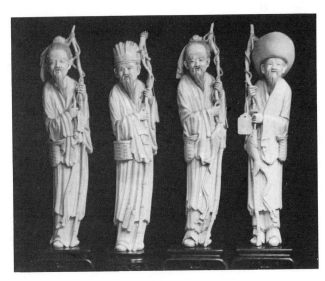

6-19. Old men and fishermen are frequent subjects for carvings from Hong Kong. The craftsmanship is crude. Figures range in size from 8 inches and up. (*Photograph courtesy of Edward J. Tripp Co.*)

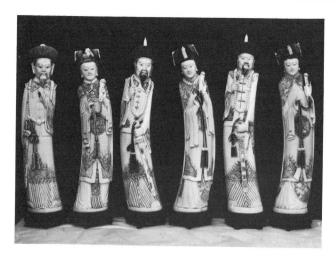

6-20. The kings and queens represented here show better Hong Kong craftsmanship. Details are colored for effect, and the figures range in size from 8 to 16 inches; some are 42 inches tall. (*Photograph courtesy of Edward J. Tripp Co.*)

For a price guide on ivory carvings, write to the Edward J. Tripp Company, Route 1, Box 161, Blue Ridge, TX 75004.

The prices given in table 6-2 are average prices for standard Hong Kong–made ivory figures of average quality and thickness, in perfect condition, and sold in the retail market. These prices are not definitive, as price always varies according to seller, market, and item.

In addition, take the following factors into consideration. Carved ivory scenes from mainland China range in price from one to three thousand dollars. For Japanese ivory figures that are proven authentic, add 150 to 200 percent to the value. Hong Kong copies of Japanese carvings are also worth an additional 75 to 100 percent increase in value. However, carvings from Africa and India are not as valuable: deduct 60 to 80 percent from the value of African pieces, and 40 to 60 percent from Indian ivory carvings (fig. 6-23).

Figure 6-24 shows carved, whole-tusk ivory. Top-grade unpolished whole elephant tusk is sold according to the weight of the whole tusk: one- to seven-pound tusks cost 80 dollars per pound; seven- to thirty-pound tusks cost 100 dollars per pound; and tusks weighing thirty to one hundred pounds sell for 120 dollars per pound. For polished and capped whole tusks, add 30 percent to the value. (This information was obtained from the U.S. Customs Auction, Brooklyn, New York.)

Hardstone Carvings and Gemstone Sculptures

Some of the most collectible and therefore most expensive carvings come from the German carvers of Idar-Oberstein, West Germany. Cameo engraving and carving was first introduced to Idar from Paris in

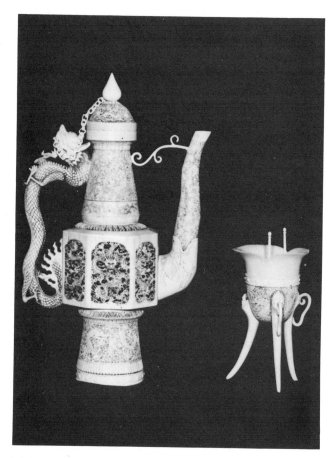

6-21. This 12-inch-tall item is an excellent example of Hong Kong quality workmanship. (*Photograph courtesy of Edward J. Tripp Co.*)

6-22. Brunswick ivory billiard balls, made in the United States, circa 1930. (*Photograph courtesy of Edward J. Tripp Co.*)

Table 6-2. Price Guide for Ivory Carvings*

Standing Figures

6″ 300–375
8″ 375–475
10″ 475–675
12″ 675–790
14″ 790–950
16″ 1,200–1,400
18″ 1,600–1,800
20″ 2,000–2,400
24″ 3,500–3,900
26″ 4,500–4,900
30″ 5,500–6,500
36″ 7,500–9,000
40″ 9,000–12,000
Ivory snuff bottles: 45–450
10″ seated king and queen, with screen: 3,500
6″ ivory chess set: 3,900–4,900
18″ necklace, 8–10mm round beads: 150–250
18″ necklace, 8mm flat beads: 75–140
18″ necklace, 3mm round beads: 60–120

Ivory Village View Bridges—Whole Tusk

27″	2,500–3,500
31″	2,800–3,800
33″	3,000–4,000
37″	4,200–5,200
38″	4,500–5,500
40″	8,000–10,000
49″	12,000–14,000

Doctor's Ladies

4″	115–150
5″	150–190
6″	210–240
7″	325–390
8″	390–475
10″	575–650
12″	750–890
20″	2,750–3,200

Ivory Concentric Billiard Balls

7 Layer	100–145
8 L	145–165
9 L	165–180
10 L	180–240
12 L	310–370
14 L	590–640
16 L	1,000–1,200
18 L	2,700–3,800
20 L	4,500–5,500
22 L	6,500–8,000
24 L	9,500–10,000

* *Note:* These prices, which are given in dollar amounts, should be used as guidelines only.

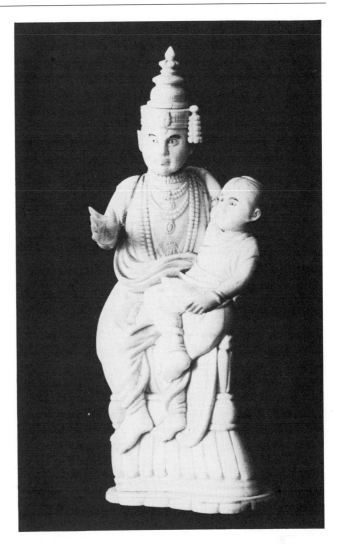

6-23. Indian carving of elephant ivory showing average-quality workmanship. Size, 6½ inches. (*Photograph courtesy of Edward J. Tripp Co.*)

6-24. Entire tusk carved with village scene and capped at the large end. Carved in Hong Kong. (*Photograph courtesy of Edward J. Tripp Co.*)

the first half of the nineteenth century. Given the concurrent development and growth of the gemcutting industry, it was inevitable that the creation of sculptures from gem materials should also develop. The Idar-Oberstein craftsmen's artistic expression, skills, and use of state-of-the-art tools have proved them masters of all lapidary activities.

Noted German carver Gerhard Becker says that the carving field has become extremely popular with an "astonishing trend of using more and more valuable rough for gem carving." This is true for sculpture as well as cameos, he believes. Becker considers movement and creativity important factors in estimating carving value. In addition, he believes that appraisers should be prepared to judge the artistic merits of gem sculptures. Of great importance is the harmony between a sculpture and the base upon which it is mounted. Becker innovated the use of bases made from finely carved rock crystal, smoky quartz, and agate (figs. 6-25 and 6-26). He instituted this practice partly to avoid the common way in which minerals and gems were combined.

Little attention is paid to the risk run by the carver who takes on the challenge of a new work, and Becker thinks that appraisers should make this a consideration: "There is a large investment of time by the sculptor with materials lost because of breakage or other problems that do not surface until the end of a carving project." Becker believes that the time required for the sculptor to consider the design, search for the correct material, and create the gem sculpture should be factored into final evaluation. Overall, Becker advises, "Take craftsmanship first and then materials into consideration" (figs. 6-27 and 6-28).

In determining value on gemstone carvings, consider the following factors:

1. Craftsmanship. How well did the artist render the subject or convey a discernible message?
2. Suitability of the material for the subject. How do the form and pattern of the material relate to the subject?
3. Color.
4. Luster. Evaluate the final polish and finish.
5. Signature. Remember that signed pieces are more valuable.
6. Desirability.
7. Function. Does it have a use besides decoration?
8. Provenance. If proven, it adds value.

When writing up the appraisal report for a hardstone carving, do not fail to note the following particulars:

6-25. Rock crystal elephant group on red jasper stand. *(Photograph courtesy of Gerhard Becker)*

6-26. Agate mallard duck alighting gracefully on a wave of rock crystal. *(Photograph courtesy of Gerhard Becker)*

1. Size of item in inches, giving height before width.
2. Subject matter, written description, and photograph.
3. If signature is present, indicate where it is positioned. Also, note if the signature has been authenticated.

6-27. A masterpiece of detail carving in agate. *(Photograph courtesy of Gerhard Becker)*

6-28. Rock crystal owl group perched on a stand of rough amethyst. *(Photograph courtesy of Gerhard Becker)*

4. Condition: new, old, repaired, old and not repaired, etc.
5. If the carving has been repaired, indicate the quality and extent of the repairs.

Repairs

The cautious appraiser will scan all carvings under ultraviolet light. Repairs will usually appear as yellowish, whitish, or very pale bluish blotches or lines, depending upon the bonding or cement used to mend any break or crack in the piece. Use longwave first and then shortwave ultraviolet light to conduct the examination, taking care that you are seeing actual former cracks, not the section where two pieces may have been joined together to form the carving. Fine and expensive items that have been repaired by a skilled restorer may resist UV detection and require examination under high magnification.

Diagram the damage, repair, or loss, on a separate sheet of paper and attach it to your report (as a plot of a gemstone would be attached to a gem report). Some still believe that a broken or repaired carving is valueless, but that is incorrect. If a carving has been restored in a proper and expert manner, it is once again marketable and therefore has value. The exceptions are carving and statues that cannot be repaired by the work of a good conservator, and items that have been allowed to chip and crack, or on which details and features have eroded owing to neglect and carelessness. These items are worth only the intrinsic value of the material.

Silver Flatware and Holloware

Appraisers of residential contents consistently claim jurisdiction over appraisals in this category. Rightly so, since the field of silver appraisals is vast and marked by many sub-specialties. Some appraisers work a lifetime to earn expertise in a small part of the world of silver articles. A few are willing to tackle the field from antique English sterling to contemporary American; these are the colleagues to whom you turn for advice when you have an unknown and very precious item to value.

In the real world of every day commerce and trade, however, you are far more likely to be given a set of Reed & Barton silver flatware, a pair of Towle candlesticks, or a Gorham tray to evaluate than you are to see great sterling antiquities. All your client will want from you is a correct answer to the question What's it worth? Before you can give an answer, you will need to identify the item and evaluate the metal content. Most homes have two kinds of silver, sterling and silverplate. You will need the following tools to iden-

tify and appraise common silver articles, just as you need proper tools to appraise gems and jewelry:

1. A 10x loupe or a strong hand lens.
2. Scales. You will need a spring scale for small objects and a balance scale for large ones.
3. Supply of plastic bags to hold small objects that are weighed on a spring scale by tying a loop at the top of the bag and hanging it onto the scale.
4. Tape measure.
5. Dropcloth for photographic background.
6. Camera and film.
7. Acid-test kit.

Silver is weighed in the troy system. One troy ounce of silver equals twenty pennyweight, and there are twelve ounces to the troy pound. See the appendix for weight tables on the troy system, pennyweight-to-gram, and troy-to-avoirdupois conversion. Also see *Analyzing Metal Fineness* in chapter 3 for more information on silver and silver fineness.

Sterling or solid-silver flatware is produced in varying weights, but there is no legal weight standard imposed on their manufacture. By trade custom, silverware is made in weights known as trade, medium, heavy, and extra heavy, with the difference in weight between each grade, on sterling forks, being about two ounces per dozen forks. Silverplated ware is made by electroplating silver onto a base metal. The thickness of the silverplate may be only about $\frac{1}{100,000}$ of an inch. The weight of each silverplated flatware piece means nothing to an appraiser, since there are no legal standards regulating the minimum amount of silver on silverplated tableware and the plating may be extremely light.

Any flatware items marked A1 or Standard, A1 Plus or A1X, AA, Double or XX, Triple or XXX, or Quadruple or XXXX have been silverplated. Sterling-silver articles should be stamped *sterling*. The key below explains other common markings:

- EPNS: Electroplate on nickel silver
- EPWM: Electroplate on white metal
- EPBM: Electroplate on Britannia metal
- EPC: Electroplate on copper
- EPB: Electroplate on brass

It is sometimes extremely difficult to read marks on silver holloware and flatware. For silver holloware, you need a strong light reflected off the back or rim of the item, preferably angled so that you can see the markings, which may be very faintly or lightly inscribed. On flatware knives, look at the junction of the blade and handle for marks. Other utensils should be stamped on the back of each handle.

Identifying the manufacturer is important; you will want to become familiar with the marks of the most common American makers. An excellent reference source is Dorothy Rainwater's *Encyclopedia of American Silver Manufacturers* (see the bibliography). If it is out of print, your library may have it.

To keep from overlooking essential details in evaluating silver articles, use the silver flatware and holloware worksheets illustrated in figures 6-29 and 6-30. On your worksheet, complete the following steps:

1. Identify the metal (sterling, silverplate, etc.).
2. Note trademarks or their absence.
3. List the weight of sterling items in troy ounces.
4. List the measurements of the item if it is holloware.
5. Note the approximate age or period of manufacture.
6. Note the pattern of silver flatware.
7. Note the decoration or motif on silver holloware.
8. Note the style and shape of holloware.
9. List any surface decoration, such as any engraving, inscription, or monogram.
10. Note any breaks, cracks, chips, and damage as well as any repairs that have been made.
11. Describe the mounts (e.g., ivory finials, ivory handles, etc.).
12. Photograph the items. If the items are flatware, photograph an entire place setting, making sure that the utensil ends showing the pattern are in the photo.

Some appraisers draw the flatware pattern onto their worksheet, which is nice but unnecessary if you can obtain a good close-up photograph. The photograph is a better aid to pattern identification and keeps the appraiser from having to rely upon memory for details in writing the description. Several indexes to pattern identification are available. One of the best known is the *Sterling Flatware Pattern Index*, published by the *Jewelers' Circular-Keystone* book club.

When evaluating silver, keep in mind that all items stamped and identified as sterling must be weighed. Some holloware and flatware can differ in price per ounce within the same style period. Bullion or spot silver prices do not affect antique silver, because its value lies in its age, quality, and design. Silverplate does not need to be weighed. In addition, weight has no bearing on the value of silver articles like religious artifacts, souvenir spoons, or wine and tobacco collections.

In her work *Early American Silver for the Cautious Collector*, Martha Gandy Fales offers practical and valuable help in dating silver holloware through the

6-29. Silver flatware appraisal worksheet.

SILVER FLATWARE APPRAISAL WORKSHEET

Appraisal for:_____ Date:_____

Purpose:_____ for _____

PATTERN:_____

Sterling_____ Silverplate_____ Other_____

No. Pcs.:

_____	Knives Dinner_____Place_____	@$_____	_____
_____	Forks Dinner_____Place_____	@$_____	_____
_____	Salad Forks	@$_____	_____
_____	Teaspoons	@$_____	_____
_____	Soup, Cream	@$_____	_____
_____	Soup, Boullion	@$_____	_____
_____	Butter Spreaders HH_____FH_____	@$_____	_____
_____	Cocktail Forks	@$_____	_____
_____	Iced Beverage	@$_____	_____
_____	Demitasse Spoon	@$_____	_____
_____	Fish Fork	@$_____	_____
_____	Fish Knife	@$_____	_____
_____	Fruit Knife	@$_____	_____
_____	Grapefruit/Melon Spoon	@$_____	_____
_____	Ice Cream Fork	@$_____	_____
_____	Salt Spoon, Individual	@$_____	_____
_____	Steak Knife	@$_____	_____
_____	Infant Feeding Spoon	@$_____	_____
_____	Baby Fork	@$_____	_____
_____	Baby Spoon	@$_____	_____
_____	Child's Fork	@$_____	_____
_____	Child's Knife	@$_____	_____
_____	Child's Spoon	@$_____	_____

TOTAL:_____

SERVING PIECES

_____	Berry, Casserole, Salad Spoon	@$_____	_____
_____	Butter Serving Knife	@$_____	_____
_____	Cake Knife	@$_____	_____
_____	Cheese Serving Knife	@$_____	_____
_____	Cold Meat or Buffet Fork	@$_____	_____
_____	Cream Sauce Ladle	@$_____	_____
_____	Flat Server	@$_____	_____
_____	Gravy Ladle	@$_____	_____
_____	Jelly Server	@$_____	_____
_____	Lemon Fork	@$_____	_____
_____	Olive, Pickle, Butter Fork	@$_____	_____
_____	Pie Server	@$_____	_____
_____	Salad or Serving Fork	@$_____	_____
_____	Salad or Serving Spoon	@$_____	_____
_____	Soup Ladle	@$_____	_____
_____	Sugar Spoon or Sugar Tongs	@$_____	_____
_____	Tablespoon	@$_____	_____
_____	Tablespoon, Pierced	@$_____	_____

TOTAL:_____

6-30. Silver holloware appraisal worksheet.

SILVER HOLLOWARE WORKSHEET

Appraisal for:_____ Date:_____

Purpose of Appraisal:_____for_____

No._____ Item:_____ Manufacturer:_____

 Pattern:_____ Hallmarks or Stampings:_____

 Weight:_____ Sterling Silver_____ Silverplate_____Other_____

 Height:_____ Width:_____ Diameter:_____ Depth:_____

 Body Shape:_____ Handle:_____ Finial:_____ Spouts:_____ Base/Feet:_____

 Decorative Motif:_____

 Repairs:_____

 Description of Object:

 Estimated Value:

No._____ Item:_____ Manufacturer:_____

 Pattern:_____ Hallmarks or Stampings:_____

 Weight:_____ Sterling Silver_____ Silverplate_____ Other_____

 Height:_____ Width:_____ Diameter:_____Depth:_____

 Body Shape:_____ Handle:_____ Finial:_____ Spouts:_____ Base/Feet:_____

 Decorative Motif:_____

 Repairs:_____

 Description of Object:

 Estimated Value:

Resources and References of Value:

finials, thumbpieces, spouts, handles, feet, lids, and bodies used. By familiarizing yourself with styles, you will be able to recognize if you have something extraordinary to appraise. Some silver terms, motifs, and styles are illustrated in figures 6-31 and 6-32. Fales reminds us that "sterling" was not stamped on American silver until about 1850 and the word "coin" was used on silver from about 1830–1860.

The majority of these appraisals, however, will concern the current replacement price of contemporary American-made silver flatware and holloware. To find this figure, the appraiser needs to use proven market-research methods: obtaining the manufacturer's suggested retail prices from individual silver companies and department stores; finding privately published silver price guides; and consulting trade journals, auction catalogs, antique stores and flea markets, and prices from estate sales. Auction hammer price is *one* useful reference that can be used to determine fair market value.

In an estate liquidation, used sterling flatware is commonly valued at either the scrap value of the silver, when sold to dealers in bulk according to the New York price quote for silver per troy ounce on that day; or the price a dealer of used silver will pay for a particular pattern as of the date of the appraisal. One of the largest nationally known dealers of used silver is the Walter Drake Company, which buys silver with a published price list guaranteed for thirty days. The company is located in the Drake Building, Colorado Springs, CO 80940.

The prices of sterling-silver and silverplated flatware have fallen dramatically since their highs in 1980–81. In 1981, some sterling-silver flatware was valued at over five hundred dollars per place setting. Now the same flatware is worth about ninety-nine to one hundred and twenty dollars per place setting. Holloware has also plunged in price.

Silverplate

If you are evaluating silverplated goods, the quality of the article is determined by these points: manufacturer; base metal; and quality of the design in terms of aesthetics and technique.

The most important factor, the manufacturer, adds

6-31. Silver terms, styles, and motifs.

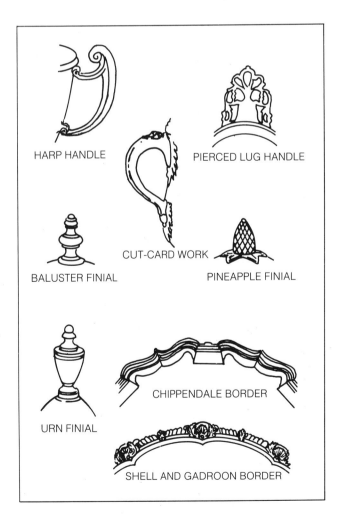

6-32. Further examples of silver terms, styles, and motifs.

value to the piece if the company is one collectors are interested in or is known for style and quality. Look and note the metal. Silverplating on copper is better and more expensive than silverplating on white metal. Is the design pleasing and well executed, with the border (usually cast and applied) cleanly detailed? Silverplate is inexpensive compared to sterling, but silverplate will have added value if the quality is extraordinary, or if the article has historical or collectible value.

When the examination of the silverplated items is finished, your client will nearly always ask: "Should I have my silver replated?" Read that: Will replating enhance the value? Your reply is that copper showing through silverplate is called "bleeding" and is commonly considered very attractive and desirable. If the client dislikes this look and wants the item to look new, he or she should consider whether the piece is worth the expense of replating. Check with a silver replater to compare the price of replating against the price of a comparable new piece.

If your clients are getting an appraisal of flatware for insurance, counsel them to ask their insurance agent what value the insurance company will accept. Explain that major silver manufacturers have normal retail prices as well as frequent sales of their flatware, with standard discounts of up to 70 percent off the list prices. The client and agent should agree on the price to be used for replacement and in so doing keep you clear of any future settlement discord.

CHAPTER 7

LEGAL AND ETHICAL ASPECTS OF APPRAISING

Appraisers have both a legal and an ethical responsibility toward their clients. The relationship between an appraiser and a client is not based on the principle of *caveat emptor* (let the buyer beware), but instead is founded on confidence and trust. It is as important to the appraiser as it is to the client that the appraiser holds a reputation for being professional and scrupulous.

In developing a code of ethics and principles of appraisal practice, the American Society of Appraisers has defined the relationship between the appraiser and client as follows:

As the vocation of property appraisals has developed during past decades from a business occupation into a profession, certain concepts have emerged and become clear. . . .

Because of the specialized knowledge and abilities required of the appraiser which are not possessed by the layman, there has now come to be established a fiduciary relationship between him and those who rely upon his findings (ASA, 1968, foreword).

A fiduciary relationship is one that is based on trust. For the appraiser, it connotes serious obligations, both spoken and written, to clients, third parties, and to the public. Moreover, a fiduciary responsibility is a duty imposed by law, one that a trustee owes to a beneficiary of the trust; an officer or director of a corporation owes to the corporation and its stockholders; a lawyer owes to his client; an employee owes to his employer; and an appraiser owes to his client. Fiduciary duties are not limited to these situations, but are present in every relationship founded on faith and trust.

One fiduciary obligation for the appraiser is keeping the nature of an appraisal assignment, as well as the client's name, confidential. Ethics deem it improper to disclose either of these, unless the client approves of disclosure, clearly has no interest in keeping the fact of appraisal confidential, or unless the appraiser is required by law to disclose the fact of the engagement to make an appraisal. It is also improper for an appraiser to reveal the amount of valuation of a property without the client's permission, unless required to do so by law. All of the major appraisal societies and gemological organizations, and many industry trade groups have a code of ethics.

Fiduciary obligation extends beyond the original client. On occasion, an appraisal report may be given by the client to a third party for use, such as to an attorney to proceed with settlement of common property. The third party may or may not be known to the appraiser, but has as much right to rely on the validity and objectivity of the appraiser's findings as does the client.

Another example of third-party usage is an appraisal report completed for insurance replacement. If the jewelry item is subsequently sold by the present owner to someone else, both the jewelry and the appraisal will be given to the new owner. In this context, the appraiser is now in a fiduciary relationship with a third party, the new owner of the property.

When the welfare of the general public is involved in the final value judgment of an item, the appraiser has obligations and responsibilities to the general public that supersede the obligation to the client. This position of trust is broad and ranges from assignments involving depositors in financial institutions—such as appraisals used to make collateral loans—to publicly displayed values of personal prop-

erty offered for sale to the general public, as in appraisals for independent auction houses and for auctions of federal, state, and city surplus property.

In agreeing to a fiduciary relationship, the appraiser has acceded to a personal and professional incumbency. The concomitant legal and moral liabilities must be grasped completely, especially by jewelers and appraisers who continue to appraise in any old way. They are prime targets for a lawsuit.

The Appraiser's Role in Gemstone Barter

There is a tradition of bartering in this country that stretches back to colonial New England. By definition, *bartering* is exchanging goods or services in return for other goods or services; in other words, trading. Implicit in this definition is that the goods or services traded be of equal value. A bold use of the idea can be traced to Peter Minuit, who successfully completed an incredible exchange when he bought Manhattan Island for trinkets valued at twenty-four dollars. Although the use of gemstones and jewelry has a long tradition as a medium of barter, such trading was given new emphasis a few years ago during a real-estate-for-jewelry barter era. While encountered by the appraiser less frequently today than in the early 1980s, gemstone barters are still around. Appraisers called in to estimate value in this market must research prices diligently.

The concept of gemstone exchange for other property is valid only if certain criteria are met. The gemstones must be of a specific minimum quality (in recent years, the full range of qualities has been used in gemstone exchanges, from gems to junk), and all parties involved must be aware that the market is highly competitive and that the sale of gemstones can be difficult and time consuming.

While it is true that some high-quality gemstones appreciate rapidly, chances are that the gemstones involved will be of commercial grade or less and may be difficult to liquidate. Even good gems may have a very small liquid market—if they are very large and not suitable for use in jewelry, their resale potential will be limited. And, although medium to low-medium quality gems that can be used in jewelry are generally easier to liquidate, resale of the gems may nonetheless be difficult because most of these stones are used in the manufacture of jewelry, a very competitive market. At the bottom of the barrel are barter gemstones of such poor quality that they can only be used in the hobby market. These are frequently compared to "fishbowl gravel" and are sold by the kilo (one kilogram equals 5,000 carats). Unfortunately,

most of the barter material comes from this latter group of stones.

The responsible appraiser will make every effort to inform and educate his client about the possibilities for sale or best use of the property. The client will look to the appraiser for an explanation of all applicable markets.

If you are called upon to perform an appraisal for barter, observe the following precautions:

1. Suggest that your client obtain an appraisal from at least two independent gemological laboratories or independent gemologists.
2. Counsel your client not to accept an appraisal from a source connected in any way with the party attempting to trade the gems.
3. Do not put a dollar figure on the gems based on projected appreciation of the gems in a vague future market. No one can predict their future value; the gemstone market is too volatile.

If your client cannot be dissuaded from participating in an exchange of property for gemstones (usually your client will be the party with the real estate), try to match the levels of the appraisals for all parties involved. The most common event is for either party to the exchange to submit a grossly overinflated appraisal, obtained from an unethical appraiser, and then offer his or her part of the deal at a fraction of the appraised value. This kind of offer is calculated to make other parties believe that they are getting more in exchange than they are trading. Any appraiser who is involved in this kind of transaction is unethical. The ethical appraiser will expose the true nature of the deal to the client and recommend that both properties be revalued to represent actual values to be traded for actual values.

It takes great skill as an appraiser and diplomat to make sure that the client receives a correct interpretation of the marketability of any gemstones offered in trade. If parcels of stones are involved, each gemstone must be appraised; the price of one stone multiplied by the number of stones in the parcel is *not* a true or representative lot valuation. This kind of appraisal requires deep and careful research.

Many stones will arrive for your evaluation encased in plastic or sealed containers. You cannot evaluate gemstones unless they are removed from these containers. Advise your clients immediately of this fact and do not be a party to any appraisal in which you cannot personally handle and examine the gemstones to evaluate them in your prescribed manner. You are courting litigation if you do otherwise. If your client gives you permission to remove the gems from their

containers, carry out the appraisal as you would normally, but make sure that you remove and examine the gemstones in front of the client and before another witness, if possible, so there will be no question later of whether the stones are the same ones the client originally brought into your office. Plot the stones (colored gems, too) in front of the client and give him or her a copy of the plot if the stones are left in your hands while you prepare the complete report. When the client returns to retrieve the stone(s), reverse the procedure by comparing the plot he has to the stone you are showing him in the microscope. You want no future cries of "stone switching" from a client.

Investment Gems—Real or Racket?

Plenty of unfortunate people suffered serious financial loss during the investment-gems craze of the early 1980s. Many did not want to believe the bad news when told that their "investments" were of poor quality and most thought themselves too smart to be conned in such a manner. All were victims of the maxim, "You can't beat a man at his own game," because they accepted the seller's valuation of quality and failed to have the gemstones appraised *before* money changed hands. Of course, each victim was hopeful that this investment—which sounded too good too be true—was true. Being an educated individual was no guarantee of invincibility to the hype; the list of those taken in included doctors, lawyers, and members of all professions. A business valuation appraiser confided that he, too, was once relieved of several thousand dollars by a gemstone investment firm. The gemstones he bought later turned out to be worth a fraction of their stated "value."

The gemstone investment firms were, for the most part, boiler-room operations run by individuals who knew nothing about gems and jewelry business but a lot about high-pressure selling. They played upon the desires of collectors and others who wanted to take advantage of the huge increases in gem and precious-metal valuations and touted gemstones as a buffer against the rampant inflation of the time. High-pressure sellers made convincing arguments by pointing to such events as Sotheby's April 1983 New York jewelry sale, which brought a world record for a jewelry auction with such lots as a Cartier Art Deco sapphire and diamond bracelet and matching clip that sold for over half a million dollars—eighty thousand dollars beyond its high estimate. It is no wonder that everyone wanted to jump onto this fast-moving gravy train. This included financial consultants who advised their clients to use gems and jewelry as tax shelters. Unfortunately, only a small percentage of players came out winners.

With the hysteria over, little apparent gemstone investment market is left. Financial advisors have reversed direction and now agree that pieces should be purchased for love of the workmanship and style because should markets collapse, tastes change, precious metals tumble, or disaster strike, the beauty of the jewelry will be the only consolation left to the purchaser. Responsible jewelers and professional appraisers, of course, have always advised their clients to take this course.

How can an appraiser help the client turn purchases into cash? Liquidity has always been a major obstacle for gemstone investors. Liquidating gems requires market exposure, price, and time. If your clients have patience, you may be able to assist them by acting as their broker. One route is to send the loose gemstones or finished jewelry to a major auction house such as Sotheby's or Christie's, whose worldwide locations will give your client the advantage of selling in a foreign market. The best option for appraisers who work at home is to use the services of a telecommunications network (see chapter 4). By using a network of this kind, you can list your client's articles for review by hundreds of network subscribers all over the United States. Most of those who have used telecommunications have only praise for electronic buying and selling.

The effects of the investment gemstone craze were not lost on the jewelry industry, which has reacted, through the Jewelers Vigilance Committee, by preparing and submitting new *Guides for the Jewelry Industry* to the Federal Trade Commission for publication in the Federal Registry (see bibliography). The guides represent the industry's wish to impose restrictions on those who sell gemstones for investment purposes and those who appraise and certify them.

Major changes in the investment section of the *Guides* state that it is an "unfair trade practice to use the words *investment gems, investment grade, investment quality* [italics added], or similar terms when such words or terms imply that specific gemstones merit a classification or grade superior to, more desirable than, or essentially different from the grades of gemstones marketed for use in jewelry."

It is also considered unfair trade practice to sell or offer to sell an industry product as a financial investment unless the seller discloses, among other facts, "that appreciation or profit cannot be assured," and "no organized market exists for the resale of industry products by private owners" (Federal Trade Commission, 1986, 23.1 (d), 2).

The *Guides* also prohibit, for obvious reasons, the use of sealed containers in the sale of gemstones for investment. One section that deals with the sub-rosa links of certain appraisers to sellers of gemstones, states:

> It is an unfair trade practice to describe, identify, or refer to an industry product as "certified" or use any other word or words of similar meaning or import, unless:
> The identity of the certifier and the specific manners of qualities certified are clearly disclosed; and
> The certifier is qualified to certify as to such matters and qualities, has examined the specific product, and has made such certification; and
> Full disclosure is made of any existing business relationship, association or affiliation of the certifier with the firm selling or offering for sale the industry product; and
> There is available to the purchaser a certificate setting forth clearly and nondeceptively the name of the certifier and the matters and qualities certified (Federal Trade Commission, 1986, 23. 1 (c), 2).

Survival Techniques for Expert Witnesses

The title of professional jewelry appraiser involves you in more than researching values, and signals additional fiduciary responsibilities and obligations. You are presumed to be expert in your field by the public, and as such can be called into court to give testimony on valuation.

Take a course in business law from your local community college. You will gain a market advantage if you do, because it is no longer enough for an appraiser to be an expert in art or jewelry valuation. In addition to knowing current prices and values, you are expected to be familiar with laws regulating taxes, insurance, and divorce. While it is unpleasant to get caught in any legal cross-fire, you can mentally prepare for court by understanding that the nature of your business exposes you to litigation, which is burgeoning in this country. Most appraisers are called to the witness stand at some point in their career, either as expert in defense of their own reports, or to disprove someone else's valuation.

Courts have ruled that qualified experts can be compelled to testify when they have knowledge pertinent to the case. Therefore, if you refuse to appear voluntarily when summoned, you can be subpoenaed. Do not let this happen—depending upon local statutes, being subpoenaed may mean that you receive little or no fee. Employment as expert, however, either in court or in giving a disposition, entitles you to compensation. The common practice is to charge either a half-day or full day's regular fee for your services.

If you are rendering appraisals for divorce cases, you will find substantial court work generated. One and sometimes both parties involved may have a grossly exaggerated idea of what used jewelry in the average estate is worth. The wife in the case will usually view the jewelry as separate property. The husband will generally remember only that thousands of dollars were spent on jewelry during the marriage and, as he recalls the occasions, that they were not intended as gifts but as family investments. He calculates the inflated price of other goods and services and assumes that the jewelry must be worth a bundle. Or, if he fancies himself to be educated about market values and jewelry sold in a secondary market, he will probably believe the jewelry is worth at least half of its original purchase price. This can hardly be the case when your appraisal provides the fair market value of the goods. If the total value of the items you examine is lower than the principals in the case expected, you will be called to justify, validate, and substantiate your numbers—in an atmosphere of hostility. Understanding that such situations will probably result in litigation should make a difference in how you appraise. This knowledge should not make a difference in your bottom-line number, but it should make a difference in the thoroughness of your research and documentation. Since most divorces take six to nine months to come to trial after filing, you will need to review all the market circumstances that affected the valuation before you appear as an expert witness.

Of course, divorce cases are not the only ones that involve angry and hostile clients. You could be called as witness for a jeweler suing another jeweler; a customer suing a jeweler; to identify jewelry in damage claims, stone-switching, or theft charges; and to value items in an inheritance case. Almost any transaction of gems and jewelry could involve you with the judicial system.

The event usually starts with a call from an attorney's secretary telling you your testimony is needed (for a mutual client) on a document you supplied weeks, months, even years ago. Moreover, you are expected to appear in court at 9:00 A.M. the next morning. In some circumstances, you will be asked to give a deposition—the testimony of a witness taken out of court before a person authorized to administer oaths. But in most cases you will have to appear in court at the appointed day and time with little advance warning. Ask your attorney (the one for whom you are testifying) for a pretrial conference. To do your job properly, you must be acquainted with what is expected of you. You need to know what creden-

tials will qualify you as an expert witness in the eyes of the court. You need information from the attorney on what you should expect in both direct and cross-examination. Of course, it is absolutely essential that you know the purpose and function of the appraisal so that you can explain the values given and be able to anticipate questions that will probably be presented by the adversary. Make sure you can spell and accurately define the technical terms you will use during your testimony. Be certain that your definition is consistent with technical dictionaries, and that you have read these definitions. Cross-examiners sometimes attempt to embarrass experts on these points.

If you have never testified or been in a trial before, and have a few days to prepare before you testify, it is worthwhile to visit a courthouse and familiarize yourself with the courtroom. Find out where each party sits and observe courtroom protocol so that you will know what will be expected of you. You will learn that you should stand when the judge arrives or leaves the bench; that you should not leave the witness stand without asking the judge's permission or being excused; and that if you wish to leave the courtroom after you have given testimony, that you should have your attorney ask the court's permission.

Prepare a list of questions that your attorney will ask you during the questioning to establish your qualifications as an expert. A list might include the following:

1. What is your name?
2. What is your present occupation?
3. How long have you been an appraiser?
4. What experience do you have in valuing the particular types of items?
5. How many times have you previously testified as expert witness?
6. To which professional appraisal organizations do you belong?
7. How did you value the articles?
8. What steps did you take to arrive at your valuation?
9. How would you define fair market value?

Also see the *Witness Testimony* section of this chapter for an example of typical questioning. You also need to take a copy of your qualifications to court. Regardless of the number of times you may have testified for a particular attorney, or how well he or she knows you personally, it is wise to have an extra list of your qualifications with you. Often the attorney will need to review your expertise quickly, or the attorney may show the list to the opposing counsel before handing it to the court stenographer to enter into record.

William F. Causey, litigation lawyer and adjunct professor of trial practice at Georgetown University, recommends that you advise your attorney to refuse to allow an opposing attorney to prevent your qualifications and background from being heard in court. He is referring to a technique in which the opposing counsel will offer to the judge to "concede" your qualifications as soon as you take the witness stand. In doing so, opposing counsel will keep the jury from hearing about your background and expertise.

"A jury rarely knows much about art, antiques or jewelry," Causey says, "and your judgment may be accepted more on the strength of expert opinion." He adds: "Your credentials are your power, your influence."

In a paper prepared by Houston attorney Robert M. Welch, Jr., for Southern Methodist University, emphasis is given to methods used to disqualify or discredit witnesses:

Cross-examination of the opponent's expert should begin with an inquiry into his or her qualifications. However, where the opponent's expert is obviously qualified, it is best to minimize the expert's qualifications and offer to stipulate that the expert is qualified. (By the same token, it is better to reject the opponent's offer to stipulate if one's own expert has credentials that will impress the trier of fact.) The attorney should probe into the expert's background and experience in order to find weaknesses that will disqualify the expert or at least show that his or her credentials are inferior to those of the attorney's own expert, or that bias exists (Welch, 1980).

A trial is a battle with you as one of the targets. Opposing counsel will search for any flaw in your valuation that can be used against you. Welch adds that the attorney should challenge an expert's testimony for accuracy if any apparent errors in the appraisal are found, or if an analysis of the property is incomplete or faulty in any manner.

If you believe that your answers will be too cautious for the opposition to make you look unqualified or make the jurors doubt your expertise, think about this: A lot depends on the line of questioning the opposing attorney takes, as well as his or her tone of voice and any innuendo the counsel tries to make about your age or character. Some attorneys have a gift for this and will try to discredit you by drawing the court's attention to any aspect about you that could be a common basis for prejudice.

Stephen A. Blass, a counselor at law based in Miami, was making this very point to a group of appraisers when one woman commented that she did not believe or understand how an attorney could

make it difficult for her to testify as an expert witness. Blass pointed out that an attorney could draw the jury's attention to the appraiser's youth and beauty by asking such questions as "How did a pretty young lady like you get involved in such a business?" or by commenting on how attractive she looked in court. Moreover, in using a condescending tone of voice or in appearing amused by the witness's answers, the opposing counsel can give a jury the message that the witness's testimony is not to be taken seriously. The games are not just for women witnesses. Female attorneys can be as ruthless as their male counterparts. A young jewelry appraiser followed Blass's comments with tales of his own court adventures. He recounted how a shrewd woman lawyer tried to discredit him as witness and cast doubts about his ability by asking questions about his age ("Aren't you awfully young to be in such a position of trust?"), and about his Italian heritage.

Can you stop this as a witness? Yes. If your attorney does not stop the harassment, you can turn to the judge and say: "Your Honor, is this pertinent to my testimony?" Or, you can recognize the game for the high courtroom drama it is, stay calm, and answer the questions with a yes or no.

Twenty Rules For Expert Witnesses:

1. Listen carefully. You cannot answer what you have not heard.
2. Understand. If you do not understand, ask for the question to be repeated or rephrased.
3. Pause. Reflect before answering. A pause conveys a sense of thoughtfulness and thoroughness.
4. Never guess. If you do not know, say so.
5. Do not volunteer information. Answer only the questions that are asked.
6. If interrupted, stop and wait. Attorneys will use the interruption to divert attention from your answer, but sometimes judges may ask questions.
7. Answer loudly and clearly. Address the courtroom. Speaking clearly shows confidence.
8. Beware of mental math. While you are calculating—often erroneously—you will look indecisive. Carry a pocket calculator.
9. Stay calm. Opposing attorneys will try to rattle you.
10. Be independent. State your professional opinion, even if it is not what the attorney wants to hear.
11. Speak to the jury. The final decision rests with them.
12. Admit you have prepared your testimony. This shows your professionalism to the jury and also shows the opposing attorney that you are prepared.

13. Admit that you are being paid. This is your professional prerogative. But be sure it is not a contingency fee.
14. Be confident. Relay information in a positive manner.
15. Know all documents and evidence. Fumbling with notes or documents can make you appear indecisive and unprofessional.
16. Keep it simple. The jury must understand what you are saying. Avoid obscure and esoteric terms.
17. Define terms accurately. If you are talking about a pavilion on a diamond, explain that this is the bottom portion of the stone.
18. Ask to be allowed to answer questions. Remember this when the opposing attorney interrupts you, or when you feel you need to explain your answer. However, do not ramble when given the opportunity to speak.
19. Be thorough. Make sure the attorney on your side knows what is important to ask you so that you provide a complete explanation.
20. Give definitive, thoughtful, and concrete answers so that you appear to be the expert you are (Causey, 1986, personal interview).

Witness Testimony

The following is an excerpt from actual testimony given by an expert witness during a divorce trial by jury. The testimony illustrates a typical line of questioning and successful answering by the witness—clear, brief, and to the point.

Q. State your name and occupation.
A. Anna Miller, gems and jewelry appraiser.
Q. How long have you been appraising?
A. About eighteen years.
Q. What are your qualifications?
A. I am a graduate gemologist of the Gemological Institute of America, former wholesaler and retailer of gems and jewelry with a full-time jewelry appraising business for the past ten years.
Q. Do you belong to any appraisal organizations?
A. Yes. I am a senior member of the American Society of Appraisers, a member of the National Association of Jewelry Appraisers, a master gemologist appraiser designate of the Accredited Gemologist Association, and a member of the Appraisers Association of America. I am a member of numerous other appraisal-related organizations, in which I hold either a local or national office.
Q. Is this a fair and accurate description of your qualifications which is appended to this appraisal report?

A. Yes.

Q. Were you paid $X as a fee for the appraisal?

A. Yes.

Q. Is this a reasonable fee?

A. Yes.

Q. Pass the witness.

Q. How did you go about obtaining these values you have listed on this report?

A. These items have been researched for fair market value. Each item was examined, identified, and researched for comparable items in the most appropriate market for the goods.

Q. What is fair market value?

A. The price an item will bring between a willing buyer and a willing seller, neither under compulsion to buy or sell and both having all relevant information.

Q. Do you mean that you appraised *each* object?

A. Yes. Each individual object.

Q. How many items is that?

A. A total of six hundred items.

Q. How long did it take you to appraise each object?

A. That depended upon the item.

Q. Isn't a diamond just a diamond?

A. No. It is not.

Q. What makes a difference?

A. Diamonds, like colored gemstones, have quality grades and fine quality diamonds and colored gemstones are more expensive than commercial or lesser-quality material. Fine designer quality jewelry is more desirable than commercial quality jewelry, etc.

Q. But after you look at each piece, isn't that all you do, just go back to your office and write it down?

A. No. It is not.

Q. Well, tell us what you do next.

A. First, each item with gemstones has gemstones identified, graded and measured; metal fineness is confirmed through acid testing; weights of metals are confirmed through individual weighing of items; any extraordinary jewelry is confirmed through markings or stampings, or hallmarks of manufacturer. All items are individually researched as to their value in the appropriate secondary market.

Q. Didn't you appraise these items in the aggregate and take them into consideration as a total unit?

A. No.

Q. Well, did you take into consideration any fees involved in selling these items; is there any overhead or profit margin in your evaluation?

A. That, sir, would be covered by mark-ups in a new jewelry market and jewelry that would be resold by a retailer. It is usually not a factor in estates such as this. However, on the jewelry which might be sold at auction, fees have been taken into account, where it is appropriate to do so.

Q. How much are you being paid for your testimony today?

A. I'm not being paid for my testimony.

Q. What do you mean? Do you mean you are *not* being paid?

A. I'm being paid my regular fee for my time spent in court. My testimony is not for sale.

Total time on the witness stand in this case was over an hour. When the opposing attorney repeats or rephrases the same question over and over, he or she is attempting to confuse or anger the witness. The witness must be patient and cooperative under the scrutiny of the jury, who may decide the case partly on the basis of the appraiser's professionalism and credibility. The witness must remain in control of the situation even when confronted by an aggressive and belligerent adversary.

If you make a mistake in answering, admit it immediately. If the opposing lawyer traps you into agreeing to a statement that you know is not true, correct the mistake immediately, before you become enmeshed in confusing and embarrassing explanations that can compromise your credibility.

Brent L. Burg, a former judge, gives this advice to expert witnesses:

If you are asked on the stand about the work you did not do because the client refused to pay for it, all you can answer is: "I was not asked to provide that information, only the information that I have provided."

Jurors draw upon their own experiences when they make a decision. They don't hear everything that is said and only one thing usually sticks in their mind. They will make up their mind about you as an expert witness and your personality will sell your testimony. But, give an *opinion*, don't be an advocate.

If you have to give testimony against another expert witness and the opposing attorney says to you, "How do you account for the difference in prices?" Your answer could be: "This is my opinion."

Do not malign the other expert witnesses. Some jurors develop a liking for, and may identify with, the other witness, therefore they may take it personally if you besmirch him or her.

Never lie. If you don't know something, say so.

Do not get angry or lose your temper. If you do, you lose credibility (Burg, 1986, personal interview).

Opponent Experts

If there are experts on the opponent's side, the attorney should apprise you of this fact as soon as their names are known. Interrogatories (questions asked in writing) will be sent to the opposing side asking the name and addresses of the experts who will be used at trial and whether they have prepared any written appraisal reports. Sometimes appraisal reports are not prepared until just before trial, to avoid discovery.

When you know who the opposing expert is and can find out about his or her background and qualifications, you will be able to offer pertinent questions for the attorney to use in drawing attention to any weaknesses of the other's valuation or expertise. In this way, you can help your attorney gain a psychological advantage.

Opportunities for Witnesses

If you have qualified as an expert witness and given testimony in trials enough to know whether you can tolerate (even enjoy) the experience, be aware that there is a growing need for expert witnesses in this country. You may be able to parlay witnessing into a lucrative part of your appraisal business. In today's litigious society, specialists who testify for a fee make up an expanding industry. Fees for trial preparation range from an hourly low of twenty dollars for arboriculture experts to two hundred and fifty dollars for physicians. Daily fees for court testimonies can add up to two thousand dollars and more. Gems and jewelry experts can earn from five hundred to fifteen hundred dollars per day depending upon geographical area, level of experience, profile in the industry, and ability to handle the job. Being a paid witness is ideal for retirees who have expertise to market. You can build a clientele by advertising in legal trade papers, which may have a special classified advertisements section. The IRS also hires experts to testify, and according to those who have worked for them, the pay ranges from seven hundred to over a thousand dollars per day.

A group of people called jury selection specialists investigate prospective jurors for attorneys to find those best suited for a jury panel. Usually trained psychologists, the investigators observe how prospective jurors respond to questions to ascertain the truthfulness of the answers. These clues can be applied to expert witnesses as well and are helpful to review whether you will be a one-time witness or plan to make it a sideline of your business: The clues to truthfulness include the juror's choice of words, the immediacy of response, and how well eye contact is maintained. Anxiety is revealed through unfinished sentences, deep breathing, and blocked or disjointed thoughts. A loud voice indicates a tendency to be domineering.

If you wish to read or purchase a copy of your testimony, tell the court reporter that you want a copy of the transcript. The usual charge is approximately three dollars and fifty cents per page. The reporter can look back at the records and estimate how many pages of testimony you have given. It is interesting to review your own testimony and especially helpful to recognize where your answers to cross examination could have been more succinct. This review leads to more careful and professional responses next time.

Dressing for Court Appearances

Although it is irrational, people judge you by the way you dress. Before you are to appear in court, consider whether what you plan to wear will give you a professional image—it is important to do so. Tailored, conservative dress will give you maximum credibility with the jury and judge. Wear a dark business suit, a white shirt or blouse, conservative shoes, a dark tie, and dark belt, and be as neat and well groomed as possible. Do not wear loud clothing or white shoes. Many psychological studies have been conducted on how the different kinds of clothing people wear in court affect the jury. Lawyers say that brightly colored clothing may distract juries so that they focus on what the witness is wearing, not saying. Similarly, do not wear a sports jacket and slacks; wear a business suit. Dressing appropriately will help your credibility, your appeal, and will make the jury think more highly of you. You are an expert and a professional—look like one.

Attorneys from coast to coast agree that witnesses should leave their expensive jewelry at home. If you appear in court wearing diamond rings and an eight-thousand-dollar Rolex Presidential wristwatch, you may unintentionally antagonize a juror who holds a minimum-wage job. Jurors may become prejudiced and resentful if they see you sitting in the witness stand wearing obviously expensive jewelry while discussing your fee schedule.

One counselor, ever mindful of public and peer scrutiny, tells about the time he was going to the Texas State Capitol to talk with some people about running for state office. His own advisors told him not to wear any rings and to make sure he wore a plain watch with a leather band. He was puzzled, "Why?" he asked. "Because Republicans don't trust flashy jewelry," was the carefully considered reply. Neither do jurors.

Avoiding Fee-Collection Problems

The golden rule for appraisers has become "get your money up front." If that is impossible, at least get a retainer. Few of us can afford to work without being paid—as one Houston attorney so eloquently expressed it: "We are not in this for the art form."

Getting paid can be a problem. Depending upon the individual case and the economic conditions in your area, obtaining your fee can become almost a full-time exercise in persuasive diplomacy. Prevent this aggravation by getting contracts signed before you begin work. Then reiterate your fee structure (retainer now, balance upon delivery of completed document) before you leave the premises. It is important to have the attorney you are working for sign a contract exactly as you would any other client. Many will balk, as they do not like signing contracts. If you do not wish to lose the job over their refusal to sign, or if the attorney is not present to do the actual signing before you begin work on the project, write a letter asking for full payment before you relinquish the report (fig. 7-1).

The form shown in figure 7-2 is an example of a contract that can be used between appraiser and attorney. Like all the forms in this text, this contract is meant to serve as an example only, and should be carefully examined by the appraiser's legal advisor before adoption. Contract laws differ throughout the United States; be sure the forms you use are legal in your area.

All appraisers generate the written report. This document represents the appraiser's methodology, analytical acumen, efforts, values, and business ethics. It is your leverage; once it passes into the hands of attorney or client, you have lost the advantage. If you still have trouble collecting your fee, one Texas judge suggests that a call or letter to the state Bar Association might get results. "Anytime a complaint is filed against a member, the grievance committee reviews the charge and duly notes it in the attorney's record. The attorney can be suspended, disbarred, or reprimanded in some other way." "And," he added, "you might get paid."

If you have been called to court by an attorney who is notoriously slow to pay, you have explained that you need your fee before testifying, and the attorney fails to bring it—what do you do?

"It is within your right to say, I'm sorry, the deal was I'd get paid before I took the stand. I'll be glad to go to the judge and tell him our arrangement, but until I get my fee, I won't testify."

What if you are subsequently subpoenaed?

"Then," the judge said, "you will have to testify. But I think a subpoena in this instance unlikely because the attorney will realize that by this type of action the witness may become hostile or very forgetful."

Collecting Fees for Bankruptcy Appraisals

Be sure of your legal rights as appraiser before you become involved in valuing property for a bankruptcy appraisal. There may be situations in which you cannot collect your fee if the appraisal contract was signed after the client started bankruptcy proceedings. Or, if you have collected a fee, you may be subject to suit by the creditors for return of the fee. Bankruptcy laws are complex and frequently attended by lengthy court procedures. The court-appointed trustee may wish to have you appointed by the court as appraiser. This will necessitate three forms: an application for appointment of appraiser; an oath of appraiser; an order appointing you as appraiser. In this instance, your fee will be stipulated and recorded, but it still does not guarantee that you will receive payment for services rendered.

The operative word in this arena is caution. Proceed thoughtfully and find out all the ramifications before involving yourself in this type of appraisal job.

7-1. Sample form letter for requesting payment for services rendered.

Dear Counselor:

According to your instructions, we have completed the appraisal of jewelry and gemstones for Mr. I. Stone, 1010 Main Street, City and State.

The inventory was extensive and two days were required for the summary. Each item was individually examined, photographed, and recorded, noting gold content and metal weight, identification of gemstones and their estimated weights. Fair market values have been established for the dissolution of common property.

A statement of appraisal services is enclosed. Please be advised that the original document, with photographs and four copies of the report, will be delivered to your office upon receipt of the full payment.

Sincerely,

Appraiser

7-2. Sample court-appearance or deposition agreement.

THIS MEMORANDUM OF AGREEMENT this day made and entered into by and between_____ hereinafter referred to as Appraiser and_____hereinafter referred to as Client.

That, in consideration of the mutual covenants herein contained and of the payment hereinafter provided to be made by Client to the Appraiser, the parties hereto agree as follows:

1. *SCOPE:* The Appraiser agrees to appear in court or through deposition, if requested, and serve as an Expert Witness providing true and objective testimony based upon appraisal and or expertise.
2. *FEE:* As full consideration for such services performed by Appraiser, the Client agrees to pay Appraiser therefore as follows:
 Upon completion of testimony by Appraiser, in court or through deposition, the sum of $_____per day or a minimum of $_____per half day or less. Time includes portal to portal travel. In the event services extend beyond one day, the same rate schedule continues whether testifying or waiting.
3. *REIMBURSEMENTS:* It is agreed that all out-of-pocket expenses including, but not limited by, travel, transportation, lodging, and meals associated with this requested service shall be promptly reimbursed Appraiser by Client.
4. *RETAINER:* Client shall provide a retainer prior to any testimony by Appraiser to cover such rate schedule and reimburseables as cited in articles 2 and 3. Such fee and expense shall be due and payable upon completion of the Appraiser's testimony. If payment is not received within five (5) days, then a late payment penalty of one (1%) percent per month compounded shall occur.
5. *ATTORNEY'S FEE:* In the event action is commenced to enforce or interpret the provisions of this agreement, the Appraiser shall be entitled in addition to such other relief as the court may award to a reasonable sum as and for attorney's fees and costs.
6. *ASSIGNMENTS:* This agreement shall be binding on the successors and assigns of the party hereto, but the same shall not be assigned by the Appraiser without written consent of the Client.
7. *GOVERNING LAW:* This agreement shall be governed by the law of the State of _____.

This agreement is executed on the_____day of_____19_____

APPRAISER:_____　　CLIENT:_____

Printed Name:_____　　Printed:_____

Address:_____　　Address:_____

_____　　_____

PREPARING THE APPRAISAL DOCUMENT

The Appraisal Report

Just as we judge and are judged by first impressions, so will your appraisal report—and the way it is presented—reflect upon your professionalism. An appraisal report is a legal document that should be effective and useful to the client and easy to read and understand.

The report includes the appraiser's opinion of value and the evidence that supports this opinion. The report itself is the single most significant product of the appraisal, since it is the appraiser's professional opinion, and it is the only physical evidence by which the client can judge the work.

Reports should be submitted on well-designed forms and typed on bond paper—handwritten appraisals are completely unacceptable. Reports should be closely reviewed before being delivered to the client to make sure no errors in math or spelling are present. Sloppy reports brand you as an amateur, or as lazy or incompetent. Insurance appraisals should be stapled into their own folders or covers to convey the importance of the document to the client. At the time of presentation, the client should be counseled to keep the document in a safe place, preferably a bank safe-deposit box. Reports validating data for fair market value generate a multipage document that looks best when presented to the client either velo or spiral bound, with front and back covers. If you are not familiar with this type of binding, contact your local print shop to see if it offers this service (most do and at reasonable rates.) Velo binding is a clean-looking soft plastic strip that uses a heat-sealing system to ensure a tight binding along the spine. Spiral bindings utilizes a plastic retaining material on the spine, joining prepunched holes through the printed matter. Every appraisal report should include the following items:

A. Cover and cover sheet (fig. 8-1).
 1. A cover gives a professional look to the appraisal and supports your image as a responsible valuer.

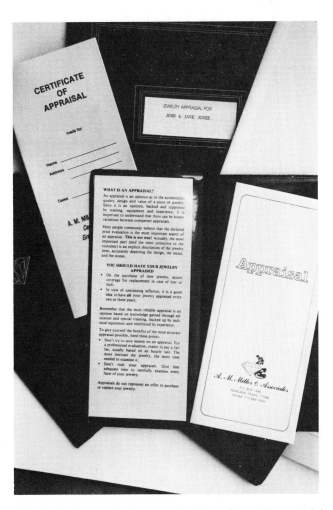

8-1. Sample appraisal report, showing a few of the essential elements.

2. The cover sheet should:
 - identify the report as a jewelry appraisal.
 - include the name of the client for whom the appraisal was executed and the date.
 - include the name and address of the appraiser.
B. Letter of transmittal (fig. 8-2).
 1. Introduction and table of contents.
 2. Client's name and address and location of the property being appraised.
 3. Date of the appraisal.
 4. Statement of the value.
 5. Limiting conditions that affect the final value.
 6. Purpose of the appraisal.
 7. Statement of confidentiality.
 8. A reference that the letter of transmittal is not the appraisal but rather a letter transmitting the appraisal that follows in the report.
C. Cover letter (fig. 8-3).
 1. The purpose of the cover letter is to contain a statement of the purpose and function of the appraisal.
 2. The cover letter includes a definition and explanation of the value and includes basis of the value conclusions.

3. The cover letter also contains a statement on the status of the market; notes any additional fees or taxes that may affect the final value figure; and details any restrictions on the use and/or publication of whole or part of the appraisal report.
4. The cover letter also defines and explains any future responsibilities of the appraiser for legal proceedings based upon the appraisal report.
5. Clear statement on the disinterestedness of the appraiser.
D. Appraisal preface (fig. 8-4).
 The appraisal preface is an overview of the valuation process applied to different marketplaces. The preface contains explanations, definitions, and limitations of various markets. To include it as part of the report will help your client understand the different markets and prevent possible misunderstandings as to the extent of the services rendered.
E. Body of the appraisal report, or the certificate of appraisal (fig. 8-5).
 1. Definitions and complete descriptions of the property. The description includes both writ-

8-2. Sample letter of transmittal for an estate, or probate, appraisal.

Date

Mr. John Doe, Attorney
First Bank of Houston
P.O. Box 1000
Houston, Texas 77024

Dear Mr. Doe:

In accordance with your request, I have conducted an investigation of the personal jewelry property of Mr. Andrew Scott, 2000 Opal Avenue, Houston, Texas, on December 20, 1986, in order to form an opinion of current Fair Market Value for dissolution of common property.

Based on the inspection of the items, the research and analysis undertaken, and subject to the assumptions and limiting conditions contained herein, it is my conclusion that the current Fair Market Value is $175,000.

The document which is attached to this letter of transmittal includes the following sections:

1) Summation of Conclusions
2) Appraisal Preface with Definitions
3) Description and Valuation of the Property
4) Photographs of the Property
5) Limiting and Qualifying Conditions
6) Qualifications of the Appraiser

All information concerning this appraisal is regarded as confidential. We retain a copy of the document, together with our original notes, and do not permit access to them by anyone without your authorization.

Thank you for this opportunity to be of service.

Cordially,

ten and photographic pictures of the item(s) to include all physical characteristics (i.e., material, size, construction, etc.), as well as information on style, hallmarks, signatures, etc. Gemstone plots and terms.

F. Signatures: 1) The principal appraiser; 2) consultants, collaborators, or associate appraisers; 3) dissenting appraisers and opinion(s).

G. Reference source page (fig. 8-6). Validate provenance here. Some appraisers consider the reference page to be unnecessary paperwork. However, if you are faced with the need to back up your statements and verify the prices that you used, the reference page may prove invaluable. A reference page can also reveal your strengths and weaknesses of research.

H. Statement of limiting conditions (fig. 8-7).
I. Appraiser's certification statement (fig. 8-8).
J. Qualifications of appraiser (fig. 8-9).
K. Dissenting opinions (if any) with signatures.

Every page of the certificate of appraisal should be numbered with a total number of pages listed on the first page. All items should be individually numbered on the appraisal pages and photographed items should be numbered to match with the appropriately described article. Photograph captions should state the scale at which the items were shot, such as 1:1 ratio.

Every page of the certificate of appraisal should have the client's name and date along with the pur-

8-3. Sample cover letter for an estate, or probate, appraisal.

A. Appraiser
Date

FOR: John Doe, Attorney
RE: Andrew Scott Estate
Cause #0000

In accordance with the instructions of John Doe, Attorney, I have made an inventory of items identified to me as being the jewelry property of Mr. Andrew Scott, 2000 Opal Avenue, Houston, Texas, and investigated and researched each item to determine Fair Market Value. The purpose of the appraisal is to estimate the Fair Market Value of the jewelry common property for divorce settlement.

As used in this report, the term Fair Market Value represents the mode of prices that could be realized in an orderly sale of the various items in the most common and appropriate market to that item. Fair Market Value of any item of property is not to be determined by the sale price of an item in a market other than that in which such item is most commonly sold to the public taking into account the location of the item wherever it is appropriate. Further, Fair Market Value as provided in this report takes into consideration items of like kind and quality by the greatest number of reasonably knowledgeable willing buyers and willing sellers, neither being under any compulsion to buy or sell, in the market in which these items were most commonly sold to the public—to an ultimate consumer who is buying for a purpose other than for resale in the purchased form.

All diamonds and colored gemstones in the jewelry were examined, identified and graded for the qualitative and quantitative properties defined separately in this report, and are in accordance with the standards of the jewelry appraisal profession and trade.

The market analysis and values provided are based upon my eighteen years of experience as a wholesale gemstone dealer, retail jewelry store owner and appraiser, during which time I have sold and appraised large quantities of like items. Market data approach was used to obtain FMV. Values in this report are based on the most common and appropriate markets: auction and retail. I have made no investigation as to the title or ownership of the property appraised. Information given me concerning origin or acquisition of certain items has been accepted as fact when this information was not contradicted by my findings. Let it be stated that I do not have a present or contemplated interest in the purchase and/or resale of the property appraised and the fee for this appraisal is not contingent upon values submitted.

My instructions for this assignment were to provide my best impartial opinion as to the appropriate markets for the jewelry and their Fair Market Value in those markets. In my opinion the property described herein is fairly stated as being $175,000.

ONE HUNDRED SEVENTY FIVE THOUSAND DOLLARS

This report has been prepared in accordance with the principles and procedures for the evaluation of personal property as prescribed by the American Society of Appraisers. This appraisal report is only to be used and interpreted in its entirety.

A. APPRAISER (Signature) _____

8-4. Sample appraisal preface.

I. WHAT IS AN APPRAISAL?
 An appraisal is an informed opinion as to the authenticity, quality, design and value of a gem or jewelry article. The opinion is backed by appraiser training, market experience, and gemological equipment.

II. FAIR MARKET VALUE
 Fair market value is defined as "the most probable price in cash, or in other precisely revealed terms, for which the appraised property will sell in a competitive market under all conditions requisite to fair sale, with the buyer and seller each acting prudently, knowledgeably, and for self-interest, and assuming that neither is under undue duress."

 Implicit in this definition is the presumed consummation of the sale at a specified date and the passing of title from seller to buyer under conditions whereby:

 1. The buyer and seller are typically motivated.
 2. Both parties are well informed, and/or advised, each acting in what he or she considers his or her own best interest.
 3. A reasonable time has been allowed for exposure to the open market.
 4. Payment is made in cash or its equivalent.
 5. The price represents a normal consideration for the property sold unaffected by special financing amounts and/or terms, services, fees, costs or credits incurred in the transaction.

III. RETAIL REPLACEMENT VALUE FOR INSURANCE
 The retail replacement (new) value is required by an insurance company before it will insure jewelry beyond a certain dollar amount or schedule it separately on one's homeowner policy. This appraisal is the record consulted by the insurance firm to determine the insured amount for jewelry that is lost, damaged, or stolen, depending upon the terms of the actual insurance policy.

 This type of value is determined by using either a Market Data Comparison or a Cost Approach depending upon individual circumstances and market conditions prevailing at time of appraisal. The Market Data Comparison approach compares the qualities of the subject item to an article with similar or identical qualities, and researches and records current verifiable sales of such merchandise. The Cost Approach establishes value of an item by breaking down the item (hypothetically) into its component parts such as precious metal content, gemstone weights and qualities, labor for setting and any other fees that would impact on the final value. The sum total of value also includes the appropriate retail markup according to the norms of jewelers in the locale, supply and demand, and the current state of the marketplace.

IV. ANTIQUE JEWELRY APPRAISAL
 Antique, heirloom, and collectible jewelry is always valued using the Market Data Comparison approach. Cost approach and revenue approaches are not applicable to this market.

V. JEWELRY INSURANCE
 Homeowner's and Apartment Tenants insurance policies commonly include coverage for personal property with the value of jewelry included up to a certain limit. Most policies restrict jewelry coverage for theft, burglary or robbery to $500 aggregate, with a few companies providing coverage to $1,000 aggregate. Such insurance usually will not cover the property owner for "loss" of an item or for loss of a single stone from the item. In order to obtain coverage for the full value of the item(s), an appraisal for each item will be required and the coverage scheduled on your policy, with a specific description of the article and a replacement value on each item. For full and proper value coverage, a detailed professional appraisal is paramount.

VI. IN CASE OF LOSS
 Most insurance policies contain a clause which permits the company to replace the jewelry in like kind with a comparable replacement rather than make cash payment for the loss. If so, use your appraisal to verify that the quality of the replacement is similar to the lost item. The original appraiser of the insured item should be consulted for verification of the quality and value of the proposed replacement.

VII. APPRAISAL UPDATE
 We recommend that your appraisal is updated periodically. Check annually with us about the necessity of updating your appraisal.

VIII. NOTICE
 This appraisal is not an offer to buy unless specifically stated.

8-5. Sample certificate of appraisal form, initial page only.

Certificate of Appraisal
COMPANY NAME
(Logo)

Appraisal for_____ Date_____

Address_____

Current_____values for the purpose of_____

Article Number	Article and Description	Appraised Value
	Total Appraised Value This Page	

This report consists of_____pages. This appraised value_____

_____$_____dollars.

Signed at_____Date_____, 19____

Signature_____

Appraiser's Name_____

Page <u>One</u> of _____Pages

8-6. Sample reference source page.

The subject jewelry property has been researched in numerous reference books, price guides, auction catalogs and from personal calls upon retail jewelers who sell comparable or identical merchandise in this geographical region. Research for appropriate pricing has also been conducted by telecommunications network.

Among the materials used for research are:

Rappaport Diamond Index (Date)

Johnson Matthey Precious Metal Price Reports (Date)

The Guide, Gemworld International, Inc. (Date)

Quoted prices in dealer catalogs: _____.

Questions About Old Jewelry by Jeannenne Bell

Art Nouveau Jewelry by Joseph Sataloff

8-7. Typical limiting conditions clause.

It is understood and agreed that fees paid for this appraisal do not include the services of the appraiser for any other matter whatsoever. In particular, fees paid to date do not include any of the appraiser's time or services in connection with any statement, testimony or other matters before an insurance company, its agents, employees or any court or other body in connection with the property herein described.

It is understood and agreed that if the appraiser is required to so testify or to make any such statements to any third party concerning the described property, appraisal, applicant shall pay appraiser for all of such time and services so rendered at appraiser's then current rates for such services with half of the estimated fee paid in advance to appraiser before any testimony.

Unless otherwise stated, all colored stones listed on this appraisal report have probably been subjected to a stable and possibly undetectable color enhancement process. Prevailing market values are based on these universally practiced and accepted processes by the gems and jewelry trade.

8-8. Sample appraiser's certification statement.

(___Appraiser's name___) deposes and says: That the statements contained in this report and upon which the opinions expressed herein are based are true and correct to the best of (his/her) knowledge and belief.

That no direct or indirect personal interest exists; that the appraisal fee is not contingent upon values stated herein.

Valuations stated are based on items of comparable or identical equal and condition, available in the wholesale or retail marketplace depending upon the purpose and function of the valuation.

This report has been made in conformity with the requirements of the code of professional ethics and standards of professional conduct of (professional appraisal organization).

(Appraiser's name)

Date

8-9. Statement of the appraiser's qualifications.

THE QUALIFICATIONS OF (___Appraiser___) FOR THIS SERVICE ARE:

Graduate Gemologist of the Gemological Institute of America, New York, New York. Senior Member of the American Society of Appraisers; Senior Member of the National Association of Jewelry Appraisers; Master Gemologist Appraiser designation from the American Society of Appraisers.

(Appraiser's name) is engaged as an independent appraiser of gems and jewelry for private clientele, banks, insurance companies, law firms and museums. She/he is a guest speaker for colleges, civic groups and seminars. She/he instructs appraisal classes for the American Society of Appraisers and has been instructor for gemological classes at numerous community colleges.

(Appraiser's name) is qualified as expert witness in the State of _____, Civil and County Courts and in United States Federal Court.

(Appraiser's company name) maintains a fully accredited gemological laboratory certified by the Accredited Gemologists Association.

pose of the appraisal. The total number of pages in the report should be reiterated on the last page.

The illustrations of the various sections of a sample appraisal are provided as a framework or point of departure for your own reports. Of course, you may vary in style or approach to suit the needs of your appraisals. Figures 8-10 through 8-13 illustrate a sample explanation of diamond terminology that might be included in an appraisal report as well as several sample cover letters sent to various individuals: an insurance claim adjuster, clients receiving an insurance appraisal, and an executor receiving an estate, or probate, appraisal.

Developing a Professional Brochure

If you want a profitable sales tool, take the time to create a professional and informative brochure. Once placed in a prospective client's hands, either by you or by mail, it will have his or her undivided attention. The brochure is capable of establishing a bond between you and the customer; it is almost as if you were talking directly to him or her, presenting the service.

A well-designed brochure is an important communication tool. If your budget does not permit you to hire a public relations firm to create a folder for you, you can go to a creative copywriter and work closely with an offset printer or manage the entire project yourself. You need not be a graphic artist to design your own brochure. You will need the following supplies to start: blue or green-lined graph paper, a T-square, ruler, scissors, paste, and X-acto knife. These are the steps:

1. Decide what size you want the brochure to be. Although there is no standard size, a basic 8½ × 11-inch paper folded once or twice and then trimmed by the printer (final size of 8½ by 7½ inches), is easy for the printer to manage and will be more economical. Measure a piece of paper and fold it to the size you would like the brochure to be. It should be large enough to contain all the information you wish to disseminate about your business, but small enough to fit into a standard business envelope.

2. If you want to have photographs printed in the brochure, have them developed immediately. If you are going to include a picture of yourself, make it a studio portrait for a professional look. In printing parlance, the photographs that will go into your brochure are called *halftones.*

3. Gather the information and type it *exactly* as you would like it printed. You are going to use an offset printing procedure that gives you exactly what you see.

4. Cut the typed information from the paper in paragraphs, and arrange it on the graph paper that has been cut or folded to the size of the finished brochure.

You are about to do a paste up by moving the paragraphs around until the page looks balanced and the copy flows along smoothly from subject to subject. When you are satisfied, paste the copy to the page. If you have decided on photographs, indicate their sizes and positions in green or blue lead pencil. The photographs will be stripped in later by the printer.

If you are going to use a logo, as shown in figure 8-14, you will need to have it ready for display on your brochure. You can use a photograph of the logo or a crisp, clean drawing. Major appraisal associations have logos as camera-ready art; all you do is clip and paste. If you need bold type or special headlines to announce your services, then experiment with the greatest invention in the graphic arts field, transfer lettering. It is available in dry lettering, which is cut from the original transparent page and transferred to the layout paper, or rub-on lettering, where individual letters are transferred by rubbing them onto the layout paper with a stylus. Your art supply store (perhaps even your office supply store) has this material for sale. One trade name is Letraset. While you are at the art supply store, get a roll of 2-point border. This is thin black tape available in a roll and used to make straight lines or to box in any messages or announcements you wish to emphasize in the brochure.

5. Look over the information you have put in your brochure. You do not want it to look crowded. The front cover should tell who the appraiser is and the nature of the business. Inside, the reader should see the type of appraisals performed, qualifications of the appraiser, location of the service, and the fee arrangement. On the back page are discussed quality standards used to grade diamonds and the gemological instruments used in identification.

If you appraise items other than jewelry (silver, coins, and so on), you will wish to list those areas of expertise. You may also want to add that you are available for lectures and workshops.

If you can provide gemprints and/or laminated reports, be certain to state this in the brochure.

6. Are you pleased with the results of the layout? Read it over for typographical errors. Would you pick it up and read it if you were John Q. Public? Put it away overnight and then take a good look at it the next day. If it still looks good, take it to the printer.

7. All towns have an offset printer. Take your camera-ready copy and your photograph(s) to the printer and select a stock for your brochure. The printer can tell you what kind of stock will take a clean ink

8-10. An explanation of diamond grading terminology that would be included in an appraisal of diamonds.

IDEAL BRILLANT-CUT PROPORTIONS

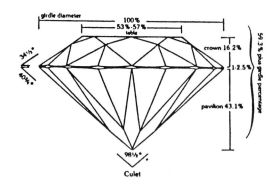

QUALITY STANDARDS

GIA CLARITY GRADING SCALE

Flawless

| VVS₁ | VVS₂ | VS₁ | VS₂ | SI₁ | SI₂ | I₁ | I₂ | I₃ |

Flawless

Imperfect

GIA COLOR GRADING SCALE

| D | E | F | G | H | I | J | K | L | M | N | O | P | Q | R | S | T | U | V | W | X | Y | Z |

Colorless Very Light Yellow Light Yellow Yellow Fancy Yellow

Mounted Stones Appear Colorless Mounted Stones Appear Increasingly Tinted Mounted Stones Appear Yellow

Small Mounted Stones Appear Colorless

DIAMOND PROPORTIONS
RANGE OF ACCEPTABLE PROPORTIONS

Table Percentage.............	54% to	66%
Depth Percentage	57.5% to	62.5%
Crown Height	11.0% to	16.0%
Pavilion Depth	41.5% to	45.5%
Crown Angles	30.0° to	35.0°
Pavilion Angles..............	39.7° to	42.4°
Girdle Thickness	Thin, Medium,	Slightly Thick
Culet Size	Small, Medium	

THE ABOVE RANGES APPLY FOR ROUND
BRILLANT CUT STONES. FANCY SHAPES
VARY CONSIDERABLY FROM ABOVE RANGES.

INSTRUMENTS USED

☐ Master Stones
☐ Gemolite (Binocular Dark Field Illum.)
☐ Leveridge Gauge (Micrometer)
☐ Diamondlite (Color Grading)
☐ Proportionscope
☐ Diamond Balance
☐ Long/Short Wave Ultra Violet
☐ Illuminator Polarscope
☐ Colormaster

☐ Refractormeter
☐ Thermal Reaction Tester
☐ Pen Light
☐ Emerald Filter
☐ Dichroscope
☐ Heavy Liquids
☐ Spectroscope
☐ Photographic Equipment
☐ Metal Tester
☐ Gemprint
☐ Dwt. Scale

INTERNAL CHARACTERISTICS

—Feather
—Included Crystal
—Cloud
—Knot
—Bruise
—Pinpoint
—Internal Graining
—Bearded or Feathered Girdle
—Laser Drill Hole
—Indented Natural

EXTERNAL CHARACTERISTICS

—Pit
—Cavity (Now shown in red)
—Natural
—Scratch and Wheel Marks
—Extra Facet (Shown in Black)
—Surface Grain Lines
—Nick (Now shown in Red)
—Chip (Now shown in Red)
—Abraded facet junction

*RED SYMBOLS DENOTE INTERNAL CHARACTERISTICS. GREEN
SYMBOLS DENOTE EXTERNAL CHARACTERISTICS. SYMBOLS
INDICATE THE NATURE AND POSITION OF CHARACTERISTICS,
NOT NECESSARILY THEIR SIZE.*

8-11. Sample transmittal letter sent to an insurance claims adjuster.

Date

Mr. Matthew Goodboy
The Hartford Company
1212 Emerald Avenue
Houston, Texas 77001

Re: Claim #66/B/O—Jewelry

Dear Mr. Goodboy:

Enclosed is our appraisal for insurance purposes of the items indicated to have been stolen in the above claim. A copy of this document is enclosed for your convenience.

The values given represent, in my opinion, the current Fair Market Value of the items in the appropriate market based upon recent available sales information for items of comparable quality and kind. They do not include any costs or fees that may be incurred in replacing the items, such as sales tax.

The named appraiser has never personally examined the jewelry items that were stolen. The insured was interviewed to obtain descriptions of the pieces and I examined some photographs provided by the insured. All values were researched based upon this information.

Information regarding this appraisal is regarded as confidential. A copy of the document is retained by my office, with our working notes. Access to them is not permitted without your authorization.

I hope this information is helpful to all parties concerned. If I can be of further service, please do not hesitate to call.

Cordially,

8-12. Sample transmittal letter sent to the recipients of an insurance appraisal.

Date

Mr. and Mrs. John Doe
123 Ruby Street
Los Angeles, California 92100

Dear Mr. and Mrs. Doe:

Enclosed you will find our appraisal for insurance purposes of your jewelry located at the above address, and examined by me on _____. A copy of this document is enclosed for the convenience of your insurance agent.

These items have been examined, researched to the best of our ability, and identified for the purpose of retail replacement valuation. In our opinion the values given represent the current retail replacement level based upon recent available sales information for items of identical or comparable quality and kind. The figures represent the average retail replacement in the average fine jewelry store and not any one jewelry store in particular. Averages are based upon appropriate markets for individual items. These figures, however, do not include sales tax or any other charges that might be payable, and you may wish to take this factor into consideration when calculating your insurance needs.

We recommend all items in this report be covered from breakage as well as theft and mysterious disappearance. The total replacement cost of the items listed is $_____. The photographs are included in this report and are ready for reference in the event of a claim under any insurance policy.

All information regarding this appraisal is confidential. We retain a copy of the document, together with our original notes, and do not permit access to them by anyone without your authorization.

It was a pleasure to be of service to you.

Cordially,

8-13. Sample transmittal letter sent to the executor of an estate, the recipient of a probate appraisal.

Date

Mr. J. Jones, Executor
3000 Diamond Drive
Los Angeles, California 9000

Re: Estate of Jane Doe: Appraisal of
 Personal Property located at 456 Garnet
 Avenue, Oceanside, California

Dear. Mr. Jones:

Enclosed you will find our appraisal for estate purposes of the jewelry personal property at the above address, indicated to be part of the estate of Jane Doe, deceased. The items were examined by me on January 20, 1987. A copy of this document is enclosed for your convenience.

These pieces have been examined, researched to the best of our ability, and identified for the purpose of valuation. The values given reflect the current Fair Market Value of these or comparable pieces, on or about the date of death, December 20, 1986. The current Fair Market Value is defined as the price agreed upon by a willing buyer and a willing seller, both knowledgeable of relevant facts, neither under any compulsion to buy or sell, and given a reasonable amount of time to complete the transaction. The values do not, however, include any costs that may be incurred in the sale of the items, such as advertising, commissions, fees, etc.

Each item has been itemized individually on the appraisal, and photographed. Our working notes are available if you should require them.

All information regarding this appraisal is regarded as confidential. We retain a copy of the document, together with our original notes, and do not permit access to them by anyone without your authorization.

We appreciate this opportunity to be of service.

Cordially,

impression. Ask to look at card stock. There is usually a great variety of colors and types, from leatherlike to pebble finish. Putting color combinations together can be a challenge. Look around at the printer's samples of brochures and letterheads and pick out color and stock combinations that appeal to you. Cream-color stock with burgundy print was popular a few years ago, but keep in mind that colors and card stocks move in trends. You will want to put some thought into the correct look for this venture, because your brochure will speak for you in many situations and may be your only opportunity to make a good impression.

8. Once you have chosen your card stock and ink, the printer can make a quotation for the job. If you wish to have matching envelopes in which to mail the brochures, this is the time to make inquiry. If there is any portion of the paste-up you are concerned about, talk with the printer. He or she can straighten the copy if it needs it and make headlines if you have not already done so.

9. The last step is the most satisfying. Pick up the finished brochures and distribute them to prospective clients.

When you are working with the printer you may wish to inquire about a matching business and Rolodex card. These are good additions to the brochure and can be mailed in the same envelope. A Rolodex card is an excellent way to maintain high visibility with insurance agents, attorneys, bank loan officers, other clients, and their secretaries.

8-14. A custom-designed logo adds a professional look to your reports and brochures.

APPENDIX

CUTTING STYLES

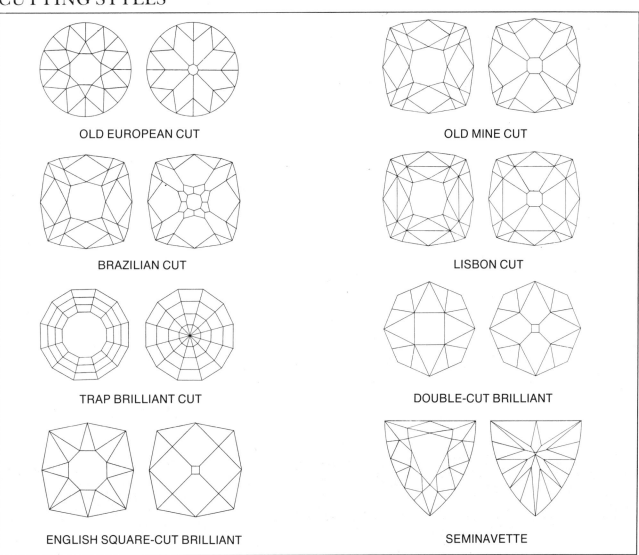

OLD EUROPEAN CUT

OLD MINE CUT

BRAZILIAN CUT

LISBON CUT

TRAP BRILLIANT CUT

DOUBLE-CUT BRILLIANT

ENGLISH SQUARE-CUT BRILLIANT

SEMINAVETTE

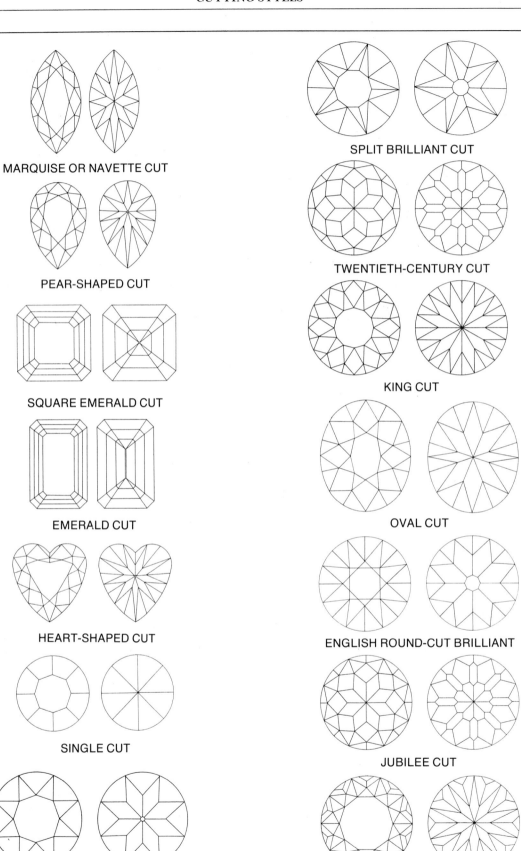

MARQUISE OR NAVETTE CUT

PEAR-SHAPED CUT

SQUARE EMERALD CUT

EMERALD CUT

HEART-SHAPED CUT

SINGLE CUT

SWISS CUT

SPLIT BRILLIANT CUT

TWENTIETH-CENTURY CUT

KING CUT

OVAL CUT

ENGLISH ROUND-CUT BRILLIANT

JUBILEE CUT

MAGNA CUT

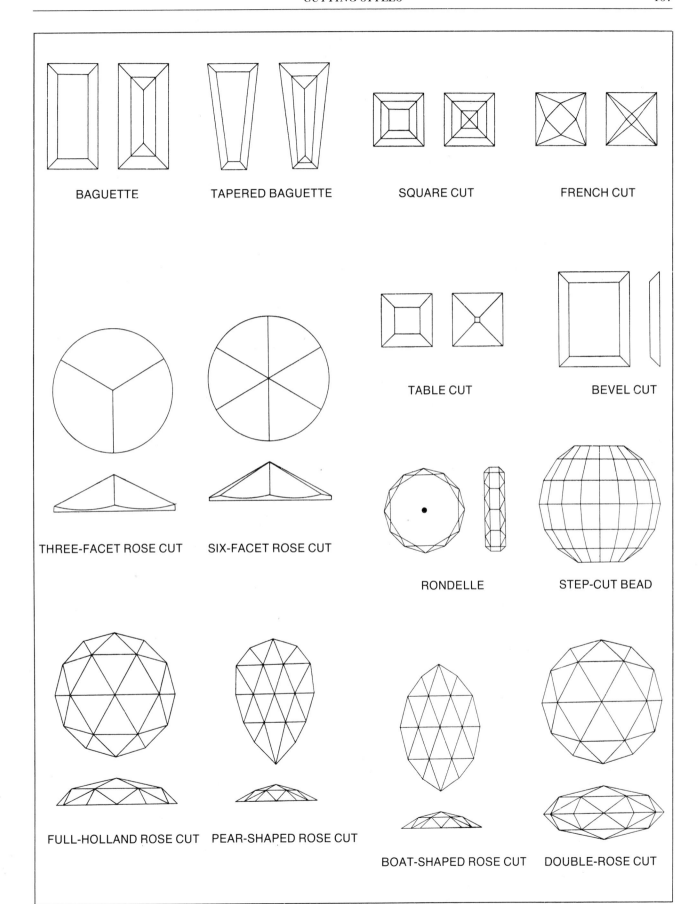

BAGUETTE TAPERED BAGUETTE SQUARE CUT FRENCH CUT

TABLE CUT BEVEL CUT

THREE-FACET ROSE CUT SIX-FACET ROSE CUT

RONDELLE STEP-CUT BEAD

FULL-HOLLAND ROSE CUT PEAR-SHAPED ROSE CUT

BOAT-SHAPED ROSE CUT DOUBLE-ROSE CUT

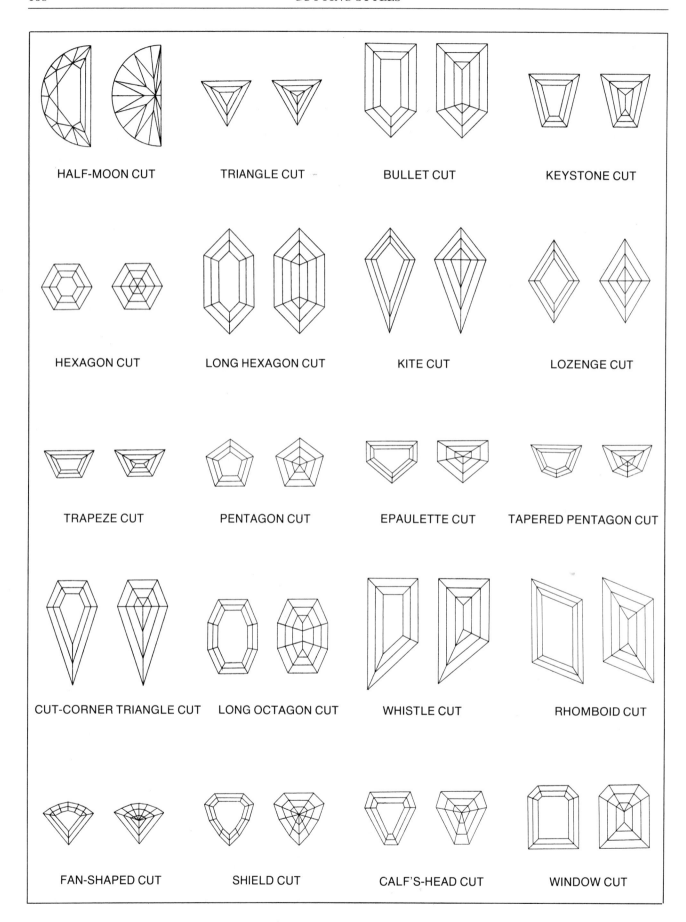

HALF-MOON CUT TRIANGLE CUT BULLET CUT KEYSTONE CUT

HEXAGON CUT LONG HEXAGON CUT KITE CUT LOZENGE CUT

TRAPEZE CUT PENTAGON CUT EPAULETTE CUT TAPERED PENTAGON CUT

CUT-CORNER TRIANGLE CUT LONG OCTAGON CUT WHISTLE CUT RHOMBOID CUT

FAN-SHAPED CUT SHIELD CUT CALF'S-HEAD CUT WINDOW CUT

Size-to-Weight Conversion Chart: Standard-Size Cabochon Gems

Type of Stone	Millimeter Size							
	8/6	10/8	12/10	14/10	16/12	8	10	12
Ruby and Sapphire	1.9	4.1	6.9	8.7	4.5	3.1	5.8	10.6
Emerald	1.3	2.8	4.7	5.9	9.9	2.1	4.0	7.2
Amethyst	1.3	2.7	4.6	5.8	9.7	2.0	3.4	7.1
Tourmaline	1.4	3.1	5.3	6.7	11.1	2.3	4.5	8.1
Peridot	1.6	3.4	5.8	7.3	12.1	2.6	4.9	8.9
Rhodolite Garnet	1.8	3.9	6.6	8.4	14.0	2.9	5.6	10.2
Lapis Lazuli	1.3	2.8	4.7	6.0	10.0	2.1	4.0	7.3
Coral	1.3	2.7	4.6	5.8	9.7	2.0	3.9	7.0
Black Onyx	1.2	2.6	4.5	5.7	9.5	2.0	3.8	6.9
Chrysoprase	1.3	2.7	4.6	5.8	9.7	2.0	3.9	7.1
Jade (Nephrite)	1.4	3.0	5.1	6.4	10.7	2.2	4.3	7.8
Hematite	2.5	5.3	9.0	11.3	18.9	4.0	7.6	13.8
Ivory	.9	2.0	3.5	4.4	7.2	1.5	2.9	5.3
Turquoise	1.3	2.8	4.8	6.0	10.0	2.1	4.0	7.3

This chart is meant to be used as a weight conversion and comparison guide. For example, this chart shows that a properly proportioned medium size 14/10mm ruby cabochon will convert into a weight of approximately 8.7 carats which, comparatively speaking, is 1½ times the weight of the same size emerald cobochon.

Source: Seymour Amstein, Walter Amstein Inc., New York City. Reprinted courtesy of Modern Jeweler.

Size-to-Weight Conversion Chart: Opal Cabochons

Round Cabochons		Oval Cabochons		Pear Shaped		Marquise	
MM	CTS	MM	CTS	MM	CTS	MM	CTS
2¼	0.054	5 × 3	0.16	5 × 3	0.13	6 × 3	0.15
2½	0.066	5 × 3½	0.25	6 × 4	0.25	8 × 4	0.40
2¾	0.078	6 × 4	0.30	7 × 5	0.35	10 × 5	0.70
3	0.090	7 × 5	0.45	8 × 5	0.45	12 × 6	1.00
3¼	0.114	8 × 6	0.70	8 × 6	0.60	15 × 7	2.00
3½	0.135	9 × 7	1.00	9 × 6	0.70		
3¾	0.16	10 × 8	1.50	10 × 7	1.00		
4	0.17.5	11 × 9	2.00	12 × 8	1.50		
4¼	0.20	12 × 10	2.50	13 × 8	1.70		
4½	0.25	14 × 10	3.00	14 × 9	2.10		
4¾	0.28	14 × 12	4.00	15 × 10	2.90		
5	0.33	16 × 12	4.50				
5¼	0.36	18 × 13	5.20				
5½	0.40	20 × 15	8.00				
5¾	0.50						
6	0.60						
6¼	0.65						
6½	0.70						
6¾	0.75						
7	0.80						

Size-to-Weight Conversion Chart: Caliber-Cut Gemstones

mm.	1	2	3	4	5	6	7	8
				Round Stones				
2.0	.03	.04	.04	.04	.04	.04	.04	.04
2.5	.05	.06	.06	.08	.08	.08	.08	.09
3.0	.10	.11	.11	.13	.13	.14	.14	.16
3.5	.16	.18	.20	.20	.21	.22	.23	.24
4.0	.24	.27	.29	.30	.31	.33	.34	.36
4.5	.34	.39	.40	.43	.46	.46	.48	.51
5.0	.47	.53	.56	.59	.62	.64	.66	.70
5.5	.62	.72	.74	.78	.83	.85	.88	.94
6.0	.82	.92	.96	1.00	1.07	1.09	1.14	1.21
6.5	1.04	1.17	1.22	1.27	1.37	1.39	1.46	1.55
7.0	1.30	1.47	1.53	1.60	1.70	1.73	1.82	1.92
7.5	1.60	1.78	1.84	1.95	2.07	2.13	2.25	2.37
8.0	1.94	2.16	2.23	2.37	2.51	2.59	2.73	2.88
				Oval Stones				
5 × 3	.20	.23	.23	.24	.26	.27	.29	.30
6 × 4	.42	.48	.49	.52	.55	.56	.59	.62
7 × 5	.75	.86	.90	.94	.99	1.01	1.07	1.12
8 × 6	1.24	1.40	1.46	1.52	1.63	1.65	1.73	1.83
9 × 7	1.89	2.13	2.22	2.31	2.47	2.52	2.64	2.80
10 × 8	2.72	3.08	3.21	3.35	3.56	3.64	3.82	4.04

Pear-Shaped Stones

5 × 3	.17	.18	.20	.21	.22	.22	.23	.24
6 × 4	.35	.40	.42	.43	.47	.47	.49	.52
7 × 5	.64	.73	.75	.79	.85	.86	.90	.96
8 × 6	1.05	1.20	1.25	1.30	1.39	1.42	1.48	1.57
9 × 7	1.63	1.83	1.91	2.00	2.12	2.17	2.28	2.41
10 × 8	2.35	2.67	2.78	2.90	3.08	3.15	3.30	3.50

Rectangular Stones

4 × 2	.09	.10	.10	.10	.11	.11	.12	.13
5 × 3	.24	.27	.29	.30	.33	.33	.35	.36
6 × 4	.52	.60	.62	.65	.69	.70	.74	.78
7 × 5	.95	1.08	1.13	1.18	1.25	1.27	1.34	1.42
8 × 6	1.57	1.78	1.86	1.94	2.07	2.11	2.21	2.34
9 × 7	2.41	2.73	2.85	2.96	3.16	3.22	3.38	3.58
10 × 8	3.50	3.96	4.12	4.30	4.58	4.67	4.90	5.19

Square Stones

3 × 3	.13	.14	.15	.16	.17	.17	.18	.19
4 × 4	.31	.35	.36	.38	.40	.42	.43	.46
5 × 5	.60	.69	.72	.74	.79	.81	.85	.90
6 × 6	1.04	1.18	1.24	1.29	1.37	1.39	1.47	1.55
7 × 7	1.65	1.87	1.96	2.04	2.17	2.21	2.33	2.46

Marquise Stones

4 × 2	.05	.06	.07	.07	.07	.08	.08	.08
5 × 2½	.10	.11	.13	.13	.14	.14	.15	.16
6 × 3	.18	.20	.21	.22	.23	.24	.26	.27
7 × 3½	.29	.33	.34	.35	.38	.39	.40	.43
8 × 4	.43	.48	.51	.53	.56	.57	.60	.64
9 × 4½	.61	.69	.73	.75	.81	.82	.86	.91
10 × 5	.85	.95	.99	1.04	1.10	1.12	1.18	1.25

Heart-Shaped Stones

4 × 4	.18	.20	.21	.23	.24	.25	.26	.27
5 × 5	.40	.44	.46	.49	.52	.53	.56	.59
6 × 6	.63	.70	.73	.77	.82	.84	.89	.94
7 × 7	.95	1.06	1.09	1.16	1.23	1.27	1.34	1.41
8 × 8	1.35	1.50	1.55	1.65	1.75	1.80	1.90	2.00

Chart gives average weights in millimeters for more than fifty varieties of gemstones. Calculations are based on gems with no bulge factor and a depth of 60 percent of the narrow diameter. Weights are rounded to the nearest point (1/100 of a carat), and all weights are approximate.

The list is intended only as a guide; most stones will vary from these ideal-cut gemstone weights. Observe the cut of the stone. Gemstones with high crowns and/or heavy pavilions may weigh as much as 20 percent more than chart weights. Deep stones may weigh as much as 20 percent more than chart weights; shallow stones may weigh up to 20 percent less than chart weights.

Key: Gemstones categorized according to specific gravity.
1. Quartz (amethyst, citrine, etc.) and beryl (emerald, aquamarine, etc.)
2. Tourmaline (green, pink, etc.)
3. Andalusite and spodumene (kunzite)
4. Peridot and zoisite (tanzanite)
5. Topaz (Imperial, blue, etc.)
6. Spinel (all colors) and grossular garnet (tsavorite, etc.)
7. Chrysoberyl (alexandrite, etc.) and rhodolite/pyrope garnets
8. Corundum (ruby, all sapphires), zircon, and almandite garnet

Pennyweight-to-Gram Conversion

DWT.	GRAMS	DWT.	GRAMS	DWT.	GRAMS
0.20	0.31	7.00	10.89	13.80	21.46
0.40	0.62	7.20	11.20	14.00	21.77
0.60	0.93	7.40	11.51	14.20	22.08
0.80	1.24	7.60	11.82	14.40	22.39
1.00	1.56	7.80	12.13	14.60	22.71
1.20	1.87	8.00	12.44	14.80	23.02
1.40	2.18	8.20	12.75	15.00	23.33
1.60	2.49	8.40	13.06	15.20	23.64
1.80	2.80	8.60	13.37	15.40	23.95
2.00	3.11	8.80	13.68	15.60	24.26
2.20	3.42	9.00	14.00	15.80	24.57
2.40	3.73	9.20	14.31	16.00	24.88
2.60	4.04	9.40	14.62	16.20	25.19
2.80	4.35	9.60	14.93	16.40	25.51
3.00	4.67	9.80	15.24	16.60	25.82
3.20	4.98	10.00	15.56	16.80	26.13
3.40	5.29	10.20	15.87	17.00	26.44
3.60	5.60	10.40	16.17	17.20	26.75
3.80	5.91	10.60	16.48	17.40	27.06
4.00	6.22	10.80	16.80	17.60	27.37
4.20	6.53	11.00	17.11	17.80	27.68
4.40	6.84	11.20	17.42	18.00	27.99
4.60	7.15	11.40	17.73	18.20	28.30
4.80	7.46	11.60	18.04	18.40	28.62
5.00	7.78	11.80	18.35	18.60	28.93
5.20	8.09	12.00	18.66	18.80	29.24
5.40	8.40	12.20	18.97	19.00	29.55
5.60	8.71	12.40	19.28	19.20	29.86
5.80	9.02	12.60	19.60	19.40	30.17
6.00	9.33	12.80	19.91	19.60	30.48
6.20	9.64	13.00	20.22	19.80	30.79
6.40	9.95	13.20	20.53	20.00	31.30
6.60	10.26	13.40	20.84		
6.80	10.58	13.60	21.15		

To convert pennyweights to grams: Dwts. \times 1.552 = Grams.
To convert grams to pennyweights: Grams \times 0.6430 = Dwts.

The Troy System

1 gram	=	15,4324 grains
1 gram	=	.643 pennyweights
1 gram	=	.03215 troy ounce
1.55517 grams	=	1 pennyweight
31.10348 grams	=	1 troy ounce
1000 grams	=	1 kilogram
1 kilo	=	32.15076 troy ounces
1 pennyweight	=	24 grains
1 pennyweight	=	.05 ounces troy
20 pennyweights	=	480 grains
20 pennyweights	=	1 troy ounce
14.583 troy ounces	=	1 pound avoir
16 avoir ounces (7000 grains)	=	1 avoir pound
avoir weight × .911	=	1 troy weight

To convert troy ounces to grams:
Oz.(t) × 31.1035 = Grams.
To convert grams to troy ounces:
Grams × 0.0322 = Oz.(t).

Avoir and Troy Weights

Troy Oz.	Adv. Lbs.	Troy Oz.	Adv. Lbs.
.91 oz.	1 oz.	12.74 oz.	14 oz.
1.82 oz.	2 oz.	13.65 oz.	15 oz.
2.73 oz.	3 oz.	14.58 oz.	1 lb.
3.64 oz.	4 oz.	29.16 oz.	2 lb.
4.55 oz.	5 oz.	43.74 oz.	3 lb.
5.46 oz.	6 oz.	58.32 oz.	4 lb.
6.37 oz.	7 oz.	72.90 oz.	5 lb.
7.28 oz.	8 oz.	87.48 oz.	6 lb.
8.19 oz.	9 oz.	102.06 oz.	7 lb.
9.10 oz.	10 oz.	116.64 oz.	8 lb.
10.01 oz.	11 oz.	131.22 oz.	9 lb.
10.92 oz.	12 oz.	145.80 oz.	10 lb.
11.83 oz.	13 oz.		

The Carat System

1 carat = ⅕ gram
1 carat = 100 points
1 carat = 4 pearl grains
1 pearl grain = ¼ carat
1 point = 1/100 carat

To convert carats to grams: Carats × 0.2 = Grams.

Diamond Prices 1980–1985

Figures represent a sampling of prices which diamond dealers in various cities charged their customers in the months given. The diamonds are graded G-1 in color and Vs₁ in clarity, using GIA terms.

Carat weight of diamonds; medium price per carat

Date	.04–.08	.09–.16	.17–.22	.23–.28	.29–.35	.46–.55	.69–.79	.95–1.15
January 1980	587	640	980	1,220	1,400	1,950	2,605	4,650*
July 1980	570	655	1,080	1,385	1,550	2,738	3,566	5,600*
September 1980	570	655	1,080	1,385	1,550	2,738	3,566	5,650*
November 1980	570	655	1,080	1,385	1,550	2,738	3,566	5,650*
January 1981	550	605	1,000	1,200	1,250	2,675	2,975	5,425*
February 1981	536	612	903	1,100	1,275	2,100	2,925	5,300*
March 1981	537	657	1,075	1,375	1,585	2,425	3,000	5,000*
April 1981	600	645	1,175	1,345	1,620	2,440	3,065	5,150*
May 1981	600	645	1,175	1,345	1,620	2,440	3,065	5,150*
June 1981	600	645	1,175	1,345	1,620	2,440	3,065	4,875*
July 1981	600	645	1,175	1,345	1,620	2,440	3,065	N.A.
August 1981	600	645	1,175	1,345	1,620	2,440	3,065	N.A.
September 1981	501	552	810	1,100	1,400	2,000	2,275	N.A.
October 1981	501	552	810	1,100	1,400	2,000	2,275	N.A.
November 1981	501	552	810	1,100	1,400	2,000	2,275	N.A.
December 1981	467	550	837	900	1,200	1,800	2,300	3,800*
January 1982	532	565	829	1,050	1,250	2,000	2,300	4,400*
February 1982	495	580	875	1,100	1,225	2,000	2,400	4,000*
March 1982	495	580	875	1,100	1,225	2,000	2,400	N.A.
April 1982	475	500	900	1,200	1,400	1,800	2,250	N.A.
May 1982	450	550	826	936	1,206	1,816	2,200	3,450*
June 1982	456	550	791	936	1,325	1,775	2,170	3,075*
July 1982	456	550	791	936	1,325	1,775	2,170	3,075*
August 1982	450	535	750	888	1,325	1,775	2,150	3,100*
September 1982	477	550	812	945	1,090	1,750	2,200	3,200*
October 1982	470	520	750	935	1,162	1,840	2,200	3,075*
November 1982	475	525	750	940	1,250	1,900	2,250	3,000*
December 1982	475	525	750	940	1,250	1,900	2,250	3,000*
January 1983	475	525	750	940	1,250	1,900	2,250	3,200*
February 1983	490	560	835	965	1,260	2,000	2,500	3,300*
March 1983	490	560	835	965	1,260	2,000	2,500	3,300*
April 1983	490	560	835	965	1,260	2,000	2,500	3,300*
May 1983	490	560	835	965	1,260	2,000	2,500	3,300*
June 1983	490	560	835	965	1,260	2,000	2,500	3,300*
July 1983	490	560	835	965	1,260	2,000	2,500	3,300*
August 1983	490	560	835	965	1,260	2,000	2,500	3,300*
September 1983	490	560	835	965	1,260	2,000	2,500	3,300*
October 1983	490	560	835	965	1,260	2,000	2,500	3,300*
November 1983	490	560	835	965	1,260	2,000	2,500	3,300*
December 1983	490	560	835	965	1,260	2,000	2,500	3,300*
January 1984	490	560	835	965	1,260	2,000	2,500	3,300*
February 1984	490	560	835	965	1,260	2,000	2,500	3,300*
March 1984	490	560	835	965	1,260	2,000	2,500	3,300*
April 1984	490	560	835	965	1,260	2,000	2,500	3,300*
May 1984	490	560	835	965	1,260	2,000	2,500	3,300*
June 1984	490	560	835	965	1,260	2,000	2,500	3,300*
July 1984	490	560	835	965	1,260	2,000	2,500	3,300*
August 1984	490	560	835	965	1,260	2,000	2,500	3,300*
September 1984	490	560	835	965	1,260	2,000	2,500	3,300*
October 1984	490	560	835	965	1,260	2,000	2,500	3,300*

Carat weight of diamonds; medium price per carat

Date	.04–.08	.09–.16	.17–.22	.23–.28	.29–.35	.46–.55	.69–.79	.95–1.15
November 1984	490	560	835	965	1,260	2,000	2,500	3,300*
December 1984	490	560	835	965	1,260	2,000	2,500	3,300*
January 1985	490	560	835	965	1,260	2,000	2,500	3,300*
May 1985	482	550	810	950	1,235	1,950	2,460	3,300*
August 1985	482	550	810	950	1,235	1,950	2,460	3,300*
December 1985	482	550	810	950	1,235	1,950	2,460	3,300*

N.A. Prices not available this month.
*Starting in November 1979, prices for .95 to 1.15 carat diamonds were dropped.
Prices given are for 1.00 to 1.15 carat stones, graded H color, VS$_2$ clarity.

Source: Jewelers' Circular-Keystone Directory, June 1986.

Gold and Silver Prices

	Prices per Troy ounce			Prices per Troy ounce	
Month	**Gold**	**Silver**	**Month**	**Gold**	**Silver**
Jan. 1971	$ 37.75	$ 1.70	Jan. 1979	$218.85	$ 5.985
April 1971	$ 39.15	$ 1.74	April 1979	$240.00	$ 7.460
July 1971	$ 40.65	$ 1.60	July 1979	$281.80	$ 8.572
Oct. 1971	$ 42.85	$ 1.36	Oct. 1979	$385.25	$15.800
Jan. 1972	$ 45.60	$ 1.47	Jan. 1980	$643.00	$36.800
April 1972	$ 48.70	$ 1.59	April 1980	$528.00	$16.400
July 1972	$ 65.90	$ 1.70	July 1980	$663.50	$16.750
Oct. 1972	$ 64.95	$ 1.795	Oct. 1980	$682.00	$21.390
Jan. 1973	$ 64.45	$ 2.02	Jan. 1981	$574.75	$15.500
April 1973	$ 91.30	$ 2.23	April 1981	$523.00	$12.170
July 1973	$126.30	$ 2.72	July 1981	$426.00	$ 8.620
Oct. 1973	$102.25	$ 2.87	Oct. 1981	$441.25	$ 9.500
Jan. 1974	$126.80	$ 3.40	Jan. 1982	$401.00	$ 8.250
April 1974	$173.55	$ 5.045	April 1982	$327.75	$ 7.130
July 1974	$141.25	$ 4.31	July 1982	$310.25	$ 5.160
Oct. 1974	$155.95	$ 4.68	Oct. 1982	$418.50	$ 8.780
Jan. 1975	$169.75	$ 4.22	Jan. 1983	$465.00	$11.560
April 1975	$173.65	$ 4.09	April 1983	$429.25	$11.260
July 1975	$164.50	$ 4.515	July 1983	$423.50	$12.24
Oct. 1975	$142.65	$ 4.465	Oct. 1983	$383.00	$ 8.750
Jan. 1976	$136.05	$ 4.25	Jan. 1984	$365.25	$ 7.92
April 1976	$128.20	$ 4.26	April 1984	$380.25	$ 9.125
July 1976	$123.10	$ 5.04	July 1984	$369.25	$ 8.415
Oct. 1976	$114.75	$ 4.355	Oct. 1984	$345.35	$ 7.56
Jan. 1977	$131.35	$ 4.39	Jan. 1985	$298.85	$ 5.97
April 1977	$148.70	$ 4.805	April 1985	$329.25	$ 6.67
July 1977	$143.00	$ 4.465	July 1985	$314.85	$ 6.05
Oct. 1977	$154.45	$ 4.64	Oct. 1985	$326.80	$ 6.26
Jan. 1978	$164.95	$ 4.78	Jan. 1986	$332.60	$ 5.87
April 1978	$181.35	$ 5.265			
July 1978	$184.25	$ 5.315			
Oct. 1978	$222.70	$ 5.805			

Note: Prices given are early month figures.

Source: Jeweler's Circular-Keystone Directory, June 1986.

Weight Estimation Formulas: Diamonds

ROUND BRILLIANT: Diameter2 x Depth x .0061.

OVAL BRILLIANT: Average the length and width to determine diameter. Apply formula: Diameter2 x Depth x .0062.

The conversion factor used in the following formulas is based on the length-to-width ratio of the diamond. For example, a stone with a length of 9mm and a width of 6mm would have a length-to-width ratio of 1.5:1.

EMERALD CUT:
Length \times Width \times Depth \times .008 (1:1 ratio)
.0092 (1.5:1 ratio)
.010 (2:1 ratio)
.0106 (2.5:1 ratio)

MARQUISE CUT:
Length \times Width \times Depth \times .00565 (1.5:1 ratio)
.0058 (2:1 ratio)
.00585 (2.5:1 ratio)
.00595 (3:1 ratio)

PEAR SHAPED:
Length \times Width \times Depth \times .00615 (1.25:1 ratio)
.0060 (1.5:1 ratio)
.0059 (1.66:1 ratio)
.00575 (2:1 ratio)

All formulas are based on stones with thin-to-medium girdles. Adjust weight as follows for stones with thicker girdles: medium up to slightly thick, add two to four points per carat; thick to very thick, add five to ten points per carat. All measurements should be taken in millimeters.

Source: Gemological Institute of America.

Weight Estimation Formulas: Colored Stones

Round Faceted Stones:
Diameter2 \times depth \times S.G. \times .0018 = carat weight.

Oval Faceted Stones:
(Average the length and width to obtain diameter).
Diameter2 \times depth \times S.G. \times .0020 = carat weight.

Emerald-Cut Faceted Stones:
Length \times width \times depth \times S.G. \times .0025 = carat weight.

Rectangular Faceted Stones:
Length \times width \times depth \times S.G. \times .0026 = carat weight.

Square Faceted Stones:
Length \times width \times depth \times S.G. \times .0023 = carat weight.

Navette or Boat-shaped Stones:
Length \times width \times depth \times S.G. \times .0016 = carat weight.

Pear-shaped or Teardrop-shaped Stones:
Length \times width \times depth \times S.G. \times .00175 = carat weight.

Cabochons:
Length \times width \times depth \times S.G. \times .0026
(.0029 for very flat or shallow domed stones).

Check for bulge factor, usually present; depending upon bulge factor, add 2 to 6 percent. All measurements should be taken in millimeters. To ensure accuracy, measurements should be made to 1/10 millimeter.

Source: Gemological Institute of America.

Gem Identification Report*

Date_____

Client_____ Item #_____

Address_____

Refractive Index_____; Birefringence_____(_____)_____

Comments_____

Polariscope Reaction: DR ☐ SR ☐ AGG ☐

Optic Character: Uniaxial ☐ Biaxial ☐ Indeterminable ☐

Optic Sign: Positive ☐ Negative ☐ Indeterminable ☐

Pleochroism: Weak ☐ Dichroic Colors_____

 Medium ☐ Trichroic Colors_____

 Strong ☐ _____

Specific Gravity:_____Determined by: Liquids ☐ Hydrostatic ☐ Indeterminable ☐

Fluorescence: Longwave_____ Shortwave_____

Microscopic Examination:_____

Luster: Polish_____Fracture_____

Absorption Spectra:

4000	5000	6000	7000

| VIOLET | VIOLET BLUE | BLUE | BLUE GREEN | GREEN | YELLOW GREEN | YELLOW | ORANGE | RED |

Ancillary Tests:_____

Comments:_____

Weight:_____ Actual ☐ Estimated ☐

Consistent with the observations indicated above, I believe this gem to be:

Variety_____

Species_____

Prepared by_____

* Reprinted with permission of the National Association of Jewelry Appraisers.

Quality Analysis: Colored Stones

Date _____

Client _____

Address _____

Item # _____

Measurements: _____ mm X _____ mm X _____ mm Deep

Shape and Cut: Round ☐ Oval ☐ Marquise ☐ Emerald ☐ Pear ☐

Heart ☐ Cabochon ☐ Other _____ Comments _____

Hue:

Red-Violet ☐	Reddish Orange ☐	Yellow ☐	Bluish Green ☐	Blue-Violet ☐
Violetish Red ☐	Orange ☐	Greenish Yellow ☐	Blue-Green ☐	Bluish Violet ☐
Red ☐	Yellowish Orange ☐	Yellow-Green ☐	Greenish Blue ☐	Violet ☐
Orangish Red ☐	Yellow-Orange ☐	Yellowish Green ☐	Blue ☐	Reddish Violet ☐
Red-Orange ☐	Orangish Yellow ☐	Green ☐	Violetish Blue ☐	

Tone

VERY LIGHT	LIGHT	SLIGHTLY LIGHT	MEDIUM	SLIGHTLY DARK	DARK	VERY DARK	EXTREMELY DARK

Comments: _____

Intensity

DULL	SLIGHTLY DULL	MEDIUM	SLIGHTLY INTENSE	INTENSE	VIVID

Comments: _____

Clarity:

FLAWLESS	LIGHTLY INCLUDED	MODERATELY INCLUDED	HEAVILY INCLUDED	EXTREMELY INCLUDED

Comments: _____

Proportions:

POOR	FAIR	GOOD	VERY GOOD	EXCELLENT

Comments: _____

Brilliancy:

POOR	FAIR	GOOD	VERY GOOD	EXCELLENT

Comments: _____

Finish:

POOR	FAIR	GOOD	VERY GOOD	EXCELLENT

Comments: _____

Additional Comments: _____

NOTE: The information contained in this report represents the earnest and considered opinion of this appraiser and/or its parent company with regard to the numerous existing characteristics of the submitted gem(s). The conclusions expressed herein are a result of the interpretation of data gathered from gemological instruments and accepted appraisal/grading procedures and techniques. In that conclusions may vary due to the subjective nature of gemstone analysis, neither this appraiser, its parent company nor any of its employees and officers can be responsible for any action that may be taken on the basis of this report. This report is not a guarantee or warranty of the quality or value of the submitted stone(s).

Prepared by _____

* Reprinted with permission of the National Association of Jewelry Appraisers.

Quality Analysis: Opals

Date _____

Client _____

Address _____

Item # _____

Measurements: _____ mm X _____ mm X _____.

Shape and Cut: Round ☐ Oval ☐ Marquise ☐ Emerald ☐

Pear ☐ Heart ☐ Cabochon ☐ Other _____

Comments _____

Body Color: ☐ White ☐ Black Other _____

Comments _____

Transparency of Body: ☐ Transparent ☐ Semi-Transparent

☐ Translucent ☐ Semi-Translucent ☐ Opaque

Predominant Spectral Hue: ☐ Red ☐ Orange ☐ Yellow ☐ Green ☐ Blue ☐ Violet

Secondary Spectral Hue: ☐ Red ☐ Orange ☐ Yellow ☐ Green ☐ Blue ☐ Violet

Hue Intensity:

POOR	FAIR	GOOD	EXCELLENT

Phenomena Saturation:

POOR	FAIR	GOOD	EXCELLENT

Additional Hues Present: ☐ Red ☐ Orange ☐ Yellow ☐ Green ☐ Blue ☐ Violet

Hue Pattern: ☐ Mosaic ☐ Pinfire ☐ Flash

Other _____

Comments: _____

Prepared by _____

Quality Analysis: Change-of-Color Stones

Measurements: _____ mm X _____ mm X _____ mm.

Shape and Cut: ☐ Round ☐ Oval ☐ Marquise ☐ Emerald ☐ Pear

☐ Heart ☐ Cabochon ☐ Other_____

INCANDESCENT LIGHT SOURCE

Hue:

☐ Red-Violet	☐ Yellow-Orange	☐ Blue-Green
☐ Violetish Red	☐ Orangish Yellow	☐ Greenish Blue
☐ Red	☐ Yellow	☐ Blue
☐ Orangish-Red	☐ Greenish Yellow	☐ Violetish Blue
☐ Red-Orange	☐ Yellow-Green	☐ Blue-Violet
☐ Reddish Orange	☐ Yeliowish Green	☐ Bluish Violet
☐ Orange	☐ Green	☐ Violet
☐ Yellowish Orange	☐ Bluish Green	☐ Reddish Violet

Other_____

Tone:

☐ Very Light	☐ Slightly Dark
☐ Light	☐ Dark
☐ Slightly Light	☐ Very dark
☐ Medium	☐ Extremely Dark

Intensity:

DULL	SLIGHTLY DULL	MEDIUM	SLIGHTLY INTENSE	INTENSE	VIVID

FLUORESCENT LIGHT SOURCE

Hue:

☐ Red-Violet	☐ Yellow-Orange	☐ Blue-Green
☐ Violetish Red	☐ Orangish Yellow	☐ Greenish Blue
☐ Red	☐ Yellow	☐ Blue
☐ Orangish-Red	☐ Greenish Yellow	☐ Violetish Blue
☐ Red-Orange	☐ Yellow-Green	☐ Blue-Violet
☐ Reddish Orange	☐ Yellowish Green	☐ Bluish Violet
☐ Orange	☐ Green	☐ Violet
☐ Yellowish Orange	☐ Bluish Green	☐ Reddish Violet

Other_____

Tone:

☐ Very Light	☐ Slightly Dark
☐ Light	☐ Dark
☐ Slightly Light	☐ Very Dark
☐ Medium	☐ Extremely Dark

Intensity:

DULL	SLIGHTLY DULL	MEDIUM	SLIGHTLY INTENSE	INTENSE	VIVID

Clarity:

FLAWLESS	LIGHTLY INCLUDED	MODERATELY INCLUDED	HEAVILY INCLUDED	EXTREMELY INCLUDED

Finish:

POOR	FAIR	GOOD	VERY GOOD	EXCELLENT

Proportions:

POOR	FAIR	GOOD	VERY GOOD	EXCELLENT

Brilliancy:

POOR	FAIR	GOOD	VERY GOOD	EXCELLENT

Comments: _____

Prepared by_____

* Reprinted with permission of the National Association of Jewelry Appraisers.

Quality Analysis: Cultured Pearls

Date_____

Client_____

Address_____

Item #_____

Body Color:
- ☐ Pink Rosé
- ☐ Pale Pink
- ☐ White Rosé
- ☐ Very Light Cream Rosé
- ☐ Very Slight Green White Rosé
- ☐ Greenish White Rosé
- ☐ White Without Rosé
- ☐ Cream Rosé
- ☐ Greenish Cream Rosé
- ☐ Cream
- ☐ Green-White
- ☐ Green-Cream
- ☐ Dark Cream Rosé
- ☐ Dark Cream
- ☐ Gold Rosé
- ☐ Blue
- ☐ Gray, Silver
- ☐ Yellow, Gold

(decreasing desirability) Sphericity:
↓
- ☐ Round in All
- ☐ Round in Most
- ☐ Slightly Off-Round
- ☐ Off-Round
- ☐ Semibaroque
- ☐ Baroque

Luster:

VERY BRIGHT	BRIGHT	HIGH	MEDIUM	SLIGHTLY DULL	DULL

Nacre Thickness:

VERY THICK	THICK	MEDIUM	THIN	VERY THIN

Continuity:

POOR	FAIR	MEDIUM	GOOD	EXCELLENT

Blemishes:

SPOTLESS	LIGHTLY SPOTTED	SPOTTED	HEAVILY SPOTTED

Comments:_____

Measurements:_____

NOTE: The information contained in this report represents the earnest and considered opinion of this appraiser and/or its parent company with regard to the numerous existing characteristics of the submitted gem(s). The conclusions expressed herein are a result of the interpretation of data gathered from gemological instruments and accepted appraisal/grading procedures and techniques. In that conclusions may vary due to the subjective nature of gemstone analysis, neither this appraiser, its parent company nor any of its employees and officers can be responsible for any action that may be taken on the basis of this report. This report is not a guarantee or warranty of the quality or value of the submitted stone(s).

Prepared by_____

* Reprinted with permission of the National Association of Jewelry Appraisers.

Quality Analysis: Cat's-Eye and Star Stones

Measurements: _____ mm X _____ mm X _____ mm.

Shape: ☐ Round ☐ Oval ☐ Navette ☐ Emerald ☐ Pear

☐ Heart ☐ Other _____

Hue:

☐ Red-Violet	☐ Yellow-Orange	☐ Blue-Green
☐ Violetish Red	☐ Orangish Yellow	☐ Greenish Blue
☐ Red	☐ Yellow	☐ Blue
☐ Orangish Red	☐ Greenish Yellow	☐ Violetish Blue
☐ Red-Orange	☐ Yellow-Green	☐ Blue-Violet
☐ Reddish Orange	☐ Yellowish Green	☐ Bluish Violet
☐ Orange	☐ Green	☐ Violet
☐ Yellowish Orange	☐ Bluish Green	☐ Reddish Violet

Other: _____

Tone: ☐ Very Light ☐ Slightly Light ☐ Slightly Dark ☐ Very Dark

☐ Light ☐ Medium ☐ Dark ☐ Extremely Dark

Intensity:

DULL	SLIGHTLY DULL	MEDIUM	SLIGHTLY INTENSE	INTENSE	VIVID

Ray Centering:

POOR	FAIR	GOOD	VERY GOOD	EXCELLENT

Ray Intensity:

VERY WEAK	WEAK	MEDIUM	STRONG	VERY STRONG

Ray Movement:

POOR	FAIR	GOOD	VERY GOOD	EXCELLENT

Phenomena Completeness:

POOR	FAIR	GOOD	VERY GOOD	EXCELLENT

Comments: _____

NOTE: The information contained in this report represents the earnest and considered opinion of this appraiser and/or its parent company with regard to the numerous existing characteristics of the submitted gem(s). The conclusions expressed herein are a result of the interpretation of data gathered from gemological instruments and accepted appraisal/grading procedures and techniques. In that conclusions may vary due to the subjective nature of gemstone analysis, neither this appraiser, its parent company nor any of its employees and officers can be responsible for any action that may be taken on the basis of this report. This report is not a guarantee or warranty of the quality or value of the submitted stone(s).

Prepared by _____

* Reprinted with permission of the National Association of Jewelry Appraisers.

Jewelry Appraisal Update

Date of Original Appraisal _____

Appraisal Type _____

Addenda Number _____

Addenda Date _____

Client's Name _____

Address _____

Precious Metal Base Price _____

NOTE: I have personally examined the following described article(s) and have found (it) them in good condition unless otherwise noted and it (they) does (do) not require any repairs at this time with the values and description as listed in this appraisal being correct to the best of our knowledge and belief based on present day market values and accepted appraisal procedures in accordance with the standards and ethics of the National Association of Jewelry Appraisers. In that mountings prohibit full and accurate observation of gem quality and weight; it must be understood that all data pertaining to mounted gems can only be considered as provisional. Additionally, because jewelry appraisal and evaluation is not a pure science but rather a subjective professional viewpoint, estimates of value and quality may vary from one appraiser to another with such variances not necessarily constituting error on the part of the appraiser. Therefore, due to the very subjective nature of appraisals and evaluation, statements and data contained herein cannot be construed as a guarantee or warranty. We assume no liability with respect to any action which may be taken on the basis of this appraisal or for any error in or omission from this report (except for fraud, willful misconduct or gross negligence). Unless specifically noted otherwise, this report does not represent an offer to buy and shall be for the exclusive use of the above mentioned client.

ITEM'S APPRAISAL LOCATION	ITEM'S VALUE ON ORIGINAL APPRAISAL OR PREVIOUS ADDENDA	UPDATE VALUE

Prepared by _____

* Reprinted with permission of the National Association of Jewelry Appraisers.

Appraisal for IRS Tax Deduction (Donation). Chrysoberyl Var. Alexandrite: Sales Information and Data Sheet

Date	Size (in carats)	Information/Source	Sale	Lot	Price (in dollars)	Per-carat Price	Color Change	Clarity	Country of Origin
July 1985	75.00				900,000.	12,000.	Good	Good	Sri Lanka
	66.00	Smithsonian Inst.							
	57.08	British Museum							
	48.20	Smithsonian Inst.			See Appraisal				
Oct. 1977	35.40	Sotheby's	4028	39	*140,000.	3,944.	Brownish green / Deep wine red		Sri Lanka
Oct. 1977	34.50	Sotheby's	4028	246	125,000. / 150,000.	4,000.	Fair to good		Sri Lanka
1985	30.78				52,170. / 92,340.	** 1,500. / 3,000.	15%	Clean	Sri Lanka
Oct. 1980	26.35	Sotheby's		592	50,000. / 60,000.	2,277.			
1985	24.00 to 27.00				*275,000.	10,784.	Good		Sri Lanka
Oct. 1978	22.30	Sotheby's	4163	299	*145,000.	6,500.	Fairly good	Good	Sri Lanka
1976	19.95				*250,000.	12,531.	80%	LI_1	Sri Lanka
1985	19.76				*118,560.	6,000.	50% to 80%		Sri Lanka
1986	17.00				* 90,000.	5,294.	Good	Clean	Sri Lanka
1985	13.00				* 90,000.	6,923.	Good	Clean	Sri Lanka
Apr. 1980	12.12	Sotheby's	4364	180	* 95,000.	7,838.	75% / Dark murky green / Burgundy red		Sri Lanka
1984	12.00	Christie's			* 36,000.	3,000.	Average		
Feb. 1979	11.60	Sotheby's		149	22,000. / 25,000.	2,155.			Sri Lanka
1986	9.71				70,833. / 116,520	** 7,300. / 12,000.	75%	Clean	Sri Lanka
1976	6.13				*160,000.	26,101.	100%	LI	U.S.S.R.
1986	26.00				*182,000. / 312,000.	** 7,000. / 12,000.	70%	Clean	

* Indicates actual sale.

** Indicates dealer selling price. Second price is adjusted fair market value.

Source: This data was compiled by Bill Sufian, IRS Valuation Engineer, New York, and Joseph W. Tenhagen, Appraiser, Miami.

GLOSSARY

Metal Finishes

Appliqué. One color of gold soldered onto another.

Basse taillé. Enamelling technique in which design is carved into metal recess and translucent to semitransparent enamel is applied.

Bloomed gold. Matte surface formed by acid treatment. Popular in the mid to late nineteenth century, bloomed gold jewelry discolors easily.

Braun email. Dark reddish enamel effect achieved by firing linseed oil in engraved lines.

Bright cut. Deep, sharply cut engraving, typically used from 1810–1830.

Burnishing. Luster added to metal finish.

Champlevé. Technique in which etched design is filled with enamel. Resembles cloisonné work but more surface metal is left exposed.

Chasing. Accent technique used to punch detail onto repoussé-finished work.

Cloisonné. Technique in which cells to hold the enamel are created by soldering wire to a base.

Diamond cutting. A process of decorating metal jewelry, especially chains, with a pattern of sharp cuts in the metal. The designs have bright finishes and patterns ranging from symmetrical straight lines to curved lines.

Embossing. Relief ornamentation applied to the front of a metal surface with engraved dies or plates used to drive down the surface mechanically and leave a relief design.

Enamelling. Colored powdered glass fused onto metal surface with heat.

Engine turning. Machine engraver used to produce a brilliant surface, which often serves as a base for enamel.

Engraving. Metal surfaces decorated from the front with incised lines and patterns, using chisels called *gravers*. Differs from carving in that pattern depth is only suggested with shaded lines.

Etching. Chemical engraving.

Filigree. Gold wire twisted and soldered into intricate patterns.

Florentine. Metal surface textured in crosshatching pattern with liner tool.

Gilding/gilt. Metal dipped in gold or electroplated with gold.

Granulation. Tiny round balls fastened to surface by heating process. Typical of the Etruscan styles popular from 1850–1880.

Grisaille. Layers of enamel applied over a gray ground, producing a monochromatic effect. Technique popular since the sixteenth century.

Guilloché. Translucent enamel fired over engine-turned or hand-engraved gold surface. Enamelling is sometimes fired five or six times.

Hammering. Indentations pounded into metal.

High polish. Mirrorlike finish.

Matte. Soft, dull finish.

Oxidized. Blackened finish caused by immersion in potassium sulfide.

Parcel gilt. Partially gilded.

Pliqué-à-jour. Enamel confined within unbacked metal frames to give stained-glass effect. Popular from 1890–1910.

Repoussé. Raised, modeled designs that are hammered and punched from the back of a metal plate to raise the design on the front. The work is done with hand punches and hammers, or is mechanically imposed with metal dies.

Roman gold. Surface that has been matted and then gold-electroplated.

Satin. Finish with the grained texture of satin cloth.

Taille d'épargne. Blue, black, or white enamel set in deeply engraved line designs. Popular mid-nineteenth-century technique.

Opal Terms

Black opal. Opal that has an opalescent play of color against a gray or black background.

Cachalong. Porous, opaque opal that absorbs water quickly.

Cherry opal. Opal with a cherry-red ground color that occasionally has a play of color.

Common opal. Nontranslucent opal with no play of color. Some of this variety is not so common at all—colors may be sky blue, lemon yellow, orange, red, or green.

Contra luz. Opal, usually from Mexico, that shows its best colors against the light.

Fire opal. Translucent Mexican opal with red or orange overall color and no play of color. Not synonymous with precious opal. Red opal with a play of color is called *precious fire opal.*

Flame opal. Precious opal with elongated streaks of prismatic flamelike colors.

Flash opal. Precious opal with a broad-flashing play of color.

Girasol opal. Water-clear opal with broad floating colors.

Harlequin. Precious opal with play of color similar to a checkerboard mosaic.

Hyalite. Pure, transparent, colorless opal that has formed as crusts.

Honey opal. Pale, amber-colored opal, usually with a play of fire.

Hydrophane. A variety of cachalong that becomes almost transparent in water except for its prismatic colors.

Jelly opal. Translucent, colorless opal with a play of fire—a variety of precious opal.

Lechosos or milk opal. Opal with play of color against a pure white ground color.

Matrix opal. Host rock that is impregnated with tiny flecks and veinlets of natural opal, which cannot easily be separated from the matrix.

Pinfire opal. Iridescent opal with small, closely spaced pinpoints.

Play of color. Optical phenomenon of several prismatic flashing colors seen within or near the surface of an opal as the gem is moved.

Play of fire. A degree of colored flame that can be seen within transparent precious opal ranging from amber colored to red.

Precious opal. Opal that has the prismatic play of color for which this gem is noted. If it does not change color, it is not precious opal.

Seam opal. Narrow rows of precious opal that have formed in the fissures and cracks of a host rock.

Wood opal. Opal pseudomorph formed on wood, found in many countries as well as in the United States. Commonly colored in shades of beige, gray, cream, white, brown, and black.

Antique and Period Jewelry Terms

Albert. Man's vest watch chain, single or double width, popularized by Prince Albert of England.

Antique. Item judged to have been made at least one hundred years ago.

Argentan. French term for nickel silver, German silver, or other nonprecious imitation.

Art Deco. Design style of the 1920s through 1935, characterized by geometric forms and motifs, fine handicraft, and the use of precious materials.

Art Nouveau. Japanese-influenced design style popular from 1890 through 1910, characterized by curves, flowing lines, asymmetry, and the use of natural forms and motifs.

Arts & Crafts movement. Late Victorian/Edwardian (1860–1910) design style characterized by handmade silver and enamel pieces set with rough or flawed stones.

Asterism. Optical phenomenon of a rayed figure, such as a star, seen in a cabochon-cut stone.

Baguette. Rectangular cut used mainly for small diamonds.

Bail. Suspension loop on pendants, lockets, and similar articles.

Baroque pearl. Pearl of irregular shape, more common than spherical pearls. May be natural or cultured.

Base metal. Any nonprecious metal.

Basket mount. Ring head with openwork sides and shank sections.

Bead set. Stone set flush with the mount and secured with metal beads, as in pavéd pieces.

Belcher link. Simple round links common in Georgian and Victorian chains.

Belcher mount. Ring mounting with the setting claws, or prongs, formed in the shank of the ring or brooch.

Bezel set. Collar burnished over the girdle of a gemstone. Also called *collet set.*

Blister pearl. Pearl formed naturally on the inside shell of a mollusk. Usually hollow.

Blue white. FTC-regulated industry term that may be used to describe only diamonds that have a blue or bluish body color. The term has been so widely misused that it has become nearly meaningless.

Bohemian garnet. Dark red rose-cut garnet, widely used in nineteenth-century jewelry.

Bombé mount. Convex mount often used in period jewelry, especially in bracelets and brooches.

Briolette. Oval or teardrop-shaped stone covered with small triangular facets.

Buff top. Stone cut with cabochon crown and a faceted pavilion.

Cabochon. Round or oval domed stone, polished but not faceted. Commonly used in cutting cat's-eye or star stones.

Caliber cut. Gemstones cut to a special or exact size and used to highlight or outline a jewelry item. Commonly used from the 1920s to the 1930s.

Cameo. One-piece gemstone material carved to leave a raised design and show the design and background in different colors. Commonly used materials include carnelian, chalcedony, and sardonyx.

Cannetille. Open-coiled wirework technique popular during the first half of the nineteenth century.

Cartouche. Shield or scroll motif.

Cast. Piece formed by pouring molten metal into a hollow mold.

Cat's eye. Well-defined streak of light the length of a cabochon. The optical phenomenon is termed *chatoyancy.*

C clasp. Simple, C-shaped clasp found on antique brooches.

Channel set. Rows of gems secured by metal flanges. No claws or beads are used.

Clawed collet. Gemstone ring setting characterized by integral triangular, flat claws or prongs. Typically used in early nineteenth-century jewelry.

Closed back. Setting in which the pavilion of a stone is completely enclosed; may be foiled.

Collar. Metal band encircling a gemstone.

Collet set. See Bezel set.

Composition. Plastics, including celluloid, Bakelite, and similar varieties. Earliest examples date to the 1850s.

Crown. Portion of the gemstone above the girdle.

Cruciform. Cross-shaped article or jewelry section.

Culet. Small facet polished across the pavilion point of a faceted stone.

Cultured pearl. Pearl created by artificial introduction of a nucleus into a mollusk, which stimulates accumulation of nacre and forms the pearl. Cultured pearls take approximately three years to form in salt water; less in fresh water or the South Seas.

Curb chain. Chain characterized by flattened links.

Cushion cut. Square or rectangular stone with rounded corners, as in old mine-cut stones.

Demi-parure. Small ensemble of jewelry, usually brooches and earrings or a necklace and earrings.

Doublet. Two-part assembled stone, frequently a garnet crown over glass pavilion. May imitate any stone.

Emerald cut. Rectangular step-cut or trap-cut stone with a 45-degree corner angle.

En esclavage. Plaques joined by two or more parallel chains. Necklace style popular in the early nineteenth century.

Estate jewelry. Previously owned jewelry, not necessarily antique items.

Faceting. Process of polishing a gemstone into a series of planes for maximum beauty and brilliance.

Fancy color. In sapphires, any color other than blue; in diamonds, gold, blue, pink, green, and deep brown.

Filigree. Fine wire bent and soldered to create a design. May be backed or open.

Fob. Seal or other decorative item suspended from a man's watch chain.

Foiling. The practice of backing a stone in thin metal foil in a closed-back setting to add color and/or brilliance to the stone. Common in antique jewelry, even in diamonds.

Fracture. Break of any sort other than cleavage; may occur in any stone.

French ivory. Celluloid made to resemble ivory. Popular in twentieth-century jewelry.

French jet. Black glass used to simulate jet. Popular in late nineteenth- to twentieth-century jewelry.

Gallery. Area below the setting in a ring. May be pierced, carved, or otherwise designed.

Girandole. Brooch or earrings with swinging pear-shaped drops. Popular in the eighteenth and nineteenth centuries.

Girdle. The extreme edge of a fashioned gemstone that divides the crown and pavilion.

Gold filled. Base metal joined with layers of gold, similar to rolled gold. A stamped fraction may indicate the ratio of gold content to total metal weight.

Green beryl. Green gemstone not intense enough to be called emerald.

Gypsy setting. Setting style in which the stone is set with table flush to the surface of the shank.

Habillé. Cameos "dressed" with gems and/or metal jewelry.

Hair compartment. Glazed recess on the reverse side of a jewelry article that holds the hair of the owner's friend, lover, or relative. Not necessarily memorial items, hair compartments were common in jewelry made during the 1840s.

Hair jewelry. Braided human hair made into watch chains, earrings, and other jewelry items, as mementos or memorial pieces.

Hallmark. British system of marking precious metals, used since 1300 to signify metal fineness, maker, and town in which the item was assayed.

Holbeinesque. Nineteenth-century Renaissance-style jewelry named after Hans Holbein *fils*, the German painter.

Hololith ring. Finger ring cut from one piece of gemstone material.

Illusion setting. Stone surrounded by metal, making it appear larger than it is.

Imperial jade. Translucent, evenly colored, emerald green jadeite. The finest jadeite, Imperial jade is extremely rare.

Incrustation. Overlay of gemstones, gold, and the like on the surface of another substance.

Intaglio. Design incised on a hardstone carving material; the opposite of a cameo.

Lavaliere. Delicate pendant worn on or attached to the neck chain and dating to approximately 1900.

Mabe pearl. Cultured blister pearl, usually filled and backed with mother-of-pearl bead; used for earrings, rings, and other jewelry articles.

Maker's mark. Initials or trademark stamped or engraved on jewelry.

Marquise. Stone or jewelry item that is essentially oval but has pointed ends.

Matrix. Parent rock supporting the growth of a gem or mineral, usually turquoise or opal.

Mazarin cut. See Single cut.

Micromosaic. Small pieces of *tesserae,* or glass, grouted to form a design, usually in jewelry from Rome.

Mosaic. Pieces of glass or gems set in grouting to form a pattern.

Mourning or memorial jewelry. Common remembrances of relatives or acquaintances. May be engraved with details or have hair compartments. If enameled, these items are usually black or blue. White enamel, indicating purity or innocence, was used only for memorials of children and unmarried women.

Native cut. Cutting style characterized by facet irregularities. Common in pre–twentieth-century jewelry, items made in India, and in synthetic gemstones.

Natural pearl. Pearl formed naturally in the mollusk, probably as a reaction to a virus and not because of irritation caused by grains of sand, as previously thought. X-radio-

graphy is sometimes used to prove natural origin.

Nickel silver. An alloy of 65 percent copper, 5 to 25 percent nickel, and 10 to 30 percent zinc.

Niello. A mixture of silver, lead, and sulphur used like enamel.

Old European cut. Diamond cut with circular shape and large culet; table diameter is usually 50 percent or less than that of the girdle. The cutting style was commonly used between 1885 and 1915.

Old mine cut. Diamond cut with a cushion shape, large culet, and the girdle placed nearly halfway between the table and culet. Table diameter is usually 50 percent or less than that of the girdle. The cutting style was commonly used in the last half of the nineteenth century.

Open back. Setting that allows interplay of light within the set stone.

Parure. Suite of antique (usually late eighteenth to nineteenth century) jewelry that may include a necklace, pendant, brooch, earrings, and bracelets.

Paste. Glass that has been molded, faceted, carved, or otherwise made to resemble gem material.

Pavéd. Bead-set jewelry whose surface has been "paved" with small stones.

Pavilion. Portion of the gemstone below the girdle.

Pietra dura. Pieces of polished gem material set in a ground of slate, lapis lazuli, or similar material. It is produced primarily in Florence, and is also called Florentine mosaic work.

Pink sapphire. Corundum not red enough to be called ruby.

Piqué. Gold and silver worked into tortoiseshell in patterns of lines, scallops, or geometrical designs. Styles include flowers (*piqué posé*), stars and dots (*piqué point*), and larger points (*piqué clouté*). Also, European clarity grade of diamonds in the imperfect range.

Provenance. Documented history of an item, including origin and important owners.

Rebus. Words represented by pictures of objects or by symbols, the names of which, when sounded in sequence, reveal a message. Often used in intaglios for seal purposes.

Reconstituted amber. Fragments of amber compressed under heat and pressure to form beads.

Registration mark. Mark or symbol indicating the registration date of a design, not commonly used on jewelry. When present, it confirms British manufacture and the approximate production date. Also called *kite mark*.

Reverse intaglio. Incised carving on the base of a rock-crystal cabochon that is then colored and backed by mother-of-pearl. Popular technique from the late nineteenth through the first half of the twentieth century. Sometimes called *Essex crystal*.

Revivalist jewelry. Jewelry pieces reviving ancient or period styles and techniques, produced throughout the last half of the nineteenth century.

Rococo. Early to mid-nineteenth-century design style featuring curved lines and shell, scroll, and foliage motifs.

Rose cut. Cutting style in which a stone is cut with a flat base, a pointed, faceted top, and at least three regularly placed triangular facets. The style originated in India, was a common early diamond cutting style, and is still often used for garnets.

Rose gold. Gold of any karat alloyed with copper or with copper and silver.

Round brilliant cut. Standard modern cutting style for round diamonds and most colored stones, featuring fifty-eight facets, thirty-three above the girdle and twenty-five below. Not all round brilliant-cut gemstones will have a faceted culet.

Sautoir. Long rope of beads or chain, continuous or open-ended, popular from the early nineteenth century onward. Modern versions are often completed with tassels.

Seal. Intaglio carving with design reversed so that it is readable when impressed in wax.

Senaille. Cutting style similar to rose cut but characterized by irregular facet shapes and arrangement.

Silk. Microscopic needlelike inclusions found in ruby, sapphire, chrysoberyl, and similar materials. Responsible for producing the cat's-eye or star effect.

Single cut. Round brilliant cutting style featuring eighteen facets. Used for smaller stones.

Soudé emerald. Fused emerald doublet. The term is commonly misapplied to nonfused emerald doublets.

Split ring. Ring that will hold suspended lockets, fobs, and so on, similar to the modern key ring.

Star set. Star engraved into the metal surface of a jewelry item, with the stone bead set in the center. Sometimes confused with gypsy settings.

Step cut. Cutting style with horizontal, layered facets, as in emerald cut. Also called *trap cut*.

Style. Refers to jewelry article with the appearance of being made in a designated period but actually made at a later date.

Sugar loaf. Highly domed, even-ridged cabochon popular from 1910–1930.

Swiss cut. Old diamond cutting style halfway between a single and a full cut. Usually has thirty-two facets.

Synthetic. Man-made material with essentially the same optical, chemical, and physical properties as its natural counterparts.

Table. Flat top facet of a gemstone.

Target brooch. Round brooch often pavéd with turquoise. Popular from the mid to late nineteenth century.

Tesserae. Tiny pieces of glass tubing used to produce Roman mosaics.

Tested. Metal that has been acid tested to ascertain type and fineness.

Tiffany setting. Head for setting stones with four or six long, slender prongs and a round, flared base.

Trap cut. See Step cut.

Tremblant. Jewelry item with sections mounted on tiny springs to allow movement.

Triplet. Three-part assembled stone that is intended to resemble a fine gemstone, such as a crown of garnet, layer of colored cement, and glass pavilion that looks like a fine emerald.

Vegetable ivory. Palm tree nut (tagua nut) that can be carved and polished.

Vermeil. Gold plated on a sterling-silver base.

(Prepared by Waller Antiques, Ltd., Victoria, British Columbia)

BIBLIOGRAPHY

Adair, John. 1945. *The Navajo and Pueblo silversmiths.* Norman, OK: University of Oklahoma Press.

Altobelli, Cos. 1986. *Handbook of jewelry and gemstone appraising.* Los Angeles: American Gem Society.

American Indian Art Magazine. 1986. Great Lakes Issue 11, no. 3 (Summer).

American Institute of Real Estate Appraisers and the Society of Real Estate Appraisers. 1981. *Real estate appraisal terminology.* Rev. ed. Ed. Byrl N. Boyce. Cambridge, MA: Ballinger Publishing Co.

American Society of Appraisers. 1968. *The principles of appraisal practice and code of ethics.* Rev. ed., July 1986, reprint series #33. Pamphlet.

Anderson, Ronald A., and Walter A. Kumpf. 1976. *Business law.* Cincinnati: South-Western Publishing Co.

Appraisers Guild. 1985. *The jewelry appraiser's manual.* Garden Grove, CA: Appraisers Guild.

Babcock, Frederick M. 1976. A look at valuation science. In *Commentary on personal property appraising.* ASA Monograph #7. Washington, DC: Corporate Press.

Babcock, Henry A. 1980. *Appraisal principles and procedures.* Washington, DC: American Society of Appraisers.

Baker, Lillian. 1978. *One hundred years of collectible jewelry.* Paducah, KY: Schroeder Publishing Co.

———. 1986. *Fifty years of collectible fashion jewelry: 1925–1975.* Paducah, KY: Collector Books.

Barlow, Ronald S. 1979. *How to be successful in the antique business.* El Cajon, CA: Windmill Publishing Co.

Becker, Vivienne. 1982. *Antique and twentieth-century jewelry.* New York: Van Nostrand Reinhold.

Bell, Jeanenne. 1985. *Answers to questions about old jewelry: 1840–1950.* Florence, AL: Books Americana.

Berk, Merle. 1986. Deborah Aguado. *Lapidary Journal* 39, no. 12 (March): 36.

Biddle, Julia. 1981. Appraising an appraiser. *Colored Gem Digest* 2, no. 3 (Fall): 18.

Blakemore, Kenneth. 1971. *The book of gold.* New York: Stein and Day.

Brugger, George A. 1981. A short course in survival techniques for expert witnesses. *ASA Valuation* 27, no. 1 (November): 11–20.

Brunner, Herbert. 1971. *Kronen und herrschaftszeichen in der schatzkammer der residenz Munchen.* Munich: Verlag Schnell & Steiner.

Burack, Benjamin. 1984. *Ivory and its uses.* Rutland, VT: Charles E. Tuttle Co.

Canadian Jeweller 1986 Trade Mark Index. Ed. Simon Hally. 107, no. 7 (July). Annual publication.

Changing Times. 1985. Your jewelry: What it's worth. *Changing Times* 39, no. 2 (February).

Chu, Arthur, and Grace Chu. 1978. *The collector's book of jade.* New York: Crown Publishers.

Clair, Bernard E., and Anthony R. Daniels. 1982. *Consultation with a divorce lawyer.* New York: Simon & Schuster.

Covington, Margaret. 1985. Use of expert assistance in jury selection. *Case & Comment* 90, no. 4 (July/August): 20–26.

Davenport, Cyril. 1904. Cameos. Extract from *The Smithsonian Report,* reproduced in facsimile, 1967. Seattle: Shorey Book Store.

David, Mary L., and Greta Pack. 1982. *Mexican jewelry.* Austin: University of Texas Press.

Dolan, Maryanne. 1984. *Collecting rhinestone jewelry.* Florence, AL: Books Americana.

Drucker, Edward. 1980. Appraiser's fees: The other side of the coin. *The Appraiser's Information Exchange.* Newsletter of the International Society of Appraisers. (October): 8.

Ehrhardt, Roy. 1974. *American pocket watch identification and price guide.* Bk. 2, rev. ed. Kansas City, MO: Heart of America Press.

Ehrhardt, Sherry, and Peter Plane. 1984. *Vintage American and European wristwatch price guide.* Kansas City, MO: Heart of America Press.

Fales, Martha Gandy. 1970. *Early American silver for the cautious collector.* New York: Funk & Wagnalls.

Farrell, Eileen, and Marie E. Thomas. 1983. The search for

a perfect language. *The Goldsmith* 163, no. 6 (October): 33–39, 87.

Farrell, Eileen. 1985. The pros and cons of price lists, part two: The appraiser—friend or foe? *The Goldsmith* 166, no. 6 (March): 83–86.

Federal Trade Commission. *Guides for the jewelry industry.* Rev. April 15, 1986. 16 Code of Federal Regulations, part 23. Washington, DC: U.S. Government Printing Office.

Federman, David. 1986. The seven deadly sins of appraising. *Modern Jeweler* 85, no. 10 (October): 42–49.

Gemological Institute of America. 1967. *The jeweler's manual.* Los Angeles: Gemological Institute of America.

Gill, Spencer. 1975. *Turquoise treasures.* Portland, OR: Graphic Arts Center Publishing Co.

Gump, Richard. 1962. *Jade, stone of heaven.* Garden City, NY: Doubleday & Co.

Harris, Ian. 1979. *The price guide to antique silver.* Suffolk, Great Britain: Baron Publishing.

Hemrich, Gerald I. 1966. *The handbook of jade.* Mentone, CA: Gembooks.

Henzel, S. Sylvia. 1982. *Collectible costume jewelry with prices.* Lombard, IL: Wallace-Homestead Book Co.

Herzberg, Carol. 1983. Experts' clues aid in evaluating antique jewelry. *National Jeweler* 27, no. 14 (July 16): 28.

Holland, Margaret. 1978. *Phaidon guide to silver.* Oxford, Great Britain: Phaidon Press Ltd.

Huffer, Helene. 1983a. Gem identification, treatment, appraisals, antiques: Conference tackles industry issues. *Jeweler's Circular-Keystone* 154, no. 8 (August): 110–20.

———. 1983b. Appraisal groups test and title. *Jeweler's Circular-Keystone* 154, no. 11 (November): 53–54.

———. 1983c. How much markup is enough? *Jeweler's Circular-Keystone* 154, no. 12 (December): 60–61.

———. 1985. Which appraisal system is best? *Jeweler's Circular-Keystone* 156, no. 3 (February): 146–54.

Jenkins, Emyl. 1982a. *Why you're richer than you think.* New York: Rawson, Wade Publishers.

———. 1982b. Your day in court. *The Appraiser's Information Exchange.* Newsletter of the International Society of Appraisers. (May/June): 6–7.

———. 1986. It's no big deal—Form 8282: To sign or not to sign. *ASA Valuation* 31, no. 1 (June): 37–39.

Jensen, Shelle S. 1986. Tapping the corporate jewelry market. *Modern Jeweler* 85, no. 2 (February): 91–92.

Jeweler's Circular-Keystone. 1970. *Sterling flatware pattern index.* 2nd ed. Radnor, PA: Chilton Co.

———. 1984. *Brand name and trade mark index.* 11th ed. Ed. Helena Matlack and Arlene Robinson. Radnor, PA: Chilton Co. Updated periodically.

———. 1986. *Jeweler's Circular-Keystone 1986 Directory.* Radnor, PA: Chilton Co. Updated annually.

Kaplan, Arthur Guy. 1985. *The official price guide to antique jewelry.* Orlando, FL: House of Collectibles.

Kovel, Ralph M., and Terry Kovel. *A directory of American silver, pewter, and silver plate.* New York: Crown Publishers.

Kramer, Bobbie. 1983. History of class rings. *Southern Jeweler* 58, no. 6 (April): 9.

Kremkow, Cheryl. 1985. Bernd Munsteiner: Gem sculptor. *The Goldsmith* 168, no. 1 (October): 37–38.

Laure, Ettagale. 1983. Bulgari: Simply a sense of style. *Modern Jeweler* 82, no. 12 (December): 26–31.

Legrand, Jacques. 1980. *Diamonds: Myth, magic, and reality.* New York: Bonanza Books.

Leithe-Jasper, Manfred, and Rudolf Distelberger. 1982. *The Kunsthistorische Museum Vienna.* London: Philip Wilson Publishers and Summerfield Press.

Liddicoat, Richard T., Jr. 1975. *Handbook of gem identification.* Los Angeles: Gemological Institute of America.

Lipshy, Bruce. 1985. Customer service: The first core value at Zale Corporation. *Texas Retailer* 12, no. 4 (Winter): 16.

Lorene, Karen. 1984. *Jewelry Newsletter* 3, no. 2 (Fall).

MacBride, Dexter D. 1976. Personal property appraisal guidelines. In *Appraisal Monograph #7.* Washington, DC: American Society of Appraisers.

Matlins, Antoinette L., and Antonio C. Bonanno. 1984. *The complete guide to buying gems.* New York: Crown Publishers.

McCarthy, James Remington. 1945. *Rings through the ages.* New York: Harper & Brothers.

Medoff, Rosalind S. 1986. Value added, selecting organic gemstone material. *Lapidary Journal* 40, no. 2 (May): 42–49

Meilach, Dona Z. 1981. *Ethnic jewelry.* New York: Crown Publishers.

Moss, Barbara. 1981. Pearls: What to tell the customer. *The Goldsmith:* 70–71.

Muller, Helen. 1980. *Jet jewellery and ornaments.* Ayesbury, Great Britain: Shire Publications.

Naas-Kemper, Roberta. 1985. The story behind the names. *National Jeweler* 29, no. 16 (August): 63.

Ng, John Y., and Edmond Root. 1984. *Jade for you: Value guide to fine jewelry jade.* Los Angeles: Jade N Gem Corporation of America.

Newman, Harold. 1981. *An illustrated dictionary of jewelry.* London: Thames and Hudson.

Northrup, C. Van. 1986. Professionalism and the International Society of Appraisers. *The Appraisers Information Exchange.* Newsletter of the International Society of Appraisers.

Pliny the Elder (Gaius Plinius Secondus). N.d. *Historia Naturalis.* Book 37, *A Roman book on precious stones,* trans. Sydney H. Ball. 1950. Los Angeles: Gemological Institute of America.

Poynder, Michael. 1976. *The price guide to jewellery.* Suffolk, Great Britain: Baron Publishers.

Purtell, Joseph. 1971. *The Tiffany touch.* New York: Random House.

Rainwater, Dorothy T. 1979. *Encyclopedia of American silver manufacturers.* New York: Crown Publishers.

Retail Jewelers of America. 1979. *Appraisal guidelines.* New York: Retail Jewelers of America.

Rice, Patty. *Amber: Golden gem of the ages.* New York: Van Nostrand Reinhold Co.

Ring, Alfred A. 1972. *Real estate principles and practices.* 7th ed. Englewood Cliffs, NJ: Prentice-Hall.

Robinson, Larry. 1986. What to do about discount competition. *Jeweler's Circular-Keystone* 156, no. 3 (March): 76.

Rosen, Elly, and C. Van Northrup. 1985. The great appraisal challenge. *Modern Jeweler* 84, no. 7 (July): 55–66.

Ruppenthal, A. N.d. *Die edelstein gravierkunst/The art of gemstone engraving.* (Three-language edition.) Idar-Oberstein, West Germany: Ruppenthal Co.

———. N.d. *Edle steine und mineralien/Precious gemstones and minerals.* (Three-language edition.) Idar-Oberstein, West Germany: Ruppenthal Co.

Ruskis, John J. 1981. Random suggestions for those working with gold and silver. *The Appraiser's Information Exchange.* Newsletter of the International Society of Appraisers: 13.

Sataloff, Joseph. 1984. *Art Nouveau jewelry.* Bryn Mawr, PA: Dorrance & Co.

Scarisbrick, Diana. 1984. *Il valore dei gioielli e degli orologi da collezione/Antique jewellery and watch values.* (Dual-language edition.) Turin, Italy: Umberto Allemandi & Co.

Schabilion, Shirl. 1983. *All in a nutshell.* Flora, MS: Keystone Comedy.

Shugart, Cooksey, and Tom Engle. 1985. *The complete guide to American pocket watches.* 5th ed. Cleveland, TN: Overstreet Publications.

Shuster, William G. 1983. How to buy or sell a store. *Jeweler's Circular-Keystone* 156, no. 10 (October): 140–41.

Sinkankas, John. *Van Nostrand's standard catalog of gems.* New York: Van Nostrand Reinhold Co.

Sitwell, H.D.W. *The crown jewels and other regalia in the Tower of London.* London: The Dropmore Press, Ltd.

Smith, Len Y., and G. Gale Roberson. 1960. *Business law.* St. Paul: West Publishing.

Snell, Doris. 1980. *American silverplated flatware patterns.* Des Moines: Wallace-Homestead Book Co.

Tardy. 1942. *Poincons d'or et de platine.* Paris: Tardy International Hallmark.

———. 1981. *International Hallmarks on silver.* Paris: Tardy International Hallmark.

Tavenier, Jean-Baptiste. 1676. *Travels in India.* Reprint. Trans. Valentine Ball, ed. William Cooke. New Delhi: Oriental Books Reprint Co. 1977.

Thomas, Sally A., and Hing Wa Lee. 1986. Gemstone carving in China: Winds of change. *Gems & Gemology* 22, no. 1 (Spring): 32–34.

Valant, Francine. 1973. The care and cleaning of gems and jewelry. *Rocks and Minerals.* Official journal of the Rocks and Minerals Association. 48, no. 6: 423–24.

Victorian Silverplated Holloware. 1972. Des Moines: Wallace-Homestead Book Co.

Walker, Marguerite P. 1982. The cost, income and market approaches to valuation as utilized by personal property appraisers. *ASA Valuation* 28, no. 1 (November).

Welch, Robert M., Jr. 1980. *The closely-held business in divorce division: Discovery and valuation.* Paper read at Southern Methodist University Center for Advanced Professional Development, March 28.

Wertz, Edward, and Leola Wertz. 1968. *The handbook of gemstone carving.* Mentone, CA: Gembooks.

Westropp, Hodder M. 1874. *A manual of precious stones and antique gems.* London: Sampson Low, Marston, Low & Searle.

Zeitner, June Culp. 1986. Netsukes. *Keystone Marketing Catalogue:* 70.

———. 1986. Opal in the United States. *Lapidary Journal* 40, no. 3 (June): 44.

SOURCES OF ADDITIONAL INFORMATION

American Diamond Industry Association
Lloyd Jaffe, chairman
c/o Lloyd Jaffe Inc.
71 W. 47th St.
New York, NY 10036
Lloyd Jaffe, chairman

American Gem and Mineral Suppliers Association
P.O. Box 2166
Upland, CA 91786
Founded in 1950, its 200 members are retailers, manufacturers, wholesalers, or publishers in the gem, mineral, lapidary, and allied fields.

American Gem Society
5901 W. Third St.
Los Angeles, CA 90036
AGS is a nonprofit professional organization composed of jewelers throughout the United States and Canada. Its purpose is to advance gemological knowledge, guide ethical practices, and enhance the public image of the jewelry industry.

American Gem Trade Association
P.O. Box 581043
Dallas, TX 75258
A nonprofit organization formed to represent and promote the colored stone industry. More than 465 members; sponsors annual gem fair in Tucson each February; offers a code of ethics for the industry.

American Society of Appraisers
11800 Sunrise Valley Drive
Suite 400
Reston, VA 22091
Founded in 1936 and represented by over five thousand members. ASA is the only multidiscipline appraisal testing/certifying society in the nation. ASA has eighty chapters in the United States and abroad.

American Watch Association, Inc.
1201 Pennsylvania Ave. N.W.
P.O. Box 464
Washington, DC 20044
AWA is open to members of the industry and has fifty full and associate members, including firms that manufacture, assemble and import watches, and firms that supply components to the industry. AWA represents its members at federal and state governmental levels on all foreign-trade issues; participates in trademark integrity activities and consumer product warranty regulations.

Appraisers Association of America Inc.
60 E. 42 St.
New York, NY 10165
A group of over twelve hundred appraisers in a variety of fields, who establish and maintain ethical standards, improve appraisal skills, and publicize the profession.

Association of Women Gemologists
P.O. Box 1844
Pearland, TX 77588
Formed in 1982, AWG is a group of women gemologists and women working in the gem industry, whose purpose is to improve gemological skills, exchange information, publicize women in the industry, and provide a network for members.

Canadian Jewellers Association
Howard Bldg.
1491 Yonge St.
Toronto, Ontario, M4T 1Z4 Canada
Founded in 1918 with more than two thousand retail, wholesale, and manufacturing members.

Canadian Jewellers Institute
1491 Yonge St.
Toronto, Ontario M4T 124 Canada
The CJI offers a training course to retail jewelers that leads to the Graduate Jeweler designation.

CIBJO—International Confederation of Jewellery, Silverware, Diamonds, Pearls and Stones
P.O. Box 29818
The Hague, Netherlands, 2502LV
Founded in 1961 to coordinate the work of independent national trade organizations of manufacturers, wholesalers, stone dealers, and retailers and to harmonize trade practices in such matters as quality standards for precious metals and gemstone nomenclature. Member countries: Austria, Belgium, Canada, Denmark, Finland, France, Great Britain, Italy, Japan, Netherlands, Norway, Spain, Sweden, Switzerland, United States, and West Germany.

Cultured Pearl Association of America Inc.
411 Fifth Ave.
Room 801
New York, NY 10016
Members are dealers and importers promoting the use of cultured pearls.

Diamond Manufacturers and Importers Assoc. of America Inc.
521 Fifth Ave.
Suite 1700
New York, NY 10017
Founded in 1932. Membership includes two hundred diamond manufacturers, importers, and wholesalers who maintain contact with government agencies whose rulings affect the diamond industry; keeps members informed of new developments; helps the FTC formulate trade practice rules.

Indian Arts & Crafts Association Inc.
4215 Lead SE
Albuquerque, NM 87108

International Society of Appraisers
P.O. Box 726
Hoffman Estates, IL 60195
A society of personal-property appraisers recognizing over one hundred areas of expertise. Two thousand members.

Jewelers of America, Inc.
1271 Avenue of the Americas
New York, NY 10020
JA is the national trade association dedicated to promoting the welfare of all retail jewelers. The association offers benefits, services, and educational programs designed to aid its twelve thousand members in their retail operations.

Manufacturing Jewelers & Silversmiths of America Inc.
Biltmore Plaza Hotel
Kennedy Plaza
Providence, RI 02903
Founded in 1903, MJ&SA's approximately twenty-three hundred members are manufacturing jewelers and silversmiths, suppliers, sales representatives, and artisans.

The National Association of Jewelry Appraisers
4210 N. Brown Ave.
Suite B
Scottsdale, AZ 85251
Founded in 1981, NAJA is a professional association of individuals with an interest in the valuation and appraising of gems and jewelry. Seven hundred and eighty-nine members.

National Association of Watch and Clock Collectors Inc.
514 Poplar St.
Columbia, PA 17512
More than thirty thousand members in one hundred thirty-six chapters in United States and eight chapters abroad. Disseminates horological material and information.

Precious Metals Institute
5 Mechanic St.
Attleboro, MA 02703
General industrial and public information regarding all silver, gold, and platinum products, including solid and bi- or tri-metals.

The Silver Institute
1026 16 St., N.W.
Washington, DC 20036
Worldwide association of miners, refiners, fabricators, and manufacturers.

Society of North American Goldsmiths
6707 North Santa Monica Blvd.
Milwaukee, WI 53217
Five thousand designers and artisans working in precious metals and gems.

Watchmakers of Switzerland Information Center, Inc.
608 Fifth Ave.
New York, NY 10020
Provides information and assistance on Swiss jeweled-lever and electronic watches in the United States for retail jewelers and others.

INDEX